We Love Magazines

Edited by Andrew Losowsky, designed by Jeremy Leslie

First published in Luxembourg
© Editions Mike Koedinger SA 2007
All rights reserved. No part of this book may be reproduced
without the prior written permission of the publisher

Book published by Editions Mike Koedinger SA
10 rue de Gaulois, L-1618 Luxembourg
Grand-Duchy of Luxembourg
www.mikekoedinger.com

Book produced by John Brown
136-142 Bramley Road, London W10 6SR
United Kingdom
www.johnbrowngroup.co.uk

Publisher: Mike Koedinger
Editor: Andrew Losowsky
Design and art direction: Jeremy Leslie
Designer: Malin Persson
Picture editor: Graham Harper
Researchers: Ariane Petit, Nicole van de Burg
Managing editor: Rosie Mellor
Sub editors: Stuart Maddison, James Debens
Pre-press: John Brown

Cover photograph: PSC
Cover illustrations: Mio Matsumoto
Typeface: Verlag by Hoefler & Frere-Jones
Printed in Luxembourg by Victor Buck on Tauro Offset paper by M-real
ISBN 978-3-89955-188-4

Exclusive worldwide distribution: Die Gestalten Verlag
Contact: sales@die-gestalten.de

Contents

Introduction

People of all ages and backgrounds gather together at the magazine rack. They read magazines for work and for pleasure, to follow popular obsessions, and to practise curious hobbies. Magazines are part of the moment in which they were produced, creations whose look and feel date incredibly quickly – adding to their allure. They both reflect society, and actively contribute to it through original writing and design. The magazine is a living, evolving medium that, at its best, is thrilling and invigorating both to consume and to create.

This book is about the shared pleasure of magazines. It explores this magic through individual stories and by examining wider issues such as advertising and distribution. This book also includes the most comprehensive directory ever compiled of international pop culture magazines and the shops in which to buy them. This book is a love letter, written to a medium that continues to sustain and surprise.

In creating this book, there were two major challenges: firstly, how to define what a magazine is (and isn't); secondly, deciding who 'we' are in our title, and why our opinions should matter.

The commonly accepted meaning of the word 'magazine' is a commercial, periodical publication intended for general consumption (unlike, say, an academic journal). But even this definition doesn't cover what magazines are. Do magazines have to be commercial? Those supported by arts foundations and charities aren't; customer and members' magazines usually won't be, at least not directly. Periodical? An event can produce a one-off magazine, and many microbudget magazines appear too irregularly for the term 'periodical'. And must 'publication' refer to printed work of a certain format/size/sensation? *Granta* looks and feels like a book. *Visionaire*, *Las Más Bella* and *Shift!* constantly change format, almost never publishing in a traditional manner. Meanwhile, 'magazine shows' exist on television; electronic magazines arrive by email; e-magazines can be downloaded as PDFs; and web magazines appear online. Plus, as niche audiences become ever more specific, 'general consumption' can no longer be assumed either.

Perhaps the only restriction that we can safely employ is that a magazine is something that appears in numbered editions (even a special publication is referred to as a 'one-off'). This means that we can refer to a specific issue of a magazine, published on a particular date; editions can be seen in the context of their forebears or successors. Constantly updated websites, therefore, don't qualify. Online publications that appear in numbered editions, such as

thisisamagazine.com, do. Apart from that, 'magazine' is defined as much by what it's not – a newspaper, a book, a journal – as what it is. Definition, therefore, is left to the publication's creators, and to audience perception (so this book will refer to *The Economist* as a magazine, although they call themselves a newspaper).

As for who 'we' are, this book has been shaped by the thoughts and opinions of magazine lovers all over the world, from Romania to South Africa, Australia to the USA. Even the production of the book has been an international effort – published in Luxembourg, edited in Spain and designed in London. Through surveys, emails, telephone conversations and face-to-face discussions, this book has been formed by the experiences of people who know magazines best: those who make them, and those who read them. Some areas and territories are probably under-represented; others have their stories told from a different perspective to what you may expect. This is, by its nature, a personal book about magazines and magazine culture. It isn't a complete study of every significant publication – such a work could never hope to be – but aims to celebrate, entertain and inform with genuine pleasure and analytical expertise, just as the very best magazines always have.

The conversation doesn't end here. This book was created as an accompaniment to the Colophon2007 magazine symposium, and the event's website offers an ongoing resource for magazine lovers and creatives, as well as a place to add your favourite magazines to our database, and to tell the stories that should have been in this book. Visit www.welovemags.com and help us create our next edition.

Andrew Losowsky, Madrid, 2007

Colophon2007

Colophon2007 took place in Luxembourg on 9-11 March 2007. The event was initiated both to celebrate and to encourage the growing number of independent magazines created around the world. We wanted to praise successes, acknowledge lessons learnt, and also to invite the people behind these magazines to share their knowledge and experiences.

The symposium took place in the Casino Luxembourg centre for contemporary art, where ten groundbreaking, independent magazine makers were invited to build a 3D representation of their publications. The same ten magazines (*Carl*s Cars*, *Coupe*, *Frame*, *Omagiu*, *Rojo*, *S-magazine*, *Shift!*, *Streets/Fruits/Tune*, *thisisamagazine.com* and *Yummy*) were also asked to create their own chapters for this book.

During the three days of the event, the Casino was the venue for presentations by publishing specialists, a series of round-table discussions and portfolio shows from both students and professionals. There were also several accompanying exhibitions, including a Magazine Graveyard, a series of classic covers, a celebration of 20 years of the Luxembourg fanzine *X Non Magazine*, and a special tribute to *Magazine*, the French title dedicated to independent publishing.

Perhaps the most vital part of the whole event was the Room With a View, a glass room overlooking the city, that acted as library, coffee house and magazine store. Here, everyone attending Colophon2007 met, exchanged ideas and borrowed/bought the best independent magazines currently being published worldwide.

Magazines never cease to amaze and inspire. The event and this book are dedicated to their wonder.

Mike Koedinger, Luxembourg
Jeremy Leslie, London
Andrew Losowsky, Madrid
Curators of Colophon2007

The eternal spirit of adventure

By Professor Samir Husni

Francis Ford Coppola has his hands in many cookie jars. Besides being, of course, an acclaimed film director, he is the founding editor of a literary magazine that offers the best of modern storytelling. One section in particular of his editor's note in the autumn 2006 issue is worth repeating:

Perhaps the most obvious example of my love of stories is the magazine you are holding now, Zoetrope: All-Story, which I founded nearly a decade ago to support the best of modern storytelling. I established the magazine under the business name AZX – the AZ reflecting the name of my film company, American Zoetrope, and the X to signify the intention of the magazine: to be perpetually experimental. Over the years, I've tried to reinvent the magazine with new ideas. I've introduced the concept of the guest designer, whereby the leading artists of our time – musicians, filmmakers, photographers, painters, architects – were invited to design the magazine. The editors and I have experimented with the content as well, dedicating issues to various unifying themes: Utopia, love, foreign affairs and cinema, among them.

Coppola's 'X' should be something that every magazine embodies. Continuous magazine creation is unpredictable and experimental; every publication is at once both fixed (in concept) and in flux (in content).

Anja Lutz, editor of the German publication *Shift!*, represents the more extreme end of the scale. "When we first started *Shift!*," she says, "we were very involved in formal experimentations, finding new forms of what a magazine could be. From folded posters to loose spreads, held together with a butcher's hook, to cards in a plastic box." And yet each edition is unmistakably *Shift!*.

Life cycle

New magazines are dreamt up each day. Only some will succeed. *The New York Mirror* noted that magazines "spring up as fast as mushrooms, in every corner and, like all rapid vegetation, bear the seeds of early decay within them". The same article spoke of hundreds of publications that folded after a "frost, a killing frost" – but said that "hundreds more are found to supply their place, to tread in their steps and share their destiny".

It's not a new event. That excerpt from the *Mirror* appeared in November 1828. In the 175 years or so since that was written, something has remained constant and true: no matter how many obstacles may face new magazines, people just keep on making them.

That excerpt also brings up a second constant: every magazine will begin and it will one day end. Magazines, just like their readers, have a natural lifespan. The legendary Clay Felker, the founding editor of *New York* magazine, once wrote: "There appears to be an almost inexorable life cycle of American magazines that follows the pattern of humans: a clamorous youth, eager to be noticed; vigorous, productive

Zoetrope: All-Story

Shift!

The New York Mirror

New York

middle age marked by an easy-to-define editorial line; and a long, slow decline, in which efforts at revival are sporadic and tragically doomed."

The only way to try to avoid that decline is through thoughtful, relevant change. To know where and when to make those changes, a magazine must never forget the spirit of its birth. The ideas that first brought a magazine into being are its 'DNA', and form the foundation for how the publication must look, feel and behave. This information will never substantially change; any detouring from it may weaken the magazine and sometimes even kill it. Yet this DNA provides only a foundation for how the magazine can grow and mature. There is a lot more work to be done in the months and years after issue one.

Launch and evolve

The assumption in creating a magazine has to be that this growth and maturity will come. Statistics suggest otherwise – about half of all new publications in the USA will not reach their first anniversary, and 70 per cent of those that fail will not even have had a second issue. Through lack of planning and forethought about distribution, about 25 per cent of new magazines in the USA never even have the chance to put their launch issue on the newsstands. However, once you make it through that tricky start phase, the newsstand is more forgiving than it used to be. My research shows that a magazine born in the late 1970s had a life expectancy of 1.5 years; a magazine today can expect 2.4 years of life.

A new magazine is immediately in a difficult bind. On the one hand, the launch issue is a unique opportunity to grab readers with the title's (hopefully) fresh outlook and great content. The reader expects something polished and new. On the other hand, the launch can never be the perfect issue (and if it were, then development would be tricky). Magazines evolve, change and, ideally, improve as the editions rack up – through better-targeted content and more appropriate design.

Serial adventures: List magazine only lasted one issue; Octavo conceived a series of eight editions of the magazine, and closed on its completion; when your readers know you, you can be more playful, as Marmalade proved with its Mistakes masthead.

Hopefully, the magazine's reach will increase in time, too; this may lead to quite considerable changes in content and philosophy.

A launch is sometimes used as a calling card to hook a wealthy publisher, who may then dictate a magazine's look and feel. Australia's *Russh* was one title offered up for early adoption. Kym Ellery, its market editor, says that today's magazine is nothing like *Russh* issue one. "We had a different publisher then and the first three issues are not a very good reflection of us today. Issue four is [now] considered our first issue."

Russh

"It's a great feeling..."

Many famous magazines would not have survived had it not been for their adoption by another parent. One such is *Harper's*. The generous funding awarded to it by the MacArthur Foundation keeps it going issue after issue without having to worry who is going to pay the next bill to the printer. Another example is *Wallpaper**, now owned by IPC (a subsidiary of Time Warner), which took on the title and its substantial debts, and increased its circulation dramatically – but the changes led to the magazine being disowned by its founder, Tyler Brûlé.

Harper's

*Wallpaper**

Yet another example is *Golf For Women*, started by Debbie and Woody Brumitt, two of my former students. It soon had a circulation of 10,000, which caught the attention of the Meredith Corporation. Meredith bought the infant publication and, since then, has passed it on to Condé Nast. It now has a circulation around the 500,000 mark.

Golf For Women

Whether the publisher changes or not, magazines can never stand still. Ralf Herms from *+Rosebud* in Germany says his magazine has changed and evolved since its launch (see examples, right), as "the editors and contributors also changed perceptions and positions". He adds: "What remains vital is the idea of intentionally starting from scratch for each and every issue. This approach creates extra miles to go, but also opens up a vast variety of directions and possibilities, and therefore gives us almost infinite freedom of choices to develop the project."

+Rosebud

Beautiful/Decay

Amir H Fallah, the founder and creative director of *Beautiful/Decay*, says this ability to grow and change is what keeps such a long-term commitment still enjoyable. He says, "It's a great feeling to know that the project is ongoing and that you have the freedom to continually refine it. I think that is one of the best things about publishing a magazine. If you make a mistake in one issue, you can fix it in the next."

Missionaries and merchants

The disposability of the medium means there is always room to enhance and refine. Lauren Shantall from *Design Indaba* in South Africa feels this strongly: "The challenge lies in the process of refinement – to maintain standards and keep pushing them to new levels of excellence is no easy task, and an absolute delight and satisfaction when this goal is reached.

Design Indaba

The 'where to go' is still here. That said, innovation in content – and attitude towards content – is key, and keeps the magazine fresh."

The way that magazines develop depends on the motivations of the people behind them. These people can roughly be split into two categories: the missionaries and the merchants. The missionaries are those who believe in a better world, and that their magazine will help to form it. They are emotionally tied not just to the philosophy of the magazine, but also to its very survival. Every slight on the publication is taken personally; it is their baby and they care passionately about its development. The merchants, however, can be considered as publishers who may still love their publication, but regard publishing as a job. The main role of the magazine is as a profit-maker for the company.

The divide between missionary and merchant can be clearly demonstrated. In 2006, Time Inc. put 18 of its magazine titles, including *Parenting*, *Field & Stream* and *Outdoor Life*, up for sale. For Time Inc. the costs associated with the magazines outweighed the benefits, and so a prudent business decision was made that barely raised an eyebrow in media circles. However, if Hugh Hefner or Jann Wenner were forced to sell *Playboy* or *Rolling Stone*, there would not only be articles in all

Parenting
Field & Stream
Outdoor Life
Playboy
Rolling Stone

These people can be split into two categories: missionaries and merchants. Missionaries believe in a better world, and their magazine will help form it. Merchants regard publishing as a job.

the serious newspapers, but also the men themselves would probably be in mourning for years. Hefner and Wenner are of the missionary type of magazine owners: in it for the long haul, passionately and intimately attached to their projects since the very beginning. "Hugh Hefner, in essence, only ever invented one magazine of substance," says Felix Dennis, owner of Dennis Publishing, which produces *Maxim* and *The Week*. "Last time I counted, I have been involved in the launch of more than 50 magazines, only 14 of which are still published. Death and failure run in the family, so it doesn't do to get too attached to any one title, in my experience. And there is another truth – I am a poor consumer of popular media; I watch no television, see no movies and couldn't, quite frankly, care less about magazines, with the exception of *The Week*, *The Economist*, *New Scientist*, *The Spectator* and, occasionally, *The New Yorker*. My magazines are not my 'babies' – they are my business."

Maxim
The Week

The Economist
New Scientist
The Spectator
The New Yorker

Taking risks

There is some merchant/missionary crossover. Both seek to provide readers and advertisers with engaging, good-looking content, a healthy circulation and strong approval ratings. Crucially, both types of publisher have to satisfy their own needs, too – simply by staying in business.

Tempo

Markus Peichl, founder of *Tempo* magazine in Germany, wrote in 2006: "In the 1980s, I started a magazine that is still sometimes called a 'legend among magazines' today... The magazine was called *Tempo*. It ran from 1986 to 1996... *Tempo* is not a legend for me. It was simply a wonderful opportunity and an unquenchable urge. I did as best I could, which often meant a lot of late nights. I loved and hated it. It was my family, my solitude, my fortune and my curse at once."

The more interesting, independent, risk-taking products almost always come from missionaries. These are the people more likely

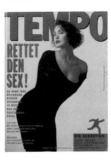 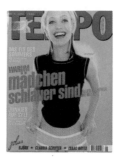 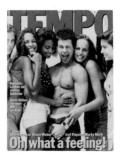

both to celebrate and to suffer as markets and trends change – they remain closely attached to their original vision, so they are often less flexible to the whims of the marketplace than a sales-driven publisher.

This is both their weakness and their strength, as a missionary will also avoid the paralysis of analysis. They tend not to dwell on rationalisation and overanalysing of the audience and marketplace. The ego is their worst enemy and greatest friend; these people do what they do because they want to.

Chimurenga

Ntone Edjabe, founder of the South African magazine *Chimurenga*, is another of these remarkable individuals. Looking back at his magazine's beginnings, he says: "The total sense of irreverence is probably what stands out most when I look at issue one – we truly did our best to come up with the most un-magazine-looking publication possible.

"Following our subsequent entry into the publishing business, we had to learn to conform, to some extent. We have, however, retained a level of unpredictability – our 'comics' issue is an example of how we keep the readers on their toes," Edjabe adds.

Spinning off

Martha Stewart

Focus

Bilt

FHM

Men's Health

Occasionally, the way to develop a magazine's content is to transfer its philosophy into a spin-off title, in the hope that your readers will follow the power of the brand. *Martha Stewart*, *Focus*, *Bilt*, *FHM*, *Men's Health*, *Story*, *Libelle*, *Maxim*, *Qvest*, *Choc*, *Real Simple*, *People*, *Make*: and *Jackie* are just a few brands with their own stables of magazines around the world.

The publishers could see the opportunity for development, often led by advertiser demand, but didn't want to stretch the original publication that far beyond the limits of its 'DNA'.

The last two examples are worthy of further attention. *Make:* is a technology junkie's dream come true. Created by book publisher O'Reilly, its first issue appeared in 2005. Its pages are filled with technology-related projects that readers can undertake for themselves using mainly household objects and a few tools.

Make:'s editors constantly receive mail with new ideas for projects to feature in the next quarterly edition. These ideas always fall into two categories: hard ideas and soft ideas. The hard ideas are the more technical – circuitry, fabrication and so on – while the soft ideas are more in line with bookbinding and rubber-stamping.

All the ideas involve technology and a hands-on approach, but the two types are easily separated from one another. Because softer ideas fitted the philosophy of the magazine, but not its original brief, O'Reilly took these ideas and launched a sister title, *Craft:*. *Jackie*, on the other hand, is a women's fashion magazine based in the Netherlands. It was started by Femmetje de Wind and Yves Gijarth, and named after Jackie Onassis; the magazine was meant to reflect the status and passion of the former US First Lady through style and fashion features, and real-life stories. After 15 issues, *Jackie*'s creators decided that their outlook could work just as well for the opposite gender, but instead of adapting their original vision, they created a new title, *JFK* – launching in September 2006. Its motto is: "Behind every great man stands a great magazine".

In fact, President Kennedy himself was a big fan of magazines. He once summed up the role that they play in society: "To confront the great issues of our times; to open up the conflict of opinion;

Story

Libelle

Maxim

Qvest

Choc

Real Simple

People

Make:

Jackie

Craft:

JFK

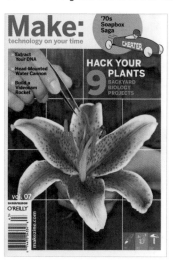

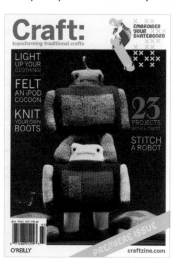

to welcome the unpopular idea and the controversial issue; to show curiosity, and compassion and concern; to be literate and spirited; to give a faithful picture of America; to bring people broadened knowledge and deeper understanding on every subject in the universe."

That role remains the same, although magazines now look quite different from those JFK was familiar with. As Benjamin Compaine noted in the *Journal of Communication*: "The most significant reason for the magazine's survival has been its ability to adapt to a changing role in society."

Journal of Communication

The art of survival

As society changes, so must magazines in order to survive. Creating a magazine that is a reflection of the times is one thing – keeping it going successfully as those times, and your staff, move on is quite another.

The art of magazines is in many ways about launching a template, with clear design and editorial boundaries, which is then adapted to the content of each issue. As the creators get better at it, those concepts become tighter and more identifiable to the reader – or, sometimes, they might go more playful and experimental.

After all, the readers only live with the magazine for a relatively short period of time each issue; its creators do so as a full-time (and more) job. The content has to be kept fresh, not just for the reader, but also for the people creating it – all without losing the 本質 essence of what makes that magazine unique.

Working on the development of a magazine is a unique demonstration of potentially unending improvement and development. It's not about creating a planned series of content with its own carefully planned narrative arc, as with, say, a 23-part TV series or a trilogy of books – instead, successful magazine creation is about consistency and surprise, experimentation and regular features, originality and familiarity; a community of readers and a benevolent dictatorship of editorial and design. 氣功 獨裁

It's a series with a beginning but no planned end, and only unclear a vague idea of how that series will pan out. And no matter how remarkable one edition is, it will only sit on the newsstand for the same length as all the others.

As we pick up the latest issues of our favourite magazines, we do so with the spirit of adventure; we constantly ask ourselves, "What will they think of next?" It's that eternal questioning and anticipated thrill that brings us back to magazines time and again – and is just one of the many reasons why we love them.

Prof Samir Husni is chair of journalism at the University of Mississippi.

Magazine 1/10

Carl*s Cars

Norway

Some call *Carl*s Cars* a niche magazine. Its Oslo-based founders, Karl
Eirik Haut and Stéphanie Dumont, consider instead that it is: "The
established media [that is] narrow in its content." *Carl*s Cars* is about
people, car culture, art, fashion, music and a fine taste for the retro-
chic. New photoshoots sit alongside 1970s Mitsubishi car ads featuring
geishas. The fictional Carl chooses the content of each issue, and his
magazine's glossy look and sublime design are enhanced by its sharp
sense of humour and critical eye on our consumerist society. As its
creators themselves put it, "the thick cover of *Carl*s Cars* should feel like
a firm handshake when you pick it up to read, because Carl is a nice guy".

How did Carl's Cars start?
On a napkin. Several names where written down and
passed around the table. A part from the denomination,
it started because we had stories we wanted printed.

What does the name refer to?
'Carl' is a fantasy person and 'cars' is his subjective
and highly personal choice of stories he presents to
the readers in the magazine.

Who is the magazine aimed at?
People who relate to several interests and hobbies,
like you are into art but also into cars.

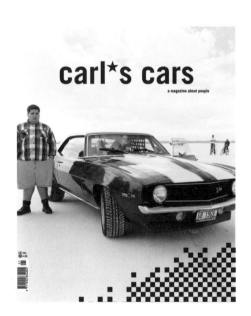

*What is the driving force
behind the magazine?*
The contacts and friends we
already have, and the new
opportunities we get to meet
interesting people. When we
started, there wasn't a magazine
about pure car culture.

Why use the format of a magazine to express that?
A magazine is like a close friend that you can
bring with you wherever you want, even in bed.

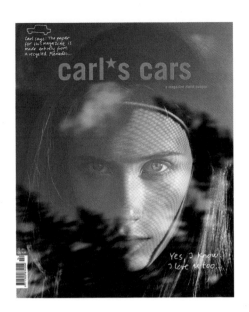

carl says: The paper for this magazine is made entirely from a recycled Mercedes...

carl★s cars
a magazine about people

Yes, I know... I love it too...

CARL'S INTER VIEW

You describe it as "the first magazine which blends car culture with music, fashion, film and design." How are these connected to car culture?
Writers, film-makers, musicians, artists, video game creators and others have often referred to or employed cars in their art. We find this interesting that cars not only exists as objects on the road, but at the same time as virtual fantasies or symbolic carriers. They are quite present in our consciousness, where they even don't pollute as much as in reality.

Does the magazine often get put with motoring magazines on the shelf? Does that bother you?
We are always happy when new people get to discover the magazine. Sometimes it has been placed among interior magazines. We find it all flattering, but its real home is in the lifestyle shelf.

Which is your favourite issue so far? Why?
Our first, because it launched the idea. Then all the ones with artists talking about why cars are occupying them.

Where is the magazine on sale? Carl's Cars is sold in 20 countries.

What's the hardest part of creating Carl's Cars?
To create it exactly the way we want, the way we imagine it in our minds. The most fun part is to work with people, the hardest part is the last days before going to the printers. Changing ideas at the last minute is now forbidden. Officially.

A CAR TALK WITH MATTHEW BARNEY

PHOTO SØLVE SUNDSBØ

Matthew Barney, why is your art loaded with references to interesting cars?

My relation to cars isn't really about loving them, it's about needing them.
In Boise, Idaho, where I grew up, the mountains are facing the city and there's
snow for the most of the year. People are dependent on their cars. The big
amounts of salt in the streets made my father's many Subaru 4x4s rust apart,
but they were still the best for getting around in wintertime.

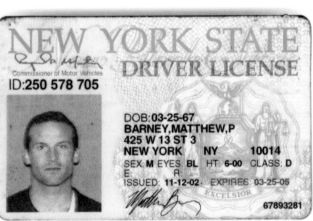

NEW YORK STATE
Commissioner of Motor Vehicles
DRIVER LICENSE

ID:**250 578 705**

DOB:**03-25-67**
BARNEY,MATTHEW,P
425 W 13 ST 3
NEW YORK NY 10014
SEX:**M** EYES:**BL** HT:**6-00** CLASS:**D**
E: R:
ISSUED: **11-12-02** EXPIRES: **03-25-05**

EXCELSIOR

67893281

Matthew Barney kindly lets us have a look at his driver's licence.

Olivier Theyskens, do you think that exhaust can be beautiful?

One of my fashion collections had to do with clouds from several shades. In general I think volutes are beautiful like smoke out of chimneys or pipes. But I have to say that I hate pollution and exhaust are for me cars' assholes!

A CAR TALK WITH OLIVIER THEYSKENS

PHOTO XAVIER CARIOU
& DAMIEN BENETEAU

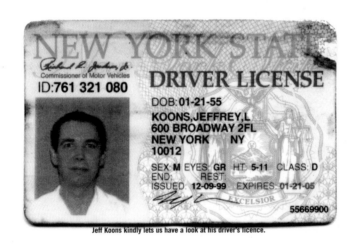

Jeff Koons kindly lets us have a look at his driver's licence.

Jeff Koons, do you read car magazines?

Once a year I buy about 100 magazines, all sorts, everything from swimsuit publications to fashion monthlies. I do it to see how objects are displayed and how people are represented, because this interest me a lot. There are some car magazines among them, and I especially like Lowrider Magazine. I find that the older customized and lowered American cars are photographed in a very sexual way.

A CAR TALK WITH JEFF KOONS

PHOTO LARS BOTTEN

Carl*s Cars

Riddervoldsgt. 12
N-0258 Oslo
Norway
Website: www.carls-cars.com
Email: karl@carls-cars.com
Parking lot boy/Editor-in-chief:
Karl Eirik Haug
karl@carls-cars.com
Hood girl/Creative director:
Stéphanie Dumont
stephanie@carls-cars.com
Format: 230 x 280 mm

Great moments #1

McClure's and the Standard

Oil Company (1902)

Ground-breaking magazine journalism is a distinct art from that of its newspaper cousin. Ironically, although monthly, fortnightly or even weekly magazines have a longer shelf life than newspapers, it is the content of what the British call "tomorrow's fish'n'chips paper" that currently lasts longer. Few magazines have searchable online archives of their articles; newspapers do so as a matter of course. Whereas in-depth interviews, 'how-to's and 'inside stories' fit the magazine format well, the biggest journalistic scoops are usually delivered through immediacy of the daily paper. Newspapers can bring down governments and drastically change public opinion; magazines rarely do.

McClure's Magazine

It wasn't always thus. We could have chosen any of a host of international examples, but one of the earliest and most impactful pieces of magazine journalism was published in a mammoth 19 parts by the American title *McClure's Magazine*. Founded by Samuel McClure in 1893 with lofty investigative ambitions, in November 1902 it published the first part of Ida Tarbell's *The History of the Standard Oil Company* (the series continued until 1904). This told a tale of unethical practices and price hikes enforced by the petroleum company owned by John Rockefeller (by whom Tarbell's own father had been put out of business). The billionaire immediately threatened to sue. Not only was Tarbell's story vindicated, however, but its subsequent publication in book form helped to change American company law. In the furore, Standard Oil was broken up out of existence – and 'muckraking' journalism was born.

This and other pieces were vital to magazines at the turn of the 20th century and their revelations led to further law changes. Even the women's magazine *Cosmopolitan* ran pieces with titles such as 'The Treason of the Senate', that played a leading role in US constitutional amendments 16 (federal income tax), 17 (elections to the Senate) and 19 (women's suffrage).

Cosmopolitan

However, as newspapers increasingly invested in longer-term investigations, and as technology helped them become far more immediate, magazines shifted away from muckraking. Some reacted

Le maire de « Chaty » et
PHOTO G

LES " QUEULOTS " DE FA
raine. — Vers 1440, un seigneur fit co
la Moselle, au lieu dit « Fal », devenu a
de 3oo âmes.

Ce dur seigneur exigea des
et surtout une obéissance absolue.
seigneur vint en mai passer une v
ment des violettes. Agacé, ainsi qu
nouilles et de crapauds des nombreus
actuelle le village, il obtint, afin de bi
les hommes du village, munis d'un
loppé de fil de chanvre ou de lainage

En 1444, ce seigneur étant mort,
vant ce qui avait été pour eux un d

Les hommes décidèrent de n
drait par la suite « maire de Ch
le premier dimanche après C
son élection, et nomme un « o

Le dimanche 22 février
queuler tous les habitan
remarqua que, sans hé
Campagne, qui se reti
mélangée de purin.

MY TEMPTATION AND FALL

86 MY TEMPTATION AND FALL [M

I replied, Captain Robert Smith, at the Naval and Military Club. It was necessary not to hesitate, and this was the answer that I found on the tip of my tongue.

I had chosen as my destination a well-known restaurant in Regent Street, because it possessed two exits, which made of the café on its ground floor a thoroughfare. By walking in at one door and out at the other I could break the thread of my movements, so that if my cabman were to be made the subject of police interrogation he would be unable to give any useful information. On reaching the restaurant, I went to the bar, and tendered a five-pound note in exchange for some brandy. For I had resolved that during the next hour all the notes must be changed, and changed as far as possible in places where notes were so frequently passed that no particular attention would be paid to the customer presenting them. I then strolled through the café and out by the other door, where I hailed another cab. No one appeared to be following me. I was now about to undertake my most anxious job — namely, to change the fifty-pound note.

It has often been said that a man may starve if he has no friends, no introductions, and a thousand-pound note, so impossible would he find it to get change. Much the same difficulty attaches to the possession of a fifty-pound note. My first impulse was to destroy the note for fifty pounds, regarding it only as a piece of incriminatory evidence against me. But, on second thoughts, fifty pounds formed so large a portion of the fruit of my crime that I had not the heart to sacrifice the sum. I had myself driven to the emporium of a famous Bond Street jeweler. Here I entered in the furred coat and new silk hat, displaying the gold-headed cane. In this way I made a sufficiently imposing figure, and when I bought a small diamond ring, priced twenty guineas, and presented the fifty-pound note in payment, the change — five five-pound notes and four sovereigns — was given me without question.

I now had seven five-pound notes that required to be cashed immediately, while I felt that I must get rid of the fur-lined coat; for this had served its purpose as a conspicuous garment and was now a source of danger to me. If I was already wanted by justice, the most noticeable point in any description furnished to the police would be the fur-lined coat. But the police could not as yet have communicated with the pawnbrokers' shops, and the possession of property was making of me a man of thrift. I called another cab, and drove north, dis-

missing the man near King's Cross Station, which was a good locality fo posal of the notes in accordance with I pawned the coat for four pounds ten shop near the Great Northern Station prepared as an answer to any possible a story of a discovery, made upon the just as I was leaving town, that I had r with me. I asked for an advance of fiv on the coat, knowing that it must b at least sixty, and I took the sum to v shopman beat me down with great equ for I preferred ninety shillings to pape I then went into a ready-made cloth and bought a black overcoat of the spectable kind, which cost two pounds this I paid with a five-pound note.

For disposing of the other five-pou I had already my plan in my mind. I to me that a booking-office at a railwa was the finest place to melt ill-gotten small face value. Firstly, the clerk in so little of the individual presenting that he can not retain any recollection secondly, he is sure to have lots of ch that no delay occurs. I went into th Cross Railway Station and bought shilling ticket for one place, and at a booking-office a two-shilling ticket for place, and at each booking-office I c note. Then I walked on to St. Pancras Station, and cashed two more five-pou there, at the expense of four shillings' railway tickets. A five minutes' walk me to Euston, where I did the same.

The pin, sleeve-links, watch, an remained for disposal. These and the ring which I had bought in Bond pawned for sixteen pounds, receiving pound notes and six sovereigns. W note I bought a pair of boots, direc Frazer's boots to be sent to Captain Smith of the Naval and Military Clul the other note I bought an umbrella, Mr. Frazer's stick in the shop to be fi a new ferrule. I lit Mr. Frazer's r cigar, and then slipped the empty case pocket-book into the slot of a pillar I had previously torn out the letters an randa. I was now quit of all the stol erty that could be identified, and, as I my lodgings, I heard the clock strike s

If any Captain Robert Smith is a of the Naval and Military Club, ar memoirs should meet his eye, he will un now the meaning of the two parcels th have puzzled him considerably.

IN SEPTEMBER, "THE IMMODEST ANTIQUE" — THE NEXT ADVENTURE OF THE INDUSTRIOUS CHEVALIER

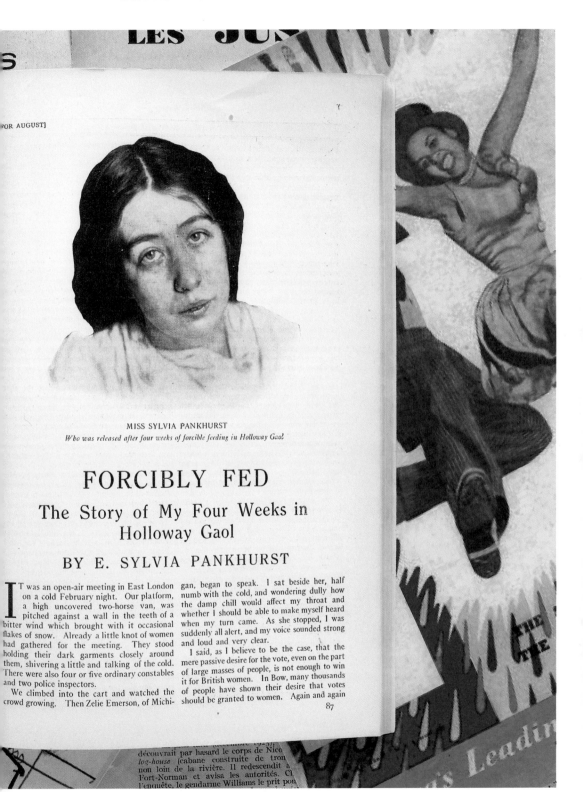

MISS SYLVIA PANKHURST
Who was released after four weeks of forcible feeding in Holloway Gaol

FORCIBLY FED

The Story of My Four Weeks in Holloway Gaol

BY E. SYLVIA PANKHURST

IT was an open-air meeting in East London on a cold February night. Our platform, a high uncovered two-horse van, was pitched against a wall in the teeth of a bitter wind which brought with it occasional flakes of snow. Already a little knot of women had gathered for the meeting. They stood holding their dark garments closely around them, shivering a little and talking of the cold. There were also four or five ordinary constables and two police inspectors.

We climbed into the cart and watched the crowd growing. Then Zelie Emerson, of Michi-gan, began to speak. I sat beside her, half numb with the cold, and wondering dully how the damp chill would affect my throat and whether I should be able to make myself heard when my turn came. As she stopped, I was suddenly all alert, and my voice sounded strong and loud and very clear.

I said, as I believe to be the case, that the mere passive desire for the vote, even on the part of large masses of people, is not enough to win it for British women. In Bow, many thousands of people have shown their desire that votes should be granted to women. Again and again

87

by adding depth to already-existing stories, particularly through vivid photojournalism. Others turned to more lucrative fare – thus the rise of the scandal magazine in the 1950s and 1960s, as embodied in the salacious magazine editor portrayed by Danny DeVito in the film *LA Confidential*.

Today's celebrities-going-shopping stories owe much of their banality to that era. Meanwhile, as the web and television now gradually steal the newspapers' position as the revealer of news, newspaper journalism and design are becoming more magazine-like, providing analysis alongside the facts. As a result, magazines such as *Time* and *Newsweek* have struggled to remain relevant, and magazine journalism is seemingly being pushed into an ever-shrinking corner.

But it's not all one-way traffic. Seymour Hersh revealed the atrocities in the Abu Ghraib prison not in the pages of *The New York Times*, but in *The New Yorker*; both he and the magazine maintained in-depth investigations into the origins of the second Gulf War. And – in perhaps the ultimate magazine scoop from under the noses of the papers – it was *Vanity Fair* that finally uncovered the identity of *The Washington Post*'s Watergate mole, Deep Throat (revealed to be former FBI Associate Director William Mark Felt Sr.).

The age of indulgent, 12,000-word magazine articles may be all but gone. But that doesn't take away from the power of good journalism, as magazines such as *The Economist* and *Mother Jones* continue to demonstrate.

Time

Newsweek

The New York Times

The New Yorker

Vanity Fair

The Washington Post

The Economist

Mother Jones

From the top:
The New Yorker
exposes the
Abu Ghraib
prison atrocities;
Vanity Fair *reveals*
the real Deep
Throat

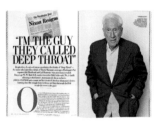

Hold

the

front page

By Andrew Losowsky

*You there, walking along the road thinking of other things! Stop and take
a look at the gravestone of Thrason, and feel sorrow.*
— Gravestone on the outskirts of Athens, inscribed around 540BC

Magazine covers are more than just 'Page One'. They're the public face of
the publication. They are its image and its main marketing tool. They aim
to catch the eye of the passer-by and to tantalise the onlooker with the
promise of fascinating content within.

They play a significant role in our media-centred culture;
several books have been written about magazine covers. Exhibitions have
been held of them. And when in a country where you don't speak the
language, magazine covers provide an instant window into another culture
and its preoccupations. Through careful use of psychology and image,
magazine covers can even have a powerful effect on behaviour.

What makes them special

Why are the language and context of the magazine cover quite so
extraordinary? On one level, film posters use a similar vocabulary,
consisting of a strong image and headline to sell an idea – but the content
they promise isn't instantly accessible, the poster instead being a reminder
of a product that you have to go elsewhere to experience.

What about book covers? They aim for the same 'pick me
up' effect, with commercial success often determined by an image, the
author's name (in effect the book's brand, or masthead) and a blurb (or
back coverlines). But books, like films, exist in a wider context. People
often read reviews and interviews with the author to help them decide
what to buy. They are discussed in other media, and to buy a book is to
enter into a greater commitment than purchasing a magazine. Plus,
a flick through a book's pages is almost always unsatisfying; the content
will remain hidden and out of context unless you start reading from the
very beginning.

Newspapers are easier to dip into, they are using
increasingly magazine-like cover images, and they, too, sell copies partly
on the strength of their front pages... but those frontages are far more
than mere marketing of what's inside. They will actually tell (or at least
include the start of) a significant story right there in front of us. We can
begin reading the story without even picking up the paper. We can react
to the biggest story that that edition has on offer before we decide if it
merits further reading. And no matter how magazine-ified they become,
both the physical sensation and cultural significance of newspapers make
us consider them in a very different way.

The magazine cover is a unique format. Broadly speaking,
all magazine covers around the world, in all genres and industries, are
designed with an identical goal in mind – to get someone to pick up the

*"David King's early
City Limits covers
remain among my
favourites. Simple,
cheaply produced
and vivid, they were
great examples of
the front cover as
poster. They featured
a single sans serif
typeface (a tough,
bold grotesque) and
bold CMYK colours
applied liberally
around and over
coarsely reproduced
halftones"*
– Jeremy Leslie

magazine and read what's inside. But the context of that act varies hugely, and we should understand the significance of these contexts in order to appreciate fully the effectiveness of any given cover.

Selling

A great cover can help sell a magazine – but it's not the only factor at work. In the USA and UK, for instance, the newsstand cover is only the first stage in making a sale. If the cover works successfully, then consumers (or at least those not in a hurry) will usually pick up the magazine and leaf through it before making the purchase (unless the publications are

plastic-wrapped away from casual eyes – which is why such protection can have a negative effect on sales if not packaged with a free gift as compensation). However, in some other countries including Russia and Spain, magazines are usually sold in small kiosks where browsing is not permitted. They are displayed in tight racks showing only the masthead. The cover's effect shifts from being the first point of entry, leading to a purchase, to an added bonus once the purchase is made. Unsurprisingly, with nothing else to go on, brand loyalty is far higher in such places.

 In Spain in particular, the cover is no longer the main frontline weapon in the sales war; instead, occasional giveaways – buy one magazine, get one from a different genre free – help to introduce consumers to new brands. Frequent and large cover mounts also allow individual titles to become more visible, forcing the magazine off its tiny space in the rack and onto the floor in front of the kiosk.

 Even in countries where products are within reach, the design and nature of the different possible points of sale have to be considered. If a magazine's main sales points are art museum shops and

"Nowadays, covers all seem to look the same"
– Garth Walker

independent design stores, their audience is more likely to be curious and open-minded, and to take more time over their choice. In such cases, there is more freedom to experiment over the choice of cover image – although the competition is also more likely to be experimental. In other

> ## "Once the purchase has been made, a magazine's cover will sit on the purchaser's desk/coffee table/next to the toilet, competing not with other magazines but with myriad other distractions."

"Fortune was founded not to make money but as an artistic experiment. It had a terrible business plan, hiring too many people and assuming high printing and paper costs right from the start. Did it die a beautiful death? Not at all. Right from the start, art director T. E. Cleland and art editor Eleanor Tracy created beautifully designed, illustrated covers, and the magazine was packed with advertisements. Fortune's case should become a role model for mediocre publishing houses with their tedious instant magazines. Where are today's farsighted publishers with such vision and verve?"
– Horst Moser

genres, a publisher can afford to risk the potential implications of an edgy cover image if, say, 90% of the readership comes from existing subscribers.

If, however, a company is launching a new mainstream magazine on the newsstand, then the cover is likely to be the least prominent of the launch's probable attention-grabbers; there will almost certainly have to be substantial investment in expensive display stands and both in-store and external advertising. These are essential tools in generating sales and establishing a brand at high speed. The cover becomes the final piece in a very expensive jigsaw.

And the cover's battle doesn't even end at the cash register. Once the elusive purchase has been made, a magazine's cover will sit on display on the purchaser's desk/coffee table/next to the toilet, competing no longer only with other magazines, but with myriad other distractions. If the cover provides no impulse to read the publication, then that purchase may well be a one-time-only event.

The battle continues

Although sales figures aren't an issue, magazines away from the newsstand face competition in other areas. Free magazines in bars compete for attention with well-designed flyers and sometimes television screens; giveaways in railway stations, airline seat pockets or supermarkets have to wrestle with the lure of the newsstand itself. Newspaper supplements battle with the increasingly magazine-like newspapers they arrive in. And unsolicited customer magazines have to overcome the potential cynicism of recipients by creating a genuinely interesting product that is accessible right from the start.

There is one upside, however, about the way a magazine cover sells itself: the process is a promiscuous one. The very act of reading a magazine in public allows the cover to advertise to a whole new potential readership.

The development of the image

"Believe it or not, many magazines – including Esquire *– used to publish covers that didn't have celebrities..."*
– Esquire's archive of magazine covers, www.esquire.com

Esquire

Many people say that the quality of magazine covers – and indeed of magazines – has declined greatly in the last half century. In many respects, both positive and negative, today's magazine marketplace is certainly not what it was 50 years ago. As sales prices have dropped and variety increased, the magazine marketplace has become both more democratised and more competitive. In some sectors, profitability seems to dominate over risk-taking. In other areas, improvements in both the capacity and availability of technology have allowed ground-breaking, professional publications to emerge from small teams and shoestring budgets, pushing the boundaries of the medium.

The cover makers

A good example of the commercial sector's shift in emphasis can be seen by looking at one of the all-time magazine greats. Whenever people write or talk about the greatest ever magazine covers around the world, one name always seems to crop up: that of ad man George Lois, for his work on *Esquire* in the 1960s.

Simple, bold, effective and unencumbered by multiple coverlines, Lois' work was often powerful and extremely effective. Probably his most famous image, *The Passion of Muhammad Ali*, graced the cover of the April 1968 issue. It is often held aloft as one of the best ever pieces of editorial design.

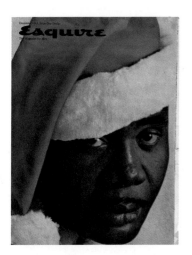 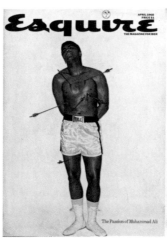

In the current climate, however, it's doubtful that this cover would have appeared at all – not only because of its simplicity and daring, but also because Lois would probably have been fired several years earlier. In December 1962, Lois designed a cover featuring another boxer, Sonny Lipton, as a morose Santa Claus. According to some reports, the cover was so unappealing that it cost the magazine up to $750,000 in lost ad sales and cancelled subscriptions. What publisher today would accept

"My favourite cover was the totally white one, with all the white pages inside. Totally striking for its uncompromising concept, but since I forgot the name of the magazine (like all the content, it was printed in transparent varnish on white paper), it might not have been that successful after all..."
– Anja Lutz

"Any of George Lois' Esquire covers are my all-time favourites: Ali as Saint Sebastian, the Kennedy brothers and Martin Luther King. They were graphic, visual takes on monumental events in American history. Because, with events or celebrities, everyone is getting the same PR and access to whatever the story is, what great art directors can do on good magazines is redefine the story of the moment"
– John O'Reilly

such a blow with a shrug and continue to grant Lois his creative freedom? This and other reasons – such as the fact that Lois was given around two months' notice for each cover – help explain why *Ali* and other covers were very much products of a particular place and time.

Along with his regular collaborator, the photographer Carl Fischer, Lois became one of a handful of creatives associated with producing the covers of a single publication (he didn't do any other art direction in the magazine). Such figures are rare, but bring a unity of style that helps make a magazine instantly recognisable. America seems particularly fond of the role: say Norman Rockwell, and you think of the *Saturday Evening Post*; an Annie Liebowitz gatefold is *Vanity Fair*; Charles Burns' illustration equals *The Believer*.

Saturday Evening Post

Vanity Fair

The Believer

Recurring themes

In the absence of regular exclusive contributors, one strategy for maintaining brand image is to allow greater freedom over the choice of cover image, but complete consistency in their frame. Among magazines that use a simple one-colour border round their more varied cover images are *National Geographic*, *Time* (both USA), *L'Express* (France) and *Der Spiegel* (Germany).

Others strive for such identifiability through distinctive rules that cover contributors must stick to. The New York-based fashion magazine *Very*, for example, always has a natural, unstyled face on the cover. Since its formative years in the early 1980s, *i-D*'s cover has always

National Geographic

Time

L'Express

Der Spiegel

Very

i-D

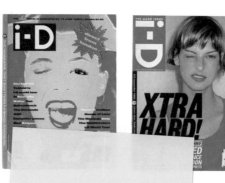

carried a winking face as suggested by the 90-degree clockwise rotation of the magazine's name. The short-lived *George* (USA) dressed its cover stars as George Washington (George Clooney and Cindy Crawford were among those who complied). *Playboy* in the 1960s and 1970s hid the iconic bunny silhouette in every cover, often with great wit and imagination. It's also possible to show continuity through coverlines; each issue of Argentine fashion title *d-mode* is coverlined with a simple 'd-': d-football, d-corazón, d-tokyo ('de' in Spanish means 'of' or 'about'). Such additions are recognisable 'trademarks' for the

George

Playboy

d-mode

browser while remaining fresh for regular readers. Even the masthead can be subject to that desire to keep things fresh. Each issue of designers' magazine *Dot dot dot* (The Netherlands) plays a game with the reader – those in the know must spot the magazine when they see it on the shelf. The clue is always the same: the front covers, above, contain a representation of three dots; domino spots, splashes of ink, rocket exhausts or the Postscript code for an ellipsis ('...'). A quick glance at the spine confirms the title.

 Ray Gun was perhaps equally inventive – just as every page inside was like a graphic-design toy box, the masthead played along, too, each issue writing the magazine's title in a different style. This wasn't actually revolutionary: in the 1920s, magazines such as *Vogue* did exactly the same thing, leaving the decision of how to sketch out its name to the illustrator of each elegant issue. *Scram*, the American "journal of unpopular culture", continues the tradition; each of its covers is either a distinctive comic styling, or apes some other area of once-popular culture, e.g. a women's magazine from the 1950s. The pretence always extends from the cover image and treatment to the styling of the magazine's very name. New readers may be confused, but regular ones can decipher the graphic code. You either get it or you don't.

New readers wanted

Magazines don't only sell to the knowing regular, of course. In order to capture both the fickle and the unaware, covers regularly use two specific sales tools, and they are both applied with such uniformity that many magazines in the same sector seem to be almost interchangeable. First, a celebrity, smiling at the camera; second, that celebrity face is surrounded by coverlines advertising the content, preferably so that all of them could apply to the image in one sense or another.

 Neither is a new idea. Celebrities have sold magazines since the silent-film era, and coverlines existed long before photography. At the turn of the 20th century, magazine covers were still either single-image pieces of art or little more than long lists of the contents, in the style of an academic journal. The development of covers into more carefully directed marketing tools led to the merging of the two.

The power of the image

Coverlines can be invasive. The UK magazine *Grafik* avoided the problem of squeezing them in by suggesting an earlier era, printing the list of

Dot dot dot

Ray Gun

Vogue

Scram

"The beautifully illustrated covers of The Believer make one want to pick up and read a literary magazine again" – Sean O'Toole

"The design is unique and consistent, visually appealing and informative, nostalgic and on top of the zeitgeist" – Ralph Herms

Grafik

Domus

Rojo

contents in the centre of its front cover, backed by an abstract image. The classic architecture magazine *Domus* at one time used single-word coverlines printed on a semi-transparent polywrap, which was then removed following purchase, allowing the image to emerge unsullied (now, its coverlines are printed in small type in a thin coloured band next to the spine – the image remains the most prominent feature). *Rojo* in Barcelona takes this love of the image to an extreme – its covers are treated as such works of art that nothing, not even a masthead or price, is allowed to encroach on their purity. As with *Dot dot dot*, the masthead is instead 'hidden' on the spine.

The New Yorker

The Vancouver Review

*Wallpaper**

As pure sell, coverlines aren't necessary for subscribers. American magazines such as *The New Yorker* place a flap on the left-hand side of the cover for their (relatively small) newsstand sales, not included on subscriber copies. (*The Vancouver Review* echoes that placement but, strangely, without the flap, choosing distinctive images that lose nothing from being half-hidden.) *Wallpaper** takes a similar, though more extreme, line to *The New Yorker* concerning what it sees as the poster-like qualities of its covers: every month, subscribers receive special, coverline-free copies, while the newsstand edition has coverlines overlaid in the standard way. Subscriber copies are therefore seen as being more limited-edition. And in its tenth year of publication, special subscriber-only covers were commissioned as an extra incentive to sign up.

In conceding some ground to the advertising of their content, a number of other magazines keep things as pure as they can by running a single coverline and image relating to one story. This suggests confidence both in the strength of that story, and that the reader will trust

Newsweek

The New Republic

The Economist

Veja

Life Week

that the rest of the content is as strong. *Time, Newsweek, The New*

Focus

Stern

Republic (USA), *The Economist* (UK), *Veja* (Brazil), *Life Week* (China) and the German 'big three', *Der Spiegel, Focus* and *Stern*, all carry single-topic covers, varying the techniques used between typography, illustration, photography and photomontage to try to keep things fresh. But it's a big gamble, not taken lightly: *Der Spiegel*, for instance, reportedly has four full-time staff members who work on nothing else.

These are not typical magazines, of course. They require
a surety in their brand that often comes from a lack of direct competition.
The mainstream will usually shy away from single-topic covers, instead
using a different yet compatible brand to help lift a title above its identikit
rivals – something usually found in the comforting embrace of celebrity.
This certainly doesn't come cheap; in 2005, a *Women's Wear Daily* article
suggested that celebrity cover images cost a magazine about US$100,000

Women's Wear Daily

*Advances in digital paper and low-cost, throwaway screens
suggest that the first ever animated front cover isn't far away.
The newsstand may yet prove even more attention-grabbing.*

to create, style and shoot. The irony is that mainstream magazines, in
searching for cover images that will stand out from their rivals, so often
end up looking identical.

The march of technology

Fortunately, perhaps, famous faces aren't the only things that engage
people's attention. Covers have long been the arena for new printing
effects and fripperies that force us to take a closer look. While magazine
production has changed beyond recognition in most areas over the last
50 years, many of the effects used by *Flair* magazine (USA) in the 1960s
– foil-blocking, lenticulars, die-cuts – remain the mainstay of techniques
still used to surprise and amuse the reader, albeit in more advanced forms.

Flair

There still seems to be plenty of room for originality
in their usage. The American magazine *Flaunt*'s die-cuts continue to
intrigue and engage the browser. Varnish continues to be employed in
ever-imaginative ways by the Netherlands' *Graphic*. Perhaps the ultimate
in big spenders on cover effects was the cultish, short-lived US interior-
design magazine *Nest*. It employed pretty much all of *Flair*'s techniques
and more, also adopting specially moulded plastic overlays and, in one
instance, drilling a hole that began on the cover and ran all the way
through the magazine. The latter in particular was an idea that one would
expect more from a handmade fanzine in the 1970s/1980s than from
a slick 1990s newsstand title.

Flaunt

Graphic

Nest

Perhaps as a reaction to digital media, such personalised,
physical uniqueness and object fetishisation is increasingly common in
professional magazines. Sometimes, that feeling of personalisation comes
in the printing: digital printing was combined with other technology by
American civil liberties magazine *Reason* to print individual covers on each
of the 40,000 copies of its June 2004 edition, the cover image being
a satellite photograph of the subscriber's own house. At other times,
it comes from the object itself: small-run Spanish title *Blank* makes
the covers of each of its copies unique, with one issue that was covered in

Reason

Blank

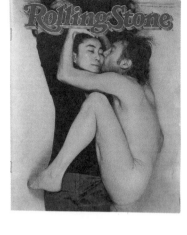

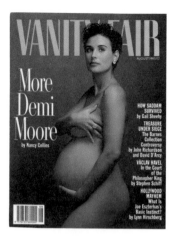

Rolling Stone

a variety of stickers, and another one that was spray-painted like graffiti.

From low-fi to high cost, technology continues to play a huge part in magazine cover development. And what's next? Advances in digital paper and low-cost throwaway screens suggest that the first ever animated front cover isn't far away. The newsstand may yet prove even more attention-grabbing.

While their contents may soon be forgotten, magazine covers live on, reprinted, displayed and included in many, many books dedicated to the art. Sometimes, a cover image will be so iconic that it becomes separated from its context to become a part of our culture's visual memory, as with John and Yoko's *Rolling Stone* cover from January 1981, and Demi Moore's pregnant portrait from August 1991's *Vanity Fair*. Other times, the magazine may even play on a consumer's recognition of its previous classic images, as when *Time* echoed its 1945 cover on the death of Hitler following both the fall of Saddam in 2003 and the death of Abu Musab al-Zarqawi in 2006.

The evolution of magazine covers is a mirror of the changes in magazines themselves. No matter whom you're talking to, and however much things have moved on, the essence of the medium remains the same. The iconography and the celebrities are different now, but magazine covers exist, today as they always have, to say the same three words: "Pick me up."

Andrew Losowsky is the editor of this book.

Magazine 2/10

Coupe

Canada

If you want to know how magazines can look when removed from the commercial mainstream, acquaint yourself with *Coupe*. This Vancouver-based publication uses a large-size format to present material not usually associated with magazines. Each issue takes a theme, which is sometimes pretty loose, and plays around with words and images to create a stimulating, highly visual, but largely unstructured mood board. Yet, it is clearly still a magazine. The running order is skilfully managed to take best advantage of the flow of pages, using changes in pace to maintain interest. *Coupe* is an experiment made all the more enjoyable by the obvious glee of its creators.

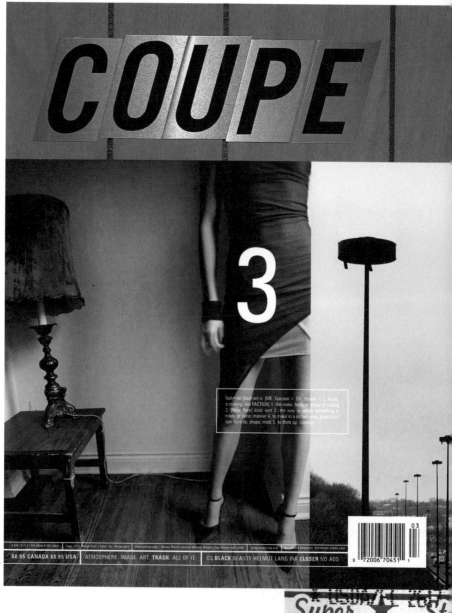

How did Coupe Magazine begin?
Quietly. The premiere issue of Coupe was launched in April 1999. There was no promotion, no marketing, no fanfare. It basically just appeared one day on the magazine racks. That's the way I wanted to do it. I wanted it to grow organically. I didn't even send out any review copies to the media. But that didn't stop them from finding it and writing about it, most of the articles written were from a puzzled viewpoint.

SYNTHETIC H-APPINESS CAN BE A REALITY. IT IS JUST A PHONE CALL AWAY. ACT NOW.

TRIPES

REG $3.00
WAX $5.00

o-Kent, F.Z.S.

(Milford-on-Sea.

HORNED OX-RAY, GOBLIN-FISH.

llies attain enormous proportions. One taken at Barbadoes required seven
yoke of oxen to draw it.

took the train to new york the following monday. the important thing is to create an island of chaos in a sea of order.

CHANGE CAN BE DIFFICULT. BUT IT'S BETTER THAN **A PUCK IN THE FACE.**

IN A SUPERMARKET CULTURE. SO

WHO **WANTS** TO BE A MILLIONAIRE.

WHO NEEDS TO BE A MILLIONAIRE.

WHO HAS TO BE A MILLIONAIRE

DIGLYCERIDES.

Who is the magazine aimed at?
Coupe is aimed right between the eyes of anyone who likes it.

HRISTOPHER MILLS BIO

WISH I WAS A BIRD
RDS ALWAYS LOOK LIKE THEY'RE
VING THE MOST FUN
I WAS A BIRD, I'D TRY TO FLY IN
RONT OF THINGS THAT MATCH THE
OLOURS IN MY FEATHERS DURING
ERTAIN SEASONS. I'D MAKE SURE TO
ON TOP OF THE TRENDS
ASHING PATTERNS, MULTIPLE
OLOUR ACCENTS, MODERNS MIXED
TH CLASSICS, ETC.)

I WERE A BIRD, I'D BE THE BEST
RIEND OF A KILLER WHALE WHO I'D
NLY SEE ONCE OR TWICE A YEAR
D FLY PAST HIM IN THE OCEAN AND
OUT OUT, "HI THERE, PETE! WHAT'VE
OU BEEN UP TO?"
EN PETE THE KILLER WHALE WOULD
Y "OH NOTHING MUCH." (PETE'S A
TOE A MOPER), THEN HE'D GO BACK
TO THE OCEAN FOR ANOTHER YEAR.

I KNEW HOW TO BUILD A HOUSE I'D
KE UP HANG GLIDING
LIVED IN THE SUBURBS I'D HAVE A
OTORCYCLE BY NOW, BUT MY GIRL-
RIEND WOULD BE TWICE AS FAT AS
E IS NOW. (BUT I WOULDN'T MIND
CAUSE I'D BE TWICE AS FAT AS HER)
D HAVE TO GET THE MOTORCYCLE
XED A COUPLE OF TIMES A YEAR.

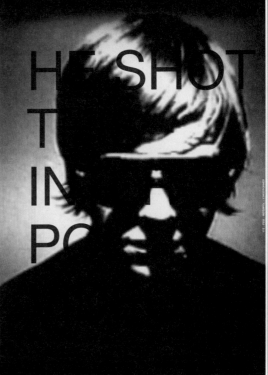

HE SHOT
T
IN
PO

GENESIS 3.23

What does the name refer to?
A coupe is a 2 door sedan. One of the initial concepts for *Coupe* was that of a magazine with 2 specific editorial subjects per issue. And they would be juxtaposed off each other. I thought locking into this concept may be too limiting so the idea was scrapped. But I liked the name and its ambiguousness so I stuck with it.

What is the driving force behind the magazine?
I can't play a musical instrument so I create magazines. I think Coupe has more in common with making records or art than making magazines. Oddly I think the driving force behind Coupe may be music.

Why use the format of a magazine to express that?
Like I said, I can't play.

Each issue of the magazine varies greatly in design and tone. What is the common strand between them all?
I think each issue, on some level, is personal. Personal art is my favourite kind of art. I have a hard time connecting if it isn't. As far as the look of Coupe goes I think there is a strong connection between all the issues even though the word mark and general look may change dramatically. I think the attitude and aura of Coupe remains a constant.

Your typography has often won awards, and sparks comment. What is it that makes your use of typography stand out?
I know what I like and I don't give too much credence to what's going on out there typographically. I know which fonts I wear well.

CO UPE

紐約喬維諾槍店

Which is your favourite issue so far? Why?
Issue 3 was an important step in finding the strongest voice of Coupe. I realized that the further I got from the confines of the traditional magazine the more comfortable I felt. But currently my favourite issue is #15. It featured a collection of 24 typographic landmarks (at least in the eyes of Coupe) in the city of Toronto. Accompanying the photos of of the landmarks were handmade typographic pieces of art. Unexpected and refreshing results occur when creating by hand that just doesn't happen on the Mac. I would like to move Coupe off the computer as much as possible but I'm not sure how realistic that notion is.

I'M A CRUISER.
YOU'RE A LOSER.

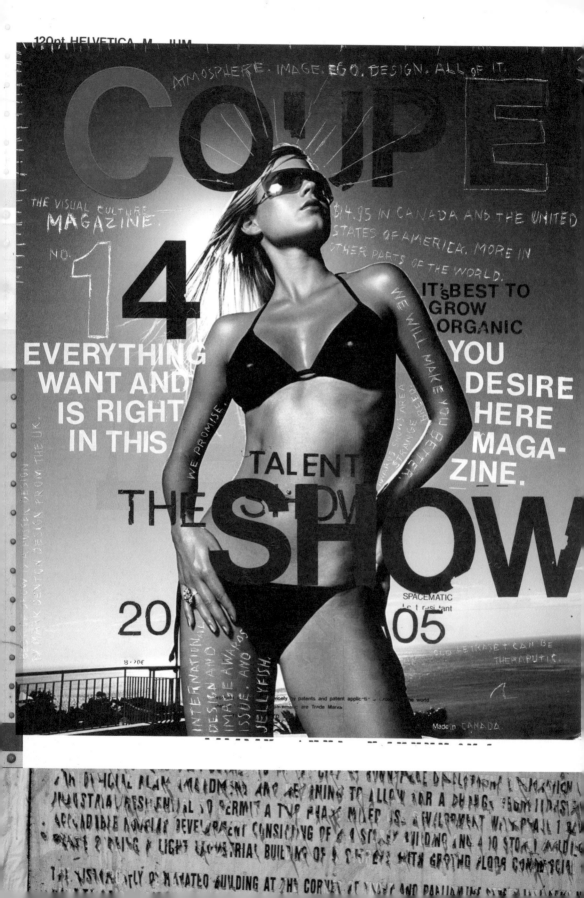

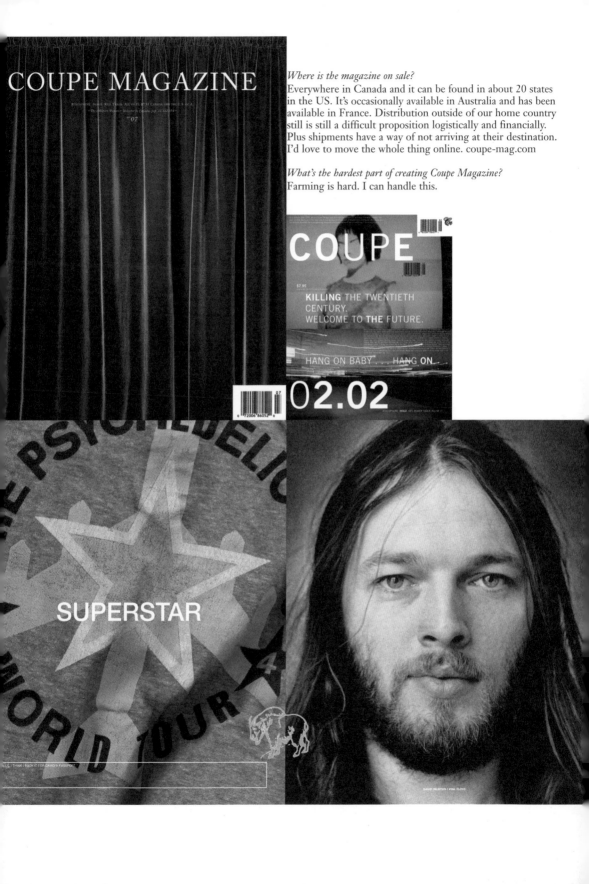

COUPE MAGAZINE

Where is the magazine on sale?
Everywhere in Canada and it can be found in about 20 states in the US. It's occasionally available in Australia and has been available in France. Distribution outside of our home country still is still a difficult proposition logistically and financially. Plus shipments have a way of not arriving at their destination. I'd love to move the whole thing online. coupe-mag.com

What's the hardest part of creating Coupe Magazine?
Farming is hard. I can handle this.

COUPE

$7.95

KILLING THE TWENTIETH
CENTURY.
WELCOME TO **THE** FUTURE.

HANG ON BABY . . . HANG **ON**

02.02

SUPERSTAR

Coupe
9 Davies Avenue, Suite 500
Toronto
Canada
Website: www.coupe-mag.com
Email: info@coupe-mag.com
Editor and creative director:
Bill Douglas
editor@coupe-mag.com
Art direction and design:
The Bang
Format: 245 x 294 mm

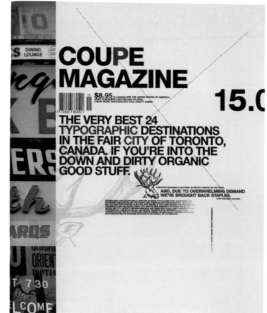

Great moments #2
The launch of *Vu* magazine
(1928)

At one time, quality photojournalism was the unique preserve of magazines. While news could be telegrammed and telegraphed in soon after the event, photographic film required sending (often by ship), processing, developing, drying, selecting and cropping for the page. Even the introduction of wirephoto (aka 'Belino') systems in the 1920s couldn't compensate for the poor printing and paper quality that left newspaper images muddy and lacking in contrast. When photography bloomed in the 1930s-1950s, it was magazines that benefited most.

Vu
Berliner Illustrierte Zeitung
Münchner Illustrierte Presse

One of the very best of the early news photographic publications was the French magazine, *Vu*. Modelled on German magazines *Berliner Illustrierte Zeitung* and *Münchner Illustrierte Presse*, *Vu* was the creation of editor and former art director, Lucien Vogel. According to Vogel's daughter (herself an accomplished photographer, who published some of the first photographs of Second World War concentration camps): "At *Vu*, the only instructions given to photographers were to go to such and such a place. They did what they liked, taking the photographs as they wished." And what photographers they were: Man Ray, Brassaï and all of the original Magnum photographers were commissioned by *Vu* – including the first print reportage by a young snapper called Henri Cartier-Bresson.

Once *Vu* received the photographs, layout artists used cellulose paper to create imaginative layouts that were then printed in héliogravure. Vogel himself had been art director of *Vogue*, the eventual destination of *Vu*'s own art director, Alexander Libermann. Together, they used photomontage and colourisation to create a strong, unique look.

Vogue

Lilliput

While *Vu* enjoyed popularity in pre-war France, in 1934, the Hungarian chief editor of *Münchner Illustrierte Presse*, Stefan Lorant, arrived in the UK. He launched his own pocket illustrated magazine, *Lilliput*. It was sold in 1938 to the publisher Edward Hulton, who put Lorant to work with Tom Hopkinson to establish a new illustrated journal, the *Picture Post*. It is thought that Hulton was expecting a conservative weekly magazine in the mould of the political journal, *The Spectator*. Instead,

Picture Post
The Spectator

ÉCHOS
PHOTOGRAPHIQUES

Le maire de « Chaty » et le nouveau « Queulot »
PHOTO GANSLOFF

Une imposante cérémonie s'est déroulée à Lyon en l'honneur des sauveteurs de la catastrophe de Fourvière. M. Herriot a remis la Légion d'honneur au chanoine Gaillard. — Ci-dessus le général Serrigny épinglant la Légion d'honneur sur le drapeau des sapeurs-pompiers.
PHOTO KRAHENBUHL

LES "QUEULOTS" DE FAILLY — **Une curieuse coutume lorraine.** — Vers 1440, un seigneur fit construire un château dans une vallée de la Moselle, au lieu dit « Fal », devenu aujourd'hui Failly, petit village lorrain de 300 âmes.

Ce dur seigneur exigea de ces braves paysans beaucoup de travail et surtout une obéissance absolue. Pendant de nombreuses années, ce seigneur vint en mai passer une vingtaine de jours au village, au moment des violettes. Agacé, ainsi que sa femme, par les milliers de grenouilles et de crapauds des nombreuses mares qui entourent encore à l'heure actuelle le village, il obtint, afin de bien dormir pendant son séjour, que tous les hommes du village, munis d'un queulot (bâton dont le bout est enveloppé de fil de chanvre ou de lainage usagé) frappent l'eau des marais.

En 1444, ce seigneur étant mort, les paysans résolurent de fêter dorénavant ce qui avait été pour eux un dur labeur.

Les hommes décidèrent de nommer un maire du châtiment qui deviendrait par la suite « maire de Chaty ». L'élu, queuloté par tous les habitants, le premier dimanche après Carnaval, reçoit une hallebarde en souvenir de son élection, et nomme un « queulot » parmi les plus jeunes mariés du village.

Le dimanche 22 février, l'on put voir le « queulot », muni de sa queue, queuler tous les habitants du village, le bâton trempé dans la boue. On remarqua que, sans hésiter, il queula M. Guerinaux, sous-préfet de Metz-Campagne, qui se retira avec les pantalons couverts d'une boue gluante mélangée de purin.

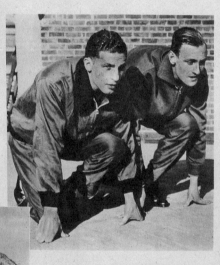

Les deux grands champions français de course à pied, Séra Martin et Jean Keller, sont aux États-Unis, où ils défendent les couleurs françaises. Les voici sur le toit du Wanamaker, où une belle piste a été aménagée, s'entraînant pour les épreuves qu'ils auront à disputer. De gauche à droite : Séra Martin et Jean Keller! — PH. PAC ET ATL

Pour la première fois un avion sur skis, piloté par Faure, a atterri à Mégève, en présence de M. Juillet, préfet de la Haute-Savoie, et du maire, M. Richy, président d'honneur des Sports de Mégève.
PHOTO MARAND

N° 155 VU P. 310

LES JUSTICIERS DU POLE

VIII
QUELQUES
HISTOIRES DE
TRAPPEURS
ET CHERCHEURS
D'OR

par

VICTOR FORBIN

Chercheur d'or lavant les sables aurifères dans un
torrent du Canada.

PHOTO PACIFIC CANADIAN RAILWAYS

L a protection que la
Royale Gendarmerie
canadienne doit aux
hommes blancs éga-
rés dans les solitudes arcti-
ques lui impose de rudes
corvées. Parfois, l'effort
aura été accompli « pour la
gloire » : mise en mouve-
ment sur des racontars
d'Indiens ou d'Esquimaux,
une patrouille parcourra
des centaines ou des mil
liers de kilomètres en
plein hiver, et cela bien
souvent pour constater
que les trappeurs ou cher-
cheurs d'or auxquels elle
portait des secours sont
loin de l'existence où l'existence
en parfaite santé et pos-
sèdent des vivres en abon-
dance. Mais c'est loin
d'être là une règle géné-
rale.

La lecture de ces rapports
de police où je puise ma
documentation détaché,
d'une énorme masse de
faits, d'étonnants traits de
mœurs à l'actif des aven-
turiers égarés dans les gla-
ces polaires. Est-ce tou-
jours l'appât du gain qui
les pousse à fuir la civili-
sation? sont-ils sollicités
par l'attrait de l'inconnu ?
le charme de la vie sau-
vage, mais libre, qui les
entraîne vers ces
déserts où l'existence est un perpétuel combat ?

Je ne puis m'empêcher d'établir un rapproche-
ment entre ces risque-tout des régions arctiques
et notre Légion étrangère. Nombreuses semblent
être les énergies qui, ne trouvant pas leur emploi
dans les centres civilisés de l'Amérique du Nord,
vont le chercher au delà du Cercle polaire. Parmi
ces trappeurs et ces prospecteurs, vous pourriez
relever les nationalités les plus diverses et toute une
collection de castes, plus ou moins dissimulées
sous de faux états civils : un Anglais de famille
noble, un Français qui fut le titulaire d'une chaire
d'université, un ancien officier allemand, un prince
russe. J'ai été particulièrement surpris d'apprendre
qu'un chercheur d'or, secouru sur le rivage de
l'Océan Glacial par la gendarmerie, était originaire
du lointain et tropical archipel des Fidjis !

Les histoires dramatiques sur ces intrépides
aventuriers abondent dans les rapports de la gen-
darmerie ; j'en exposerai quelques-unes.

En août 1923, deux prospecteurs, Nicol
et Beaman, partirent de Fort-Norman, poste
situé sur le Haut-Mackenzie, en annonçant leur
intention de remonter la rivière du Gravier à la
recherche de gisements aurifères. Nicol avait une
parent habitant dans l'Ontario, province du Canada
oriental. Inquiète de ne plus recevoir du nouvelles
de son frère, elle manifesta son angoisse par une
lettre adressée, en octobre 1924, à la direction de
la Gendarmerie montée. Celle-ci télégraphia
aussitôt à Fort-Norman, d'où des patrouilles furent
lancées sur la piste des deux prospecteurs. Vaine-
ment, elles remontèrent la rivière du Gravier
presque jusqu'à sa source, dans les Montagnes
Rocheuses, plus exactement dans celle de leurs
chaînes qui sépare du Territoire de Yukon le dis-
trict du Mackenzie.

Un an plus tard (décembre 1925), un trappeur
découvrit par hasard le corps de Nicol, dans une
log-house (cabane construite de troncs) située non
loin de la rivière. Il redescendit aussitôt à
Fort-Norman et avisa les autorités. Chargé de
l'enquête, le gendarme Williams le prit pour guide.
L'expédition quitta le poste le 20 janvier 1926.
Elle avait à franchir près de 300 kilomètres, en
suivant la route offerte par la rivière congelée.
Une couche de neige cache une crevasse ; le
gendarme tombe dans l'eau glaciale, tord ses vête-
ments sous la bise, les fait sécher sur un feu de
branchages. Enfin, le voici parvenu au but, et il
rédige bientôt son rapport :

« Le corps est assis sur un banc et replié sur les
genoux. Nicol a dû mourir après le 20 mars 1924

à en juger par un calendrier accroché à une poutre,
car c'est le dernier jour marqué par une croix.

« Un ours a pénétré dans la hutte, qu'il a mise
dans un grand désordre, mais sans toucher au ca-
davre. Entré par la fenêtre, il était sorti par la
porte qui ouvrait du dedans en dehors, mais non
sans avoir dévoré le sucre, les fruits secs, la mar-
melade ; rats et souris avaient continué le pillage.

« Après des recherches minutieuses dans les
environs, j'ai d'abord découvert, à un mille et
demi dans la forêt, une hutte abandonnée, puis, à
quelque distance de là, une petite tente, sous
laquelle gisait le corps de Beaman. A portée de sa
main droite s'était un cahier où il avait écrit
l'emploi de son temps. Les dernières lignes, dates
du 22 mai 1923, semblent indiquer que les deux
prospecteurs ont succombé l'un après l'autre au
scorbut... »

L'affaire qui suit présente, d'un bout à l'autre,
l'attrait du mystère. Qu'était-il venu chercher sur
le rivage de l'Océan Glacial, ce jeune homme aux
allures aristocratiques qui se donnait comme un
Américain, du nom de Haverson ? Les rares propos
qu'il avait échangés avec des blancs, à l'époque de
son arrivée, décelaient en lui une haute éducation.
Fuyant la société de ses semblables, il choisit
un point isolé, en face de l'Ile Baillie,
édifia une cabane, acheta aux Esquimaux une
vieille baleinière et un canot, s'adonna à la chasse et
à la pêche.

Cette existence dura plus de deux ans. Les
Esquimaux de la région admiraient son audace,
quand ils l'apercevaient de loin, manœuvrant, à
lui seul, son bateau à voile qui aurait dû occuper
un équipage de trois à quatre hommes. De leur
village, par les temps clairs, ils pouvaient distinguer
la fumée que dégageait la cheminée de son poêle.

Or, un matin, le 19 septembre, alors que la
glace commençait à se former dans les anses, ils
n'aperçurent plus cette colonne de fumée qui leur
signalait, depuis deux ans, l'existence de leur
lointain voisin. Ces braves gens supposèrent qu'il
était malade. Traversant la baie Langdon avec un
traîneau tiré par les apportaient, à un
quartier de phoque, ils trouvèrent la cabane
vide. Les chiens de Haverson, attachés à des
piquets, mouraient de faim. La baleinière avait
disparu de son ancrage habituel.

Les Esquimaux remenè-
rent les chiens et avisèrent
aussitôt le détachement
de police de l'Ile Baillie.
Le caporal Pasley vint en-
quêter sur place. Il décou-
vrit dans la cabane un
calendrier sur lequel des
notes enregistraient cha-
que jour le nombre de
phoques et de gros pois-
sons capturés. Les ins-
criptions s'arrêtaient au
17 septembre. Dans l'a-
près-midi de ce même
jour, le vent du nord-
ouest avait soufflé en
rafales. Le canot avait
disparu. Haverson venait
de « s'embarquer dans
sa baleinière, quand la
bourrasque l'assaillit, le
poussant vers le large ou
la précipitant sur un champ
de glace contre lequel elle
s'écrasa. Il se peut aussi
(car sa carène était vétuste)
qu'un paquet de mer ait
suffi pour l'éventrer.

C'est l'opinion que la
gendarmerie consigna dans
son rapport, mais ce n'est
pas celle que professent les
Esquimaux de la région :
ils imaginent que le mys-
térieux chasseur de pho-
ques et d'ours blancs, se
jugeant encore trop rap-
proché de la civilisation
dans ce coin perdu, s'en fut demander un isolement
plus absolu à quelque lointaine île de l'archipel
arctique...

Je suis dans un rapport de date récente (1929)
une histoire qui m'apparaît encore plus tragique
que les précédentes. Elle occupe dans le livre une
dizaine de pages que je vais tenter de condenser.

M. John Hornby, un Anglais fort riche, et, sans
doute, quelque peu maniaque, s'était épris des
solitudes arctiques. Voyageant le plus souvent
seul, ou en compagnie du premier indigène qu'il
pouvait recruter, il avait accompli de véritables
prouesses et traversé des régions totalement
inconnues. Il aurait pu se faire un nom comme
explorateur ; mais, taciturne, il ne parlait à per-
sonne de ses randonnées, et l'on ne sait même pas
s'il prenait des notes.

Cependant, comme on trouve presque toujours
un businessman quand on gratte un Anglais
authentique, le bruit courut qu'il s'occupait de
prospection, lorsqu'il revint dans le nord-ouest
canadien au printemps de 1926, en amenant
d'Angleterre deux jeunes gens, dont l'un était
son cousin.

En juin 1926, l'expédition quitta Fort-Smith
pour se rendre au Grand lac des Esclaves, avec
l'intention de s'engager le plus loin possible dans
les déserts arctiques, soit entre ce lac et la Baie
d'Hudson. Au cours du mois suivant, les trois
explorateurs furent aperçus, à diverses reprises par des
trappeurs. Puis, le silence se fit.

Une année s'écoula. On s'attendait à voir les
explorateurs déboucher tôt ou tard soit sur le
rivage occidental de la Baie d'Hudson, soit sur
celui de l'Océan Glacial. L'inquiétude ne s'aviva
qu'à la fin de 1927 : la Gendarmerie montée orga-
nisa des patrouilles à l'est du Grand lac de l'Esclave.
Des rumeurs, colportées de campement en campe-
ment par les Esquimaux, donnèrent à penser que les trois Anglais avaient été assassinés.
Dès lors, la Gendarmerie envisagea l'organisation
d'une expédition pour éclaircir le mystère.

La vérité ne devait être connue que le 7 août 1928
quand un intrépide prospecteur canadien, M. H. S.
Wilson, atteignit le poste de Chesterfield, sur le
rivage de la Baie d'Hudson, après avoir franchi
l'affreux désert des Barren Grounds : le 21 juillet,
il avait découvert dans une cabane, à cent kilo-
mètres en aval du confluent des rivières Hanbury
et Thelon, les corps de M. Hornby et de ses compa-
gnons. Les malheureux avaient succombé à la

Life

Lorant and Hopkinson reinvented the photography magazine. Words were included, but it was the images that told the often-political stories. *Picture Post* is often cited as the major inspiration for the great American magazine *Life* (Lorant certainly always thought so). Lorant was in charge of the magazine from 1938 to 1940, during which time *Picture Post* sold more than a million copies per week.

Time

The Sunday Times Magazine

Stern

By the start of the Vietnam War, magazines were sending photojournalists with their reporters to the battlefield, with names such as Don McCullin and Larry Burrows shooting remarkable images for *Time, The Sunday Times Magazine, Stern* and other publications with the budgets and the courage to commission them. Magazine photography could even change lives. Gordon Parks' images of a Brazilian *favela* (shanty town) for *Life* magazine in 1961 led to reader donations so that the pictured child dying of malnutrition could be saved.

Today, those days of expensive battlefield commissions from magazines are all but over – few magazines follow *Stern's* lead in continuing to pay for expansive pieces from photographers such as Sebastião Salgado, preferring the work of local 'stringers'. But the varied styles of stringers' work come at the cost of an identifiable look and global experience that regular contributors bring.

Interview

Magazine photography has developed into the art of the interview and fashion shoots, in part thanks to Andy Warhol's *Interview* magazine, launched in 1969. Annie Liebowitz and David LaChapelle are now among the biggest names in the field, their task not to reveal hidden stories, but to provide new perspectives on the familiar and celebrity.

Colors

Great photographic stories still have a place – Tibor Kalman's *Colors*, for example, changed the vocabulary of picture captions and visual essays in 1990. But photojournalism as a genre now tends to remain in magazines that specialise in photography as art (such as the UK's *8* or Turkey's *Iz*), or as illustrations in newspaper supplements. It is no longer part of mainstream magazine consciousness.

8

Iz

From the top:
The Sunday Times
Magazine; Colors

Magazine 3/10

Frame

The Netherlands

There are many magazines about interior design out there, but only one *Frame*. Published from Amsterdam but with a global outlook, in 11 short years, it has established itself as the magazine of record for the new world of commercial interior design ('The great indoors'). Unashamedly trend-orientated, it focuses on the new and radical in offices, shops, bars and clubs. While many interiors magazines strive to let the featured work be the star, *Frame* presents its content within a constantly developing design that makes each issue a visual treat.

FRAM3

THE GREAT INDOORS

1

FRAME
Interior Design
Magazine
Amsterdam,
The Netherlands
42°43′59.27″N
2°4′50′52.38″W

Frame offers a good mix: those who like looking at pictures can look at pictures, while those who want to read about the latest developments in the world of design are certainly not overlooked. *Frame* sees design as a big party for the entertainment of as many people as possible.

Jeroen Junte, journalist for *de Volkskrant, 2000*

The Flatplan . . . 200 or so crisp, blank pages await the cream of nonresidential interior design worldwide. Filling those pages means searching, shuffling, synchronizing – as with anything in life, it's all about the right mix.

How did *Frame* begin?

It all started in 1995, in a Stube in Hanover, where Peter Huiberts (now publisher of *Frame*) and Robert Thiemann (*Frame*'s editor in chief) considered the possibility of leaving their jobs and venturing out on their own. Fuelled by mug after mug of German beer, they came up with the concept of a magazine on interior design that would fuse British and American journalism with the aesthetic flair of an Italian publication. Going international felt right. Even the morning after, in the cold light of day, they still liked the idea. More than a year passed, however, before Rudolf van Wezel (director of BIS Publishers) saw the potential of the concept and offered the duo some office space in Amsterdam.

And the target group?

First and foremost, *Frame* hopes to appeal to interior designers. But the magazine also has architects and product designers, as well as their clients, in its sights.

191 192
221 222
219 220
217 218
book exh
224 next

I want to commend you on your wonderful publication. For the past few years I have been reading *Wallpaper*. Only recently did I find your magazine, and I have to say that you blow them out of the water. No fluff or frills or unneeded pretentiousness. Just good design.

Jamie, Frame fan, 2002

The issue of *Frame* devoted to 'The Senses' was stunning – really good. People all over the world are calling to ask for the same publication.

Lars, designer, 1998

The positive approach (not entirely without a critical note) in a couple of the articles is uplifting. The composition is optimistic. You're making a good magazine.

Ed, designer, 1999

FRAME
Interior Design
Magazine
Amsterdam,
The Netherlands

What's the driving force behind the magazine?

To help interior designers shed their 'second-rate artist' self-image. To make them proud of their profession. And to inspire and surprise them, time after time.

And is the magazine itself a designer object?

From day one, *Frame* has been experimenting with cover materials, paper stocks, editorial formulas and graphic design. Transcending any and all boundaries posed by its 2D format, the magazine has striven to remain a valuable source of inspiration and to record what's happening today in the current world of interior design.

What's the hardest part about creating *Frame*?

In an age of internet and globalization, people all over the world – whoever, wherever, whenever – have access to the same information. Nonetheless, our biggest challenge is to dazzle our readers and to spark their creativity.

The Graphics ...
considered by many
readers to be the most
striking aspect of the
Frame identity, especially
when compared with
other magazines, are the
graphics. Interestingly,
Frame is recognizable,
even though each issue
has a unique new look
expressed by graphics that
respond to the content.
Strictly speaking, we
give birth to a new *Frame*
baby every other month.

What on earth
were you thinking
of – using
what looks like
Monotype Century
Schoolbook Bold
and Bold Italic
for your headings
and subheadings?

Roger, subscriber, 2003

Frame's glossy
appearance
suggests the same
sort of eager
approach to
design that design
receives from the
modern consumer.

Jeroen Junte, journalist for
de Volkskrant, 2000

P.S. Change the
graphic designers.

Arne, designer, 2002

I hereby cancel
my subscription to
Frame. I object to
the cluttered layout

NOT FOR SALE

From window and display to props and graphics: 12 shop features tha (for reasons o to the merc

Tagliatelle con Crema e Noci

Store Traffic

Stuart Weitzman
Rome

Paco Underhill

Azzedine Alaïa
Paris

Konk
Berlin

Sita Murt
Barcelona

In the film world, they talk about bums on seats. The equivalent expression in the retail business is 'store traffic'. Experts in the culture of shopping from the perspectives of retail anthropology, branding, packaging, light engineering, architecture and visual merchandising assess and comment upon the art, boutiques on the following pages. Read the truth: predictions of our

Mad as a Hatter

In designing his first stand-alone boutique in Omotesando, Tokyo, Belgian hatter Christophe Coppens drew on memories of childhood visits to the zoo.

Two Tone

Hedi Slimane draws on German minimalism to brand Dior Homme in Los Angeles.

FRAME
Interior Design Magazine
Amsterdam,
The Netherlands

The Cover . . . to date,

Frame's dozens of faces can be described only with terms like 'striking', 'vibrant', 'aesthetic', 'colourful', 'appealing', 'powerful', 'amusing' and even 'weird'. Choosing our favourite cover – from the many reviewed for each issue – is like picking a favourite child. When the genes are good, however, not a lot can go wrong.

Peter Huiberts, publisher, 2006

Why use a magazine to express all those feelings about interior design?
Interior design is a very visual profession. Is there a better way to present its output to a large audience than by showcasing it on the glossy pages of a magazine?

Dear Robert,
A cover should be intriguing. You can get that effect by using colour or a striking image. But certain covers that I thought would have a terrific impact turned out to be flops – to the extent that we're able to judge such things, of course. Our more recent covers have struck me as being rather dull. The issues of Frame that have made the biggest positive impression on me are numbers 2, 7, 16, 25, 31, 38, 42 and 43.

Peter Huiberts, publisher, 2006

Dear Peter,
I agree with you that Frame 34 wasn't one of our better covers. That

07

02

16

25

31

14

was a compromise, pure and simple (no need to go into detail). The cover of *Frame* 14, which showed shoes behind a chalk line drawn on the floor, is still on my list of favourites, though. Very minimalist, very special and a statement on retail design. Others are the covers of *Frame* 25 (it's attained a cult status now that not a single issue is available – other than at my house, of course), 37 (strong, surprising image), 42 (also rather alienating, but the colour is powerful and the gold foil is a nice touch) and, yes, I like 48 (not so characteristic of *Frame*, maybe, but a great combination of image, typography and refinement).

Robert Thiemann, editor
in chief, 2006

FRAME
Interior Design
Magazine
Amsterdam,
The Netherlands

The Printed Publication . . . apologies for late hours at the office, a mad desire to spend big bucks on designer objects, another trip abroad and thus away from friends and family: the only compensation is the printed proof of our efforts. In most cases, paging through the latest issue for the first time — especially when thousands of kilometres from home — makes all sacrifices worthwhile.

I do not want to miss an issue of *Frame* between subscriptions, as this would severely piss me off.

Ross, subscriber, 2001

I'm desperate because I can't find your great magazine in stores since April. I can't live without it. Please help me.

Pablo, Frame fan, 2000

My exposure to the projects and ideas presented in your magazine has had a great impact on the progress of my own projects.

Jill, designer, 2000

5000
copies

3750

2500

1250

How much do you feel an active part of the art and design community, or do you have a sense of being rather separated from what's really happening?

A magazine couldn't be much more internationally oriented than *Frame* is, but our editors spend most of their time at the Amsterdam office. So, yes, we're often viewing things at a distance, but only in a physical way. Thanks to instant communication – email, fax, phone – we're in constant touch with designers and manufacturers of design-related products worldwide. What's more, *Frame* is represented at about 30 design fairs annually.

How international is your readership?

Frame has subscribers in more than 50 countries, from Chile to Japan and Iceland to Australia.

Where is the magazine on sale?

Bookstores and other outlets in more than 30 countries sell *Frame*. And our recently launched 'digimag' keeps readers in touch with everything that *Frame* has to offer – all they need is an internet connection.

Concept: Merel Kokhuis and Alexandra Onderwater.
www.framemag.com
Graphic design: Koehorst in 't Veld.
www.koehorstintveld.nl

Circulation

Belgium	1107
Denmark	885
France	1008
Germany	3777
Italy	1273
Netherlands	4480
Norway	488
Spain	679
Sweden	662
Turkey	509
UK	4095
China	2200
Hong Kong	600
Japan	1100
Korea	2100
Singapore	700
Taiwan	700
Australia/ New Zealand	300
Canada	600
USA	3100

Up to 450 copies of *Frame* are distributed in the countries Finland, Greece, Poland. Up to 400 copies of *Frame* are distributed in the countries Brazil, Israel, Lebanon, Malaysia, Mexico, South Africa and Thailand.

Wow! What an amazing story you wrote about me. I am so honoured. I am thinking of all the things I should have said I could have used the opportunity to say something really deep and meaningful – to change the way the world thinks. I guess I'm just kind of simple and straight up. I feel so small and uninteresting compared with the others you interviewed. I read some of those interviews today and really enjoyed them.

Lino, designer, 2001

Frame

Lijnbaansgracht 87hs
NL-1015 GZ Amsterdam
The Netherlands
Website: www.framemag.com
Email: info@framemag.com
Editor in chief:
Robert Thiemann
robert@mark-magazine.com
Graphic design:
Koehorst in `t Veld
post@koehorstintveld.nl
Format: 230 x 297 mm

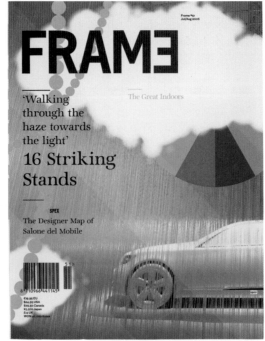

Magazine 3/10

Frame

The Netherlands

Great moments #3

The *African Drum* becomes *Drum* (1951)

The African Drum had been running unsuccessfully for a few months in 1951 as a South African magazine aimed mostly at a missionary audience, before Battle of Britain ex-fighter pilot Jim Bailey took it over and renamed it simply *Drum*. He installed his university friend, Anthony Sampson, as editor, and the two of them began to turn the title into a publication by and for black Africans. They founded a black editorial board, started a search for untrained township writers, and hired their first journalist: Henry Nxumalo, then a sports editor. The aim was to create a genuinely popular people's magazine, less highbrow and more accessible than the market leader, *Zonk*.

Nxumalo's first investigative story, published in March 1952 under the byline Mr Drum, was an exposé revealing the slave-like labour conditions in the potato farms of Bethal. The issue was an outstanding sales success. Not all of *Drum*'s journalism was so worthy; the magazine became known for an underground mix of satire, sport, sex, booze and crime, often with provocative cover girls. It became a nuisance to the apartheid authorities, whom the magazine opposed without being too overtly political. Strong journalism continued to appear in its pages. When Nxumalo was arrested in 1954 for breaking the night curfew, the result was a devastating piece about conditions in Number Four Prison.

Though Nxumalo's murder (still unsolved) on New Year's Eve 1957 hit the team hard, the magazine continued to thrive under its hard-working mixed-race staff. By the late 1950s, five editions of *Drum* were thumbing their noses at authority across the continent: in South Africa, Ghana, Nigeria, east Africa and central Africa. It had also gained a reputation for strong, uncompromising photography, helped in part by the arrival of Tom Hopkinson, Stefan Lorant's ex-colleague on *Picture Post*. The combined circulation of *Drum* by the late 1950s was around 400,000 – with every copy thought to have around 20 readers. Everyone read *Drum* magazine – as intended, it belonged to the people, and it told their story without shame or self-pity. It was far from perfect, but neither were its readers. It was political, rather than financial, pressure that led to

The African Drum

Drum

Zonk

Picture Post

20

THE AFRICAN DRUM. MARCH,

AFRICA

Forty F

Movie buffs
the APA Ph
have united t
program of 4
theatre: the
starting on Ju
see our listing
tival provide
all those mov
mit you misse
Summer Nig
and Diamond
there will als
even the mos
have already
cently re-edit
the new versio
York for the
section alwa
showings of
stated for this
full, uncut
Spring will als
be bought sir
sive movie-go
series at redu
from Citizen

West
over
s not
which
le as
The

It's pineapple-picking time in South Africa's Eastern Province and this Pondo belle and her overflowing basket make a picture packed with sunshine.

Judging by the satisfied smile on this Johannesburg boy's face he must be dreaming of his socks

★

Bamangwato (Bechuanaland) wives wave a greeting to Mr. Patrick Gordon-Walker, Secretary of State for Commonwealth Relations, in the British Parliament, after he had attended a kgotla (council meeting) at Serowe. Serowe became world famous as the centre of the recent events culminating in the banishment for five years of the chief designate Seretse Khama.

The Tamborito looks something like this when the dancers get really excited. Boscoe Holder would like us to practise it, for the tamborito may soon follow the beguine and the samba from the Caribbeans — The Islands of the Sun. Boscoe, 28, dancer, pianist and painter, would like to show that West Indians can do a lot more than the simple samba.

★

THE AFRICAN DRUM, MARCH, 1951 21

DEVELOPMENTS

"If you want to be a big man like your daddy this is the stuff to give 'em."

Nimble fingers in two different parts of Africa bend and mould local grasses into utilitarian shapes. One is making a broom, the other a hat.

Drum's closure in 1965; it was subsequently turned into a watered-down newspaper supplement.

In many ways, *Drum* was not a unique publication. Since the invention of the printing press, journals and magazines have been created to oppose established authority. From 19th-century anti-slavery pamphleteering to the punk 'zines of the late 1970s, subculture has always rallied round its own underground publications. Satire (*Oz*, *Private Eye*), feminism (*Spare Rib*, *Shrew*), art (*Minotaure*, *The Situationist Times*), environmentalism (*Good*, *Greenpeace magazine*), anti-capitalism (*Adbusters*, *Marxism Today*) and politics generally (*Seed*, *Fifth Estate*, *Mother Jones*, *Diplo*)... the history of magazines is one of both conformity and counterculture in equal measure.

Much of the alternative press has now moved online, where distribution is free and print costs are too; others have moved from being truly rebellious to becoming yet more lifestyle titles. But, as *Drum* magazine so often proved, there's nothing quite like the energy and vision of a genuinely subversive magazine to make you feel that you're not alone in the struggle.

Oz

Private Eye

Spare Rib

Shrew

Minotaure

The Situationist Times

Good

Greenpeace magazine

Adbusters

Marxism Today

Seed

Fifth Estate

Mother Jones

Diplo

From the top:
Adbusters;
Good

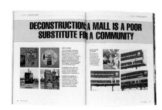
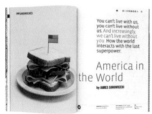

Magazine 4/10

Omagiu

Romania

Bucharest-based *Omagiu* is an impressive example of central/eastern Europe's arrival in the world of independent style publications. Each issue is monothematic (Fake, Tourism, Fashion, Problems...) and produced to extremely high standards. While its art direction fits easily within international fashion conventions, its content is determinedly local and clearly not driven by the demands of advertising or PR. *Omagiu*'s mix of stylish design and interesting content (printed in both Romanian and English) makes for a uniquely fascinating piece of east European creativity – and an always-engaging read.

OMΛgiu OMΛgiu OMΛgiu OMΛgiu OMΛgiu
OMΛgiu OMΛgiu OMΛgiu OMΛgiu OMΛgiu
OMΛgiu OMΛgiu OMΛgiu OMΛgiu OMΛgiu
OMΛgiu OMΛgiu OMΛgiu OMΛgiu OMΛgiu
OMΛgiu OMΛgiu OMΛgiu OMΛgiu OMΛgiu
OMΛgiu OMΛgiu OMΛgiu OMΛgiu OMΛgiu
OMΛgiu OMΛgiu OMΛgiu OMΛgiu OMΛgiu
OMΛgiu OMΛgiu OMΛgiu OMΛgiu OMΛgiu
OMΛgiu OMΛgiu OMΛgiu OMΛgiu OMΛgiu
OMΛgiu OMΛgiu OMΛgiu OMΛgiu OMΛgiu
OMΛgiu OMΛgiu OMΛgiu OMΛgiu OMΛgiu
OMΛgiu OMΛgiu OMΛgiu OMΛgiu OMΛgiu
OMΛgiu OMΛgiu OMΛgiu OMΛgiu OMΛgiu
OMΛgiu OMΛgiu OMΛgiu OMΛgiu OMΛgiu
OMΛgiu OMΛgiu OMΛgiu OMΛgiu OMΛgiu
OMΛgiu OMΛgiu OMΛgiu OMΛgiu OMΛgiu
OMΛgiu OMΛgiu OMΛgiu OMΛgiu OMΛgiu
OMΛgiu OMΛgiu OMΛgiu OMΛgiu

From: Andrew Losowsky <andrew@losowsky.com>
Date: August 29, 2006 7:21:54 PM EEST
To: ioana@omagiu.com
Subject: We Love Magazines / Colophon2007

Here as promised are the questions for you to answer within the pages of the Colophon book. As you
agreed with Mike Koedinger, you should incorporate these questions and your answers into the designs
for the book that you'll be creating.

Let me know if you have any queries - and we look forward to seeing your finished pages!

All best, and see you in Luxembourg,

Andrew Losowsky
Editor, We Love Magazines
www.colophon2007.com

From: ioana@omagiu.com
Date: December 7, 2006 11:22:33 PM EEST
To: Andrew Losowsky <andrew@losowsky.com>
Subject: RE: We Love Magazines / Colophon2007

Dear Andrew,

Sorry about the delay. These are my answers. I'm also going to send you the layout tomorrow. I hope is
not too late. :)

All the best from Romania! See you all in Luxembourg.

Ioana Isopescu
www.omagiu.com

How did Omagiu begin?
We started Omagiu in 2004 and had no idea of what we were getting ourselves in to. The original team
was, myself, Ioana Isopescu with a background in media, PR and print production, Stefan Cosma, visual
artist, model and TV presenter and Milos Jovanovic, graphic artist and web designer. We decided that
we had to do something for the Romanian cultural scene. It seemed easy enough. But we had no previous
experience of publishing and if we had, we'd never have had the courage to begin.

What does the name refer to?
It was a spontaneous idea. 'Omagiu' means 'homage' in Romanian, but it has a long history. Originally
'Omagiu' was Ceausescu's annual propaganda publication for the 'Golden Age', in which we were told how
many accomplishments Romania had at that time. The word was over used and abused and had bad connota-
tions. So we decided to reinforce the word, to 'render unto Caesar what is Caesar's'. The true meaning
of the word is beautiful. Our Omagiu pays homage to all those who are creative, who want to change
something and have something to say.

Who is the magazine aimed at?
Omagiu is dedicated to the creative industries, gathering together the most influential contemporary
artists, architects, designers and musicians from our generation. It is also aimed at a wider public
who want to be informed.

What is the driving force behind the magazine?
Innovation, and more practically, the editorial team: Mihnea Mircan, Ciprian Tudor, Stefan Tiron, and
our graphic designer: Sasha Iacob / (www.milc.ro), as well as our dedicated contributors: a collection
of voices announcing what's new, unique and vibrant in Romania and the outside world.

Why use the format of a magazine to express that?
We wanted the magazine to be a work of art. A tangible, visual expression of our intent and a collect-
ible item in itself. And besides, we love magazines!

You describe the magazine as "a remix culture" magazine. How unique is this perspective in Romania?
Omagiu will always be one step ahead of trends, through observing, exposing and promoting innovative
cultural areas. Omagiu provides links to sites on the internet, which illustrate the changes produced
in the contemporary artistic/cultural scene. There is no other magazine like Omagiu in Romania.

How does your content differ from that of similar cultural magazines in other countries?
Omagiu is a fusion of several types of publication, promising to be a trustworthy guide to the aesthetic
jungle of the consumer society, a magazine which debates and analyses the vast contents of the urban
culture in Romania and abroad.

Which is your favourite issue so far? Why?
That's a tricky one! They are all my babies, and like children, I love them all, but each is so dif-
ferent. If I have to choose an issue, I'll choose the next one, because the pleasure of conceiving can
be far more enjoyable than giving birth.

Where is the magazine on sale?
Europe: Berlin / PRO qm (www.pro-qm.de), Luxembourg / Fellner Art Books (www.fellnerbooks.com), Bar-
celona / Mercado (www.mercadodelborne.com), Prague / Fraktaly (www.fraktaly.cz) Wien / Prachner (www.
prachner.at) London / Tate Modern (www.tate.org.uk/modern)
Online: www.rospotline.ro
Romania: Carturesti / (www.carturesti.ro), Humanitas / (www.humanitas.ro), Inmedio & Relay (www.hdsnet.
ro), OMV / (www.hiparion.ro)

What's the hardest part of creating Omagiu?
Creating Omagiu is a joy. Managing the publishing, the distribution and the advertising can be a night-
mare. But so far, so damn good!

Sophie Krier.
Lucrurile nu sunt ceea ce par a fi.

Numele lui e Maarten **BAAS**
Un tânăr designer care nu o arde aiurea

My name is
Tania and I am
your 3D bitch

IN
TERIOR
TERR
OR

Travel into the unknown.

FOX

Beach

AVENTURI SPATIALE
SAU CUM TOVARASII RUSI TRIMIT AMERICANII IN NEANT SI INAPOI

nomad trip

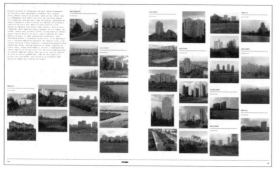

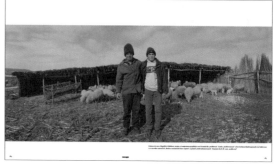

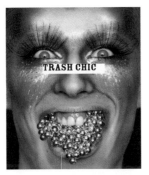

TRASH CHIC

În 1938 fabricantul Ivan J. Paolovski a ajuns cu trenul în Helsinki, venind din Vyborg, care era sub ocupație rusă la vremea aceea. El este fondatorul celei mai nordice fabrici de chibrituri din lume, construită în pădurile nelocuite din estul orașului.

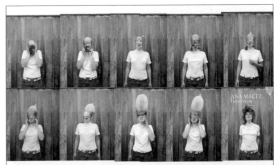

ANA MALTZ
Interview

UN5ØLV3D PRØ8L3M5
PRØ8L3M3 N3R32ØLV4T3

Philipp Ekardt

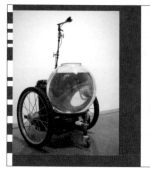

victor man, 2006

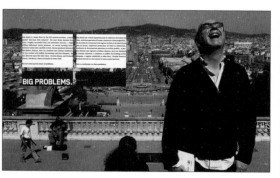

BIG PROBLEMS.

The Other Alphabet

Celălalt alfabet

Omagiu

Lascar Catargiu 14 / parter
010671 Bucharest
Romania
Website: www.omagiu.com
Email: contact@omagiu.com
Director: Ioana Isopescu
ioana@omagiu.com
Editors:
Mihnea Mircan
mihnea@omagiu.com
Ciprian Tudor
ciprian@omagiu.com
Art direction:
Alexandru Iacob, sasha@milc.ro
Alexandru Vasile, alex@milc.ro
Design by milc
Format: 240 x 278 mm

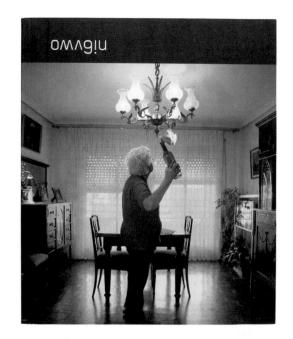

Magazine 4/10

Omagiu

Romania

The campaigns trail

The publisher

Ramon Fano

Co-publisher and co-founder of Neo2 *and its publishing company, Ipsum Planet. Barcelona, Spain*

We thought about the advertisers right at the start.

The majority of publications begin with a bang – a huge investment or promotion, lots of pages, big budgets, important names, high profile etc. They begin strongly, and then, two years later, they disappear from the marketplace, thanks to big spending and little return.

Humble beginnings

We didn't do it that way; we began in a very humble fashion, like a fanzine. We were pocket-size, 60 pages, stapled not bound, and two-colour. As time went on, little by little we increased the size, and then started to print four-colour. We changed the binding, increased our circulation, and went from local to international distribution... but we did all of this gradually, investing the profits from one number in the production of the next. We improved the magazine, and it got a better and better reception from both readers and advertisers.

Advertising connections

There are advertisers who have been with us from the very beginning. We have a great connection with them, both aesthetically and ideologically. They leave us alone to be ourselves, and give us the most freedom. At the heart of it all, we see the advertiser as the way for us to do what we want, creatively. You, as a magazine, are the medium for the advertiser to achieve what they want in terms of communication – that they position themselves directly towards their target. I believe that the less interference there is, the better the result for both advertisers and magazines.

I come from an advertising background. Before creating *Neo2*, I worked as creative director of various advertising agencies – and in a way, I'm still doing that at Ipsum Planet. The same team that creates *Neo2* also works for fashion clients, creating publicity and catalogues. So, with that in mind, I have to admit that, of course, I like advertising. I love great, intelligent ads, those that add something new to the medium of communication.

As with everything, there are good and bad advertisers. There are those that have a magnificent brand image and guard it fiercely. This type of advertising, of course, helps you to raise the prestige and cachet of your magazine (and also to attract other advertisers).

Para el... un libro de Capote el... Wilde en la derecha y el libro de Ra... frente. Para abstraerse del mundo, cualquier cuadro abstracto de María Viñas. Para vivir, Madrid. Para ...ueva York. Para flipar en colores, cualquier Gehry, Nouvel, Foster... La ...ste milenio.

Working with good advertisers that have a good product to sell is easy and gratifying. The flip side, however, is when you have an advertiser with a bad product and a poor image, and problems arise because you don't know how to support them.

Potential problems

Sometimes, problems also arise with certain brands that believe that, when they buy a space, what they are actually buying is the whole magazine, or

Trend magazine readers are consumers of image. As they say in Spanish: "No-one finds a sweet thing bitter." No-one will be upset by a beautiful image or an intelligent or ironic message. What they will dislike are bad adverts, badly produced.

a section that stretches far beyond just that space. With client relationships, the important thing that has to prevail is common sense and certain basic norms of understanding.

I suppose I would refuse an advertiser whose message was against my deepest and most fundamental beliefs. But my beliefs are so basic and common that I don't think anyone could seriously be against them. I'd love to refuse advertisers for aesthetic reasons ... but sadly there isn't so much demand that we can afford such luxuries.

Trend-magazine readers are consumers of image. As they say in Spanish: "No-one finds a sweet thing bitter." No-one will be upset by a beautiful image or an intelligent or ironic message. What they will dislike are bad adverts, badly produced, with vacuous or repetitive messages.

The situation of the market has a great deal of influence, too. The consumption habits of each country determine the level of advertising investment in different sectors. I wonder, were *Neo2* published in Paris or Tokyo, would it contain a lot more luxury-brand advertising?

Creative spaces

The only limits on selling a particular space are elegance and creativity. Certain unusual spaces have to be used in a creative way. I believe that, when there is creativity involved, everything is permitted to be sold to an advertiser, and the reader will in fact appreciate that creativity. Good advertising never bothers the reader. We began selling creative spaces [such as the cover] from the start, probably because we came from creative advertising. Advertisers often come to us asking for something different, and we work to make it fit with their budget. My favourite ads in *Neo2* from the last few years have been those of the brand Lois. Why? Because we made them.

The editor
Hector Muelas

Editor of Vice magazine. Berlin, Germany

Advertising can be the best and the worst thing in the world.

It can be sublime – creativity is an almost divine gift, and its expression is amazing, be it on a technical or a conceptual level. If you're gonna sell me something, make me think, make me like it, make it look good. If I pay attention to the ad, it's because I like it and I think it's worth it. I'm an advertising fanatic. I get loads of ideas from it.

But sometimes, advertising is cheap, ugly and terribly uninspired. You notice it and then you go, "Whoa! And on top of that, they're doing this to sell something that I don't actually need." What a waste of money, all these creatives and art directors sticking their thumbs up their asses and getting paid great salaries to shit these terrible turds.

United vision

Before I worked in magazines, I would see ads only in content terms. But now it's one of the first things I check every time I see a mag – the ads, number of pages, placement, clients. This united vision makes a lot more sense with lifestyle magazines, where the ads and the content work together as a whole. But I do believe it's the end of times for lifestyle magazines. They're over. And if they are not, they fucking should be.

We don't need another lifestyle magazine, please. My generation is smarter than people want to think. You see the band

I do believe that it's the end of times for lifestyle magazines. They're over. And if they're not, they fucking should be. We don't need another one. My generation is smarter than you think.

Placebo on the cover, a feature on Placebo inside and then an ad from the record label... people notice these things. Lifestyle magazines are big advertorials, they're like flipping through an IKEA catalogue. "Check those new sneakers, limited edition." Are there really people who still care about that? You wanna sell? Fine – we'll do business with you. But there are a lot of ways to do it that are far more creative. Please, don't embarrass yourselves.

Creative collaboration

Brands come to us and say, "We have this money and we want to spend it with you. We've developed a campaign that runs in every single other

... (susanna@viceland.de)
Stefanie Eifert (stefanie@viceland.de)
Katarina Haage (kati@viceland.de)
Alexa Karolinski (alexa@viceland.de)
VERANTWORTLICH Hector Muelas
VICELAND.COM

magazine but, with you, it would look stupid. So, what should we do together? Let's come up with an idea." We have an amazing network of contributors and a worldwide setup, so we can pull stuff that other people can't.

For example, I'm very proud of our Nike photobook. The concept was really simple: we asked some really cool photographers (including Terry Richardson and Ryan McGinley) to spend time with the Nike skate team, and take pictures. We chose the best pictures and did a mini photobook. Super cute, super nice, with no excessive branding whatsoever. That has a value; it's not another obvious advertorial. It's an amazing collection of photography that you'll keep on your bookshelf.

example of alternative advertising

Anything but 'lifestyle'

We're not a lifestyle magazine. *Vice* in Germany is still sometimes unclassified by some of the marketing people. I guess the States and the UK are more open to the concept, but in countries like Germany, there are lots of clients still going on about our identity: what are we? Are we lifestyle? Are we a 'satirical' magazine?

Those definitions don't really matter. It's the way we treat our subjects that attracts advertisers. We do complete immersion. If you want to write an article about a gang, you go and live with them and talk to them and make friends with them – you even give the gang members a pen and paper. You might not like them, it might get a bit rough – but it's reality, so deal with it.

People really love or hate the magazine. We constantly polarise; you're never gonna hear: "*Vice*? Yeah, it's OK." We have an amazing product that reaches people in a very honest way, and I guess advertisers like that. If we are perceived as authentic, as 'the voice of our generation' – as many people have called us – then the brands that advertise with us will be perceived as authentic, too.

Of course, you have the more traditional advertisers that push you to do this or do that, or who are not happy because you are not featuring their brands, threatening to take their advertisement out if you don't do what they say... but that's the usual story. We let our fantastic sales team deal with that and come up with solutions. Otherwise, it's the brands ruling the media – and that, on an ethical level, can't be accepted.

A new way of selling ads

We do amazing ad sales. I remember one time, Shane Smith – one of our founders and a director of the company – pointed at our European Boss, Andrew Creighton, and said: "I remember you some years ago. We'd go to clubs and everybody wanted to party with you. Everybody wanted to drink with you, sit on your table, talk to you. Everybody loved you. You were the centre of the fucking goddamn universe. And that is how you sell ads."

You need charisma. You are not selling a space; you are offering brand integrity, and you are offering a human side to the whole process, even a friendship. If I do business with you, it's because I like you, I trust you and I trust what you stand for. When you deal with one of our guys or girls, they are *Vice* themselves.

And I party with loads of our advertisers. I'm the editor, I don't give two shits if they give us money or not. I love them; they're great guys. I like to spend time with them. And if we make business together, that's even better. If not, whatever... let's have another beer.

The international revolution

Our publishers and ad sales throughout the *Vice* network are in constant touch with each other. They sometimes sell ads in our edition, or we sell ads in their editions, depending on who's got the best relationship with the client, or where the client is based. And it's going very, very well. *Vice* in the US has been doing this for 12 years. We are expanding, opening editions every year, growing into a big independent media company worldwide, including TV, film, records, marketing, creative solutions.

Nobody can stop us now; we are starting a revolution.

The ad sales manager

Michael Belgue

Advertising Director, HoBo *magazine. Vancouver, Canada*

We aim for advertisers that complement and accentuate the editorial that we feature.

We would like our advertisers to appear as edited as our content. There is not the traditional distance between the two sides – advertisements in our magazines bring to the reader the same admiration and joy as our editorial, at least on an aesthetic level.

The challenge

For us, the main selling challenge is our international distribution. An advertiser sees that our address is in Canada and thinks we are Canadian, when, in fact, our distribution is greater in the US and western Europe than it is in our own country. People don't know how to classify us, and which office should be buying from us. We naively thought our great distribution would be a good thing – media planners would be able to buy one issue of *HoBO* to cover many markets, but, in fact, planners don't give a shit what is happening outside their little jurisdiction. They are very closed-

minded, and are not necessarily working in the best interests of the brand they represent.

I would assume that sales methods differ for other magazines. Just look at the difference between a magazine such as *HoBO*, and a title such as *OK!*, or even *Vogue*, for that matter. Buying and

Media planners don't give a shit about what is happening outside their own little jurisdiction. They are very closed-minded, and are not necessarily working in the best interests of the brand.

selling is a purely numbers-based exercise for those publications. It has nothing to do with extending nor reflecting the culture of the brand that advertises there. If we had to sell space based purely on numbers, then we'd be dead in the water because we simply don't make economic sense from a numbers-only perspective.

Ads we don't run
We sell only full pages or spreads, further enforcing the look through art direction. If an ad is ugly (to our eyes), or the brand doesn't represent the values or share a point of view with the magazine, we will suggest art changes, or simply not run the ad. This obviously creates problems, and is perhaps at times not the smartest move from a business standpoint, but one has to draw the line somewhere.

The team
A good advertising manager has patience, adaptability and the ability to communicate the culture of the magazine. We have a very small team, and we all work together with editorial as one unit, so we all speak every day. One side cannot exist without the other, and certain issues reflect on editorial, and vice versa.

As the magazine is fashion-oriented, and the bulk of our advertisers comes from that industry, naturally some expect editorial coverage. Occasionally, it works out conveniently as we are already featuring something from that brand in a fashion shoot, but, at other times, we just can't do it. I suppose we should be thankful that we don't have advertisements for household cleaning products or something, because you can't really hide anything like that. Generally, if someone wants to buy advertising space from us, they do so regardless of whether or not we will feature them editorially.

We have never had a complaint from an advertiser, but we have had potential advertisers, from America only, state that they would not be in any issue in which there was nudity. There was no mention about what we could or could not say, which I find strange, but there was a problem with skin exposure.

Generally, though, we have never had an issue with any advertiser not being happy. I think this comes back to the fact that we try to place ads in a very complementary way for both the magazine and the advertiser. This is quite different than the norm, and the advertisers are happy with it.

The media planner
Griff Leader

Media planner, MindShare Worldwide. Representatives in 66 countries. London, UK

Media planning can be described simply as the practice of placing a commercial message in the right place at the right time and for the right price.

Modern consumers are highly selective in their media choices and clients need to know they are talking to the right people in the right environment, and with a relevant, interesting message.

Why media planners matter
If a client wishes to book a single page in one magazine, then there is no point using a planning agency. However, this rarely happens – it is more likely a client would want to run many ads across a range of titles, and possibly in a number of markets.

There are many benefits to working with an agency such as MindShare. MindShare works constantly to develop specialist knowledge relating to each medium, in each market, and offers expert advice on how

A good print advertisement is all about creating a message that captures the attention of the consumer, is both appealing and relevant in its content, and is persuasive in its promotion.

best to maximise an advertising budget across a range of opportunities. In most cases, the agency will be able to command far better rates than its clients would acting alone, due to its combined buying power across its client portfolio around the world.

Careful objectives
Title selection is achieved through balancing various criteria, based on the objectives provided in the client brief. These objectives may, for example, simply require the message to be communicated to as many people as

FEATURE

FEAT

12

FEATURE

FEATURE

24

INTERVIEW

INTERVIEW

36

AD

AD

AD

TURE

possible, or to a select group of professionals. Primarily, the delivery of print criteria is driven by circulation, readership and price. Other influential criteria include relevant editorial/features, creative flexibility and accountability.

Simply speaking, a good print advertisement is all about creating a message that captures the attention of the consumer, is both appealing and relevant in its content, and is persuasive in its promotion. There are many ways of achieving this through a combination of imagery and copy-writing, and/or creating a degree of differentiation to the publication itself, e.g. fold-out ads or heavier-stock paper.

Advertorials are rarely recommended and are an infrequently used method. In these days of on-demand information, it can be argued that the advertorial's days are numbered, yet they continue to appear. They can be useful communication tools when used in an appropriate environment, e.g. in titles where the consumer has time to digest lengthier commercial messages. However, all too often these appear either as long, text-heavy messages, or an advertiser's attempt at journalism.

Avoiding controversy

In general, print advertising is rarely controversial. Stringent checks are made on advertising copy prior to printing, so attempts to pass material deemed controversial are addressed before hitting the presses.

Complaints usually occur when an advertiser attempts to shock, or where their message may be deemed to offend consumers. Print is not a medium often used to shock or to deliberately create controversy. In order to do so, an advertiser needs a mass/broadcast media, such as TV or outdoor advertising; these would do this job far better than print.

Enhancing magazines

Technically, it can be argued that advertisements should not add anything to a magazine's content. When was the last time an editor launched a new publication with the aim of having commercial messages support his or her magazine's journalistic content?

Research has shown, however, that well-placed advertising can reflect and enhance a magazine's personality, growing reader rapport and loyalty. The presence of a blue-chip conglomerate makes a magazine seem more worthy, for example; an aspirational lingerie advertiser makes it more sexy, and so on. In a trusted and considered environment, consumers often benefit from the discovery of new products/services that can serve only to drive repeat readership.

Other, more visual magazines appear to rely on advertising to carry or elevate their image and stature within more harshly judged peer-group sectors, e.g. fashion. It is not uncommon for a glossy female

title to carry 20-30 pages of advertising before the reader comes across any journalistic contribution.

Measures of success

In gauging the efficacy of a campaign, the most recognisable measure is revenue. Other, less immediate factors are also important – such as brand awareness and preference. Attributing the success of advertising is a more complex task, and it is common for the overall success of a campaign to be judged on a combination of factors. Many clients will invest in research to track the performance of their advertising such that, increasingly, advertisers are turning to investment/procurement analysts to audit ROI (return on investment), leading to the direct correlation of results versus ad spend.

This places more pressure on the advertising community to ensure that it is offering accountability, as well as the reassurance of campaign recognition and message delivery.

The client

Mirjam Michels

and Margaret Sap

adidas International Marketing (global). Amsterdam, the Netherlands

The media landscape is continuously evolving, and so is our consumer.

In order to remain a relevant and credible brand, a great amount of our time is invested into exploring new media opportunities and new media trends. adidas aims to portray its brand image via various online and offline media; media that relate to our different target consumers and fit the respective brand messages we want to transmit. All media outlets are considered carefully on a continuous basis – the long-time mantra of "the medium is the message" still counts.

The plan

Every brand concept has its own media plan. We have a dedicated group of global and local media planners within our agency network that brings another level of expertise and special media knowledge, as well as long-established relationships with media owners. The process from local briefing to a final seasonal media plan sign-off can take several months.

While frequency within one medium is important to reach a certain level of recognition, repeat advertising is not a given, and every media investment is signed off and reviewed each season depending on consumer and concept relevance. The disadvantages of print make heavy print investment more difficult to justify year on year.

The partnerships

adidas tends to think in terms of partnerships, and this certainly counts for our media relations, too. Established media are often part of our media strategy yet, at the same time, we invest in independent media, as we consider the topics and design styles in those kinds of media relatively

Some magazines misbalance the split between ads and good editorial. Sometimes, you wonder what happens to those print revenues – quality content is not always present.

progressive and their target audience influential. The split between established and independent varies per season, depending on the message or image we need to portray, and the audience we want to reach out to.

Very occasionally, we may ask the creative director of a magazine to create a page that gives their (personal) view on adidas, or we might develop special campaigns with certain magazines to highlight one of the key concepts, but only on a very exceptional basis.

A clear separation

Within adidas, advertising and PR are two separate disciplines that operate independently from each other, and we prefer to keep it this way. It allows us to be a credible and creative partner for magazines, as we don't want money to become a key factor within the relationship. We therefore never negotiate on advertising versus free editorials.

It would be a pity for the fashion industry if, for example, stylists are bound to use certain brands in their fashion editorials, simply because those brands advertise heavily on the title. Magazines that work like this risk losing their credibility.

Some magazines also misbalance the split between ads and good editorial. Sometimes, you wonder what happens to those print revenues – quality editorial, interesting editorial photography or documentary features are not always present.

Campaign success

In judging if our strategy is working, it's never about one ad, it's about the overall campaign. We measure success in several ways, both through qualitative media results based on the circulation and reach of the

magazine and through quantitative studies we conduct occasionally, analysing the print creative and the way it was perceived within the chosen media by our target audience. Other questions we might ask include: did we buy well? Were we happy with the reach and frequency levels? We have our own research groups that give us quarterly reports – but the influence of an individual ad in an individual magazine is hard to measure concretely.

We are a brand that believes in creativity and an open relationship with media. We reach out to a target audience that looks out for innovation and quality. And it is great if we can fulfill those needs together with magazines that also reach out to those people.

Here's how we consider print media:

Advantages of print advertisements:
- Affinity – people buy magazines that are very close to their lifestyle.
- People look for print advertising in high-end fashion magazines, seeking it as they do fashion editorial.
- It's good for image building.
- There are plenty of opportunities for different creative formats.
- Print builds slowly, so it's a good way to have a regular presence.

Disadvantages of print advertisements:
- Print ads can be easily avoided.
- Print is a very expensive medium.
- People are exposed to advertisements only for a few seconds – therefore, there is very little you can say/get across in that time.

How to stand out in a magazine environment:
- Impactful formats.
- Simplicity: people don't spend much time with it.
- Premium positions (outside back cover, inside front cover, early right-hand pages, and within the first third of the magazine).

Magazine 5/10

Rojo

Spain

Rojo is a compendium of new artwork, mostly photographic or illustrated, sent in by contributors from all over the world. The Barcelona-based founders of this book-like publication call it an "emotionally structured, text-less magazine" – there is "no theme and no censorship". To keep its content current, each issue is put together one week before the print deadline. It's a highly successful magazine distributed in around 30 countries, thanks to an internet-based creative community where users are both readers and contributors. Besides the quarterly magazine, the *Rojo* team has also produced, or been involved in, more than 200 design-orientated events worldwide since its founding in 2001. In 2006, *Rojo* started its own monographic book collection, with artwork by some of the magazine's regular contributing friends including Boris Hoppek and the Neasden Control Centre.

WHAT IS YOUR MAGAZINE ABOUT?
ROJO® IS A PLACE WHERE EVERYBODY CAN HAVE THEIR ARTWORKS AND PICTURES PUBLISHED.
A MAGAZINE THAT IS MADE OUT OF WHAT CONTRIBUTORS SEND IN. NO THEME. NO CENSORSHIP.
WE LIKE TO THINK ROJO® IS AN ISLAND IN THE MIDDLE OF A FURIOUS SEA OF INFORMATIONS. IN ROJO®
YOU CAN RELAX AND ENJOY ART AND IMAGES WITHOUT BIG HEADLINES, ADITIONAL INFORMATIONS
OR ANYTHING THAT DRAWS YOUR ATTENTION FROM THE WORKS.

WHO'S BEHIND THE PROJECT?
ROJO® IS DAVID QUILES GUILLÓ, MARC MASCORT I BOIX AND ALEJANDRA RASCHKES.
WE ALL COME FROM VERY DIFFERENT BACKGROUNDS, NONE RELATED TO THE PUBLISHING BIZ.
EVERYONE AT ROJO® WANTS TO MAKE A MAGAZINE THAT MAY BE ENJOYABLE BY EVERYBODY,
EVERYWHERE. ALL OUR MOTIVATIONS ARE DRIVEN BY ONE OBJECTIVE:
INSERT HAPPINESS AMONG READERS AND CONTRIBUTORS DAY-TO-DAY ROUTINES.

HOW DO YOU PRODUCE ONE ISSUE? HOW MUCH TIME DO YOU SPEND ON IT? HOW BIG IS YOUR TEAM?
ROJO® IS AN ONGOING PRODUCTION FACTORY OF ISSUES. WE HAVE NO SUBMISSION DEADLINES AS WE
WORK ON AN ATEMPORAL BASIS OF CONTRIBUTIONS. ISSUES ARE CREATED ONE WEEK BEFORE GOING
INTO PRINT, AND CONTENTS ARE SELECTED FROM ALL THE SUBMISSIONS SEND SINCE ROJO® OPENED
IN 2001. THIS MEANS EVERY ISSUE CAN INCLUDE WORKS RECEIVED ONE WEEK BEFORE GOING INTO
PRINT, OR FROM MONTHS OR YEARS AGO. WHEN THE MAGAZINE IS READY, WE UNLOAD THE TRUCK
(WE STILL ENJOY UNLOADING THE MAGAZINES... IT IS A GOOD WAY OF PRINTING WHAT IS HANDABLE BY
US THREE, LITERALLY...) AND WHEN DONE, WE ENJOY LOOKING AT IT FOR HOURS AND FINDING OUT THE
LITTLE MISTAKES THAT MAKE US HUMAN.
ROJO® TEAM IS 3 PEOPLE IN BARCELONA, WORKING FULLTIME WITH 40 ASSOCIATE DIRECTORS WORLD-
WIDE AND WITH MORE THAN 600 ACTIVE ART CONTRIBUTORS. WE ALSO GET LOADS OF SUPPORT FROM
FRIENDS OF ROJO® EVERYWHERE... FROM THESE LINES THANKS TO YOU ALL!

WHAT HAVE BEEN THE IMPORTANT STEPS IN THE LIFE OF YOUR MAGAZINE?
ALL STEPS HAVE BEEN IMPORTANT. THE FIRST PRESENTATION PARTY IN BARCELONA WHERE WE
DISCOVERED THAT BEING NEAR THE READERS IS AS IMPORTANT AS DOING A GOOD ISSUE...
NOW WE HAVE ORGANIZED UP TO 210 EVENTS WORLDWIDE AND WE LOVE TO SAY WE KNOW MANY OF
OUR READERS AND CONTRIBUTORS. MAKING FREE DISTRIBUTION OF THE MAGAZINE FOR 2 YEARS AND
THEN SWITCHING TO REGULAR DISTRIBUTION MADE EVERYTHING EASIER TO REACH MORE PUBLIC
(FROM 6 COUNTRIES TO 29 COUNTRIES) THE SPECIAL PROJECTS... AND LATELY THE COLLECTION OF
ARTIST BOOKS... EVERYTHING SUMS UP AND WHEN WE STOP AND THINK ABOUT ROJO®, USUALLY WE
GET SCARED, STOP THE COMPUTERS AND GO FOR A BEER.

WHICH ARE THE KEY INGREDIENTS FOR THE SUCCESS OF YOUR MAGAZINE?
WE WOULD NOT SAY WE ARE SUCESSFULL... WE JUST HAPPEN TO BE APPEALING TO SMALL GROUPS OF
NICE PEOPLE IN MANY PLACES... AND THAT SUPPORTS THE PROJECT... SUCCESS IS A WORD WE WOULD
NEVER USE... LETS SWITCH IT FOR THE WORD SURVIVAL. IT FITS ROJO® MUCH BETTER.

WHAT ARE THE DIFFICULTIES YOU ARE CONFRONTED WITH?
EVERYONE WOULD SAY IT IS GETTING ADVERTISING (AND EVERYONE IS RIGHT). WE ALSO BELIEVE THE
MAJOR DIFFICULTY ROJO® MAY CONFRONT IS LOSING THE PASSION THAT MADE US MAKE THIS ART
JOINT.

WHAT WOULD BE "THE" THING TO HELP THE MAGAZINE TO IMPROVE?
HAVING MORE COMPANIES AND BRANDS TRUSTING NEW AND UNSEEN TALENT.

WHERE DO YOU WANT THE MAGAZINE TO BE IN FIVE YEARS?
CELLEBRATING THE 10TH ROJO®ANNIVERSARY WITH READERS, FRIENDS, ARTISTS AND EVERYONE THAT
HELPED OUT IN ANY WAY... IN AN NICE PRESENTATION EVENT WHERE WE WILL BE RELEASING A NEW
PRINTED ISSUE.

TELL US ABOUT YOUR AUDIENCE! WHO ARE THE READERS OF YOUR MAGAZINE?
ANYONE THAT LIKES TO LOOK AND ENJOYS THE INNER NEED OF UNSEEN VISUALS AND ARTISTS.
ALL AGES, ALL GENDERS...

IS REMAINING INDEPENDENT IMPORTANT TO YOU? IS IT PART OF THE STRATEGY?
WE MUST SAY... WE MUST SAY... WE MUST SAY IT... BUT WE THINK NOT... OK... OK... WE SAY IT...
BEING INDEPENDENT IN BUSINESS STINKS, AS THERE IS NO FINANCIAL STABILITY, NO EXTRA PAYMENTS,
LOADS OF WORKING WEEKENDS, NO SECRETARY TO ATTEND UNDESIDERABLE CALLS, NO COFFEE
BREAK... NO HOLIDAYS... BUT WE DO NOT KNOW THE OTHER WAY... THE CORPORATE WAY... AND WE
MUST SAY THAT WE ARE HAPPY NOW DOING IT INDEPENDENT... SO THIS MEANS YES...
IT IS PART OF THE STRATEGY... AND THE STRATEGY IS TO DO THINGS HAPPILY.

WHAT'S YOUR RELATIONSHIP WITH ADVERTISEMENT? DOES IT INFLUENCE YOUR CONTENT?
WE LOVE OUR ADVERTISERS AND WE OFFER THEM ALL THE RESOURCES WE HAVE TO IMPROVE THEIR
COMMUNICATION TO THE PUBLIC. CONTENT IS NOT INFLUENCIATED BY ADVERTISERS AT ALL... AS WE
INCLUDE ADVERTISING AS CONTENT OF THE MAGAZINE.

WHICH IS YOUR RELATIONSHIP WITH YOUR PRINTER?
WE LOVE OUR PRINTER. WE ALWAYS FIGHT... BUT THIS IS PART OF A LOVE RELATIONSHIP.

WHICH MAGAZINES DID INFLUENCE YOU MOST?
WE WERE INFLUENCED BY ALL MAGAZINES I READ... AS WE DECIDED TO CREATE A MAGAZINE THAT HAD
NOTHING TO DO WITH THE REST. WE STOP LOOKING FOR THINGS IN OTHER MAGAZINES LONG AGO...
ROJO® HAS CREATED ITS OWN PATH... BUT WE DO ENJOY MANY OF THEM AS ONE MORE READER.

WHAT DO YOU THINK OF YOUR ISSUE 01, WHEN YOU LOOK BACK AT IT?
WE DID NOT KNOW THEN THAT WRITTEN TEXT COULD BE A BARRIER. WE THINK OF IT (ROJO®START) AS
A NECESSARY FIRST STEP OF A LEARNING PROCESS... AND AS AN INCREDIBLE DOCUMENT DISPLAYING
CLEAR INTENTIONS OF BREAKING MAGAZINE STANDARDS... IT WAS FOR FREE, HAD 4 DIFFERENT
COVERS, INCLUDED NO HEADER AND ARTICLES WERE IN 6 DIFFERENT LANGUAGES WITHOUT ANY
TRANSLATION. WE WANTED TO HAVE A CREATIVE TOOL THAT COULD BE EASILY ACCESSED BY YOUNG
ARTISTS IN NEED OF WORLDWIDE EXPOSITION AND FIVE YEARS LATER, WE ARE STILL WORKING HARD
TOWARDS THIS GOAL.

WHAT QUESTION DID YOU NEVER ASK IN YOUR MAGAZINE BUT WOULD HAVE LIKED TO?
ROJO® IS AN IMAGE DRIVEN TEXTLESS MAGAZINE... NO QUESTIONS ASKED.

Rojo

Ros de Olano 34
08012 Barcelona
Spain
Website:
www.rojo-magazine.com
Email: info@revista-rojo.com
Editorial director:
David Quiles Guilló
david@revista-rojo.com
Format: 210 x 280 mm

Great moments #4

The birth of *New York* magazine (1968)

When the *New York Herald Tribune* went out of business in 1967, it took with it one of the best Sunday supplements around. But not for long. On 8 April 1968, the proverbial phoenix arose. On that day, the standalone *New York* magazine appeared on the city's newsstands, thanks to Clay Felker, editor of the original supplement, his business partner and designer Milton Glaser (also known as the creator of I♥NY, among other design classics) and Jack Nessel, Felker's previous number two.

New York

What they created was the first modern city magazine, combining useful information with sparky articles, celebrity contributions and genuine interaction with the city and how people lived in it. While *The New Yorker* continued to plod along its serious-minded, highbrow path, *New York* was fresh, young and lively.

The New Yorker

In the early years, dozens of editors and writers were crowded into a space that had only one bathroom; they wore coats in the winter because there was no heating, and they fought constantly because there was no precedent to follow. "Out of the intensity, the tension, we created a magazine that reflected that energy," said Glaser later. The magazine became a big success. It was bought in 1976 by Rupert Murdoch, who pushed Felker and Glaser out and merged the well-established listings title *Cue Magazine* into it, making *New York* a combined listings and city magazine. It continues thus today.

Cue Magazine

In the same year that *New York* first hit the streets, Tony Elliott began a 'fanzine to London and its events' that he called *Time Out*. Using money given to him for his 21st birthday, he created a folded sheet about London life away from the over-reported mainstream, and instigated an equal-pay policy, whereby everyone who would work for the magazine, from office-cleaner to publisher, would receive the same wage. Perhaps its greatest art director, Pearce Marchbank, arrived at the magazine in 1970, creating the familiar logo and bringing in friends who would help give the magazine its left-leaning identity. He stayed with the magazine, with varying levels of commitment (he worked on the rival *Event* for a while – described overleaf), until 1983.

Time Out

Event

BEST BETS

RECOMMENDATIONS OF CURRENT AND CHOICE EVENTS OF THE WEEK

The Bard on the Boards

The summer Shakespeare season is under way once more at Stratford, Connecticut, and this year there will be three Shakespeare plays and one by Bernard Shaw in repertory. Shaw is represented by his delightful *Androcles and the Lion*, complete with very cuddly-looking lion costumes. Their version of *Love's Labours Lost* will be performed to a new rock score by two composers rejoicing in the names of Frangipane and Dante. Productions of the other two plays, *As You Like It*, and *Richard II*, promise to be more conventional. Call CI 5-5656 in New York for reservations.

Forty Films at the Lyceum

Movie buffs will be happy to hear that the APA Phoenix and Janus Films have united to provide a superlative program of 40 movies at the Lyceum theatre: they'll be shown nightly, starting on July 1. (For further details, see our listings.) Not only will the festival provide a chance to catch up on all those movies you're ashamed to admit you missed (*Potemkin*, *Smiles of a Summer Night*, *L'Avventura*, *Ashes and Diamonds*—the list goes on), but there will also be showings that not even the most redoubtable fans can have already seen. Truffaut has recently re-edited *The 400 Blows*, and the new version will be shown in New York for the first time; a 20-minute section always cut from previous showings of *King Kong* will be re-instated for this performance; and the full, uncut version of *The Virgin Spring* will also be shown. Tickets can be bought singly, but truly compulsive movie-goers can also buy them in series at reduced prices. Here, a still from *Citizen Kane*.

Art or Artifact?

There is an exhibition at present at the Museum of Contemporary Crafts, 29 West 53rd Street, which includes works in many different media by artists from all over America. Don't go expecting to see traditional crafts, however. The exhibit is not entitled "Objects Are . . .?" for nothing. It's designed to illustrate the way in which functional objects are becoming *objets d'art*, and even the necklaces double as pieces of sculpture, with their own stands, built especially to display them. The exhibition will remain through September 8.

12

Check-Out on Sonny & Cher

On June 28 at the new Madison Square Garden there will be a "Soul Together" concert, featuring Aretha Franklin, The Rascals, and Sonny and Cher plus many more, all of whom will be appearing without fee. Proceeds from the concert will go to the Martin Luther King Memorial Fund, and to a summer program to aid underprivileged children. Tickets range in price from $4 to $12.50.

Painted Realism

The Museum of Modern Art opens its major summer exhibition, "The Art of the Real: U.S.A. 1948–1968," on July 2. On display will be about 40 paintings and 20 sculptures, some of which were specially commissioned for the show. The exhibition was devised by E. C. Goosen, who is chairman of Hunter College's art department, and who wanted to stress, among other things, the increasing interaction between painting and sculpture. Included in the show are two Ellsworth Kellys, and work by Carl Andre, and Kenneth Noland. The enigmatic painting here is one done in 1962 by Paul Feeley.

Black Velvet on 57th Street

A marvelous place to combine eating and shopping has just opened at 130 East 57th Street. It's called *The Irish Pavilion*, and already it's crowded most of the time. The long low interior is part restaurant, part display-case for the lovely Irish crafts and antiques, all of which are for sale. Collages by the young Irish artist Noel Sheridan hang on the walls, and the tables are piled high with hand-woven wools and linen, pottery, old copperware, Professor Higgins-style hats in Irish tweeds, Galway glass, and those chunky ivory-colored hand-knitted sweaters that fishermen in Ireland really do wear. Tradition has it that no two sweaters are alike in their intricate patterns—each was created unique, so that if the wearer met an accident at sea, and was later washed ashore, his family would always be able to identify him. The Pavilion has none of this Gaelic melancholy, however. They serve excellent Irish coffee, and, for those who want to down a lunchtime toast to Brendan Behan, they serve draught Guinness for men, and "Black Velvet"—Guinness mixed with champagne—for the ladies.

Musical Waterloo

Out in the Allamuchy Mountains in Northwestern New Jersey, about an hour's drive from New York (via U.S. 46 and Interstate 80), is the charming Village of Waterloo, restored to the way it looked around 1800. This summer Waterloo joins the music festival circuit, with concerts every Saturday night from June 29 to August 31. The concerts are given in a 2,000 seat tent theatre, but there's room for an overflow of 1,000 on the lawns outside. The first concert has the New Jersey Symphony under its new conductor, Henry Lewis, playing music by Haydn, Poulenc, Copland and Ravel, with Marian Anderson narrating Copland's *Lincoln Portrait* and Gold and Fizdale as soloists in Poulenc's Two-Piano Concerto. Go early, so you can also visit all the other fun things in the Village (Grist Mill, General Store, Blacksmith Shop, Canal House, etc.). If you think New Jersey is all swamps and Supermarket Cities, you'll be amazed at how beautiful the countryside is in that part of the state.

13

Time Out soon had its rivals. When the magazine controversially scrapped its equal-pay policy in the early 1980s, a few companies tried to take advantage of the resultant chaos in the organisation. Richard Branson launched a short-lived magazine called *Event*, and a number of *Time Out* staff who resigned over the change created their own magazine, *City Limits*, which lasted for a decade until 1991.

City Limits

Time Out is not only still the leading magazine about London, but now has franchise operations all over the world, from *Time Out Mexico City* to *Time Out Mumbai*. Meanwhile, few are the major cities that don't have some kind of publishing dedicated to the cities themselves and what goes on in them. *New York* has become a global phenomenon.

Time Out Mexico City

Time Out Mumbai

From the top:
New York;
Time Out

Magazine 6/10

S magazine

Denmark

As an erotic fashion photography title, *S Magazine* immediately stands out. Its eroticism has nothing to do with the rise of 'porno chic', but instead is a showcase for superlative photography and lively design. The magazine describes itself, in its seven-point manifesto, as a publication "for the more discerning voyeur" – and it includes erotic fashion imagery aimed at both men and women. It rarely publishes articles, but its focus is instead on large-format photography, immaculately reproduced. Created by Design City Copenhagen, *S Magazine* manages to achieve the near impossible: an amazing, high-class erotic product.

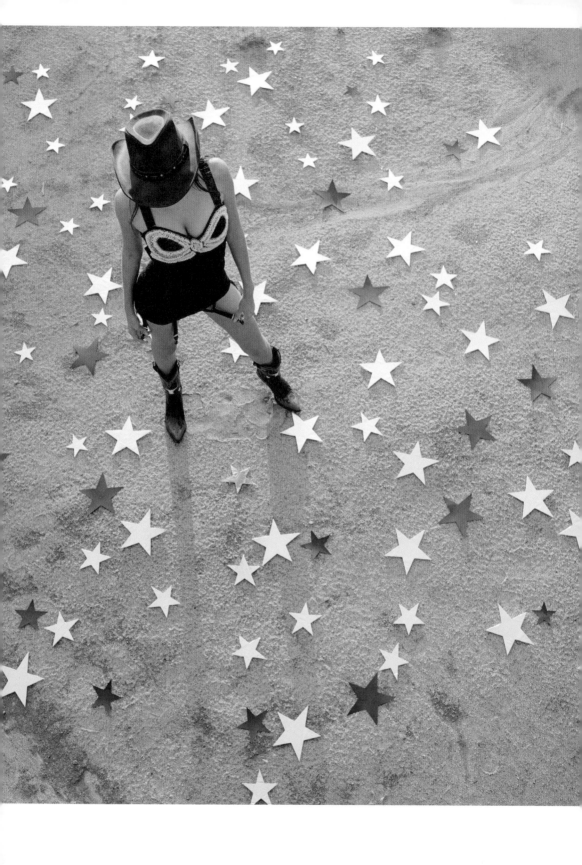

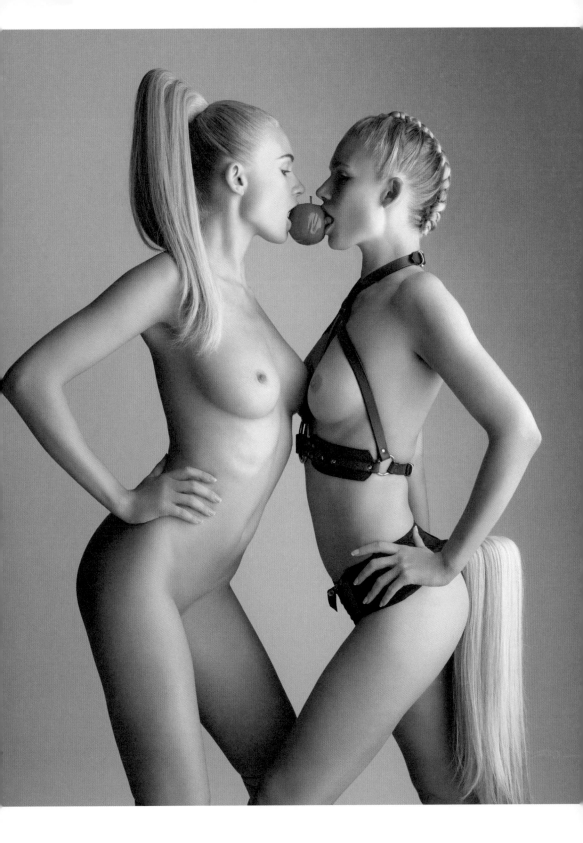

What is your magazine about?
It's about photography, fashion and sexuality. It's a playground for photographers, where they can explore the media without editorial constrains. It's also a place were they can have there more personal work published.

Who's behind the project? Tell us about the founders, their backgrounds and their motivations!
We started out as a small group from the fashion business in Denmark and the company is based in Copenhagen. Today our fashion editor is from New York and we have different picture editors around the world.
What motivated us was the strict boundaries that you tend to find in commercial work and we basically wanted to give the creative freedom back to the photographers, stylists…the people behind any good picture.

How do you produce one issue? How much time do you spend on it? How big is your team?
We are open for submissions from everybody, but we do approach some photographers from whom we would like to see contributions from. How much time? All our spare time! It takes around 3 months to produce each issue, equally shared over the time span between every issue. We are around six people on the editorial board.

What have been the important steps in the life of your magazine?
Getting the international network up and running and having a great international distributor in Comag.

Which are the key ingredients for the success of your magazine?
The mix between the big well renowned photographers and the new and upcoming, good printing and the whole idea about creative freedom. And of course our ongoing theme of fashion meets porn.

Where do you want the magazine to be in five years?
To be among the ten most influential magazines in the world and still be seen as guarantee for the highest quality in photography.

Tell us about your audience! Who are the readers of your magazine?
All kinds of visual interested people. Men and women.

Is remaining independent important to you? Is it part of the strategy?
Independence gives us the ability to make the decisions ourselves. So yes this was a part of the strategy from the beginning.

What's your relationship with advertisement? Does it influence your content? Do you care about advertising-driven-editorials?
We have a good relationship with our advertisers but they have no influence on the editorial content of the magazine, so we rather loose an advertiser, than not run a certain story.

Which magazines did influence you most? What are you looking for in other magazines?
All of them, you get influenced by everything you see it be that you think that's a great idea or you say that's not the way to do it. It all ads up.

What do you think of your issue 01, when you look back at it?
It was a great issue. Of cause the quality has increased a lot since. But it had freshness to it that we strive to uphold in all the issues.

S magazine

Nygade 4, 1th
DK-1164 Copenhagen
Denmark
Website: www.spublication.com
Email: info@spublication.com
Editor-in-chief: Jens Stoltze
stoltze@spublication.com
Art director: Ulle Luv
luv@spublication.com
Format: 230 x 297 mm

S magazine

Denmark

Great moments #5

i-D creates the Straight Up (1980)

"My personal take on fashion is to celebrate people and bring the theatre of fashion to the everyday" – Terry Jones.

The word 'fashion' has always been a loaded one. Is it about conforming or not conforming? If everyone's wearing this season's outfit, is it already over? Go back 25 years, and fashion magazines were about learning what to wear – about seeing pictures of outfits out of reach to all but the super-rich, about using the publications as paper telescopes to gaze at the catwalks of Milan and Paris with appropriate awe and admiration. Even as punk took the 1970s by storm and designers such as Vivienne Westwood and Zandra Rhodes took the punk aesthetic from the streets and put it into the shops, the fashion magazines staunchly refused to budge. It was the catwalk that set the trends, not the people on the street!

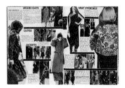

Vogue
Good Housekeeping
Vanity Fair

It is perhaps surprising, then, that the first magazine to take street fashion seriously was created by the former art director of *Vogue* (also a former designer on *Good Housekeeping* and *Vanity Fair*), a man called Terry Jones. He had left *Vogue* in 1977 after five years at the helm, and had formed his own studio: informat Design, experimenting with hand-made, free-form collages, taking his inspiration from the street and its visual language. In 1980, he launched his own magazine, taking the initials of his studio as its title. *i-D* was made up of a handful of photocopied pages, and cost 50p.

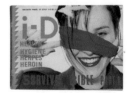

i-D

Rather than telling readers what they should be wearing next season, the magazine reported on what they were wearing right now. Its apotheosis was the Straight Up feature: a regular series of head-to-toe portraits of young people, mostly photographed by Steve Johnston, usually posing next to blank walls in the centre of punk, the King's Road in London's Chelsea. A typical caption read: "Colin is wearing black pleated trousers that he made himself. The cardigan is from Marks & Spencer, £9.99, and the shoes from Axion in the King's Road, £5.99. Fave music – Siouxsie and the Banshees and David Bowie." Soon, the Straight Up feature included a Q&A. New icons were born every single month.

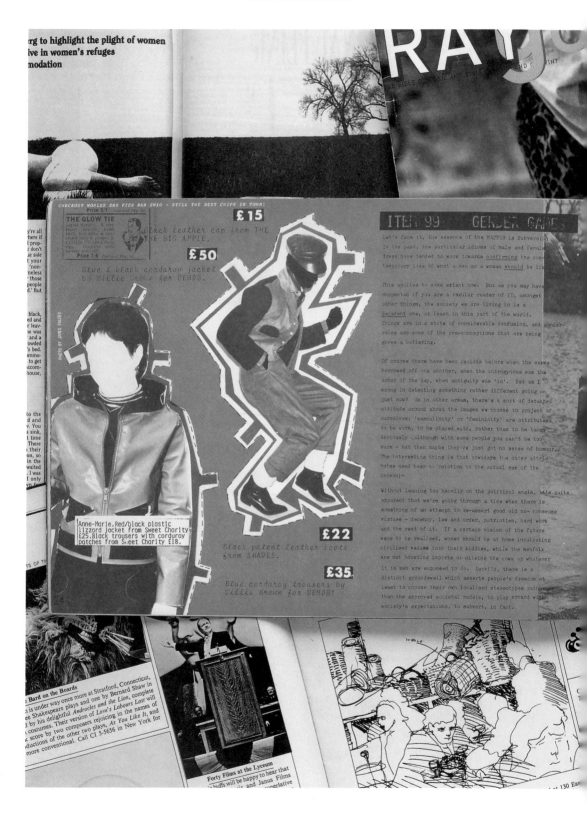

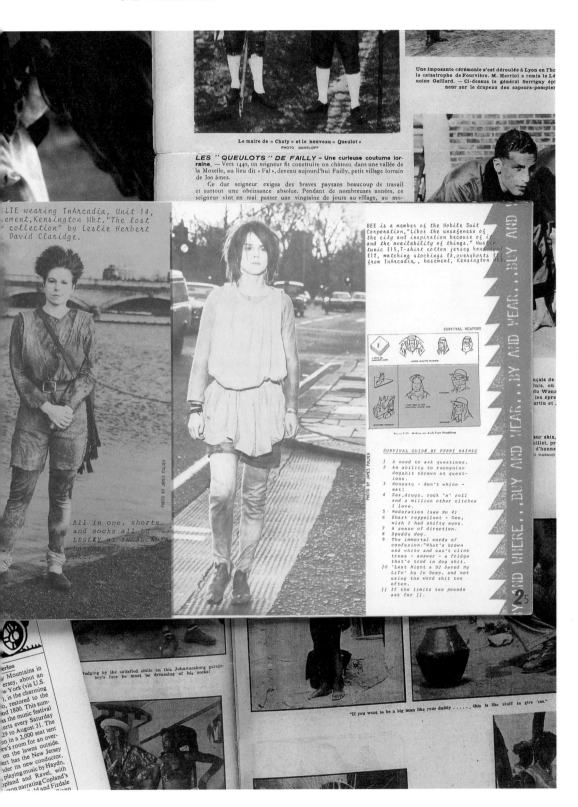

Une imposante cérémonie s'est déroulée à Lyon en l'ho
la catastrophe de Fourvière. M. Herriot a remis la Lé
noine Gaillard. — Ci-dessus le général Serrigny épi
neur sur le drapeau des sapeurs-pompiers

Le maire de « Chaty » et le nouveau « Queulot »
PHOTO GANSLOFF

LES '' QUEULOTS '' DE FAILLY — Une curieuse coutume lorraine. — Vers 1440, un seigneur fit construire un château dans une vallée de la Moselle, au lieu dit « Fal », devenu aujourd'hui Failly, petit village lorrain de 3oo âmes.

Ce dur seigneur exigea des braves paysans beaucoup de travail et surtout une obéissance absolue. Pendant de nombreuses années, ce seigneur vint en mai passer une vingtaine de jours au village, au mo-

LIE wearing InArcadia, Unit 14,
ement, Kensington Mkt. "The lost
collection" by Leslie Herbert
David Claridge.

BEE is a member of the Mobile Suit Corporation, "Likes the unsafeness of the city and inspiration because of it. and the availability of things." Muslin tunic £15, T-shirt cotton jersey hand-dyed £12, matching stockings £8, overshorts £12 from InArcadia., basement, Kensington Mkt

SURVIVAL WEAPONS

PHOTO BY JAMES PALMER

All in one, shorts
and socks all by
LESLEY at InArcadia
basement Kensington
Mkt.

PHOTO BY JAMES PALMER

SURVIVAL GUIDE BY PERRY HAINES

1 A need to ask questions.
2 An ability to recognise
 dogshit thrown at quest-
 ions.
3 Honesty - don't whine -
 eat!
4 Sex,drugs, rock 'n' roll
 and a million other cliches
 I love.
5 Moderation (see No 4)
6 Shark repellent - Gee,
 wish I had shifty eyes.
7 A sense of direction.
8 Spuddy dog.
9 The immortal words of
 confusion:"What's brown
 and white and can't climb
 trees - answer - a fridge
 that's trod in dog shit.
10 'Last Night a DJ Saved My
 Life' by In Deep, and not
 using the word shit too
 often.
11 If the limits ten pounds
 ask for 11.

nçais de
Unis, où
du Wana
les épre
artin et

ur skis,
uillet, pr
d'honne
O MARAND

2 5

erloo
y Mountains in
ersey, about an
w York (via U.S.
), is the charming
), restored to the
nd 1800. This sum-
as the music festival
erts every Saturday
29 to August 31. The
en in a 2,000 seat tent
e's room for an over-
on the lawns outside.
ert has the New Jersey
der its new conductor,
playing music by Haydn,
opland and Ravel, with
son narrating Copland's

Judging by the satisfied smile on this Johannesburg garage
boy's face he must be dreaming of his socks!

"If you want to be a big man like your daddy this is the stuff to give 'em."

119

The Face

Dazed and Confused

Self Service

Purple

Street/Fruits/Tune

This led to two things happening. Firstly, back issues of *i-D* have now become a unique documentary archive of fashion and trends away from the big brands. Secondly, a new breed of fashion titles, from *The Face* and *Dazed and Confused* to *Self Service* and *Purple*, emerged in *i-D*'s shadow; Japan's *Street/Fruits/Tune* magazines consist of nothing but Straight Ups. And perhaps most impressively of all, *i-D* is still going strong, its cover models still winking at us after a quarter-century. The magazine's longevity is attributed to how it continues to be influenced by the trends it finds – rather than the other way round.

That trends come from the street rather than the fashion houses is now a given. Back in 1981, the idea was truly shocking. It took a man called Terry Jones and his *i-D* to give us a proper sense of our own identity.

From the top:
Street, *Fruits*,
Tune.

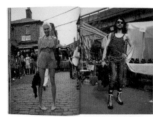

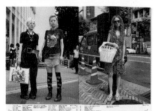

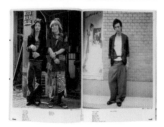

Apples

and

knives

Different skill sets
Bob Newman, born 1953

Diff
Bob N

Caught in the middle
Wladimir Marnich
born 1967

I have fond memories of the old artwork processes before computers. Although you could argue that it was less perfect and at times more difficult, for me it was relaxing. Preparing artwork meant having a break from being creative. I could spend a day or two 'playing' with my markers and rulers, squaring everything up.

One of the reasons I liked being a designer was the idea of owning many rulers, pens, pencils, Letraset, coloured papers etc. I remember, on my first day I was given a box of starter materials: a welcome pack. In particular I liked the Staedtler pencil and sharpener. Nowadays, all you get is a computer and an email address.

Of course, it sounds like it was all easy and wonderful, but there were plenty of frustrating moments when things didn't go so well. Having to repeat work because the last applied colour didn't stick properly and ruined the whole job was not as easy as an 'Apple-Z'.

The arrival of the computer was, for me personally, a bad thing; I enjoy doing things by hand. I feel my generation was caught in the middle of two things. On the one hand, I feel I don't have all the technical knowledge about the craft: typesetting, printing processes and so on. And on the other, I have a basic knowledge of the computer and what it can offer. I'm not attracted to new technologies. My feeling is that I don't know enough of anything.

There are no longer specialists. The designer has responsibility for the entire process. What was once shared among different professionals – art workers, typesetters,

There's a lot less blood in the art department these days. Computer screens don't often cut off fingers. But in the days of paste-up, everyone had stories of fingertips being sliced off and blades in the palm. I still have scars. I remember on the *Village Voice*, we had an illustrator at the paste-up table who sliced his finger open. There was blood all over, but we were on a deadline – so we had someone hold his left hand up in the air and wrap it with ice while he kept drawing with his right. He was begging to go to hospital, crying and feeling faint, but people were just shouting, "Keep drawing! Keep drawing!"

Nowadays, all art directors tend to have the same technical skill set. They might differ creatively, but they use the same programs. With DTP, to my mind, art directors lost a direct connection to the printing and production process. Quark and the other programs give you more control, but when you did all your own typesetting, or worked more intimately with negatives, I think you had much greater experience and knowledge. When you had to spec type, you were far more aware of essential typography. With desktop publishing, it just pops out. The whole process of going through a galley and marking it up using typographers' marks and really being aware of spacing – you were more precise because you didn't get a second chance. Now, you do 20 different things – it's a very different approach.

Wax

Everyone used wax, and everyone had that sad moment where you'd put a galley of type onto a waxer upside down. And you'd have to scrape all the wax off the type. You'd also have to typeset whole galleys of line corrections, and wax them and slice them,

proof-readers, image manipulators – all became the designer's job. You share your time between creating and production. It's good – you can better follow and control the whole process, but it also means more work and responsibility. A tool that was meant to make things easier and faster (which it has), has also meant the opposite: more work, less time to do it in.

The help computers brought us is undeniable. The advantage of being able to see right away how text will look in a certain font or what a logotype 'really' looks like has no comparison. But, I can't help notice a lack of ability in many students when rendering ideas with pen and paper. When I look at the work of Herb Lubalin or Alexander Brodovich, it reminds me what great designers they were. Producing that work without an immediate result makes it even more valuable. *Wladmir Marnich is an art director, based in Barcelona.*

and stick them in line by line. Everybody's nightmare was that you'd have a thin, one-line correction and you'd put it through the waxer, but it wouldn't go through properly and it would go down into the melted pool of wax. You'd have to fish it out with an X-ACTO knife or tweezers. It would be covered with a quarter-inch blob of wax on all sides that you'd have to scrape off, and then you would stick it down again.

Another thing people would do is correct lines letter by letter. If there was a typo, you'd have to find a wax galley somewhere – an old one with letters on that you could cut out and paste on top of the wrong letter. That was not a lot of fun. You'd do whole lines where you'd create all the words, and you'd have to letter- and word-space it yourself. That was a nightmare.

Type

There used to be a place in New York City called Photolettering. A legendary type house – if you can ever get a copy of an old catalogue, it's astonishing. There weren't as many typefaces 30 years ago – but then some guys had a zillion typefaces, and a lot of these have never been digitised. It's not that you didn't have

The onus is on the designer

Vince Frost, born 1964

The first magazine I worked on was just before computers came out. I was fresh out of college and we had to design and lay out the artwork on a CS10, get typesetting done, and wax and set it down. It was in five languages, so I had to typeset in each one, stick it all down by hand... a lot of work.

It would take about a week to lay it all down. It was laborious and you made decisions differently, because you knew how much effort was involved. You used to get the text from the client by fax – we had a full-time typist who would then type in all the text again. You'd mark it up with what type size you wanted – what leading, column width and so on, then you'd fax that to typesetting. The typesetter would type it all in again on their typesetting machine, then they'd fax it back over to you to check, or they'd bike over galleys of type the next morning that you'd have to stick down. If there were any mistakes, you'd have to cut it up and rearrange the type or letters, or get it reset. It was a very laborious process. There was a real art to the artworking.

We never had scanners – they were at printers or repro houses. You used to have to commission a photographer to do everything, at great expense. You'd have a Polaroid, have to get prints made, get to a scanner to scan it in... it was a really complicated process. Now, we just size pictures up and down within seconds. It's very fluid; we have all this high technology. We work on a computer, of course – there's tremendous speed and versatility. We get content from around the world within seconds, or we take pictures and immediately use them as layouts. Before, if you wanted a print, you'd have to courier it.

It's the architecture

Ingrid Shields, born 1971

I lied my way into my first job, claiming that I could use Quark XPress. I then had to sit in my studio all through the night with one of those big Quark textbooks learning the program the day before, so I could lay out my first spread the next morning.

When I arrived, I found that there was no real picture budget and it took forever to get a transparency sent over from Image Bank. So, I took basic images and mangled them in Photoshop (which also took ages), trying to make the program do what I wanted.

Like most designers, I learnt how to use software and hardware in order to do what I needed to do. Now, I can download any number of images, typefaces and illustrations instantly, so I can spend more time doing the bit that I enjoy most: 'building' the design.

I'm interested in the architecture of a magazine. When creating templates, I like watching the master pages and style-sheet sheets become the 'tool-kit' that I can hand over to someone else, so they can build variations on the same design over and over again. I imagine that touchscreen technology will make this process even more fun in the future, bringing us closer to the tools we use. *Ingrid Shields is an editorial design consultant, based in London.*

123

a lot of choice, but unless you had a huge budget, you had to be very precise about your speccing. And you had to really know, going in, what it was you wanted to do. There was less experimentation at the point of production, and more sketching.

Early computers

I was working at the *Village Voice* when we got in our first computers: little 14-inch screens. They were so small that we made the type really big. That was directly responsible for display type getting bigger – art directors had such small screens, they intuitively made things bigger on the page.

In the US, the standard at news weeklies and newspapers was called Atex. It was a really clunky word processing/typesetting system. It was like an early computer where everything you saw on the screen was in code. All the type on the page looked the same point size and font, no matter what you specced. The only thing you saw on the screen was column width and I think you saw runarounds. It composed long galleys that had to be pasted up, in whole pages. A lot of places had a whole class of people called 'coders' and they typed code into the starts of all the stories, with all the speccing information. It

You used to choose photos out of books. Now, we can look online and see a whole world of images.

You'd really make the decisions upfront; you almost planned the artwork before you designed it. If you made the wrong decision on the font – if you'd chosen six-point type through the whole magazine and the client then said, "Oh no, we want eight-point" – it was a very costly exercise to change that and run it all out again.

Repro was a real skill that I believe has totally gone down the pan. You used to give the artwork to the printer, and they would do the scans and retouching. They used to do fantastic-quality proofs, and it would be a real art form for the repro guys in how they planned out the pages. Today, what we think looks good on our computer is very inconsistent – there's no standard. A lot of the time these days, you get really crappy proofs back from printers, on different stocks, different materials, different sizes, and they all have different standards. You don't know where you stand until it's too late and you see the thing on press. A lot of the quality control and the skills of the printers – those who went through apprenticeship schemes as teenagers and had a job for life – has been forgotten and quality has been affected by that.

There always used to be someone else who was a professional scanner, proof-reader, typesetter, printer... the onus is now really on the designer. You're doing everything and it's your responsibility. In some respects, that's exciting and liberating. In other respects, you think, "Fucking hell! We've now got the responsibility to get everything right." A person can sit down at a computer now and create a magazine all by themselves.

Look at design from the 1950s and 1960s... there's a lot of stuff where we can now say, "My God! That looks like Photoshop

The warm smell of wax
John Belknap, born 1952

I was editor of my high-school newspaper in late-1960s America. My school was very conservative, and it became a game to see how outrageous our stories and layouts could be; I remember one issue even being pulped (although it's so long ago that I forget why).

We pasted up the paper every week down at a local printer. The guys would have all our typeset galleys ready on the boards, ready to paste up with wax and X-ACTO knives. The hot wax was in a small silver machine with a roller. You flicked on the switch, the roller hummed and spun, and you passed the galley through – and it was ready to put down. Unlike glue, which smells toxic, the wax smelled warm and somehow friendly. There was something benign about it; you would never dream of having an argument in that place.

Towards the end of term, the pressure to make decisions about the future intensified. One week, I found myself walking into that composing room feeling depressed. Then that lovely smell of wax filled my nose. Suddenly I had it: I could do this! I could work in newspapers! And I did. *John Belknap is creative director of the* Jewish Chronicle *in London.*

...ry precise – in some ways, you could spec the type a lot more scientifically than you can with Quark – but you couldn't see it, so you'd have to print it out. The machines were huge, the size of big old TV sets, and a big investment.

The majority of people resisted desktop publishing. It was the expense and also a fear of technology that was coming outside of the standard channels – it didn't come up through the traditional graphic design/typesetting circles. And there were a lot of union issues, too.

The presses

Printing quality is so much more scientific now. Instead of having a print manager go to the plant and see the copies roll off, there are scientifically measured standards and levels that the printers watch for and must match. Generally, there is a pre-approved range within which they can fluctuate. When I was at *Real Simple*, we had printing analysis meetings after each issue, and we would carefully gauge the quality of every page and every image, and send a critique back to the printer. In contrast, I remember going to the printer when I worked in Seattle and practically having physical confrontations at the press over bad printing, demanding that they stop the presses. Usually, when we showed up, the printer would send us over to some restaurant and ply us with lots of free food and drinks while the press was running, so we'd forget to check on the printing...

Xerox

One of the great revolutions for me was not desktop publishing, but Xerox machines that could size up and down. That was just astonishing. We worked at a place that had a stat camera. If you had a piece of type that you wanted to blow up 200%, you'd put it in the stat camera – it was like a Polaroid

or InDesign" – but we know that it was actually all done with photography, or a PMT camera, or just drawn. There's a whole variety of content that's come out of this technology, things from all over the world – people mix and match. You can mash up images and typography – plus, there are millions of fonts available and anyone can design one. There are lots of people just doing stuff that's really exciting, and others playing around with it and creating things that would never have existed without that technology.

The strange thing now is that, after all this hi-tech input and fluidity, we still do something very old-fashioned, which is to print these magazines, something that no longer has any reflection of how they're made.

I think it's all going to change dramatically in the

Bring back intimacy
Stéphanie Dumont, born 1970

When I look at work from the 1950s or 60s, I can appreciate its strong human dimension, which can be difficult to achieve using digital technology. To try to recapture this intimacy, I sometimes work in a more 'amateurish' way by hand-drawing letters or fonts, or by cutting and home-scanning pictures. I've been working on magazines since 2000, and have had Macintoshes, using more or less the same programs, the whole time. They've become progressively more sophisticated in that time – but, overall, I can't think of any radical changes that have come about since I started. *Stéphanie Dumont is creative director and co-founder of Carl*s Cars magazine in Oslo.*

_ ‍‌

camera. It was a really expensive process. But when Xerox came out, you could size up and size down instantly – to us, that was revolutionary, even though the Xerox machines only had fixed percentages: 125, 150, 75 and 50%. So, if you wanted to size something 87%, you'd have to blow it up and then shrink it down. And then when they came up with the variable sizes, that was heaven, in production terms.

On Xeroxes, we did a lot of distressed type, distorted photographic things, high-contrast photos. With stat cameras, you did a lot of stuff, too, and in the darkroom. You literally had sets of screens that you used to create photographic tricks. A lot of the initial Photoshop tricks were based on the different screens that were available for next few years. People have been talking about digital publishing for a long time. The web's been around for quite a while now, but I don't think that anyone's really got it right in terms of making it feel like it has some kind of quality and substance. It still feels kind of cheap. No matter how well-designed a website is, it doesn't feel... well, it's just not the same.

But 'electronic paper' is a really cool idea – a tactile, flexible, roll-up screen that's completely changeable. Maybe magazines will one day be replaced by television and the internet. But a magazine is someone's edit; someone's curated that publication. On the internet, you have to think, "What do I want to look at?" *Vince Frost is the creative director of Frost Design, based in Sydney.*

Non-stop change
Simon Esterson, born 1958

Looking back, I realise that the period 1970-1990s – roughly from the end of commercial letterpress printing to the introduction of the early Macs and page layout programs – was a succession of technological changes. Each seemed like a revolution, and required the learning of new skills and working methods. All of which were then made redundant by the next change.

Doing physical artwork became redundant, for example. Large chunks of my youth were spent pasting up art for low-budget magazines, usually late into the night, getting slower and less accurate. Offset printing (where repro photographed the pages, made film and then plates) liberated us from hot-metal typesetting and the printer's composing room. We could do whatever we wanted with the pages, provided we could stick it to a bit of artwork. You learnt the tricks of cutting in tiny text corrections with a scalpel. You drew guidelines all over the page with a magical non-repro blue pencil and they weren't picked up by the camera. We even used to print grid sheets in non-repro blue for reuse. There were the frustrations of keeping Rotring pens from clogging up when you had to draw column rules. And, of course, there were the wonders of Letraset. If you worked in advertising, you could afford to use all those posh London headlining houses, places like Face, but in my world, you just rubbed down like mad. The Letraset catalogue was your best friend, and you knew all the tricks to make a lowercase Helvetica 'p' if, at midnight, you discovered the sheet had none left. Letraset invented a system called Spacematic, a kind of visual kerning system to help you position type. If you were an old pro like me, you did it by eye; Spacematic was for wimps.

Now it's all gone – no more Cow Gum fumes. I remember I asked somebody in Germany for some artwork for a press ad. "Artwork?" he said. "We don't do artwork any more – it's all film." Well, that's gone, too. Just data; words, photographs, everything just data seamlessly uploaded from my FTP to yours. At least these days, when working late into the night, my Mac is still wide awake and can draw a perfect line. *Simon Esterson is the creative director of Esterson Associates, based in London.*

photostat cameras.

Of course, the other great thing about the darkroom was that a lot of the art directors got high in there. And not just from the chemical fumes, either... everyone spent a lot of time in that darkroom, doing photographic effects, and the longer you were in there, the more interesting things looked.

Complicating matters

I don't know a single person who would say, "Yes, DTP has really streamlined things – we're working a lot faster and a lot less." Some 30 or 40 years ago, typography was very stripped down and very simple. Magazine design was very simple and clean, both by design and by necessity. To me, what's interesting is how much the means of production influenced the design. And how much the design was a matter of function, and how much was a creative decision.

A lot of magazines are now hyper-designed – is that a creative aesthetic, in response to reader demand, or a result of the capacity of desktop publishing, which gives you the ability to do all that stuff? We just had our InDesign training last week, and they were showing us the drop shadow and distorted type, and all the Photoshop

Technology marches on
Jeremy Leslie, born 1961

The magazine design process has completely altered over the past 20 years. Not only has technology advanced, the whole workflow has changed (workflow – itself a new word). Some people romanticise this era; for me, the memories are far from rose-tinted.

Headlines

At my first job in the studio at *City Limits*, we used a rolled strip of photographic paper onto which each individual letter of the headline was exposed, one at a time. This was done blind – the letters didn't appear until the strip was dunked in the developer liquid – very hit and miss in terms of positioning and exposure. If you overexposed it, the character would blur round the edges; if underexposed, it would come out pale. Once you had finished that, you would then have it blown up on a PMT camera, often causing further distortion, and you cut in extra letter-spacing where needed. It was a great discipline to learn, but really, what a waste of time.

Resizing

The PMT camera in most places I worked always seemed to be run by large men recruited less for their camera skills than for their belief that every designer was trying to fool them into doing more work than was necessary. These men were the key to getting your layout completed accurately and on time, and they were regarded with some fear by every member of a studio.

Pictures would be sized up manually and added to the camera operator's work tray.

And so it began
Suzanne Sykes, born 1960

Launching *Marie Claire* in 1989, we were 100% old tech. That meant laboriously cutting up galleys (where you earned your spurs with 'designer's hand' – that swift scalpel swipe to the index finger that landed you in casualty for the day), leafing through coma-inducing type books, inhaling lung-clotting 3M Spray Mount and even electrocuting yourself with the office waxing gun (yes, really).

Despite such hazards, we dragged our Luddite heels at the introduction of 'new tech'. We were used as IPC's sole guinea pigs in this area, and hated every minute of it – until, of course, we loved it!

When the much-lauded Macs – or should I say, Mac – arrived, we all crowded round its 10cm-square screen, less than impressed. Then, we discovered that documents had to be transferred from Mac to printer by a 3.5-inch floppy disc and carried across the office; we almost despaired. Gradually, however, as Apple got its act together and we each got our own machines (even with breathtaking colour monitors!) – we realised that we could never go back. *Suzanne Sykes is art director of* Grazia *magazine in London.*

Increased control

Luke Hayman, born 1966

In my penultimate year (1987) at the Central St Martin's College of Art in London, the graphic design department purchased six or eight Mac Pluses. A few people started playing with MacPaint, MacDraw and MacWrite. I do remember one student starting to design geometric fonts – he went on to work with Neville Brody. Prior to that, there were a couple of strange machines called Plutos – to get an image from it, you'd have to shoot the screen through a darkened box onto 35mm film. I designed the cover of the course catalogue on one of these.

Then, at my first job – as junior designer at Wordsearch (publishers of *Blueprint* magazine and then later *Eye*) – typesetting quickly moved to the Mac. What is incredible to think of now was that the system folder could fit on a 3.5-inch diskette.

Those Macs were slow. I remember working on multi-page documents (books) that took minutes to save (no images). I did a street map for *Blueprint* that had perhaps only 20-30 roads on it, drawn with the type on each street – black and white, of course. I'd created it in Freehand. I think the angled type slowed it all down – it took two or three days to create. It would probably be two hours' work today.

In general, the feeling is that we now have much more control over the process with these machines. Yes, junior designers replaced typesetters – but it means that we are able to experiment and craft the job without incurring huge correction fees. *Luke Hayman is a partner at Pentagram in New York.*

aspects. And I kept saying to everybody, "Let's not use any of these things." But I could see the lights going off in their eyes: "Oh boy!"

InDesign is the first time that an advance in technology has been adopted relatively quickly. Since the second version came in, people have been embracing it furiously. I think that's never happened in the past. It gives you a universal platform, and so much power and control to the art department that you can basically eliminate the whole production department.

I think that, in three or four years from now, there won't be production departments at all; it'll all be done in the art department. You don't even need imaging departments. Production and imaging are history – because of InDesign and attendant technologies. You can just PDF files straight to the printer yourself.

We'll get rid of the photo editors next, because you don't really need them any more either. *Bob Newman is the design director of* Fortune *magazine in New York.*

The order was strictly first-come, first-served; there could be no queue barging. If you got the measurement wrong, your re-measured pic went to the bottom of the pile. There was no such thing as a private mistake – all were broadcast across the studio. And when Mr Big's shift ended, that was that. Nobody else was allowed near his pride and joy: the orange Agfa camera and its matching boxes of PMT paper, processing machines and drying racks.

The stone

Manually laying out and sticking down galleys pre-Mac was soametimes very satisfying and reassuring, a time for thinking about other things while you tested the design you had conceived. But if you were working on Fleet Street-era newspapers, you were denied this final part of the design process. I worked on a project at *The Guardian* in 1989 when they used the Atex production system. Theoretically, Atex was capable of producing whole pages as single objects, but *The Guardian* was using it only to run off galleys, which were formatted on-screen by editorial staff, then laid out using Cow Gum on boards. There was a team of print union-affiliated staff whose job it was to do the sticking down. That was all they did, at a desk named, for historical reasons, the 'stone'.

The one-off supplement I was working on demanded new formats and font sizes, yet I had to work with the old process – if I hadn't, the union staff would walk out. So, I would format the galley, go down to 'the stone' and watch as the layout artist (always a man) fiddled with my designs. If something wasn't right, I could suggest corrections, but it was up to the individual whether or not they carried them out. If they didn't, I had to go back up to the editorial floor and send amended galleys through the system.

A real revolution
Michael Bojkowski
born 1973

When I think pre-digital, it's always *i-D* magazine's 'Trash' issue. I remember picking it up in the shop, showing a friend; this was pushing the possibilities of print effects to delirious ends. I wanted to do stuff like this.

By my final High School year, Ready, Set, Go! was already established as one of the first pieces of 'desktop publishing' software (a term that still fills my head with lurid clip art and nasty type effects *à la* Microsoft Word). I had a go with it, but kept coming back to *i-D*'s cut-and-paste, where all you needed was a photocopier, a typeface catalogue and a pair of scissors.

At university, we had a year of design basics before being introduced to the Apple Mac. I remember lecturers peering through the computer lab window looking a little worried. The majority had a very limited knowledge of computers, but many of us felt compelled to test its limits. I looked around for magazines that were exploiting this new form of digital design and production, such as *Lime Lizard*, an indie music mag that was somehow slick but erratic at the same time.

Roughly at this time, David Carson's redesign of *Surfer* came along and bent mag design all out of shape. *KGB*, *Ray Gun* and

What's a network?

My first experience of designing on a Mac followed a day's training on PageMaker, courtesy of *The Guardian*. From there, it was straight down to a windowless basement to work on a one-off magazine about the (first) Gulf War. The content was made up of news reports and agency pictures from the war, the finished thing being a chronological record of the war using words and images that had run in the paper.

There was me, an editor, two Macs and a pile of floppy discs. I would design a run of pages, copy them onto a floppy for the editor to insert into his computer. A simple idea, but one that became increasingly fraught as what was supposed to be a quick-turnaround job ran over schedule and into a solid 72 hours without breaks that inevitably had us muddling files and floppies. At the end, the final pages were copied onto discs and taken to the local bureau to be run as film. Of course, when the film was checked, the pages didn't quite link up properly.

Post-technology

For several years after the introduction of the computer, designers were at the mercy of the Mac on their desk. What was supposed to be a liberator would often turn into

Fish and file sharing
Marcus Piper, born 1975

Pol Oxygen is an architecture and design magazine published in Sydney, art directed by me in London and printed in China. Contributors, both writers and photographers, from all across the globe provide truly international content. Most I talk to regularly via email, but few have I ever met (or even know the sound of their voices).

This process five years ago would have been near impossible, but now it's seamless (minus the odd technical glitch). We rely heavily on Broadband and remote login to the Sydney server. Once logged in, I can work on the same files as the editors, subs and pre-press department, in the same way I could from a desk in the Sydney office.

Commissioning is all done electronically – finding photographers and illustrators in any country is simple using the internet. Not so long ago, I would work late into the night phoning photographers and arranging shoots in foreign countries. Now, though, it is all done via email.

Tech development is a double-edged sword, though. Photography is crucial to the success of any magazine, and personally I am stuck in the film days when it comes to portrait photography. There is a feeling that digital still can't capture the

quality of the shot, the depth of field and colour. That said, it allows us to do things that used to be impossible. I shot a cover with watches in an aquarium. We selected the star of the shot: a small, bright yellow, brown-faced fish – unaware that he went black as a defence mechanism when scared. Flashes going off were clearly scary. With digital capture, we were able to wait for the fish to go yellow – checking we had the shot before breaking the set. Using film and Polaroid, we could never have done this.

Colour and the digital revolution are also vital to quality magazines. Knowing how to use the colour profile specific to your printer, ensuring it's held through repro to the printer, can mean perfectly reproducing exact colours in shots received in vibrant RGB. Developments in this area have been massive in recent years, and they are still coming. We proof everything in-house in Sydney; I was involved in developing a system to ensure correct colour settings for each magazine, each press and, more importantly, the correct PDF generation settings.

New technology has made it possible to do things you would never think about a few years ago, cheaply and efficiently – and from anywhere in the world. *Marcus Piper is an art director, based in London.*

Speak followed. Designers were getting their heads round 'the end of print' and working out if these new machines – making work a heck of a lot easier – would also do them out of a job.

The realisation soon emerged that, as 'personal computers' took over day-to-day tasks, we needed print media all the more – to make sense of things. Also, a new type of self-publisher was born: anyone with the right hard- and software. Style magazines that could manage this new pool of independent creatives – *Dazed & Confused, Tokion, Sleazenation* – put down their roots. Meanwhile, I was being coerced into tackling this 'internet / website' thing that was happening...

The revolution has calmed down immensely since my first Mac encounter. But we have still to see the first blog-like magazine: creating a new aesthetic emulating the way we read online... prepare for the next seismic shift, mayhap. *Michael Bojkowski is an art director, based in London.*

a tool of torture, as the program, associated hardware and the machine itself appeared to conspire against doing any actual design... the five-minute start-up, the dreaded 'bomb' symbol, the Syquest cartridge, SSC II plugs, broken floppies, font conflicts, the bugs in Quark, corrupted fonts, scanner failures, the need to close one program before opening another, PhotoShop's 'scratch disc is full' messages. But now, a slick coalition of Apple, IT departments and third-party software has made these problems a thing of the past, and designers really can do what was promised all along. The technology has become transparent – we ignore it and use the screen, keyboard and mouse as efficient tools that do every manual task described above, and more.

So, what next? Software still needs to be more intuitive and user-responsive. Image, type and layout are ever more integrated on the page; the software must keep up. Adobe has led the way with its Creative Suite, and it's rumoured to be looking at looser forms of layout program, halfway between Illustrator and InDesign. A program that adapts to how an individual designer works would be a great step. You'll never want drop shadows? Delete the capability. No hyphenation? Remove it. Tight kerning as default? You got it.

The *really* big change will be replacing keyboard and mouse with a new interaction device. A combination of the technology behnid the Nintendo Wii and the Apple iPhone touch screen would allow a return to the horizontal working plane with close physical control through hand movement – back to the drawing board, if you like. With the ability to twist the pages round in front of you, and to flick through pages and sections one by one, you could mimic the printed item in mid-air.
Jeremy Leslie is the designer of this book.

Magazine 7/10

Shift!

Germany

Magazines are collaborative by their very nature, but *Shift!* takes collaboration further than most. Each issue presents a range of invited contributions from artists, photographers and designers, all based around a theme. The works are presented unedited and in a format that reflects the theme. Issues have appeared as a calendar ('Ahead of Time'), a video ('Slideshow') and a computer game ('Get Rich with Art'). Other issues have included 'Doubletake', an end-of-analogue photographic project where film was deliberately double-exposed by different artists, and '19.99 – a Commercial *Shift!*', which featured only paid-for ads of all sizes from artists, designers and businesses. *Shift!* regularly tests the very definition of 'magazine' but has much to offer the mainstream in its intelligent playfulness.

Shift!
welcome

PUBLICATIONS TO DATE ZERO • MEAT/FLESH • HEAT • AHEAD OF TIME • GOETHE • (NOT ONLY) FOR CHILDREN • POWER.GAMES • BERLIN • GET RICH WITH ART • DOUBLETAKE • HIN & WEG • LICHTBILDVORTRAG [SLIDE SHOW] • 19,99 – A COMMERCIAL SHIFT! • GREETINGS FROM BEIRUT • SHIFT! RE-APPROPRIATED • INFLUENCES SPECIAL EDITION

HOW DID SHIFT! BEGIN? SHIFT! BEGAN IN 1996 AS AN EXPERIMENTAL MAGAZINE THAT SHOULD BE TACTILE, PLAYFUL, DISPLAYING THE WORK AND IDEAS OF CREATIVES FROM DIFFERENT BACKGROUNDS AND DISCIPLINES. **WHAT DOES THE NAME REFER TO?** WHAT WE LIKED ABOUT THE NAME WAS ITS DUAL CHARACTER, ON ONE HAND INDUSTRIAL AND MANUAL (AS IN 'SHIFT-WORK') AND ON THE OTHER DIGITAL (AS IN THE 'SHIFT KEY' OF THE KEYBOARD). THIS SEEMED TO ENCOMPASS THE SCOPE OF SHIFT!, THAT AS A PUBLICATION WANTED TO REDEFINE PRINT, FOCUSING ON ITS TACTILE AND FORMAL POSSIBILITIES, WITHIN A CONTEMPORARY CONTEXT. **WHO IS THE MAGAZINE AIMED AT?** FUNDAMENTALLY IT HAS ALWAYS BEEN AIMED AT OURSELVES AND THUS AT EVERYBODY WHO SHARES OUR INTERESTS AND PASSIONS. THOUGH THERE HAVE BEEN CERTAIN PROJECTS THAT WERE AIMED AT A MORE SPECIFIC AUDIENCE BY NATURE OF THE THEME AND SUBJECT OF THE PROJECT. **WHAT IS THE DRIVING FORCE BEHIND THE MAGAZINE?** FREEDOM AND CURIOSITY. SOUNDS CORNY, BUT THE FACT THAT SHIFT! CAN BE ANYTHING IN FORM AND CONTENT HAS KEPT IT FRESH AND INTERESTING FOR THE MAKERS (AND AS WE HOPE ALSO FOR THE READERS), ALLOWING US TO ENGAGE IN ANYTHING THAT RAISES OUR CURIOSITY AT ANY GIVEN TIME. IF THERE HAD BEEN ANY PRE-DEFINED FORMATS, SUBJECTS, STYLES OR AUDIENCES THAT SHIFT! WOULD HAVE HAD TO ABIDE, I DOUBT IT WOULD HAVE LASTED UNTIL TODAY. **WHY USE THE FORMAT OF A MAGAZINE TO EXPRESS THAT?** SHIFT! DOESN'T USE THE FORMAT OF A MAGAZINE. NEITHER IN FORM (WHICH IS ALWAYS CHANGING) NOR IN FREQUENCY (RANGING FORM INITIALLY THREE TIMES A YEAR TO LATELY ONE IN TWO YEARS). IN FACT I WOULDN'T CALL SHIFT! A MAGAZINE AT ALL. WE ARE REFERRING TO IT AS A PUBLICATION, BECAUSE IN ALL ITS VARIED FORMS AND APPROACHES, THE ONLY CONTINUITY SEEMS TO LIE IN THE FACT THAT WE MAKE SOMETHING PUBLIC. **WHAT ARE THE BENEFITS IN CHANGING CONCEPT AND FORMAT SO OFTEN?** WE DON'T CHANGE THE FORMAT FOR THE SAKE OF IT, BUT SINCE EVERY PROJECT IS SO ENTIRELY DIFFERENT FROM THE PREVIOUS ONE, AND SINCE THE FORM IS AN INTEGRAL PART OF A PROJECT, IT HAS TO CHANGE ACCORDINGLY. THE LATEST

PROJECTS HOWEVER ARE LESS EXTRAVAGANT IN FORM AND MORE EXPERIMENTAL IN CONTENT. WHAT ARE THE DISADVANTAGES IN CHANGING CONCEPT AND FORMAT SO OFTEN? FOR SHIFT! THERE ARE NONE SINCE WE ARE NOT A NEWSSTAND TITLE THAT DEPENDS ON RECOGNIZABILITY. OF COURSE CHANGING CONCEPT AND FORM WITH EVERY SINGLE PROJECT IS NOT AN EFFICIENT WAY OF PRODUCTION, BUT THIS IS NOT WHAT SHIFT! IS ABOUT. YOU DESCRIBE EACH ISSUE AS AN EVENT FOR BOTH THE READER AND THE CREATIVES INVOLVED. WHAT DO YOU MEAN BY THAT? SHIFT! LITERALLY STARTS FROM SCRATCH WITH EVERY NEW PROJECT. NEW IDEA, NEW PEOPLE INVOLVED, NEW NEGOTIATION OF ROLES, NEW CONCEPT, CONTENT, FORM ETC. THIS MAKES IT AN EVENTFUL JOURNEY FOR EVERYBODY INVOLVED, SINCE NO PRE-DEFINED PARAMETERS EXIST. AS THE CREATIVES INVOLVED INVESTIGATE NEW IDEAS AND AVENUES, SO WILL THE READERS... EARLIER PUBLICATIONS FULFILLED THIS PROMISE IN A MORE LITERAL WAY BY BEING PLAYFUL AND TACTILE AND THUS REQUIRING THE ACTUAL AND PHYSICAL INVOLVEMENT OF THE READER. HOW WOULD YOU DEFINE THE WORD "MAGAZINE"? A MAGAZINE IS A PUBLICATION WITH A REGULAR OUTPUT, A DEFINED SUBJECT MATTER AND AUDIENCE, A RECOGNIZABLE FORM. THIS IS WHY I WOULDN'T CALL SHIFT! A MAGAZINE, SINCE NONE OF THESE CHARACTERISTICS APPLY. THE ONLY LINK I CAN DETECT IN THE VARIOUS SHIFT! PUBLICATION IS A CERTAIN SPIRIT FOR EXPERIMENTATION AND FOR EXPLORING NEW GROUNDS. WHICH IS YOUR FAVOURITE ISSUE SO FAR? WHY? THE LATEST ONE. ALWAYS. WHERE IS THE MAGAZINE ON SALE? IN SELECTED ART BOOKSTORES AND ONLINE AT WWW.SHIFT.DE WHAT'S THE HARDEST PART OF CREATING SHIFT!? TO STOP. SOUNDS WEIRD, BUT EVERY TIME WE HIT THE MOMENT OF FINANCE, DISTRIBUTION, PRESS, ETC. I SWEAR I WILL NEVER DO THIS AGAIN. BUT A FEW WEEKS OR MONTHS LATER, THE FASCINATION FOR A NEW IDEA STARTS TAKING OVER AGAIN...

PUBLISHING = TO MAKE SOMETHING PUBLIC

what should be made public?
what should not be made public?

USE THE SPACE TO EXPRESS IN ANY WAY YOU WANT
WHAT YOU BELIEVE SHOULD BE MADE PUBLIC.

PLACE YOUR CARD IN THE SHIFT! WORKSPACE ON THE
UPPER FLOOR OF THE COLOPHON 2007 EXHIBITION
OR SEND TO SHIFT! CHORINER STR. 50, 10435 BERLIN.
ADDITIONAL CARDS WILL BE PROVIDED IN THE EXHIBI-
TION OR CAN BE DOWNLOADED AT WWW.SHIFT.DE

THIS SHOULD BE MADE
PUBLIC

Shift!

Choriner Strasse 50
D-10435 Berlin
Germany
Website: www.shift.de
Email: info@shift.de
Publisher and art director:
Anja Lutz, anja@shift.de
Format: Various

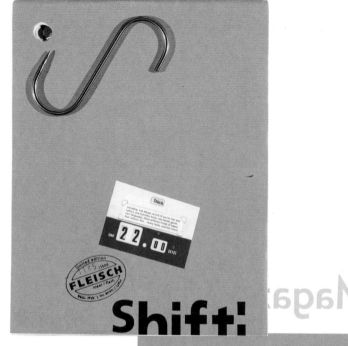

Great moments #6

The Big Issue hits the street (1991)

Gordon Roddick returned from a trip to New York with a magazine in his luggage. It was called *Street News,* and it was sold by homeless people in the city. Though the quality of the magazine was poor, he thought that the method of distribution was brilliant. He handed it to his friend, A John Bird – who had himself once been homeless – with a challenge: do this, but make it better.

And so *The Big Issue* was born. Bird founded the magazine in September 1991, with the help of Roddick and Roddick's wife's company, The Body Shop. The magazine would be sold by the homeless, who would earn a proportion of the cover sales. But it would be the creation of professional journalists and photographers. It started as a monthly, tabloid-sized publication, relaunched in August 1992 as a fortnightly A4 magazine, and relaunched again as a weekly in June 1993. The cause was a good one; the challenge as much editorial as charitable – if a cover didn't sell, then not only would sales drop, but vendors could be left without food. The magazine's distribution, as much as its content, was key to its identity.

A failed expansion to Los Angeles hurt the organisation, but local *Big Issues* are now produced across the UK and in Australia, South Africa, Namibia and Japan; many lives have benefited from both the magazines' sales and their associated foundations. Several other countries have their own variations on the theme.

The magazine is but one example of how imaginative thinking has led to alternative methods of distribution away from the usual kiosk/shop channels. In the early years of the 21st century, it was the rise of the free newspapers that seemed to threaten traditional media, but some magazines have long had free distribution chains, with advertising providing the resources for such publications as the now-global *Vice*, London's *Good For Nothing* and Barcelona's *H*. Enter a trendy bar or record shop in any major industrial capital today, and magazines are usually to be found nestling among the flyers – and often they are of surprisingly good quality.

Another type of free magazine is the customer magazine,

Street News

The Big Issue

Vice
Good For Nothing
H

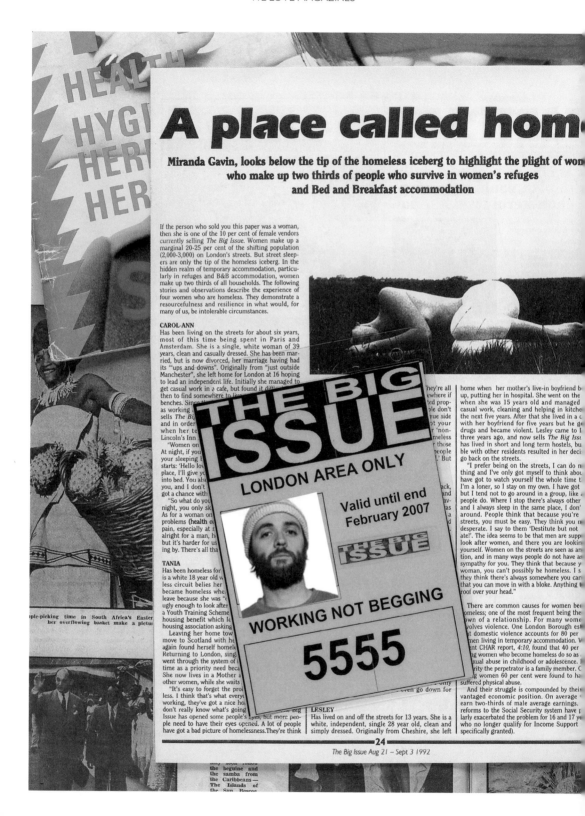

A place called hom...

Miranda Gavin, looks below the tip of the homeless iceberg to highlight the plight of wom... who make up two thirds of people who survive in women's refuges and Bed and Breakfast accommodation

If the person who sold you this paper was a woman, then she is one of the 10 per cent of female vendors currently selling *The Big Issue*. Women make up a marginal 20-25 per cent of the shifting population (2,000-3,000) on London's streets. But street sleepers are only the tip of the homeless iceberg. In the hidden realm of temporary accommodation, particularly in refuges and B&B accommodation, women make up two thirds of all households. The following stories and observations describe the experience of four women who are homeless. They demonstrate a resourcefulness and resilience in what would, for many of us, be intolerable circumstances.

CAROL-ANN
Has been living on the streets for about six years, most of this time being spent in Paris and Amsterdam. She is a single, white woman of 39 years, clean and casually dressed. She has been married, but is now divorced, her marriage having had its "'ups and downs". Originally from "just outside Manchester", she left home for London at 16 hoping to lead an independent life. Initially she managed to get casual work in a cafe, but found it dif... then to find somewhere to liv... benches. Since... as working ... sells *The Bi*... and in order... when her te... Lincoln's Inn...

"Women on... At night, if you... your sleeping b... starts: 'Hello lov... place, I'll give yo... into bed. You als... you, and I don't ... got a chance with...

"So what do you... night, you only si... As for a woman on... problems (**health** o... pain, especially at n... alright for a man, h... but it's harder for us... ing by. There's all tha...

TANIA
Has been homeless for... is a white 18 year old w... less circuit belies her... became homeless whe... leave because she was "... ugly enough to look after... a Youth Training Scheme... housing benefit which le... housing association asking...

Leaving her home tow... move to Scotland with he... again found herself homele... Returning to London, sing... went through the system of... time as a priority need beca... She now lives in a Mother a... other women, while she waits...

"It's easy to forget the pro... less. I think that's what every... working, they've got a nice ho... don't really know what's going... Issue has opened some people's... ple need to have their eyes opened. A lot of people have got a bad picture of homelessness. They're think...

...they're all ...where if ...ted prop... ...le don't ...rue side ...t your ...r 'non- ...meless ...r those ...eople ...!' But

...ack, ...nd ...as ...av- ...a ...d

LESLEY
Has lived on and off the streets for 13 years. She is a white, independent, single 28 year old, clean and simply dressed. Originally from Cheshire, she left

home when her mother's live-in boyfriend b... up, putting her in hospital. She went on the when she was 15 years old and managed to casual work, cleaning and helping in kitche the next five years. After that she lived in a c with her boyfriend for five years but he g... drugs and became violent. Lesley came to l... three years ago, and now sells *The Big Issu* has lived in short and long term hostels, bu ble with other residents resulted in her deci go back on the streets.

"I prefer being on the streets, I can do n thing and I've only got myself to think abou have got to watch yourself the whole time t I'm a loner, so I stay on my own. I have got but I tend not to go around in a group, like a people do. Where I stop there's always other and I always sleep in the same place, I don' around. People think that because you're streets, you must be easy. They think you n desperate. I say to them 'Destitute but not ate!'. The idea seems to be that men are supp look after women, and there you are lookin yourself. Women on the streets are seen as an tion, and in many ways people do not have as sympathy for you. They think that because y woman, you can't possibly be homeless. I s they think there's always somewhere you can that you can move in with a bloke. Anything roof over your head."

There are common causes for women be... omeless; one of the most frequent being the own of a relationship. For many wome volves violence. One London Borough es t domestic violence accounts for 80 per men living in temporary accommodation. V nt CHAR report, *4:10*, found that 40 per g women who become homeless do so as xual abuse in childhood or adolescence. rity the perpetrator is a family member. C g women 60 per cent were found to ha suffered physical abuse.

And their struggle is compounded by their vantaged economic position. On average earn two-thirds of male average earnings. reforms to the Social Security system have p larly exacerbated the problem for 16 and 17 ye who no longer qualify for Income Support specifically granted).

THE BIG ISSUE
LONDON AREA ONLY
Valid until end February 2007

THE BIG ISSUE

WORKING NOT BEGGING

5555

24

The Big Issue Aug 21 – Sept 3 1992

ple-picking time in South Africa's Easter... her overflowing basket make a pictur...

...may soon ... the beguine and the samba from the Caribbeans — The Islands of the Sun Roscoe

No two women's experiences of homelessness are the same. The nature of women's homelessness means that the majority of them are hidden away from the streets in temporary accommodation. But it is clear that women sleeping on the streets face par-

People think that because you're a woman you can't possibly be homeless. They think there's always somewhere you can go, or that you can move in with a bloke.

ticular problems. They are at greater risk of sexual and physical harassment and abuse. Their basic physical requirements make life on the streets more problematic. And because women stand out as a minority, they often have to contend with strong reactions from the public. In a society that places particular emphasis on the domestic sphere the homeless woman experiences a double blow, one that robs her not only her home, but also her identity.

London Brook provides free health advice for homeless young women. Pregnancy tests, contraception, counselling, condoms and emergency contraception are all available. Clients can also have coffee, showers and clean clothes.

Brook (Off the street) is open on Wednesday afternoons from 2pm to 4pm at 54 Dean Street, W1, and is completely confidential.

Drop in or phone 071-580 2991 for more details.

As the classic car market has entered a period of depression, Martin Gurdon discovers that one British car importer has succeeded in sparking a revival in one of India's last hidden treasures – the Indian built Morris Oxford

A PASSAGE FROM INDIA

...ture in the 1950s gave ...ole rash of mind-bending ...ho could forget the cine-...ghts of films like *The* ...error, especially when TV ...exhume them for later ...ectives?

...'s been a similar revival in ...d with the British launch of ...an Ambassador, which is ... than a brand new, Indian ...Oxford of the sort which ...cross Britain's pre-motor ...the 1950s.

...n it was launched in 1954, ...a prime example of the ...-produced family saloons ...to excel at building. It was ...ral design even by the stan-...times.

...r's very ordinariness – even ...made it ideal for the pound-...receive in India, where it's ...since 1959, and goes a long ...aining why it's outlived so ...ignificant designs.

...porters Fullbore Motors is ...engaging gentlemen called ...-Lloyd and Jo Burge. The ...ex-commodity dealer, and ...used to sell advertising ...otoring magazines. They've ...UK sales potential of this ...seriously enough to make ...)00 on getting it to meet ...in regulations.

...reckons it's already got 68 ...expects to sell around 20 a ...nostalgia addicts, ex-pat ...mini-cab drivers, for whom ...mplicity and £5,895 price

(about half the cost of a Ford Sierra LX) could outweigh the risk of 1950's driving characteristics matching those cute fifties looks. Local government types have already been giving the car a once over to see if it meets their mini-cab regulations.

Originally, they planned to import two versions. A wheezing 1.5 litre, powered by the Oxford's original 'B-series' engine, which like the car itself, pre-dates the Suez Crisis, and one with a Japanese designed 1.8 litre motor, mated to a five speed gearbox. This unit can be found in the Vauxhall Midi panel van, and will now be the only one generally

(Behind) Mark Owen-Lloyd, (In front) Jo Burge; founders of Fullbore Motors

available in Britain-spec Hindustans, because of the 1.5's inability to meet UK pollution standards.

They're also having to fit seat belts and a heater, since neither are available in India. British examples have white-walled radial tyres rather than the old crossplys fitted to the cars when they leave the Calcutta factory. Options include air conditioning and an external sun visor - the automotive equivalent of a green eye shade.

As for driving the thing, any rational criticism is difficult, because this would be like taunting your great-grandmother. However, the kindest description of

the build quality of the 1.8 sample I tried would be "rudimentary". With the driver's door shut you could see daylight in the gap between the wing and the door. The body welds were often crudely finished, and the paintwork has been liberally applied with gung-ho enthusiasm rather than skill.

Inside, they'd got rid of the bench seats, the leather trim and the steering column gear change. Instead you've got cloth covered and surprisingly comfortable front bucket seats. The taxi-like driving position remains, allowing you to look down on the bald patches of Cavalier drivers.

The original Oxford's teasmade-style instrument panel is also history, replaced by a charmless display which looks as if it's escaped from an East European military truck, although Fullbore says it can fit an old fashioned dashboard if you want one.

As for the car's handling characteristics, it doesn't so much corner as lurch, but the ride is surprisingly good, and it can "gullump" easily over pot holes and speed humps. But none of this matters. The Ambassador is a brand new museum piece, from the huge hand brake lever, which lives by the driver's door, to the old fashioned drum brakes. One might have some misgivings about just how quickly it could travel with the 1.8 engine, but it's fun.

The car costs more than the cheapest Lada, or Fiat Panda, or as much as a basic Citroen AX hatchback, but it has no direct rivals, and for perverse entertainment value, it's in a class of its own.

— 25 —

The Big Issue Aug 21 – Sept 3 1992

into utilitarian shapes. One is making a broom, the other a hat.

143

once derided for poor quality and blatant sells, but now treated seriously as genuine editorial products. Award-winning magazines of the highest quality are offered to American Express Black Card holders, guests at Park Lane's Dorchester Hotel, shoppers at Harrods and airline travellers all over the world. From nightclubs to digital-TV service providers, companies are increasingly using their own magazines to target individual consumers, and to increase loyalty by association – all the while sending tailored magazines direct to these customers' front doors. In some cases, if a client is adventurous enough, the magazine outshines anything on the newsstand in ambition and daring, being as it is safely away from risk-averse newsstand sales targets.

IsNotMagazine

 IsNotMagazine has another approach to distribution: it is flyposted on walls in Melbourne and Sydney as a poster. It's therefore perhaps the only magazine you can't read at home, you just have to be in the right place to see it – a very different form of 'street' magazine to that of A John Bird. The opposite is true of online titles, viewable wherever you can connect; from the *Magwerk* series to *This Is A Magazine*, the traditional paper format has been copied and then extended by the near-endless possibilities of multimedia.

Magwerk

This Is A Magazine

 But perhaps the ultimate in alternative distribution is *I Am Still Alive*, produced by London-based design studio åbäke. It describes itself as a 'parasite magazine', each edition appearing by invitation in the pages of other magazines around the world (more than 12 issues have appeared so far). It certainly makes collecting the complete set a challenge in itself.

I Am Still Alive

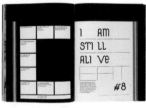

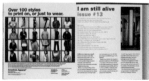

Street

Fruits

Tune

Japan

Fashion is no longer about brands, but about a more personal style that includes second-hand and hand-made clothing. Fashion is also about personal expression, as in the striking outfits of Japan's Gothic Lolitas, 'kawaii' and neo-punks. Recording all this is Aoki Shoichi, perhaps the most famous and certainly one of the most enduring witnesses of changing street trends. Shoichi publishes three monthly magazines of people's home-styled looks. The first of his documentary magazines, *Street*, was launched in 1985 and focused on London. Two other publications have joined his stable: *Tune* is dedicated to Tokyo boys' fashion, while *Fruits* shows the outfits of Tokyo's girls. With little text, the photos speak for themselves. The outfits change, but Shoichi's eye is constant and uncritical, and the result is a visual treat.

How did the three magazines begin?

STREET: A long story from now. Street fashion as a way of expression, a boring japanese fashion, a really creative fashion sense in LONDON and PARIS. That was why I stared it. Made a magazine by myself. That was 20 years before.

FRUiTS: It was a moment, I felt a change in the Harajuku kinds fashion, it was becoming more creative. I've thought that i must to record that historical event, and i make a issue. That was 9 years ago.

TUNE: For boys, during the few years a boring URAHARA fashion was the main fashion, dominating the streets, but an expect different fashion came out. It was 2 years ago.

What do the names refer to?
STREET is just as it is.

FRUiTS as colorful image and freshness.

TUNE because i wanted to use a musical word. I felt a music sense in the balance of clothes coordination.

Who are the magazines aimed at?
The fashion victims who love to dress up.

What is the driving force behind the magazines?
" People wearing themselves their clothes = The real meaning of fashion"
From that theory, I was interest in an anthropology and art viewpoint.
And a meaning in the act of recording by considering it as an art works.

Why use the format of a magazine to express that? And why three different magazines?
Magazine was the only way of media able to handle. Now you have the internet, but don't know if profit can be taken in that way.
We divide the magazines, because we don't have the same fashion target for each one.

Why do you use photographs of real people to talk about fashion?
Because I felt an art in the fashion of the real people.

Why are the three magazines different sizes?
Decide it from each image of the magazine.

Why don't you include any text or commentary about the images?
Because there is more expression in the image than what a word is able to do.

Is there a lot of repetition in the fashions in each issue?
Don't understand the meaning of the question.

Which is your favorite issue so far? Why?
I don't have that way of thinking. More it is an old issue and more can be objective, so when i see those issue I'm impressed but for the ones witch a made feeling remains me, it can not be seen in likes or dislikes.

Where are the magazines on sale?
Almost in a japanese book store.

What's the hardest part of creating these magazines?
deadlines!!

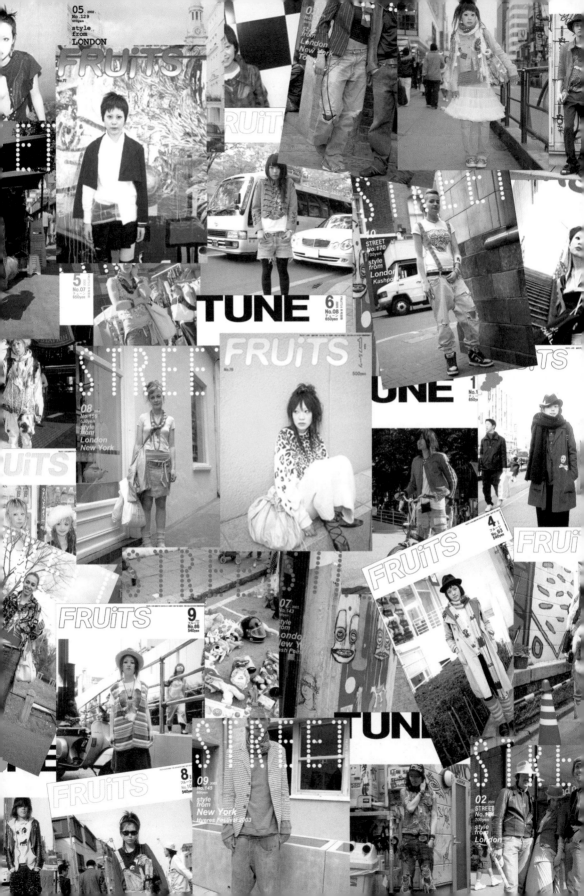

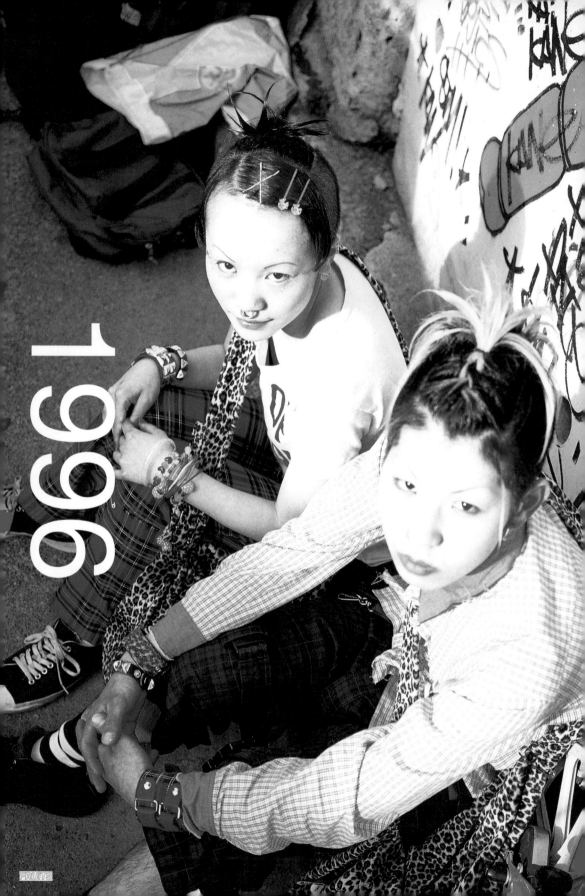

1996

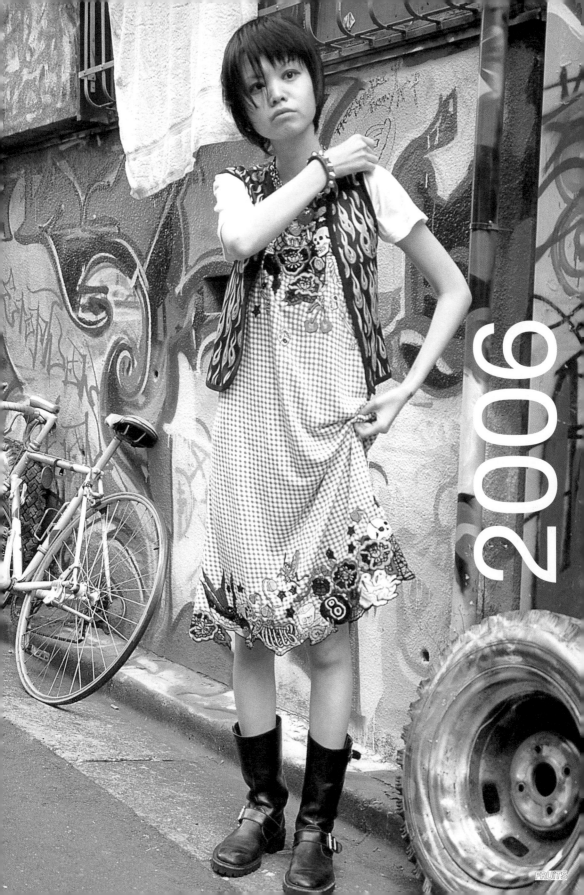

2006

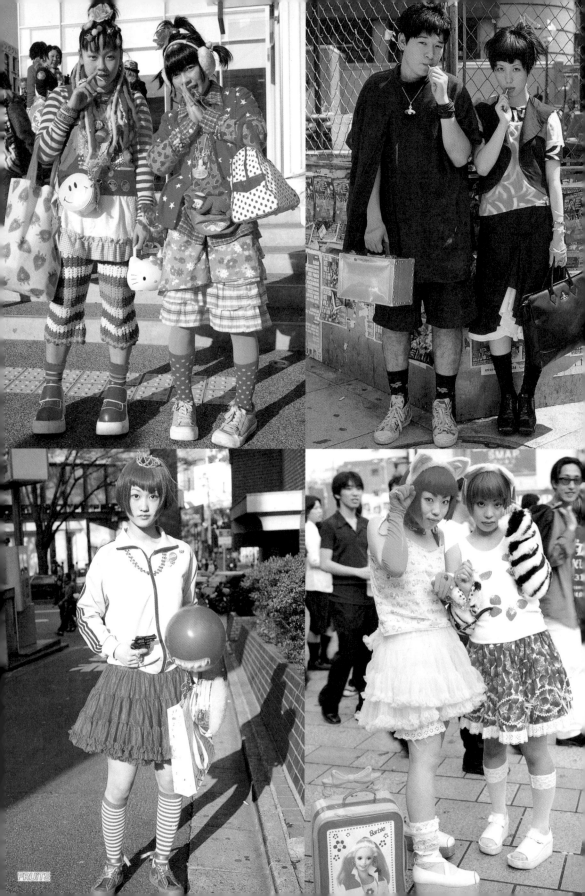

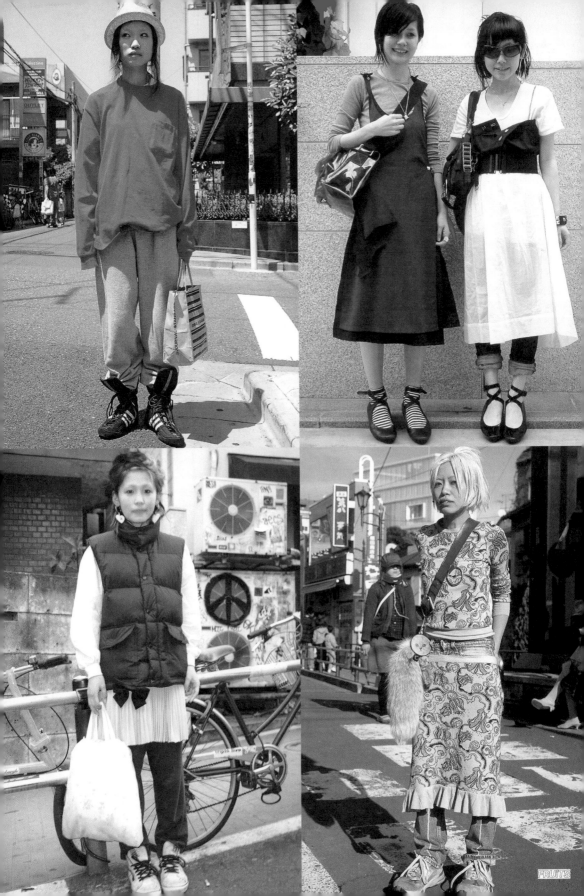

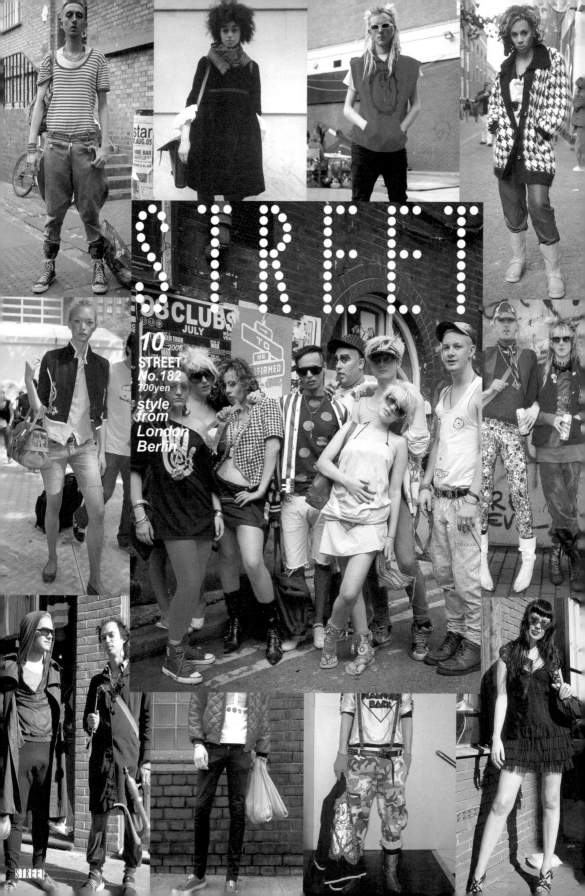

STREET

10
STREET
No.182
700yen

style
from
London
Berlin

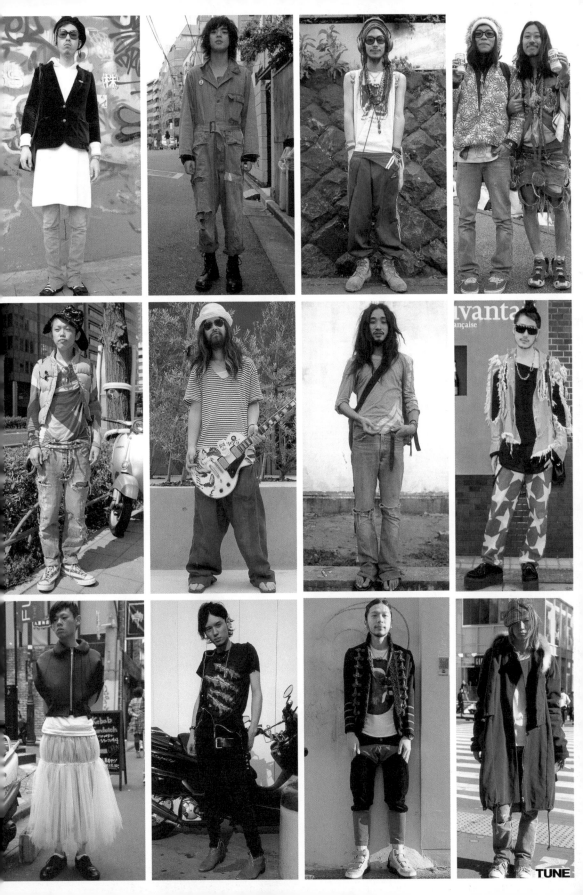

Street/Fruits/Tune

1-16-8-5F
Ebisu-Nishi
Shibuya-Ku
Tokyo
Japan
Website: www.fruits-mg.com
Email: infor@fruits-mg.com
Director: Aoki Shoichi
Format: 205 x 275 mm /
190 x 264 mm / 210 x 297 mm

Your subscription has been cancelled

By Andrew Losowsky and Nicole Van der Burg

Avant Garde
USA, 1968-1971

Avant Garde was a magazine ahead of its time – the brainchild of publishing genius Ralph Ginzburg, who described it as "a post-pyrotechnic, futuristic bimonthly of intellectual pleasure". Apart from striking political articles – and a Marilyn Monroe exclusive in issue two – *Avant Garde* gave the world a dramatic new typeface and logo, designed by Herb Lubalin. With a large x-height, an extensive set of ligatures and a strong design personality, it broke stylistic ground; one of the unique fonts of the 20th century. Not everyone approves of its influence, however. Type designer Ed Benguiat said: "The only place Avant Garde looks good is in the words, 'Avant Garde'. Everybody ruins it. They lean the letters the wrong way." The magazine had a small circulation, mostly around New York, but proved highly influential with art directors. "The magazine was of its time, but it still has resonance" – design critic Stephen Heller.

BEople
Belgium, 2001-2004

BEople, "a magazine about a certain Belgium", was a markedly original publication. It focused on Belgian art, architecture, fashion, photography and music, to try to show the world that Belgium had more to offer than cathedrals and classic paintings. Design-wise, it was striking, too. There was the big white dot instead of a model's face on the cover. The first issue did not utilise a grid and featured a wide variety of fonts. Its original viewpoint, daring design and willingness to experiment, all emerging from an unlikely source, are sorely missed.

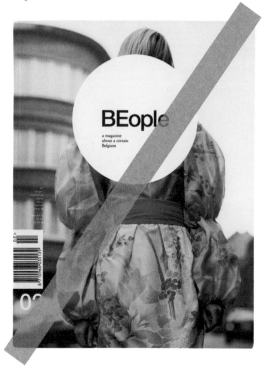

Carlos

UK, 2003-2006

Carlos launched as a magazine for Upper Class passengers on Virgin Atlantic Airways, and soon became a benchmark in customer communication. Listed as a 'Must Have' in *Vogue*, and winner of multiple awards including Launch of the Year at the British Magazine Awards, it was created as a low-cost, high-status publication for the airline by customer publisher John Brown. Printed in two colours on uncoated, off-white paper and with a brown card cover, *Carlos* presented itself as a fanzine for the Upper Class cabin 'club' experience. Its understated appearance conveyed exclusivity, and this was emphasised by the content, which refused to follow common agendas but mixed new and classic fiction with knowing pieces on fashion and media. Advertisers – on the only photographic pages, an eight-page full-colour insert – included Paul Smith and Bulgari. Virgin Atlantic decided to discontinue the publication after three years. "Rewrites the flight manual" – Rick Poynor, *Eye* magazine.

Crawdaddy!

USA, 1966-1979

Crawdaddy! was the first US magazine of rock music criticism, preceding both *Rolling Stone* and *Creem*. The very first issue kicked off announcing that it would feature "neither pin-ups nor news briefs". It quickly went from fanzine status to newsstand distribution, and is regarded as a pioneer of rock journalism that helped establish the vocabulary of the genre. However, its focus expanded to cover more general aspects of popular culture such as movies and politics. As its imitators gained circulation, *Crawdaddy!* lost popularity and eventually folded.

Eat
Japan, 2000-2004

Eat, "the world's second-best food magazine", was a quarterly bilingual publication from a culturally mixed team (British and local, in the main) based in Tokyo. Each issue was themed – starting with Temptation and ending with Sweet, via Packaging, Rotten and Pet Food on the way. From street food in Romania to edible art in Auckland, *Eat* printed in-depth stories from around the world, always based on food, with lavish designs that made each copy sought-after far beyond its limited distribution network. *Eat's* creators eventually left the magazine behind to focus on their design agency; they sell back copies via their website, www.i-eatsite.com

Econy
Germany, 1998-1999

Econy focused on economics, trends and lifestyle, a voice for the New Economy generation of the late 1990s. It carried articles about unusual business ideas, and alternative points of view. *Econy* was text-heavy, with innovative design touches from art director Mike Meiré. Despite its economic focus, money was always a problem for the magazine, which did not have a publishing house and did not pay salaries. Ultimately, *Econy* was forced to find a suitable partner and investor, but the magazine folded after that new partner and the magazine's staff fell out. Many of the staff went on to found the magazine *Brand Eins*.

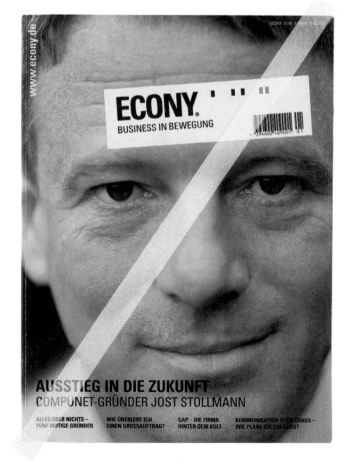

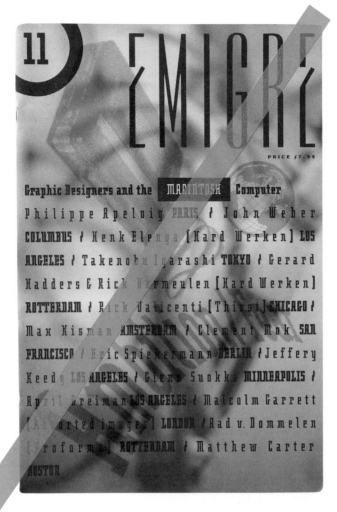

Emigre
USA, 1984-2005

Emigre was the ultimate designers' publication. It was founded, edited and designed by Dutch émigré (hence the name) Rudy VanderLans. At a time when technology was changing design forever, *Emigre* sizzled with energy and passion. VanderLans was unconventional, breezily disregarding notions of editorial balance, devoting entire issues to people barely out of design school. *Emigre* carried interviews with some of the most controversial designers of the day, and visual demonstrations of all-new digital design aesthetics. It became known for its unusual typography, and VanderLans made his money not from the magazine but from commissioning and selling original fonts; *Emigre* lives on as an independent type foundry.

The Face
UK, 1980-2004

The Face was, from the mid-1980s to mid-1990s, *the* mag read by young, culture-hungry non-conformists Europe-wide. Founded by Nick Logan, a former *NME* and *Smash Hits* editor, it was a fashion/culture bible. Its early days are remembered for Neville Brody's design and Juergen Teller's photography. In 1999, Logan sold his company, Wagadon, to publishing giant EMAP. Sales were in decline; EMAP failed to sell it on, and it was seen to have lost its influence and standing. *Pop*, its fashion spin-off, survives. "Monthly crap about nothing, which was wonderful" – Steven Redant. "It had a real influence on a whole generation" – Mike Koedinger. "On the beat with youth culture, original, direct journalism and an interesting approach to fashion" – Frederik Bjerregaard.

Lilliput
UK, 1937-1960

Lilliput was a monthly pocket magazine of humour, short stories, photographs and the arts, founded by the Hungarian photojournalist and future co-founder of *Picture Post*, Stefan Lorant. It was well printed, with an attractive cover always drawn by the same artist – Walter Trier – who always included a man, a woman and a dog in each design. One of *Lilliput's* best-known features was its 'doubles': two similarly framed photographs on facing pages, such as Hitler giving the Nazi salute opposite a dog with its paw raised. The magazine was easy to sell, especially in wartime – it carried no strong political statements; it simply made people laugh, providing a couple of hours of easy enjoyment. Contributors ranged from prime ministers to archbishops to sportsmen – and the photography was good, too.

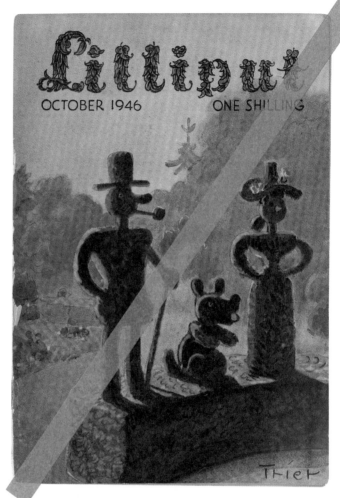

Might magazine
USA, 1992-1997

Might magazine, with its name suggesting both 'power' and 'possibility', could be summarised as an effort by twenty-somethings to say something instead of nothing. It was a smart, funny magazine, founded by Dave Eggers, and concentrated on subtle or not-so-subtle parodies, dopey articles and headline puns.

Nest
USA, 1997-2004

Nest – "a quarterly of interiors" – was unique, focusing on interior design without featuring modern masterworks or trendy lofts. It covered real homes and people expressing their individuality. This sometimes resulted in fairly ugly reportage of everyday life, but *Nest* handled everything with style and bravado – and without design templates. Issues included a special: "Decorating for the Christian home"; and an Adam and Eve cover – with scratch-off swimwear. But *Nest* never made money (its expensive covers saw to that) and remained a beautiful whim of founder Joseph Holtzman. When he closed it in 2004, people both mourned its passing and marvelled that it had carried on for so long. "They pushed the envelope, not just on covers, but with the entire magazine" – Amir H Fallah. "It was so unexpected, so extreme" – Sarah from *Le Colette*. "It was wilful, witty and showed great editorial insight – paired with the occasional overindulgence" – Sean O'Toole.

Nova
UK, 1965-1975

Nova was one of the trendsetting women's mags of the 1960s and 1970s, with cutting-edge writers, designers and editors. Its coverage of events and social change stood out against innovative fashion pages. *Nova* offered an interesting but challenging mix of articles on sex, fun and fashion mixed with editorial issues such as equality, racism and contraception. *Nova* is now seen as a style bible for editors and designers. An attempt to revive the brand in the mid-1990s missed the point of everything the original magazine stood for – innovation and not following the crowd.

Oz

Australia/UK, 1963-1973

Oz was initially published as
a satirical publication in Sydney,
and – in its second, more famous
incarnation – as a 'psychedelic
hippy' magazine in London. *Oz*
is remembered for its pioneering
coverage of contentious issues
such as homosexuality, abortion,
censorship and police brutality,
and it was strongly identified as
part of the underground press.
It was the subject of two
controversial and celebrated
obscenity trials, where, on both
occasions, the magazine's editors
and publishers, including current
magazine mogul Felix Dennis,
were acquitted on appeal after
initially being found guilty. In the
late 1960s, *Oz* became known as
one of the most visually exciting
publications of its time. Many
editions that included dazzling
psychedelic wraparounds or pull-
out posters have now become
collectors' items.

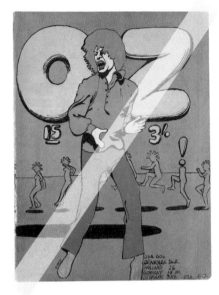

Picture Post

UK, 1938-1957

Picture Post was born out of
an idea from publisher Edward
Hulton and editors Tom
Hopkinson and Stefan Lorant.
The magazine was an immediate
success, selling 1,600,000 copies
per week after only six months.
Along with its stable-mate,
Lilliput, *Picture Post* pioneered
photojournalism and became
renowned for its campaigns
against the persecution of
Jews in Nazi Germany, and its
crusades for a minimum wage,
child allowances and a national
health service. After the Second
World War, circulation fell; sales
continued to decline in the face
of competition from television.
Today, the photographic
archive of *Picture Post* is
owned by Getty Images and
remains an important historical
documentary resource.

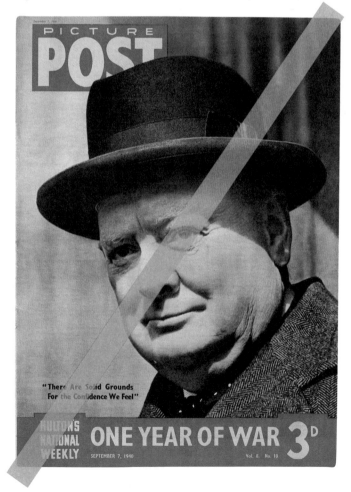

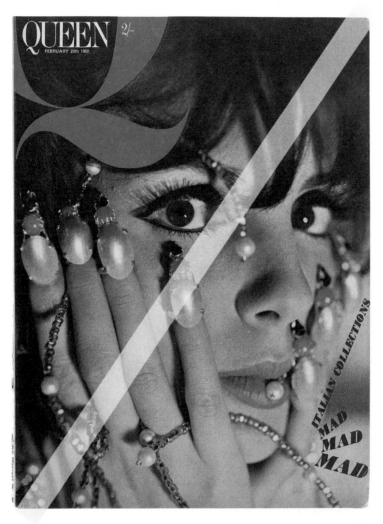

Queen
UK, 1861-1968

Queen, the "Ladies' Newspaper", was one of the longest-running British magazines for women. It was started as a weekly and initially contained very little about fashion, focusing more on "inoffensive amusements for ladies", such as social events and literature. In 1862, *Queen* was sold to William Cox, who began to include fashion plates he obtained from Paris. These plates were very popular and often pictured two adults and a child. In the 1960s, *Queen* faced fierce competition from *Harper's Bazaar* – and *Harper's* finally bought *Queen* in 1968. The titles were then relaunched in combination as *Harpers & Queen*, but the name was eventually changed back to *Harper's Bazaar* in March 2006.

RAW
USA, 1980-1991

RAW was a ground-breaking comic anthology edited by Art Spiegelman and Françoise Mouly. It is now considered the flagship publication of the 1980s alternative comics movement. The most famous work to come from its pages was Spiegelman's Pulitzer Prize-winning graphic novel, *Maus*. The first issues of *RAW* were printed in magazine format with a stapled binding; the last three were paperbacks. It was often packaged creatively, some editions having free trading cards, while other issues were intentionally marked or defaced as if by hand. The first issue featured a full-colour 'tipped-on' image glued onto each copy by hand on top of a monochrome cover. Editor Mouly had high standards; that first issue of this underground comic was printed three times before she found it acceptable.

Sassy
Australia/USA, 1987-1996

Sassy was a pro-girl, cult fave teen mag founded by Australian feminist Sandra Yates. It talked openly about sex, interviewed gay teens and exhorted girls to challenge the sexism of parents and teachers in the USA and Australia. *Sassy* courageously tried to counter the diet of non-feminist advice offered by its competitors, preferring to treat teenage girls as intelligent and perceptive, with more on their minds than just boys and party outifts. When it was sold to a new publisher in 1994, radical editorial changes led to a circulation plunge. Finally, *Sassy* was incorporated into the non-feminist *Teen* magazine. "It really opened my eyes about feminism, music, 'indie' culture, the New York scene (it was *so* NY-centric!)... it also featured 'real'-looking models. It had its faults, but it was better than anything else out there for girls. And the boy version, *Dirt*, was cool, too" – Raina Lee. "It was completely honest, totally fun – and just cool enough without being phoney" – Lonelle Selbo.

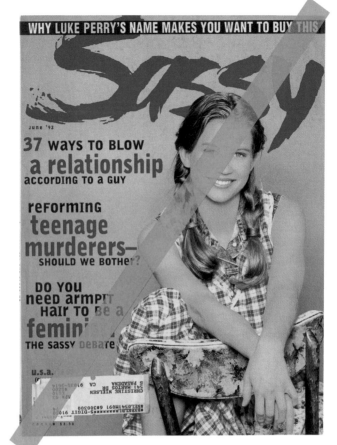

Simplicissimus
Germany, 1896-1944

Simplicissimus was a popular satirical magazine boasting bright colours, original graphics and witty illustrations. Several contributors spent time in jail, and authority figures from Kaiser Wilhelm II to the King of Bavaria tried to ban it. As a private company from 1906, many of its editorial staff were main shareholders. *Simplicissimus* opposed Hitler from the start and lost circulation with the Nazis' rise; it eventually closed in 1944. "It had great typography, an excellent grid system and interesting content" – Kimberly Lloyd.

Sniffin' Glue
UK, 1976-1977

Sniffin' Glue was a much-imitated and influential British punk fanzine created by Mark Perry, inspired by The Ramones song *Now I Wanna Sniff Some Glue*. The first issue was put together on the children's typewriter that Perry had received on his tenth birthday, with headlines in black marker. Being pretty much the first punk fanzine, *Sniffin' Glue* found a ready market with UK fans of the emerging movement. Issue three was the first to include photographs, and issue four even attracted advertising. Despite commercial success, though, *Glue* maintained its amateurish typography and DIY ethic. When the music threatened to become mainstream, Perry decided to call it a day rather than allow *Sniffin' Glue* to become just another magazine.

Speak
USA, 1995-2001

Speak was a controversial magazine that published long-form interviews, fiction, essays and features on various topics. After several inauspicious early issues, it found its niche as an 'uncommercial' glossy with ground-breaking design from Martin Venezky. Its editorial was designed for people who enjoyed a thoughtful and provocative read, and *Speak* refused to publish any promotional or biased editorial whatsoever. It did not contain music reviews or product/event coverage. At one point, *Speak* went six months without answering its office phone because its editors and writers had grown tired of publicists calling to ask them to publish promo articles. The magazine's complete archive is available at www.speakmag.com

Spy
USA, 1986-1998

Spy was primarily a New York-based satirical humour title, but with investigative journalism, too. Loosely modelled on the UK's *Private Eye*, it specialised in intelligent, well-researched, irreverent pieces targeting the American media and showbiz. One famous scoop was a picture of Arnold Schwarzenegger's father's Nazi Party membership card. *Spy* was influential in the US, due to its detached, ironic tone, its use of quasi-scientific data charts and tables, and its elaborate, classically influenced typography and layout. Like *Private Eye*, *Spy* employed a legal team to vet potentially libellous material, but it often angered its targets, occasionally driving away advertisers. "Smart, funny, and some fantastic design" – John O'Reilly.

Twen
West Germany, 1959-1971

Twen – when people talk about it, really they're talking about the influence of one man: Willy Fleckhaus, founder and art director. The innovative *Twen* (slang for 'young adult') soon became one of the all-time classic publications. It was, broadly, a lifestyle title looking at fashion, music and sexuality at a time when West Germany was still establishing its identity. *Twen's* left-leaning stance on homosexuality, politics and free thinking made it popular among young people; its revolutionary design and remarkable photography still amaze today. The 'life-size' issue, where all photos, from kissing couples to fashion, were shot by the same photographer, Frank Horvat, and printed in actual size, remains a publishing landmark. "Willy Fleckhaus = godfather of magazine design" – Ralf Herms.

Ty i Ja
Poland, 1959-1973

Ty i Ja ('You and I') was first published by the Women's League, an offshoot of the official Polish United Workers' Party. Under editor Roman Jurys, it became a vehicle for discussion of modern life, including the work of French designers, West German novelists and British photographers. *Ty i Ja* pretended the Berlin Wall wasn't there and, if it discussed the USSR at all, it preferred to cover its avant-garde artists rather than its politics. The magazine's design was chaotic, surreal and unexpected. April 1963's cover featured a bowler-hatted man sat on an ostrich that had laid an egg containing an Edwardian lady; antiquated imagery and photomontage were given new and strange twists. By 1970, the authorities were concerned by *Ty i Ja's* attitude, particularly as it continued to publish texts banned in the USSR. In 1973, the title was closed on the orders of the Central Committee.

Viva
USA, 1973-1980

Viva was an adult woman's magazine published by Bob Guccione and Kathy Keeton. Guccione was the editor of *Penthouse* and wanted to publish a companion title targeted at mature female readers. One of the first erotic magazines for women, *Viva* had articles and fiction delving into women's fantasies, covering sexuality, fashion, beauty and celebrity interviews. It usually exhibited photography containing full-frontal nudity and sexual encounters. Today, there are still very few erotic publications for women, and *Viva* could be described as a magazine ahead of its time.

Also sadly missed...

20:20 (UK)
50easy (Sp)
Actuel (Fr)
Apart (Ger)
Ark (UK)
L'autre journal (Fr)
Avenue (NL)
Baby Baby Baby (Mex)
The Baffler (USA)
Bare (UK)
Beach Culture (USA)
Bibel (NL)
Blad (NL)
Blah Blah Blah (UK)
Blitz (UK)
Blow (UK)
Il Borghese (Italy)
Bundas (Brazil)
The Business (UK)
Café Crème (Lux)
Chickfactor (USA)
City Life (SA)
City Limits (UK)
Collier (USA)
Creative Camera (UK)
Creem (USA)
Direction (USA)
Drum (SA)
Dutch (Fr)
Egg (USA)
Ego Trip (USA)
Eros (USA)
Fact (USA)
The Fashion (UK)
Flair (USA)
Fluxus (USA)
Foil (Japan)
The Fred (UK)
Gear (UK)
Grand Royal (USA)
HQ (Aus)
Hot Air (UK)
International Times (UK)
Itch (SA)
Jack (UK)
Jetzt (Ger)
Juice (Aus)
Just Seventeen (UK)
KGB (UK)
Kristall (Ger)
KRLA Beat (USA)
Lab (UK)
Line (UK)
Life (USA)

List (USA)
Look (USA)
Mademoiselle (USA)
Madison (USA)
Man About Town (UK)
Marxism Today (UK)
McCall (USA)
Melody Maker (UK)
Merz (USA)
Minotaure (Fr)
Mirabella (UK)
Modern Review (UK)
Mondo 2000 (USA)
Music Colony Bi-Weekly
(Hong Kong)
New Sounds New Styles (UK)
The Next Call (NL)
Octavo (UK)
Ojo (Mexico)
Opus International (Fr)
Palavra (Brazil)
Pil (UK)
Popular Electronics (USA)
Portfolio (USA)
Punch (UK)
Ramparts (USA)
Ray Gun (USA)
Realidade (Brazil)
Red (SA)
Reportage (UK)
The Saturday Evening Post
(USA)
Scene (UK)
Search and Destroy (USA)
Select (UK)
Seventeen (USA)
Shift (Canada)
Situationniste Times (Fr)
Sleazenation (UK)
Sony Style (USA)
Spare Rib (UK)
Der Spiegel Reporter (Ger)
Spruce (UK)
Staffrider (SA)
Street Life (UK)
Suite (Sp)
Tempo (Ger)
Transition (Uganda/Ghana)
U&lc (USA)
Underground (UK)
Ver Sacrum (Austria)
View (USA)
Voron (Russia)
Vu (France)
Wendingen (NL)
Zembla (UK)
ZigZag (UK)

Few magazines are prepared for the end. The illusion is that a good magazine concept can carry on for ever; the reality is that most don't last beyond their first year. Sometimes, those final editions carry sadly ironic coverlines – in the UK, for example, both *Sleaze* and *Smash Hits* closed with hopeful relaunches. Closure usually happens quickly, with work on the following issue under way but quickly discarded. Few magazines find they have a chance for a farewell to their loyal readers. Those who do face the tricky problem of how to say goodbye. *Picture Post* chose to reprint the same cover from its launch 19 years earlier. *Emigre* ran an issue-by-issue summary of its founder's 21-year diary. *Speak* ran an extended conversation between the editor and art director about the magazine and its intentions. *Marxism Today's* 'The End' cover was as much a statement about its politics as the publication itself. Perhaps only *Octavo* and PDF art magazine *Beast* were fully prepared for the end when it came – their founding concepts were to create, respectively, an 8-issue and a 12-issue magazine. Perhaps uniquely, the end was programmed into the beginning, so saying goodbye was always part of the plan.

Thanks to: Aaron Pogue (*Reactor*), Amir H Fallah (*Beautiful/Decay*), Anja Lutz (*Shift!*), Brian Chidester (*Dumb Angel Gazette*), Dániel Molnár (http://newfocus.hu), Francesca Caporali, Frederik Bjerregaard, Garth Walker (www.ijusi.co.za), Jeremy Leslie, John O'Reilly (*Edit*), Jonas Chau, Jonathan Bell (*things*), Kimberly Lloyd (*Qompendium*/M Publication), Klaus Stimeder (*Datum*), Lonelle Selbo (*LUSH*), Mark Hooper (*Esquire UK*), Michael Bojkowski (NMCA), Mike Koedinger, Ntone Edjabe (*Chimurenga*), Raina Lee (*1-Up*), Ralf Herms (*+Rosebud*), Sarah (*Le Colette*), Sean O'Toole (*Art South Africa*) and Steven Redant (*GUS*).

Magazine 9/10

this is a

magazine

.com

Italy

One of the first web projects to mimic the physical experience of turning the pages of a magazine, *thisisamagazine.com* launched in 2002 and continues to play with concepts of how the magazine experience might be transferred to the web. Originally Flash-based, recent issues have used PowerPoint and QuickTime to present increasingly complex content provided by artists and designers from around the world. Intriguingly, the project has since turned back on itself and publishes printed 'compendia' that seek to reflect the online experience in print. Using one-off formats, die-cuts, multi-sized pages and tip-ins, these publications contain content originally created for the web, now repurposed to make objects that are more like art books than magazines.

How did TIAM begin?
Like a game.

Why did you choose that name?
The dot com was available.

Who is the magazine aimed at?
No idea. Maybe us, who knows?

What is the driving force behind the magazine?
Alternating enthusiasm and stubbornness.

Why did you choose an online format to express that,
using a design like that of a print magazine?
Because almost everyone gets what to do when you see the
format. We constantly change our approach, we've made an
issue as a powerpoint presentation performance, an animated
gif issue, streaming video issues.

There is no explanation given to accompany any of the
pieces you display. Why is that?
We don't have any. When you see a sunset that moves you,
you don't ask for an explanation. Anyway, there are other
publications that are better at offering critical analysis.

Was it always your intention to create
compilation annuals (This is (not) a magazine)?
Yes it was.

What, if anything, do the contributions you receive
have in common?
If anything; they are searching for the new.

Do you ever edit/alter/ask for changes to what you receive?
Yes we do.

Which is your favourite issue so far? Why?
The next one. Human nature.

Where are most of your readers from?
The internet, or synternet.

What is the hardest part of creating TIAM?
Deciding when it's good enough to let go.

The following spreads are from the 5th Compendium
of This is (not) a Magazine, called Who I think I am,
released January 2007

47

da
ee

52

55

this is a magazine

Viale Coni Zugna 4
20144 Milan
Italy
Website:
www.thisisamagazine.com
www.thisisnotamagazine.com
Email:
hello@thisisamagazine.com
Edited and designed by:
Andy Simionato
andy@thisisamagazine.com
Karen ann Donnachie
karen@thisisamagazine.com
Format: Various on/off line

Great moments #7

Ray Gun uses Zapf Dingbats (1994)

"Twenty-two years after the first of my many encounters with Bryan Ferry, I find him decamped in a penthouse in Manhattan's Royalton Hotel (a midtown hostelry so faux trendy that the public urinals are described as 'water sculptures')..."

Ray Gun

So began the article that no-one read. As art director of the alternative American 1990s music magazine *Ray Gun*, former professional surfer David Carson took a scalpel to the boundaries of print design. The magazine's masthead changed each issue; the type escaped the grid and roamed free at all angles; one article began inside and continued on the cover; while others wandered off the page and were semi-legible.

But the ultimate in graphics gratification came in November 1994, when a far-from-interesting interview with Bryan Ferry arrived on Carson's desk. It was, so the story goes, too late to change it. So, he set the entire double-page article in the symbols-only typeface Zapf Dingbats. It was a ridiculous piece of design indulgence – and a now-legendary act. "We shouldn't confuse legibility with communication," writes Carson in the compilation of his work, *The End of Print*. "You may be legible, but what is the emotion contained in the message? That is important to me."

But some people felt that he had gone too far – using Zapf Dingbats may be a good in-joke for graphic designers (if he had presented the piece in Hebrew or Japanese, at least someone could have read it), but was it really what the readers wanted to see? Or, more importantly, read? The designer had become the most dominant person in the magazine – the reader all but ignored. For some, the departure of Carson from *Ray Gun* in 1996 spelt the end of the art director as 'star'. Perhaps it was only in design circles that the name of an art director had been enough to sell a magazine – but even that era was over. The designer had gone too far.

In the early days of magazines, it was the other way round. The term 'art director' was first used in 1894, referring to Aubrey

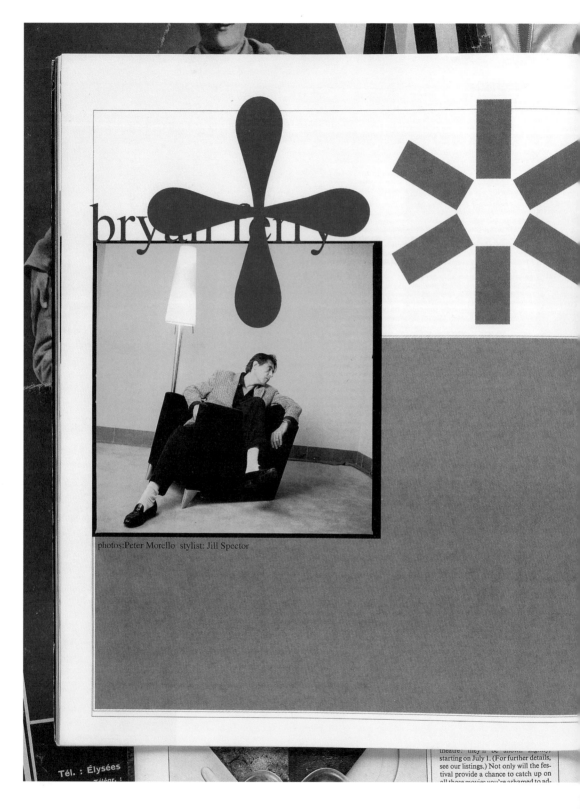

bryan ferry

photos:Peter Morello stylist: Jill Spector

person:-

Without leaning too heavily on the political angle, it's quite

way it looked around 1960. This sum-
mer Waterloo joins the music festival
circuit, with concerts every Saturday
night from June 29 to August 31. The
concerts are given in a 2,000 seat tent

Yellow Book

Vogue
Vanity Fair

Beardsley's work on *Yellow Book*, but the first art director in the modern sense is considered by many to be Mehemed Fehmy Agha, who worked for *Vogue* and *Vanity Fair* from 1929. He did exactly what you might expect from his job title: rather than using either already-existing images or the same old lithographic illustrators as everyone else, Agha commissioned – and *directed* – some of the best artists of the age to create unique images for his publications, while insisting on four-colour printing on his covers. Suddenly, the look seemed as important as the content – and not just on the front cover, but inside as well.

Soon followed the real 'golden age' of art direction, the 1930s to 1950s, when Russian émigrés Alexey Brodovitch and Alexander Libermann dominated the graphic aesthetic of the day, adapting styles and ideas from the earlier Bauhaus movement, among others. Brodovitch in particular is still fêted as one of the best ever; he brought a simplified, modern style to *Harper's Bazaar*, giving great attention to illustrating each article with flair and imagination. In his 24 years at the helm of *Harper's Bazaar* (1934-1958), he remained committed to new ideas, whether they emerged from unknown photographers or from the magazine's printers. He was among the first to bring into the mainstream a whole magic box of printing effects and design tricks, including die-cuts, gatefolds, semi-transparent paper, asymmetrical layouts and, above all, a delight in the use of white space. His legacy can be seen not just in the magazines of today, but in the very tool kits of modern graphic-design software.

Harper's Bazaar

Vogue

Vu

Alexander Libermann joined the American edition of *Vogue* in 1942, following the death of the renowned publisher and editor Condé Montrose Nast. It was the middle of the Second World War and *Vogue* had no European catwalk styles to report on. The magazine was forced to look into itself, and to wartime America, for its glamour. Libermann, who had previously art directed the ground-breaking French photography magazine, *Vu*, responded by hiring photographers such as Irving Penn, William Klein and Toni Frissell, and by using collage and illustration to make distinctive, elegant layouts. When contact with Europe was re-established a few years later, the magazine was ready for it – by now a beautiful object in itself, in which to display the latest hits from the Champs Élysées.

Esquire
Show

Vogue Italia

The Face

There were, and are, many other great art directors. *Esquire* had a string of them, particularly Paul Rand and Henry Wolf (who also produced outstanding work at *Show*); also worthy of note are Herb Lubalin and Alvin Lustig. Of the more current, there's Fabian Baron, whose minimalism on *Harper's* and *Vogue Italia* suggests him as a true successor to Brodovitch. And, of course, Neville Brody, who exploded type and was one of the first to treat headlines as both functional elements and dramatic illustration in themselves. His work on *The Face* looks dated now only because of the subsequent revolution in typography

that he helped create. *The Face* called itself, "The World's Best Dressed Magazine" – and with good reason.

Looking back at the legacy of all these and more, David Carson's work on *Ray Gun* was perhaps the highest or lowest point of magazine art direction, depending on your point of view. It was Neville Brody who, in an interview with *Creative Review*, described *Ray Gun* as *"the end of print"* – later used as the title of Carson's book.

However, reports of print's demise remain greatly exaggerated. The Bryan Ferry/Zapf Dingbats interview was the very precipice of magazine design, an art that is, as Carson says, about communication. Since that day, art direction has become cleaner and more varied than ever (in the independent sector, at least), with the rise of technology and a more design-literate public to encourage it.

In other words, magazine design has stepped back from Carson's cliff-edge – but still enjoys peering over it occasionally, often to the readers' delight. And Carson's legacy also lives on as a valuable lesson to editors: never, ever supply substandard copy to the art director. Or else.

Ray Gun

Creative Review

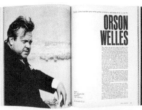

From the top:
Show (art director:
Henry Wolf);
The Face
(Neville Brody);
Vogue Italia
(Fabian Baron)

The
hard sell

By Stephen Armstrong

However good a magazine is, it is doomed without a distribution strategy. The same problems crop up. Firstly, distribution costs are going up; in autumn 2006, for instance, the Canada Post Corporation threatened to withdraw $15 million of the distribution subsidy that makes delivering magazines across this vast country affordable. Only a government edict prevented it from happening. Postal charges around the world are also rising, and customers are buying more magazines at supermarkets – a tough area for new launches and expensive niche publications to break into. On top of all that, the problem of getting a dispersed network of retailers to pay promptly can be the difference between survival and going under. None of these issues is new; all of them are difficult to solve and may require as much creative thinking as do the magazines themselves.

"The pressure on shelf space is a continuing challenge," says Hazel Isaacs, business development manager at Comag, the UK's largest third-party magazine distributor. "This has led to many retailers restricting their ranges to include only the most profitable titles. Also, if magazines are looking to export, costs and time become hugely important. Choosing air or sea affects not only how quickly titles become available, but also their price and how quickly we can provide final sales figures. For example, it can still take six months for a UK magazine to get returns claims from Australia and New Zealand."

Kilimanjaro

Shelf space can be even trickier if you have a non-standard format. Olu Michael Odukoya, editor-in-chief of London-based design magazine *Kilimanjaro*, found it almost impossible to get a large distributor to take his title, because of its size. "*Kilimanjaro* is the largest magazine in the world – it's 680mm by 480mm – and this is key to the beauty and style of the magazine," he says. "A lot of the distributors refused even to look at it. They felt that the project was a risk-taking venture. We could get it delivered in America, but actually this was a major blow as the US distributors want you to pay for your delivery and then they price your magazine as they like."

It took Odukoya three years to finalise his arrangements, and his title is now handled by Central Books. This does mean, however, that *Kilimanjaro* is found in the books section of some outlets – such as the Tate Modern gallery in London. Central Books has got his magazine on the shelves in places such as Colette in Paris, MOMA in New York and the Athenaeum Nieuwscentrum Bookshop in Amsterdam. "The distributor takes 55 per cent of the cover price, but 70 per cent of my sales come from subscriptions, so it's OK," he explains. "But distributing in Europe is still so hard in places such as Barcelona and Sweden."

Dong

For small-run magazines trying to gain a foothold in the marketplace, times have always been tough. One example is *Dong*, a German independent magazine that offers an alternative, humorous slant on fashion. When it launched, according to editor-in-chief Nicole Hardt,

the team struggled to convince German distributors that there was
a market for their publication.

"At first, we had to do everything ourselves. It was really
hard, as you don't have all the contacts or the time to take care of
everything," she says. "We had enough on our hands doing the magazine
and trying to make money! We found it was possible to build relationships
only with independent shops; there was no chance with bigger companies,
as there are too many admin problems. So, we struggled to grow. We tried
very hard to find a distributor in Germany – because we are German, all
our accounts are in Germany and we thought it might be easier – but they
all wanted us to change the concept, asking us to become thicker, more
glamorous and glossy so we could aim for a bigger circulation. The last
people we tried were the French company Import Export Press. I never
thought they would take us, but they did. The company really respects our
work, lets us be as we are, helps us to sell in the right shops and gives us
the chance to expand. We're now available worldwide, from the USA to
Taiwan, in art bookshops, museum shops and galleries."

France has an unusual relationship with magazine
distribution: all publishers have a legal right to distribution, leading to
a huge variety on offer in every kiosk. Elsewhere, however, availability
can be at the whim of the distribution company. With the vast majority
of distributors in the hands of large publishing corporations – or even
the state in some places – small publications often struggle to gain
acceptance in the first place.

Steven Salop at Charles River Associates, a US legal
firm that has examined the changing magazine marketplace, defends
distributors, pointing out that they have their own problems. "In the mid-
1990s, supermarkets started limiting the number of wholesalers they would
do business with," he explains. "For the big publishers, this also meant that
they took a smaller range of magazine titles. This is typical supermarket
policy, but magazines are a special exception. Publishers don't directly
bear the costs of returning unsold copies, and want to increase readership
to maximise advertising revenues. Wholesalers, retailers and, to some

**"The company really respects our work, lets us be as we are, helps
us to sell in the right shops and gives us the chance to expand.
We're now available worldwide, from the USA to Taiwan."**

extent, national distributors bear the costs of handling returns, but they
do not benefit directly from increased advertising revenues. As a result,
there is always going to be dissatisfaction when the distributor isn't directly
owned by the publisher."

This was the problem faced by *Etisoppo*, a small, unbound
art magazine featuring young and breakthrough artists, published

Etisoppo

in Sydney. The magazine was initially available only in Sydney and Melbourne, although it also had an internet presence. It sought national and international distributors, but struggled to make the system work. There were particular problems in Japan – where distributors were unwilling to handle the product at all – and managing distribution in other countries was time-consuming and expensive. Essentially, the distributors couldn't see how they were going to make money from a beautifully crafted but very niche magazine.

"I'd really like *Etisoppo* to be available in good bookstores where artistic people gather in the big global cities such as New York, London and Berlin," says Jun Tagami, *Etisoppo*'s creative director. "I tried it for a while, but I had very bad experiences. There were so many problems with payments. You'd get late payment, or sometimes no payment, and always your consignment of returns would have damaged magazines – but if you complained you got no answer. Some countries – like the UK – were better than others, but in the end I got sick of it. Now I'm doing it by myself. Even that is tough. Some of the big bookshops in Sydney and Melbourne didn't even bother to reply when I sent them a sample. I think that's rude." *Etisoppo* is currently on sale in Sydney, Melbourne and in one bookstore in Japan.

The cashflow problem is something all independent magazines complain about. It takes time to process returns and for cheques to arrive, and the big distributors often treat all magazines the same – as if everyone has the same deep pockets. Dutch design magazine *Dot dot dot* got so fed up by this that the editor named and shamed their debtors on the back cover and spine of one edition, under the title 'Elementary mathematics'. In the mid-1990s, American independent magazines sought a way round this problem by banding together to create their own distributor called Indy Press Newsstand Services. The company currently handles more than 50 publications and delivers them to retailers nationwide, offering indies a chance to get into the larger chain bookstores that rarely deal with small-distribution companies.

Since 2005, however, IPNS has hit financial problems, often failing to get money to small US titles for several months – money that those with tight margins desperately need. Its executive director, Richard Landry, emailed all the titles in October 2005 to explain that cashflow issues were a "major and very nasty consequence of media consolidation. The long payment cycles work to the advantage of the very biggest distributors and retailers, and to the disadvantage to the rest of us."

Dan Stoner, publisher of *Garage* – a car-culture quarterly that is run out of his, er, garage, says that autumn 2006 was especially tough for IPNS titles. "I was doing this from my kitchen table," Stoner remembers. "If a cheque didn't come in, maybe I didn't eat that week." In

Dot dot dot

Garage

the end, Stoner did pick up his cheque, but at the time of writing he was looking for a new distributor.

In one sense, Stoner is lucky. Ni Bing, editor of Chinese style magazine *Xpress*, faces the fact that the Chinese government controls both distribution and licensing of all magazines. Enterprising ventures have to launch from Hong Kong – which has a more liberal environment – then hand-deliver the copies themselves back to the mainland. In practice, this means getting a magazine beyond Beijing, Shanghai, Guangzhou, Hong Kong and Shenzhen is tricky – although Bing anticipates that restrictions will be eased.

So frustrating have publishers found the whole process that many of them have simply taken over the distribution themselves. New Delhi-based *The Little Magazine* launched six years ago as a literary title, publishing essays, short stories, poetry, plays, art and even film scripts from the likes of Noam Chomsky, Amartya Sen, Harold Pinter and Kamala Das, with the intention of being on sale across southern Asia. According to publisher Pratik Kanjilal, distribution agencies in India offer no advantages at all for small publishers. "We started our own distribution and subscription network when we launched, which now services 150 bookstores in this region," he says. "Self-distribution has protected us from mass-market forces. We are able to ensure good visibility at the point of purchase, and can supply small volumes at short notice, reducing booksellers' warehousing headaches and our returns. The only downside is that the operation eats into time we would prefer to devote to editorial."

Elsewhere, the Peruvian literary magazine *Etiqueta Negra* employs uniformed vendors to sell the magazine at traffic lights. Luxembourg-based publishing company Mike Koedinger Editions (also the publisher of this book) produces *Nico*, a European biannual style magazine, and manages its own distribution, targeting 26 key cities in the UK, Germany, France and Italy alone, as well as other territories. In this approach, it has been inspired by the success of frat-boy-come-style-zine *Vice*. A free title, *Vice* was originally launched in Montreal in 1996, but now produces editions in Australia, Austria, Great Britain, the United States, Japan, Scandinavia, Canada, Germany, New Zealand, Italy, the Netherlands and Belgium, all with local teams but co-ordinated out of the magazine's New York office.

The magazine's publisher, Andrew Creighton, explains that creating its own distribution network has enabled it to launch spin-offs, such as merchandising, a fashion brand and even a record label. "The key thing is that we control our own distribution and, most importantly, our own distribution lists," he says. "We get to choose every place that the magazine is available, rather than use a company that doesn't really understand our readership. In the US, that means we have our own people drop, say, 20,000 copies in Chicago and then use a local distributor to

Xpress

The Little Magazine

Etiqueta Negra

Nico

Vice

deliver it to the right places. In other parts of the world, we have a bonded courier service. We choose every single outlet; whether that means clothing stores, record shops, private members' clubs, universities or even hotels. That's the only way it would work with a free-distribution model, because it means we can tightly control who gets the magazine, which is

Hip urban bookstores realise that having an edgy magazine on their shelves can work in branding terms as well as increasing cashflow – customers return more often to see what's on offer.

Vogue

La Más Bella

Blow

how we ensure our demographic works for the advertisers. Otherwise, we might just as well chuck a bundle in the middle of every town."

In sourcing creativity and financial success out of adversity, *Vice* is following in a glorious tradition. British *Vogue*, for instance, was launched only because a German company had always distributed the American original. The outbreak of the First World War led to a UK version being created; French *Vogue* followed in 1920 – originally printed alongside the UK edition in London.

If there's sufficient demand, the canny publisher will always find a way. Spanish art magazine *La Más Bella* created a vending machine, the Bellamatic, which travels around galleries and art festivals. Easier to track down are the new generation of hip urban bookstores – Colette in Paris, Magma in London – that realise that having an edgy new magazine on their shelves can work in branding terms as well as increasing cashflow. The more new magazines that appear on their shelves, the more often customers will return to see what's on offer. The Tokyo equivalent of these shops – the Ayoama Book Centre – goes so far as to employ a scout based in both London and Lisbon to search out magazines in Europe and North America.

"My job is basically to look out for new magazines, or magazines that have been around a bit but seem to have hit a new creative patch," explains Michael Oliviera-Salac, the scout in question. "If I spot something good, I usually approach the publishers direct. It's often cheaper for the shop to buy magazines and have me airmail them over than it is to sort out more official lines of distribution."

Oliviera-Salac – who himself used to run a London fashion fanzine called *Blow* in the 1990s – is optimistic about the future. "Unlike in almost every other media, people create magazines out of passion," he argues. "There will always be shops that thrive on the same passion, and readers who buy with the same passion. Whatever the distribution issues facing magazines today, they'll always be overcome because magazine publishing is basically driven by love."

Stephen Armstrong is a writer based in London.

Magazine 10/10

Yummy

France

Our increased interest in food as lifestyle has led to the launch of many new food magazines in recent years, but none is as intriguing as *Yummy*. Published from France (where else?), *Yummy* sidesteps the regular subjects such as celebrity chef profiles, recipes and dietary advice, to concentrate instead on food culture in its broadest and most visual sense. Here is food as fashion, studies of packaging design, and photographic essays on 'junk food culture'. It presents an alternative view of the world of food, arguably a more realistic one, where food is to be enjoyed for what it is rather than analysed and idolised.

yummy
junkfoodesignmagazine

Who is the magazine aimed at ? Fast eaters, influencers, creative people, rock stars and fashion gurus. **What is the driving force behind the magazine ?** Love of newness. **Why use the format of a magazine to express that ?** Love of magazines. **Would you like to produce the magazine more frequently ?** Yes, but only with a team of million people. **What makes your perspective on food and culture distinctive ?** Soda = fashion accessory. **In what ways do you feel that the magazine is a design object in itself ?** Just open it. How international is your audience ? Worldwide. **Where is the magazine on sale ?** In the fashion capitals. Paris, London, Tokyo, New-York. **What's the hardest part of creating YUMMY ?** Having to find money to print it.

IMG_5301.JPG

IMG_5303.JPG

IMG_5304.JPG

IMG_5305.JPG

IMG_5307.JPG

IMG_5311.JPG

IMG_5313.JPG

IMG_5314.JPG

IMG_5315.JPG

IMG_5322.JPG

IMG_5323.JPG

IMG_5324.JPG

IMG_5326.JPG

IMG_5328.JPG

IMG_5330.JPG

IMG_5331.JPG

IMG_5332.JPG

IMG_5334.JPG

IMG_5335.JPG

IMG_5336.JPG

IMG_5338.JPG

IMG_5339.JPG

IMG_5340.JPG

IMG_5342.JPG

Eat fast, laugh

and lie.

yummy

fastfoodesignmagazine.n°2

IMG_5343.JPG

IMG_5346.JPG

IMG_5347.JPG

IMG_5348.JPG

IMG_5349.JPG

IMG_5351.JPG

IMG_5352.JPG

IMG_5354.JPG

IMG_5355.JPG

IMG_5356.JPG

IMG_5357.JPG

IMG_5358.JPG

IMG_5359.JPG

IMG_5360.JPG

IMG_5361.JPG

IMG_5363.JPG

IMG_5364.JPG

IMG_5365.JPG

IMG_5366.JPG

IMG_5368.JPG

IMG_5369.JPG

IMG_5370.JPG

IMG_5371.JPG

IMG_5372.JPG

IMG_5373.JPG

IMG_5375.JPG

IMG_5376.JPG

IMG_5377.JPG

IMG_5378.JPG

IMG_5379.JPG

IMG_5380.JPG

IMG_5382.JPG

IMG_5383.JPG

IMG_5384.JPG

IMG_5385.JPG

IMG_5387.JPG

IMG_5389.JPG

IMG_5391.JPG

IMG_5392.JPG

IMG_5393.JPG

IMG_5394.JPG

IMG_5395.JPG

IMG_5397.JPG

IMG_5398.JPG

IMG_5400.JPG

IMG_5401.JPG

IMG_5403.JPG

IMG_5404.JPG

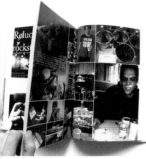

IMG_5406.JPG

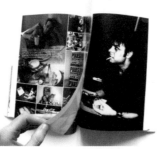

IMG_5407.JPG

IMG_5409.JPG

IMG_5410.JPG

IMG_5412.JPG

IMG_5413.JPG

IMG_5414.JPG

IMG_5415.JPG

IMG_5416.JPG

Yummy

9 boulevard Ornano
75018 Paris
France
Website: www.eat-fast.net
Email: contact@eat-fast.net
Editor-in-chief: Pascal Monfort
pascal@eat-fast.net
Art director: Alexandra Jean
alexandra@eat-fast.net
Format: 212 x 275 mm

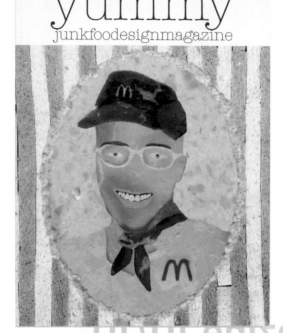

Magazine 10/10

Yummy

France

Directory

From *032c* to *Zoot*, this directory contains 1,156 magazines published in 52 countries. The list is mostly made up of independent style press but also contains selected titles from the fields of art, architecture, cinema, comics, culture, design, economics, feminism, gay, lesbian, music, photography, politics and sport. To the best of our knowledge, they were all still being published in March 2007.

The database represents two years' work by Mike Koedinger Editions. It began with a personal collection of more than 20 years' worth of magazines. The list of magazines was made public on www.welovemags.com in July 2005. Since then, we've emailed publishers around the world to complete fact sheets; we've expanded our database several times over; and we've added interviews with magazine makers. Hundreds of people have told us about their favourite magazines or added the details of their own to our list. The Colophon directory has become an unparalleled, free resource for independent publishing.

Our database is continually updated to include the latest births and deaths in the magazine world. If you know of a magazine that should be included, then please email us at update@welovemags.com; if you want to keep up with the latest in magazine developments, then you can subscribe to our newsletter via the website.

We have also compiled a list of around 300 of the most significant independent magazine stockists. Some import magazines directly from their creators, others use distribution networks such as COMAG and Import Export Press.

We hope you enjoy consulting this directory as much as we have enjoyed discovering all these magazines.

Mike Koedinger and Ariane Petit, Editors, www.welovemags.com

Magazines

Argentina

Acido Surtido
100% Argentine product
Acido Surtido is a publication on art and design distributed for free in the whole country. Not only the summoning topic/concept but also the participants are unique for each issue and define its personality.
Tri-Annual, founded in 2001, 160 x 235 mm, Free, Spanish.
Editorial Office
Virrey del Pino 2632 13 G
CPA C1426 EGV Buenos Aires
luc@pumpd.com.ar
www.acidosurtido.com.ar
Staff
Editor: Diego Cabello
Editor: Lucas Lopez
Editor: Mauro Lopez

atypica
art, culture and design
Every two months, founded in 2003, 155 x 215 mm, 40,000 copies, Free, Spanish / English.
Editorial Office
Entre Rios 773 PA
S2000 CRM Rosario, Santa Fe
guillermina@atypica.com.ar
www.atypica.com.ar

G7
G7 gives expression to personalities and events that open up new horizons for sectors such as advertising, art, fashion, cinema, music and design. Seven candidates are singled out in each issue.
Monthly, founded in 2001, 15,000 copies, $9.90, Spanish.
Editorial Office
El Salvador 5928
CP 1414 Buenos Aires
info@revistag7.com
www.revistag7.com
Staff
Editor-in-chief:
Francisco Condorelli
Production director:
Sebastián Costanzo
Publisher
Gruposiete S.R.L.

Original Voice
Editorial Office
Buenos Aires
www.superlab.com.ar
Publisher
Superestudio
Gorriti 5116 n°B
C1414JKB Buenos Aires
contacto@superlab.com.ar

Sede
It's a magazine about arts, cooking, stories, conversations, travels, sports, etc.
Every two months, founded in 2006, 125 x 180 mm, 1,000 copies, $5, Spanish.
Editorial Office
Virrey del Pino 2446 apt 8Q
1426 Buenos Aires
juanmoralejo@gmail.com
www.sedede.com.ar

Summa+
Magazine about architecture and design
7x / year, founded in 1993, 245 x 340 mm, 13,500 copies, $29, Spanish.
Editorial Office
Cortejarena 1862
C1281AAB Buenos Aires
summamas@summamas.com
www.summamas.com
Staff
Editor-in-chief: Martha Magis
Publisher
Donn S.A.

Superlab
Editorial Office
Buenos Aires
info@superlab.com.ar
www.superlab.com.ar
Staff
Editorial director:
Laura Doctorovich
Publisher
Superestudio
Gorriti 5116 n°B
C1414JKB Buenos Aires
contacto@superlab.com.ar

Tipogràfica
Graphic design magazine
Quarterly, founded in 1987, $16.60, Spanish.
Editorial Office
Buenos Aires
www.tipografica.com

Urbconnexion
Editorial Office
Buenos Aires
www.superlab.com.ar
Publisher
Superestudio
Gorriti 5116 n°B
C1414JKB Buenos Aires
contacto@superlab.com.ar

Australia

(inside)
Australian Design Review Magazine
Australian design review: *(inside)* is Australia's premier professional journal for interior architects and designers.
Quarterly, 205 x 267 mm, 12,950 copies, English.
Editorial Office
Level 3, 165 Fitzroy Street
3182 St Kilda Victoria
www.niche.com.au
Staff
Editor-in-chief and Art director:
Andrew Mackenzie
Publisher
Niche Media PTY, Ltd.

Art and Australia
Quarterly, founded in 1963, 225 x 242 mm, English.
Editorial Office
11 Cecil Street
NSW 2021 Paddington
www.artaustralia.com
Staff
Editorial assistant: Jesse Stein

Art Visionary
Annual, founded in 1999, English.
Editorial Office
Po Box 1536-N
Victoria 3001 Melbourne
artvisionary@optusnet.com.au
Staff
Editor-in-chief: Damain Michaels

Artlines
Art and people
Artlines has themed issues with a focus on art of the Asia-Pacific region.
Tri-Annual, founded in 2005, 210 x 275 mm, 12,000 copies, AU $7.95, English.
Editorial Office
Po Box 3686
4101 Brisbane
ian.were@qag.qld.gov.au
www.qag.qld.gov.au/artlines

Australian ART collector
Collecting and investing in Australian modern and contemporary art.
Quarterly, 25,000 copies, AU $18.95, English.
Editorial Office
Level 1, 645 Harris Street,
Ultimo
NSW 2007 Sydney
sven@gadfly.net.au
www.artcollector.net.au

Black+White

Magazine where art meets life
Every two months, 240 x 323 mm,
AU $12.95, English.
Editorial Office
Level 3, 165 Fitzroy Street
NSW 2011 East Sydney
www.studiomagazines.com
Staff
Editor-in-chief: Eyre
Managing editor: Nick Dent
Sub editor: Karl Mayenhofer
Sub editor: David Mills
Publisher
Studio Magazines Pty Ltd.
Level 3, 101-111 William Street
NSW 2011 East Sydney
Phone: + 61 2 9360 9550
Fax: + 61 2 9360 9723
mg@studio.com.au
www.studiomagazines.com

Cinq

CinqSportsJournal
Cinq gives you an armchair
lesson, albeit brief yet concise,
on the history of urban sports.
Editorial Office
3 Newton Street
VIC 3121 Richmond
www.cinqmagazine.com
Staff
Editor: Mark Gambino
Publisher
Furst Media
3 Newton Street
VIC 3121 Richmont

Craft Arts International

Independent journal devoted
to the documentation of
contemporary craftwork and
"new art forms" that fall within
the broad categories of the visual
and applied arts.
Tri-Annual, founded in 1984, £8,
English.
Editorial Office
Po Box 363

NSW2089 Neutral Bay
info@craftarts.com.au
www.craftarts.com.au
Staff
Editor: Cassandra Dr Fusco7¶

Cream

Australia's favourite leading-edge
pop culture magazine, covering
the latest music, fashion, film,
lifestyle, travel...
English.
Editorial Office
Po Box 1176
NSW 2000 Sydney
cream@pobox.com
www.creammagazine.com

Desktop:

Where digital technology
parallels and intersects design,
communication and publishing
culture.
Monthly, AU $8, English.
Editorial Office
165 Fitzroy Street,
3182 St Kilda
www.desktopmag.com.au
Staff
Editor: Elise Goodwin
Publisher
Niche Media PTY, Ltd.

DG

Design Graphics
Design Graphics covers a wide
range of related subjects from
high end printing, through new
media all the way to the web.
Every two months, English.
Editorial Office
Po Box 10, Ferny Creek
3786 Melbourne Victoria
email@designgraphics.com.au
www.designgraphics.com.au
Staff
Editor: Rachael Doherty

DNA

A lifestyle magazine for gay men
includes beautiful photography
and in-depth feature articles.
Monthly, founded in 2000,
AU $8.50, English.
Editorial Office
Po Box 127
NSW 1825 Lidcombe
andrew@dnamagazine.com.au.
www.dnamagazine.com.au
Staff
Editor and Publisher:
Andrew Creagh

doingbird

fashion/arts publication
Bi-annual, founded in 2001,
AU $14, English.
Editorial Office
Po Box 7167
NSW 2026 Bondi Beach
info@doingbird.com
www.doingbird.com
Staff
Editor-in-chief: Max Doyle
Fashion editor: Leslie Lessin
Editor: Malcom Watt

etisoppo

etisoppo is a collection point for
different perspectives. *etisoppo* is
also a visual exploration of Australia.
Editorial Office
Po Box 156, Avoca Street
2031 NSW Randwick
editor@etisoppo.com
www.etisoppo.com
Staff
Editor: Jun Tagami

Highlights

Hair Magazine
Bi-annual, 240 x 330 mm, English.
Editorial Office
77 Beattie St.
NSW 2041 Balmain
mark@highlightsmag.com
www.highlightsmag.com
Staff
Editor: Mark Stapleton
Publisher
Highlights Publications
77 Beattie St
NSW 2041 Balmain
Phone: +61 02 9555 2520

indesign

**Australia's largest interior
architecture magazine**
Quarterly, English.
Editorial Office
Level 1, 50 Marshall Street,
Surry Hills
NSW 2010 Sydney

Is not magazine

Is not magazine publishes
themed content on a bill poster.
It occupies public space, has no
advertising, and champions
active, critical reading.
Founded in 2005, 1500 x 2000
mm, 220 copies, AU $20, English.
Editorial Office
Level 5, Vesta House,
1 Carson Place
3000 Melbourne
info@isnotmagazine.org
www.isnotmagazine.org
Staff
Co-founder and Editor:
Natasha Ludowyk
Co-founder and Editor:
Mel Campbell
Co-founder and Editor:

Penelope Modra
Co-founder and Designer:
Stuart Geddes
Co-founder and Designer:
Jeremy Wortsman

Keep Left

Annual, 210 x 210 mm, 1,000
copies, Variable price, English.
Editorial Office
Sydney
info@kleft.com
www.kleft.com
Publisher
Symple Creative
Phone: +61 0438 337 146
www.symple.com.au

Lifelounge

Life from a different angle
Popular culture with a strong
focus on art/design, fashion,
music and alternative sports.
Every two months, founded in
2005, 200 x 250 mm, 150,000
copies, English.
Editorial Office
285 St Kilda Road
3182 St Kilda
luke@lifelounge.com
www.lifelounge.com

Like

Art Magazine
Quarterly, founded in 1996,
210 x 275 mm, English.
Editorial Office
Po Box 2476V
3001 Melbourne Victoria
Staff
Editor-in-chief: Robyn McKenzie

Lino Magazine

**Australia and New Zealand's
premier design lifestyle
magazine**
Quarterly, English.
Editorial Office
103 / 88 Foveaux Street
NSW 2010 Surry Hills
Sydney
info@linomagazine.com.au
www.linomagazine.com.au
Staff
Managing editor: Ian Ossher

Mark

English.
Editorial Office
mark@markmagazine.com
www.markmagazine.com
Staff
Publisher and Editor-in-chief:
Mark Vassallo and Dario Zonca

men's style
australia

Is the essential guide for the
young urban man in his quest to
learn more about the three Rs –
romance, recreation and
refinement.
Every two months, 215 x 277 mm,
AU $9.95, English.
Editorial Office
54-58 Park Street
NSW 2000 Sydney
Staff
Editor: Peter Holder
Publisher
ACP
32 rue de Strasbourg
75010 Paris
France
Phone: +33 06 16 399 242
magazine75010@yahoo.fr

Monster
Children

Quarterly, 210 x 297 mm, 20,000
copies, AU $9.95, English.
Editorial Office
L1, 98-104 Parramatta Road
Camperdown NSW 2050
monster@monsterchildren.com
www.monsterchildren.com

Staff
Publisher and Editor:
Campbell Milliigan
Publisher and Editor: Chris Searl

Monument

Magazine of architecture and
design.
Every two months, English.
Editorial Office
Channel Seven Broadcast
Centre, 160 Harbour Esplanade
VIC 3008 Docklands
fleur.watson@pacificmags.com.au
www.monumentmagazine.com.au

noi.se magazine

Quarterly, 240 x 340 mm,
AU $9.95, English.
Editorial Office
77 Beattie St.
NSW 2041 Balmain
editorial@highlightsmag.com
Staff
Editor: Mark Stapleton
Editorial co-ordinator:
Kellie Tissear

Oyster

Contemporary fashion magazine
featuring the cutting edge in
photography, design and lifestyle.
Every two months, 240 x 325 mm,
36,000 copies, English.
Editorial Office
Level 2, 25 Cooper St
NSW 2010 Surry Hills
info@oystermag.com
www.oystermag.com
Staff
Creative director:

Johnathan Morris
Deputy editor: Rachel Squires
Art director: Aly Clarke
Sub editor: Paul Bui

POL Oxygen

Award-winning international
design, art and architecture
magazine with a focus on people.
5x / year, founded in 2002,
25,000 copies, AU $17.50,
English.
Editorial Office
125-127 Little Eveleigh Street
NSW 2016 Redfern
oxygen@pol.com.au
www.poloxygen.com
Staff
Distribution and Circulation:
Michelle Willis
Editor: Jan Mackey
Publisher: Peter Berman
Editorial: Kellie Holt
Editorial: Jessica Gadd
Editorial: Pilar Arevalo
Design: Marcus Piper

Poster

Australia's leading design,
fashion, and art magazine.
Quarterly, founded in 2001,
220 x 285 mm, 12€, English.
Editorial Office
Po Box 1064
3182 St Kilda South Victoria
info@postermagazine.com.au
www.postermagazine.com.au
Staff
Founder and Creative director:
Nicolas Meimaris
Editorial manager:
Rowena Robertson
Advertising manager:

Cilla Maden
Publisher
Poster Australasia Ltd
www.postermagazine.com.au

refill
$12, English.
Editorial Office
157 Regent Street
Sydney
refill@refillmag.com
www.refillmag.com

Riot
Radically re-shapes the way that
pop culture content was
presented in Australia.
Monthly, founded in 2005,
English.
Editorial Office
zolton@riotmag.net
www.riotmag.net

Russh
Russh supports Australian
talent, creates all original content
and works with some of the
best designers and talents in
the world.
Every two months, founded in
2004, 236 x 303 mm, 25,000
copies, English.
Editorial Office
Sydney
info@russhaustralia.com
www.russhaustralia.com
Staff
Editor: Charlotte Scott
Publisher
Russh Magazines and
Publications
Level 1, 14-16 Kent St,
NSW 2000 Millers Point,
The Rocks
Phone: +61 2 9252 8355

Sneaker Freaker
In each issue you can expect to
find well written and researched
stories on all aspects of sneaker
culture
Bi-annual, founded in 2003, £10,
English.
Editorial Office
Po Box 1571
3066 Collingwood 3066
www.sneakerfreaker.com
Staff
Editor: Woody

The Hungry Zine
**An illustrative Zine for
hungry people**
A witty, pretty, illustration feast
for the eyes.
Quarterly, founded in 2005,
250 copies, AU $6, English.
Editorial Office
Clifton Hill
hungryzine@gmail.com
www.hungryzine.com.au
Staff
Founder and Editor-in-chief:
Kate Chmiel
Founder and Editor-in-chief:
Annette Phillips
Founder and Editor-in-chief:
Daniel Atkinson
Founder and Editor-in-chief:
Andrew Isaac
Founder and Editor-in-chief:
Sarah Strickland
Founder and Editor-in-chief:
Andrew Evans

They shoot homos don't they?
Bi-annual, founded in 2004,
148 x 210 mm, 2,000 copies,
AU $12.50, English.
Editorial Office
Po Box 1289
VIC 3066 Collingwood,
Melbourne
info@theyshoothomosdontthey.
com
www.theyshoothomosdontthey.
com

Yen
$7.50
Editorial Office
www.yenmag.net
Publisher
Paper Tiger Media Group
56-58 Catherine Street
NSW 2040 Leichhardt
Phone: +61 612 9564 4100
Fax: +61 612 9564 4150

Austria

Bob
**monothematisch /
multiperspektivisch**
Bi-annual, founded in 2005,
212 x 276 mm, 4.80€, German.
Editorial Office
Rainergasse 34
1050 Vienna
presse@club-bellevue.com
www.bob-magazine.com

Staff
Art director: Alois Gstöttner
Editor: Wolfgang Haas

Camera Austria
Exploration of photography in
the context of contemporary art,
new media and social
developments.
Founded in 1980
Editorial Office
Lendkai 1
8020 Graz
office@camera-austria.at
www.camera-austria.at
Staff
Editor: Tanja Gassler

Datum
Seiten der Zeit
With its slightly off, always iconic
covers, matte paper stock and
sharp layouts it's become a cult
favourite among art directors
around the world.
Monthly (11x / year), founded in
2004, 4.50€, 10,000 copies,
German.
Editorial Office
Ungargasse 28/2/Innenhof
1030 Vienna
office@datum.at
www.datum.at
Staff
Editor-in-chief: Klaus Stimeder
Publisher
Verein zur Förderung des
Qualitätsjournalismus
Ungargasse 28/2/Hof
1030 Vienna
office@datum.at
www.datum.at

Eikon

Focuses on Austrian and international media arts with special emphasis on fine art photography and its significance in the New Media, i.e. in the intermedial context.
Quarterly, founded in 1991, German.
Editorial Office
Kulturbüros, 1. Stock, Museumsplatz 1, e1.6
1070 Vienna
office@eikon.or.at
www.eikon.or.at

Fotogeschichte

About history and aesthetic of photography.
Quarterly, founded in 1981, 210 x 297 mm, 20€, German.
Editorial Office
Florianigasse 75/19
1080 Vienna
fotogeschichte@aon.at
www.fotogeschichte.info
Publisher
Jonas Verlag
Weidenhäuser Str. 88
35037 Marburg
Germany
Phone: +49 0 6421 25132
Fax: +49 06421 210572
jonas@jonas-verlag.de
www.jonas-verlag.de

frame
The state of art
Each issue of contemporary art magazine *frame* is related to a zeitgeisty topic.
Quarterly, founded in 2000, 230 x 290 mm, 15,000 copies, 8.70€, German.
Editorial Office
Lehárgasse 10

1061 Vienna
redaktion@frameprojects.com
www.frameprojects.com
Staff
Editor-in-chief:
Alexander Pühringer
Senior editor: Otto Neumaier
Editor: Jens-Peter Koerver
Editor: Klaus Leuschel
Editor: Markus Mittringer
Editor: Marlene Proksch
Publisher
Frame Projects
Lehárgasse 10
1061 Wien
Phone: +43 1 9610421
Fax: +43 1 9610421 19
office@frameprojects.com
www.frameprojects.com

Lürzer's Archive
Ads and Posters worldwide
A unique review dedicated to presenting the best new advertising campaigns from all over the world.
Every two months, founded in 1984, 205 x 285 mm, 9,000 copies, 13.50€, English.
Editorial Office
Glockmühlstr. 4
5023 Salzburg
office@luerzersarchive.com
www.luerzersarchive.com
Staff
Publisher and Editor:
Walter Lürzer
Editor-in-chief: Michael Weinzettl
Associate editor:
Sonja Hohenthanner
Marketing and Sales manager:
Sandra Lehnst
Publisher
Lürzer GmbH
Glockmühlstr. 4
5023 Salzburg
Phone: +43 662 64 85 85
Fax: +43 662 64 85 85 60
office@luerzersarchive.com
www.luerzersarchive.com

modart
Creative action breeds active creation
Every two months, 280 x 270 mm, 4.95€, English.
Editorial Office
Innsbruck
www.modarteurope.com
Staff
Creative director: Garry Maidment
Editor: Jason Horton
Designer: Michael Devor
Publisher
More Productions Ltd
www.modarteurope.com

Nihao
Every issue is dedicated to the creative processes of a country, its culture, its customs and distinctiveness.
Annual, 190 x 265 mm, 1,000 copies, 6€, German / English.
Editorial Office
Alte Poststr. 152
8020 Graz
ask@nihaomag.com
www.nihaomag.com
Staff
Editor: Cora Akdogan
Editor: Miriam Strobach
Editor: Viktoria Platzer
Publisher
FH Joanneum
Studiengang Informationsdesign,
Alte Poststr. 152
8020 Graz

Parnass
Quarterly, 230 x 295 mm, 9,700 copies, 15€, German.
Editorial Office
Porzellangasse 43/19
1090 Vienna
parnass@chello.at
www.parnass.at

placed
fashion art culture
Quarterly, founded in 2006, 210 x 290 mm, 8€, English.
Editorial Office
Eroicagasse 10/4

1190 Vienna
christianrosa@placedmagazine
.com
www.placedmagazine.com
Staff
Founder and Publisher:
Christian Rosa Weinberger
Founder and Publisher:
Anita Schmid

pool magazine
life and culture
Quarterly, founded in 2001, 240 x 300 mm, 28,000 copies, Free, German / English.
Editorial Office
Thurngasse 2
1090 Vienna
office@pool-mag.net
www.pool-mag.net
Staff
Editor-in-chief: Helmut Wolf
Art director: Bernie Steinbach
Creative director: Martin Weiss
Marketing and PR: Barbara Figl
Publisher
pool verlags gmbh
Thurngasse 2
1090 Vienna
Phone: + 43 1 945 72 00 - 0
Fax: + 43 1 945 72 00 - 33
office@pool-mag.net
www.pool-mag.net

SnowWorld
The F2 Boardercommunity Supply
210 x 297 mm, Free, English.
Staff
Editor: Wolfgang Schober
Publisher
Boards and More GmbH
Rabach 1
4591 Molln

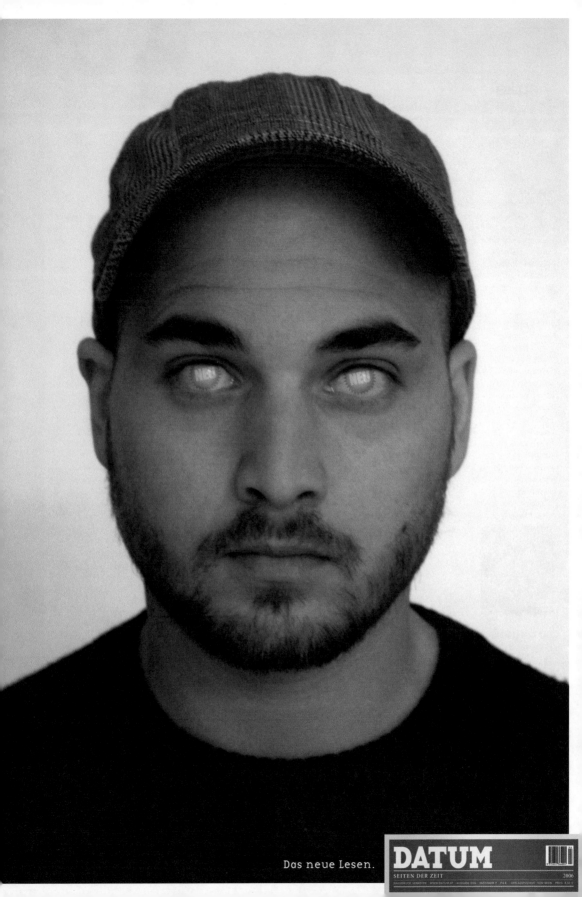

Das neue Lesen.

DATUM

SEITEN DER ZEIT

2006

spike
Art quarterly
The magazine offers new, illuminating and unconventional perspectives on art and contemporary trends. Quarterly, founded in 2004, 225 x 280 mm, 24,000 copies, 6.50€, German / English.
Editorial Office
Kaiserstrasse 113-115
1070 Vienna
i.gebetsroither@spikeart.at
www.spikeart.at
Staff
Editor-in-chief and Art director: Rita Vitorelli
Editor: Herbert Pinzolits
Editor: New Art Club
Publisher
Sportmagazin Verlag GmbH
Kaiserstrasse 113-115
1070 Vienna
Phone: +43 0 1 36 085 201
Fax: +43 0 1 36 085 200
www.vsm.at

springerin
Hefte für Gegenwartskunst
springerin is dedicated to the theory and critique of contemporary art and culture. Quarterly, founded in 1995, 230 x 275 mm, 5,000 copies, 11.50€, German.
Editorial Office
Museumsplatz 1
1070 Vienna
springerin@springerin.at
www.springerin.at
Staff
Editor: Christian Höller
Editor: Georg Schoellhammer
Publisher

Springerin
Museumsplatz 1
1070 Vienna
Phone: +43 1 522 91 24
Fax: +43 1 522 91 25
springerin@springerin.at
www.springerin.at

strukt
The magazine collects the works of young and aspiring international graphic designer and professionals around a central theme.
Irregular, 8€
Editorial Office
Rupertgasse 24
5020 Salzburg
www.strukt.at/
Staff
Editor: Andreas Koller
Editor: Gregor Hofbauer

The All Season Fashion Paper
...an independent, biannual cross-project of fashion, photography and art, exploring focal themes with graphic uniqueness.
Bi-annual, 325 x 480 mm, 4,000 copies, 4.80€, German / English.
Editorial Office
Gumpendorferstraße 10-12
1060 Vienna
office@unit-f.at
www.fashionpaper.at
Staff
Editor-in-chief:
Ulrike Tschabitzer
Fashion consultant: Nicole Adler
Fashion consultant:
Peter Schindler
Publisher
Unit F assocation for contemporary fashion
Gumpendorfstrasse 10-12
1060 Vienna
office@unit-f.at
www.unit-f.at

WeAr
global magazine
Quarterly, 248 x 340 mm, 15,000 copies, 45€, English / German / French / Italian / Spanish / Russian / Mandarin / Japanese.
Editorial Office
Erlbruckweg 1
5700 Zell am See
info@wear-magazine.com
www.wear-magazine.com
Staff
Advertising: Sabine Strobl
Managing editor: Andrea Vogel
Publisher
Klaus Vogel

Wienerin
Das Österreichische Frauenmagazin
Monthly, founded in 1984, 74,000 copies, German.
Editorial Office
Geiselbergstrasse 15
1110 Vienna
www.wienerin.at
Staff
Editor-in-chief: Karen Müller
Publisher: Peter Mosser
Publisher
Lifestyle Zeitschriften Verlag GmbH
Geiselberstrasse 15
1110 Vienna
Phone: 01 / 60117-0
wienerin@wienerin.at
www.wienerin.at

wo-mens fashion
style in progress
European Trademagazine
Quarterly, 220 x 300 mm, 6.90€, German / English.
Editorial Office
Salzweg 17
5081 Salzburg-Anif
office@ucm-verlag.at
www.ucm.verlag.at
Staff
Editor-in-chief: Stephan Huber
Editor-in-chief:

Joachim Schirrmacher
Publisher
UCM Verlag
Salzweg 17
5081 Salzburg
Phone: +43 0 6246 89 79 99
office@ucm-verlag.at
www.ucm-verlag.at

WQ
business, style and modern life
Monthly (11x / year), 212 x 280 mm, 2.90€, German.
Editorial Office
Vienna
Staff
Editor-in-chief:
Petra Reichenberger

x-ray
global style + fashion
Quarterly, 220 x 300 mm, 6.90€, German / English.
Editorial Office
Salzweg 17
5081 Salzburg-Anif
office@ucm-verlag.de
www.ucm.verlag.at
Staff
Editor-in-chief: Stephan Huber
Editor-in-chief: Ina Köhler
Publisher
UCM Verlag
Salzweg 17
5081 Salzburg
Phone: +43 0 6246 89 79 99
office@ucm-verlag.at
www.ucm-verlag.at

SITE
/2
4,-

co re ?

Belgium

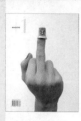

+1 Magazine
Created by the fourth year students of the Antwerp fashion department
Annual, founded in 2006, 230 x 295 mm, English.
Editorial Office
Keizerstraat 15
2000 Antwerp
www.antwerp-fashion.be
Staff
Idea and Concept:
Demna Gvasalia
Idea and Concept:
Helena Lumelsky

A Magazine
Curated by...
Bi-annual, founded in 2004, 230 x 295 mm, 11€, English.
Editorial Office
Nationalestraat 28/2
2000 Antwerp
amag@modenatie.com
www.modenatie.com
Staff
Editor: Hilde Bouchez
Editor: Gerdi Esch
Publisher
A Publisher - Flanders
Fashion Institute
Nationalestraat 28/2
2000 Antwerp
Phone: +32 475 30 93 50
Fax: +32 0 3 231 49 47

A Prior
A series of publications on contemporary art.
Bi-annual, founded in 1999, 170 x 235 mm, 2,000 copies, 20€, English.
Editorial Office
Delaunoystraat 58/15
1080 Brussels
www.aprior.org
Staff
General Manager: Els Roelandt
Publisher
vzw Mark
Ghent

A+
Revue Belge d'Architecture
Belgium's leading review in the fields of architecture, town planning, design and art.
Every two months, 240 x 300 mm, 14,078 copies, 12€, French / Flemish
Editorial Office
23 rue Ravenstein
1000 Brussels
info@a-plus.be
www.a-plus.be
Staff
Editor-in-chief: Stefan Devoldere
Publisher
CIAUD asbl
23 rue Ravenstein
1000 Brussels
secretariat@ciaud-icasd.be
www.ciaud-icasd.be

Ad!dict
Inspiration book
Bi-annual, founded in 1997, 240 x 240 mm, 12€, English.
Editorial Office
Delaunoystraat 60
1080 Brussels
www.addictlab.com
Staff
Editor-in-chief: Anja Samson
Creative director: Jan Van Mol
Publisher
Ad!dict Creative Lab
Delaunoystraat 60
1080 Brussels
Phone: +32 02 289 51 01
Fax: +32 02 289 51 02
info@addictlab.com
www.addictlab.com

BFF Magalog
Brussels Fashion Fairs Magazine and Catalogue
Bi-annual, founded in 2005, 240 x 240 mm, 4.50€, Flemish
Staff
Publisher and Creative director: Jan Van Mol
Publisher
Ad!dict Creative Lab
Delaunoystraat 60
1080 Brussels
Phone: +32 02 289 51 01
Fax: +32 02 289 51 02
info@addictlab.com
www.addictlab.com

code
Life and Artstyle
Founded in 2005, 5,000 copies, French / English.
Editorial Office
135 rue Tenbosch
1050 Brussels
backstage@codemagazine.be
www.codemagazine.be
Staff
Managing editor: Mariana Melo
Editor-in-chief: Devrim Bayar
Art director: David de Tscharner
Creative director:
Thomas Wyngaard
Publisher
Stoemp asbl
135 rue Tenbosch
1050 Brussels
backstage@codemagazine.be
www.codemagazine.be

DAMn
A magazine on design, architecture and art
DAMn is an independent publication with an open-minded view on the interchangeable worlds of design, architecture and art.
Bi-Monthly, 11€, 20,000 copies, English.
Editorial Office
Bellevuestraat 41
9050 Ghent
info@DAMnmagazine.be
www.damnmagazine.be
Publisher
DAMnation Ltd

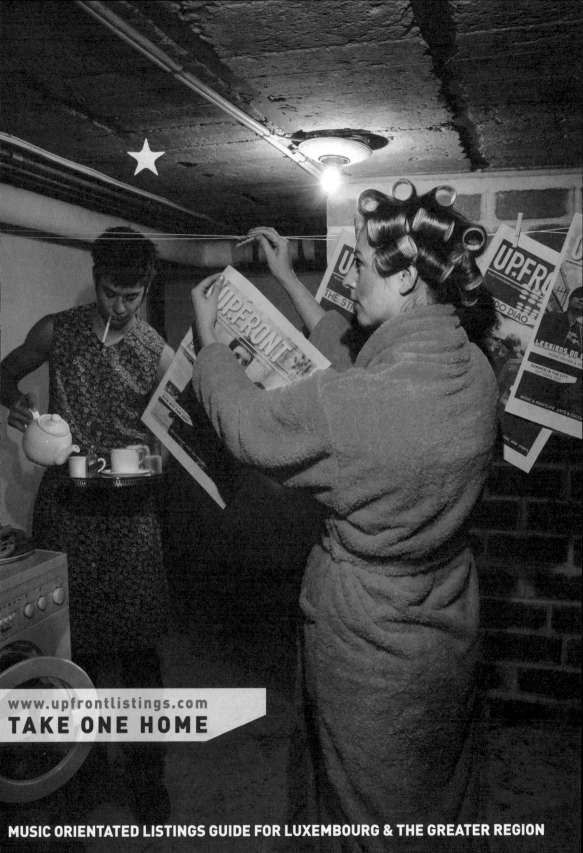

DENG

Flemish
Editorial Office
Brugstraat 51
2300 Turnhout
redactie@deng.be
www.deng.be

DITS

la revue du Musée des arts contemporains du Grand-Hornu
Bi-annual, founded in 2002, French.
Editorial Office
82, rue Sainte-Louise
7301 Hornu
info@grand-hornu.be
www.mac-s.be
Staff
Editor-in-chief: Denis Gielen
Director: Laurent Busine
Assitant: Julien Foucart
Publisher
Mac's
Site du Grand-Hornu,
Rue Sainte-Louise 82
7301 Hornu
Phone: +32 0 65 65 21 21

FL::AD

Platform for, on and by the Flemish creative region
Quarterly, founded in 2004, 240 x 240 mm, Flemish / English.
Editorial Office
Delaunoystraat 60
1080 Brussels
info@addictlab.com
Staff
Publisher and Creative director: Jan Van Mol
Publisher
Ad!dict Creative Lab

Delaunoystraat 60
1080 Brussels
Phone: +32 02 289 51 01
Fax: +32 02 289 51 02
info@addictlab.com
www.addictlab.com

flatspot

magazine pour playboy sur roulettes
Founded in 2002, 210 x 250 mm, 3€, French.
Editorial Office
23 rue aux Laines
1000 Brussels
flatspotmag@skynet.be
Staff
Editor: Alexis Vandenplas

Flux News

Quarterly, 300 x 420 mm, French / English.
Editorial Office
60 rue Paradis
4000 Liège
fluxnews@skynet.be
Staff
Editor-in-chief: Lino Polegato

Gagarin

the artists in their own words
Bi-annual, founded in 2000, 155 x 220 mm, French / English / Flemish.
Editorial Office
Kerkstraat 51
9250 Waasmunster
Staff
Editor-in-chief: Wilfried Huet

Gus

Lifestyle magazine for the gay-minded
Every two months, founded in 2001, 220 x 300 mm, 5€, French / Flemish / English.
Editorial Office
Rue du Houblon 13
1000 Brussels

info@gusmag.com
www.gusmag.com
Staff
Editor-in-chief: Frédérick Boutry
Co-editor-in-chief:
Steven Redant
Deputy editor: Steven Tate
Art director: Jean-Pol Lejeune
Fashion editor: Yannis Giotakos
Publisher
GATE BVBA
Hopstraat 13
1000 Brussels
Phone: +32 2 502 82 50

Janus

Art and philosophy
Bi-annual, founded in 1998, 226 x 300 mm, 4,000 copies, 18€, English.
Editorial Office
Av. Maeterlinck 17
1030 Brussels
c.bonduel@janusonline.net
www.janusonline.net
Staff
Editor-in-chief: Nicola Setari
Editors: Charlotte Bonduel
Francesca di Nardo
Luigi di Corato
Giovanni Iovane
Frank Maes

La Part de l'Oeil

Annual, founded in 1985, 210 x 297 mm, French.
Editorial Office
144, rue du Midi
1000 Bruxelles
lapartdeloeil@brunette.brucity.be
Staff
Editor-in-chief: Lucien Massae

Labfiles

240 x 240 mm, 5€, English.
Editorial Office
Delaunoystraat 60
1080 Brussels
info@addictlab.com
www.addictlab.com
Staff
Editor: Youssef
Publisher
Ad!dict Creative Lab
Delaunoystraat 60
1080 Brussels
Phone: +32 02 289 51 01
Fax: +32 02 289 51 02
info@addictlab.com
www.addictlab.com

L'art même

Driven to researching the principal articulations of international and contemporary themes that are at stake in art practices.
Quarterly, founded in 1998, 220 x 250 mm, 7,000 copies, Free, French.
Editorial Office
Ministère de la Communauté française, Service général du Patrimoine culturel et des Arts plastiques,
44 boulevard Léopold II
1080 Bruxelles
artmeme@cfwb.be
www.cfwb.be/lartmeme
Staff
Editor-in-chief: Christine Jamart
Editorial secretary:
Pascale Viscardy
Editor: Henry Ingberg

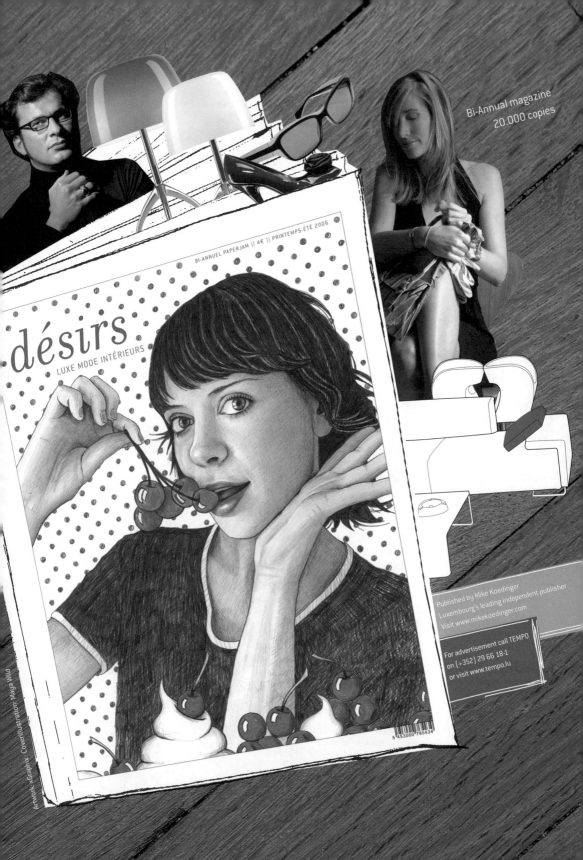

Bi-Annual magazine
20.000 copies

BI-ANNUEL PAPERJAM || 4€ || PRINTEMPS·ÉTÉ 2006

désirs
LUXE MODE INTÉRIEURS

Published by Mike Koedinger
Luxembourg's leading independent publisher
Visit www.mikekoedinger.com

For advertisement call TEMPO
on (+352) 29 66 18-1
or visit www.tempo.lu

Artwork: xGraphix · Cover illustration: Maya Wild

5 453000 765434

Lou

Monthly, founded in 2005,
170 x 225 mm, French.
Editorial Office
Brussels
info@lou-mag.be
www.lou-mag.be
Staff
Editor-in-chief: Hélène

Mochi

Monthly, 195 x 273 mm,
30,000 copies, Free, French /
Flemish.
Editorial Office
Chaussée de Wavre, 1517
1160 Brussels
info@mochi.be
www.mochi.be
Staff
Editor-in-chief: Eric Rozen

Move-X

Monthly, 265 x 210 mm,
30,000 copies, Free, French /
Flemish.
Editorial Office
Generaal Wahislaan 224
1030 Brussels
www.move-x.com
Staff
Editor: Miel Vanschoenbeek
Publisher
PPMG
Avenue Général Wahis 224
1030 Brussels

Out Soon

Monthly, 170 x 243 mm, Free,
French / Flemish.
Editorial Office
Antwerp
www.outsoon.be
Staff
Editor-in-chief: Bart Vandormael
Art director: Stijn Van Nuffelen
Publisher
Bart Vandormael
Avenue Jean Jaurès 46B
1030 Brussels

Plastiks Magazine

243 x 278 mm, 4.90€, English.
Editorial Office
Durletstraat 2
2018 Antwerp
plastiks@pandora.be
www.plastiks.org
Staff
Editor-in-chief:
Groove Merchant
Publisher
Plastiks Magazine
Durletstraat 2
2018 Antwerp
Phone: +32 486 805 585
office@plastiks.be

Pulp

International Mediaguide
A reader's digest of the best in
current print/desktop publications
and other media.
Every two months (5x / year),
150 x 210 mm, 7 €, Flemish.
Editorial Office
Van Schoonbekestraat 61
2018 Antwerp
pulp.emmanuel&@pi.be
www.pulpwebsite.com
Staff
Publisher and Editor and
Creative director:
Emmanuelle Verheyden

Rifraf

Monthly, 240 x 330 mm, 30,000
copies, Free, French / Flemish.
Editorial Office
Kerkstraat 110
2060 Antwerp
www.rifraf.com
Publisher
B Z and T bvba

Sheap

Monthly, 210 x 264 mm, Free,
English.
Editorial Office
Brussels
Staff
Editor-in-chief:
Nikol De Ceukeleer
Art director: Turtle001
Publisher
Prime Projects nv
General Wahislaan 224
1030 Brussels

The Flink Paper

The Flink Paper strongly endorses
the spirit of collaboration, which
encourages creative minds and
contributors of varied disciplines
to exchange ideas and be part of
the bigger picture.
Founded in 2003, 380 x 580 mm,
English.
Editorial Office
De Burburestraat 20
2000 Antwerpen
info@flink.be
www.flink.be/flinkpaper/paper.html
Staff
Art director: Fanny Khoo

View

Photography Magazine
Quarterly, 240 x 300 mm, 7€,
English / French / Flemish.
Editorial Office
Po Box 131
1050 Brussels
info@viewmag.be
www.viewmag.be

Voxer

The Independent Voice
Monthly, 148 x 210 mm, 20,000
copies, Free, French / Flemish.
Editorial Office
49 av. du Roi
1060 Brussels
www.voxer.org
Staff
Publisher:
Pauline Van Rijckevorsel
Publisher
Pauline van Rijckevorsel
49 av. du Roi
1060 Brussels
pauline@voxer.org
www.voxer.org

Brazil

Avesso

The other side of fashion.
Quarterly, founded in 2006,
140 x 100 mm, Portuguese.
Editorial Office
avessozinedebolso@gmail.com
www.avessozinedebolso.blogspot
.com

Eleela

A smart, sexy magazine that
showcases incredible
international photographers.
Portuguese.
Editorial Office
Av. Brigadeiro Faria Lima,
2639 cj. 73
cep 01452-000 Sao Paulo
autumnsonnichsen@gmail.com
www.revistaeleela.com.br
Staff

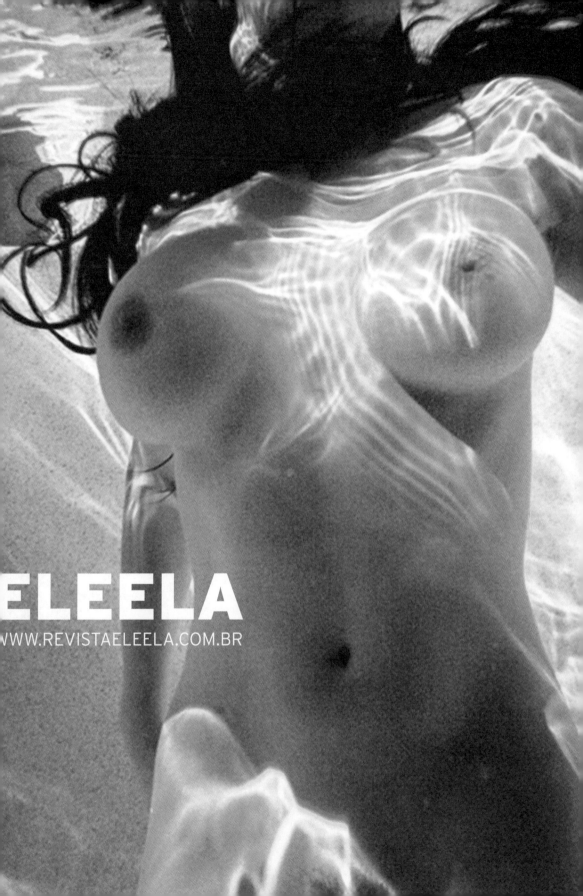

ELEELA
WWW.REVISTAELEELA.COM.BR

Editor-in-chief: Wagner Carelli
Art director: Noris Lima
Photography director:
Autumn Sonnichsen

L.u.m.i.e.r.e
access

Every two months, 230 x 275 mm,
R $10, Portuguese.
Editorial Office
Rua Ribeiro de Lima 282 14
Andar-Luz
01122-000 Sao Paulo
info@lumiereaccess.com.br
www.lumiereaccess.com.br
Staff
Director of advertising and
marketing: Geraldo Park
Editor-in-chief: Carol Delboni
Publisher
Marcos Park and Ronaldo
Gomez

s/n°

Bi-annual, 240 x 320 mm, 5,000
copies, R $20, Portuguese /
English.
Editorial Office
Avenida Mofarrej, 1200
05311-000 Sao Paulo
hyhara@hotmail.com
www.bobwolfenson.com.br
Staff
Editor-in-chief and Creative
director: Bob Wolfenson
Editor-in-chief and Creative
director: Hélio Hara
Publisher
Bob Wolfenson and Hélio Hara

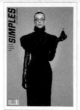

Simples
sociedade criativa

Every two months, 170 x 238 mm,
R $8, Brazilian.
Editorial Office
Sao Paulo
simples@revistasimples.net
www.revistasimples.com.br
Staff
Founder: Ale MC Falijone
Editor: Chico Lowndes
Editor-in-chief: Lara Crepaldi
Publisher
Wide Brand Experience
Rua Groenlandia 1819
CEP 01434- Sao Paulo

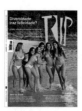

Trip

Combines interview, adventure,
non-conventional, sports, music
and journalism.
Monthly, 208 x 275 mm, 40,000
copies, R $8.90, Portuguese.
Editorial Office
Po Box 11485-5
CEP 05422-970 Sao Paulo, SP
trip@trip.com.br
revistatrip.uol.com.br

Tupigrafia

Founded in 2000, 160 x 224 mm,
R $35, Portuguese.
Editorial Office
Rua Gomes de Carvalho 1113B
CEP 04547-004 Sao Paulo
evendas@tupigrafia.com.br
www.tupigrafia.com.br
Staff
Claudio Rocha

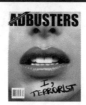

Canada

Adbusters

A not-for-profit magazine
concerned about the erosion of
our physical and cultural
environments by commercial
forces.
Every two months, founded in
1992, 230 x 272 mm, 120,000
copies, $7.95, English.
Editorial Office
1243 West 7th Ave
V6H 1B7 Vancouver
editor@adbusters.org
www.adbusters.org
Staff
Editor-in-chief: Kalle Lasn
Publisher
Abusters Media Foundation
1243 West 7th Avenue
V6H 1B7 Vancouver
Phone: +1 604 736 9401
Fax: +1 604 737 6021
info@adbusters.org
www.adbusters.org

Azure

Design Magazine
8x / year, founded in 1985, 241 x
330 mm, 28,606 copies, English.
Editorial Office
460 Richmond St. West,
Suite 601
ON M5V 1Y1 Toronto
www.azuremagazine.com
Staff
Editor: Susan

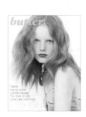

butter

A trend magazine and cultural
scrap book.
15,000 copies, Free, English.

Editorial Office
206-962 Jervis Street
V6E 2B9 Vancouver
info@mmmbutter.com
www.mmmbutter.com
Staff
Art director: Reanna Evoy
Editor: Ryan Roddy
Publisher and Creative director:
Kris Blizzard

C Magazine

Canada's premier magazine on
international contemporary art.
Quarterly, 7€, English.
Editorial Office
Po Box 5 Station B
M5T 2T2 Toronto
www.cmagazine.com
Staff
Editor: Rosemary Heather

Caustic Truths

English.
Editorial Office
152 Carlton Street
M5A 2KO Toronto
info@caustictruths.com
www.caustictruths.com

Cinema Sewer

Mixes comics, off-the-wall art,
and whip-smart writing dealing
with bizarre porn, horror, and
exploitation movies and the video
underground to bring the people
perfect toilet-time reading!
167 x 260 mm, $4, English.
Editorial Office
320-440 East 5th Ave.
V5T 1N5 Vancouver
mindseye100@hotmail.com
www.cinemasewer.com
Staff
Founder: Robin Bougie

Coupe
Atmosphere. Image, Art. Trash. All of it.
Coupe is the Vanguard visual culture magazine
Bi-annual, founded in 1999, Variable price, English.
Editorial Office
9 Davies Avenue, Suite 500
Toronto, Ontario
info@coupe-mag.com
www.coupe-mag.com
Staff
Founder: Bill Douglas

CV ciel variable
CV ciel variable aims to identify and examine leading practices and movements in contemporary artistic photography.
Quarterly, French / English.
Editorial Office
661 rue Rose-de-Lima
bureau 204
H4C 2L7 Montréal, Québec
info@cielvariable.ca
www.cielvariable.ca
Staff
Editor-in-chief: Jacques Doyon
Editor: Anaës Moroval

DayJob
Bi-annual, founded in 2002, CDN $6.95, English.
Editorial Office
600 Eglinton West
M5N 1C1 Toronto
contact@dayjobmagazine.com
www.dayjobmagazine.com
Staff
Grooming: Jodi Thibodeau
Editorial: Sean Forrest
Publisher and Creative director:

James Nixon
Publisher
Day Job Industries

Espace Sculpture
A magazine dedicated entirely to informing and educating the public on various topics relating to sculpture.
Quarterly, founded in 1987, CDN $8.50, French / English.
Editorial Office
4888 rue Saint-Denis
H2J 2L6 Montréal, Québec
espace@espace-sculpture.com
www.espace-sculpture.com
Staff
Editor-in-chief: Serge Fisette
Publisher
Le Centre de Diffusion 3D

esse
arts and opinions
Focuses on multidisciplinary and interdisciplinary practices, such as visual art, performance, video, urban music and dance, experimental theatre and all forms of social interventions, in situ or performance art.
Tri-Annual, founded in 1984, 1,400 copies, French.
Editorial Office
Po Box 56,
succ. de Lorimier
H2H 2N6 Montreal, Quebec
revue@esse.ca
www.esse.ca
Staff
Director: Sylvette Babin

ETC Montreal
Revue de l'art actuel
ETC Montreal is a contemporary art magazine which is internationally known due to its quality of writing and literary talent.
Quarterly, founded in 1987, French / English.
Editorial Office
1435 St-Alexandre bureau 250
H3A 2G4 T514-848 Montréal
Staff
Editor-in-chief: Isabelle Lelarge

herbivore
vegetarian culture
Quarterly, founded in 2003, 217 x 280 mm, CDN $6.95, English.
Editorial Office
5254 NE 32nd Place
OR 97211 Portland
herbivoreclothing.com
Staff
Editor: Josh Hooten
Editor: Michelle Schwegmann

HoBO Magazine
unf*ck the world
An original take of culture and avant-garde lifestyle magazine with fashion, travel, interviews, beautiful photos, essays, artsy and refined.
Occasionally published, founded in 2006, $20, English.
Editorial Office
7, 1214 West 7th Avenue
V6H 1B6 Vancouver BC
info@hobomagazine.com
www.hobomagazine.com

La Rampa
La Rampa is a large format folio of photography and travel. Published twice a year, featuring different international destinations and encompassing art, creativity and culture.
Bi-annual, $20, English.
Editorial Office
48 Falcon Street
ON M4S 2P5 Toronto
editor@la-rampa.com
www.la-rampa.com
Staff
Publisher: Gethin James
Editor-in-chief and Creative director: Chantal James
Publisher
La Rampa Publications Inc
48 Falcon Street
M4S 2PS Toronto
editor@la-rampa.com
www.la-rampa.com

Lush Magazine
Quarterly, 20,000 copies, CAN $12.95, English.
Editorial Office
25 Connell Court Suite 1
M8Z 1E8 Toronto
www.lushmag.com

Made Magazine
Independently produced art magazine / book.
Bi-annual, Variable format, 2,500 copies, $36, English.
Editorial Office
65 Water Street
V6B 1A1 Vancouver
michelle@mademag.com
www.mademag.com

Mix
Stunning pictures. Bold statements.
Monthly, 216 x 276 mm, English.
Editorial Office
401 Richmond Street West,
Suite 446
M5V 3A8 Toronto
editor@mixmagazine.com
www.mixmagazine.com

Modern Dog
The lifestyle magazine for urban dogs and their companions
English.
Editorial Office
Suite 202-342 Railway Str.
V6A 1A4 Vancouver
info@moderndogmagazine.com
www.moderndogmagazine.com
Staff
Editor-in-chief: Connie Wilson
Publisher
Modern Dog Inc.
Suite 202 - 342 Railway St.
V6A 1A4 Vancouver
info@moderndogmagazine.com
www.moderndogmagazine.com

Nuvo
Showcasing the finest writing,
photography, illustration, design
and production values.
Quarterly, founded in 1998,
50,000 copies, English.
Editorial Office
3055 Kingsway
BC V5R 5J8 Vancouver
comments@nuvomagazine.com
www.nuvomagazine.com
Staff
Founder and Publisher:
Pasquale Cusano
Editor: Jim Tobler

Prefix Photo
Prefix Photo is an engaging
magazine dedicated to fostering
the appreciation and understanding
of contemporary photographic,
digital and related arts.

Bi-annual, founded in 2000,
229 x 267 mm, CDN $18,
English / French.
Editorial Office
124-401 Richmond St. W.
Suite 124
M5V 3A8 Toronto
info@prefix.ca
www.prefix.ca
Staff
Founder and Publisher:
Scott McLeod
Publisher
Prefix Institute of Contemporary
Art
Suite 124,
Richmond Street West, Box 117
M5V 3A8 Toronta, Ontario
Phone: 416 591 0357
info@prefix.ca
www.prefix.ca

Seed
Beneath the Surface
205 x 275 mm, $4.95, English.
Editorial Office
206 rue de l'Hôpital
H2Y 1V8 Montreal
www.seedmagazine.com
Staff
Editor-in-chief: Adam Bly
Publisher
Seed Group
1 Place Ville Marie,
Suite 2821
H3B 4R4 Montreal
marketing@seedmagazine.com
www.seedmagazine.com

This Magazine
Every two months, founded in
1966, English.
Editorial Office
401 Richmont Street W. 396
M5V 3A8 Toronto
info@thismagazine.ca
www.thismagazine.ca
Staff
Editor: Emily Schultz
Publisher: Lisa Whittington-Hill

Toro Magazine
Canada's Magazine for Men
Presenting a compelling range of
topics, including sports,
entertainment, health, fashion,
food, travel, grooming, gear, and,
of course, women, *Toro* quickly
established itself as the ultimate
destination for the discerning
Canadian male.
8x / year, founded in 2003,
English.
Editorial Office
119 Spadina Avenue,
Suite 502
M5V 2L1 Toronto
info@toromagazine.ca
www.toromagazine.ca
Staff
Editor: Derek Finkle
Publisher: Dinah Quattrin
Creative director:
Cameron Williamson
Sales and Marketing Director:
Alicia Skalin
Publisher
Toro Publishing Inc.
119 Spadina Avenue,
Suite 502
ON M5V 2L1 Toronto
info@toromagazine.ca
www.toromagazine.ca

Warrior Magazine
Supersedes the inherently
disposable nature of the
contemporary magazine and
presents an alternative to the
ersatz writing ubiquitous in the
current market.
Quarterly, English.
Editorial Office
15 Mont-Royal West #110
Qc. H2T 2R9 Montreal
info@warriormagazine.org
www.warriormagazine.org

Chile

blank
Monthly (11x / year), founded in
2001, 217 x 280 mm, 10,000
copies, Spanish.
Editorial Office
La Pastora 138 of. d
7550141 Las Condes – Santiago
pminano@blank.cl
www.blank.cl
Staff
Directore de arte: Paula Germain
Director: Patricio Minano

Vanidades
Monthly, founded in 1992,
225 x 295 mm, Spanish.
Editorial Office
Rosario Norte 555,
Piso 18,
Las Condes
93.585.000-2 Santiago
vanidades@televisa.cl
www.televisa.cl

China

(tofu)-magazine
Founded in 1999, 195 x 220 mm,
Chinese / English / French.
Editorial Office
Po Box no 9736
Hong Kong
editor@tofu-magazine.com
www.tofu-magazine.net

chalk
Youth Culture Magazine
Founded in 1999.
Editorial Office
Hong Kong
www.shift.jp.org/chalk

City Life
210 x 297 mm, Japanese / English.
Editorial Office
79-85 Bonham Strand East,
Sheung Wan
Hong Kong
Staff
Publisher and Editor-in-chief:
Patrik Cheung
Editor: Rory Boland

LIKE NOTHING

Cream

"A Brand New Reading Experience for Every Season Starts from Here..."
Quarterly, founded in 2002, Variable price, 5,000 copies, English.
Editorial Office
9/F, Zung Fu Industrial Building, King's Road, Quarry Bay 1067, Hong Kong
editorial@creammagazine.com.hk
www.creammagazine.com.hk
Staff
Founder: Takara Mak
Editor-in-chief: Irene Leung
Marketing executive: Eric Chan
Publisher
Media Nature Limited
9/F Zung Fu Industrial Building, King's Road, Quarry Bay 1067, Hong Kong
Phone: +852 3120 3018
Fax: +852 3120 3028

IdN
International Designers Network
Bringing cutting-edge design information to our sophisticated readers.
Every two months, founded in 1992, 235 x 297 mm, 93,410 copies, $15, English / Chinese / Japanese.
Editorial Office
Shop C, 5-9 Gresson St., Wan Chai
info@idnworld.com
www.idnworld.com
Staff

Editor: Bill Cranfield
Director: Chris Ng
Publisher
Systems Design Ltd
Shop C, 5-9 Gresson Street, Wan Chai
Hong Kong
Phone: +852 2528 5744
Fax: +852 2529 1296
www.idnworld.com

Plugzine

Plugzine is a contemporary visual culture bookazine
Annual, 190 x 265 mm, 2,000 copies, $35, English / Chinese.
Editorial Office
Rm 13-2803, No.39, Jian Wai SOHO, East 3d Ring Rd.Chaoyang District
100022 Beijing
joynviscom@163.com
www.plugzine.com
Staff
Editor-in-chief and Art director: Jian Jiang

Time Out Beijing
Monthly, 205 x 272 mm, English.
Editorial Office
2 Jiuxianqiao
100015 Chaoyang Beijing
info@cimgchina.com
Publisher
Time Out Group Ltd.

WestEast
West fuses with east. East meets west. *W.E.* is a new breed of Style culture/design boutique magazine that brings the best of the two worlds together.
Editorial Office

802 Winsome House,
73 Windham Street
Central, Hong Kong
contributor@westeastmag.com
westeastmag.com

Colombia

Iconia
Spanish / English.
Editorial Office
Carrera 51 No.
103B-48 Bogota
worldwide@iconiagroup.com
www.iconiamoda.com
Staff
Director and Editor-in-chief: Andres Rodriguez Villarreal
Production director: Javier Camacho
Design director print edition: Ana Lalinde
Publisher
Iconia Group

Czech Republic

Grapheion
International review of contemporary prints, book and paper art
Annual, founded in 1996, 210 x 297 mm, 1,300 copies, 14€, Czech / English.
Editorial Office
Melantrichova 5
110 00 Prague
galerie@mbox.vol.cz
www.grapheion.cz
Staff
Editor-in-chief: Rachel de Candole
Editor-in-chief: Rachel Thompson
Editor-in-chief: PhDr. Simeona Ho'ková

Typo
Magazine on typography, graphic design and visual communication.
Every two months, founded in 2003, 250 x 310 mm, Czech / English.
Editorial Office
Sazecska 560/8
108 25 Prague 10 Malesice
redakce@magtypo.cz
www.magtypo.cz
Staff
Editor: Filip Blazek
Publisher
Vydavatelství Svt tisku, spol. s r. o.
Sazecska 560/8
108 25 Pra Malesice
Phone: +420 271 733 554
Fax: +420 272 736 252
redakce@magtypo.cz
www.magtypo.cz

Umelec International
contemporary art and culture
Devoted to current visual culture in the Czech Republic.
Every two months, founded in 1997, 220 x 315 mm, 4,000 copies, Czech / English / German.
Editorial Office
Borivojova 49
130 00 Prague
umelec@divus.cz
www.divus.cz
Staff
Editor-in-chief: Jiri Ptacek
English editor: William Hollister

EAST
IS THE
NEW
WEST

B EAST

FASHION / ATTITUDE / £1.03ers FOR THE NEW EUROPE / ISSUE 4
WWW.BEASTNATION.COM

ROMANIA

THE NEW EUROPE'S
PROVOCATIVE FASHION AND
ATTITUDE GLOSSY

Denmark

Ajour
manedsmagasinet
Monthly, founded in 1991,
265 x 360 mm, Danish.
Editorial Office
Mejlgade 28B
8000 Aarhus
Staff
Editor-in-chief: Michael Arreboe

Boom Boom
Founded in 2006, 10,000
copies, Danish.
Editorial Office
Westend 13 A
1661 Copenhagen V
sekretariat@dup.nu
www.dup.nu
Publisher
DUP
Westend 13 A
1661 Copenhagen V
sekretariat@dup.nu
www.dup.nu

COVER
Danish.
Editorial Office
Læderstræde 34, 1. sal
1201 Copenhagen
direct@cover.dk
www.cover.dk
Staff
Editor-in-chief:
Frederik Bjerregaard
Art director: Anne Strandfelt
Art director: Julie Lysbo
Creative director: Rick Shaine
Fashion director: Katrine Agger

Publisher: Malene Malling
Publisher
Malling Publications

Dansk
Dansk is the first fashion
magazine with Danish origin to
achieve international recognition.
Quarterly, founded in 2002,
DKK 90, 20,000 copies, English.
Editorial Office
Hojbro Plads 15
1200 Copenhagen
rm@danskmagazine.com
www.danskmagazine.com
Staff
Editor-in-chief: Rachael Morgan
Publisher
Style Counsel
www.stylecounsel.dk

Katalog
**Journal of photography and
video**
Quarterly, founded in 1988,
240 x 320 mm, English / Danish.
Editorial Office
Brandts Passage 37 and 43
5000 Odense
katalog@wettendorff.dk
www.brandts.dk/katalog
Staff
Editor-in-chief: Henning Wettendorff

Luksus Freestyle Magazine
**Denmark's largest magazine
about outdoor, adventure
and street culture.**
8x / year, founded in 2002,
223 x 285 mm, 16,000 copies,
Free, Danish.

Editorial Office
Esromgade 15, opg 1, st
2200 Copenhagen N
monrad@luksusmag.dk
www.luksusmag.dk

Øjeblikket
Quarterly, founded in 1991,
230 x 297 mm, English / Danish.
Editorial Office
Victoriagade 24, 2
1655 Copenhagen
oe@culture.com
Staff
Editor-in-chief: Katya Sander

Revolve
Revolve is an independent and
cutting-edge lifestyle magazine.
Quarterly, 198 x 264 mm, 9€.
Editorial Office
Prinsessegade 50
1422 Copenhagen
Staff
Co-visual editor:
Helena Christensen
Visual editor: Mikkel Mo Tang
Editor-in-chief:
Mikkel Mo Brogger
Features editor: Ben Holst

romeo + juliet
**The leading danish lifestyle
and fashion magazine for
men and women**
Monthly, 223 x 297 mm, Danish.
Editorial Office
Roskilde
info@iggy.dk
www.iggy.dk
Staff
Editor-in-chief: Anders Hjort

S Magazine
S Magazine presents only the
créme de la créme of erotic
fashion photography for the
more discerning voyeur.
Bi-annual, 230 x 297 mm,
30,000 copies, 14€, English.

Editorial Office
Nygade 4, 1th
1164 Copenhagen
info@spublication.com
www.spublication.com
Staff
Editor-in-chief: Jens Stoltze
Editorial director: Martin
Tradsborg Christophersen

Vs
Large format fashion magazine
Bi-annual, English / Danish /
Swedish / Norwegian.
Editorial Office
Nygade 3, 2.sal
1164 Copenhagen
info@vspublications.com
www.vspublications.com
Staff
Editor-in-chief:
Jakob Forup Stubkjaer

Ecuador

bg magazine
Editorial Office
Av. ordoÉez lazo,
edif. pinar del lago II, piso 5
Po Box 0101089
bg@bgmagazine.com.ec
www.bgmagazine.com.ec

Tomala
The work of Latin American
artists and designers.
Founded in 2003, 500 copies.
Editorial Office
Av. V.E. Estrada 603 y Las
Monja, piso 2, Urdes Guayaquil
Staff
Creative director and Editor:
Jaime Nunez del Arco
Design and Art direction:
Isabel Marmol

S MAGAZINE

Estonia

B East
Fashion / CULTure / Attitude
B East Magazine is the vibrant
New Europe's provocative
lifestyle and fashion glossy.
Quarterly, founded in 2005,
240 x 310 mm, 30,000 copies,
150 CZK, English.
Editorial Office
Pikk 50, #3
10133 Tallinn
beastmag@mac.com
www.beastnation.com
Staff
Publisher: Vijai Maheshwari

Finland

Arttu!
The world of designers and
design, audiovisual communication,
art education and research.
Quarterly, 240 x 320 mm,
5,000-8,000 copies, 5€, Finnish /
English.
Editorial Office
Hämeentie 135 C
00560 Helsinki
info@uiah.fi
www.uiah.fi
Publisher
University of Art and Design
Helsinki

Bulgaria
Todella hyvä lehti
Founded in 2000, 210 x 270 mm,
10,000 copies, English.
Editorial Office

Hämeentie 2 B C51
00530 Helsinki
tom@bulgariamagazine.com
www.bulgariamagazine.com
Staff
Editor-in-chief: Tom Bulgaria
Creative director:
Jesper Bange
Creative director:
Sampo Hänninen
Creative director:
Juha Murremäki
Creative director:
Jarno Luotonen
PR and Marketing:
Mikko "Champagne" Rapila
Publisher
Bulgaria Design Ltd.
Hämeentie 2 B C 51
00530 Helsinki
Phone: +358 50 303 7510

framework
Dedicated to contemporary art
and culture.
Bi-annual, founded in 2004,
240 x 340 mm, 7€, English.
Editorial Office
Merimiehenkatu 36,
D 527 5th floor
00150 Helsinki
office@framework.fi
www.framework.fi
Staff
Editorial director:
Marketta Seppälä
Graphic design: Patrik Söderlund
Publisher
Frame Finnish Fund for Art
Exchange
Merimiehenkatu 36,
D 527 5th floor
00150 Helsinki
Phone: +385 0 9 612 64 20
info@frame-fund.fi
www.frame-fund.fi

Kasino A4
**Style, Thought, People and
Tails**
Timeless themes, quality
photography and insightful
writing are fused together by a
strict layout and a fresh attitude.
Bi-annual, founded in 2005,
210 x 297 mm, 4,000 copies, 6€,
English.
Editorial Office
Siltasaarenkatu 15,
53 Helsinki
KasinoA4@WeAreKasino.com
WeAreKasino.com
Staff
Photographer: Jussi Puikkonen
Editor: Jonathan Mander
Art direction: Pekka Toivonen
Communications: Antti Routto
Publisher
WeAreKasino cooperative

PàPMagazine
PàPMagazine is a new international
"Fashion Bible". It is a tool for
professionals to understand new
aspects of world of fashion, and
current social issues.
Every two months, founded in
2001, 210 x 285 mm, English.
Editorial Office
Helsinki
Staff
Editor-in-chief and Creative
director: Tiina Alvesalo
Publisher
Oy Modabox Ltd
Pohjolnen Makaslinikatu 6
00130 Helsinki
Phone: +358 0 9 612 7770
Fax: +358 0 9 612 7771
contact@papmagazine.com

Ptah
Bi-annual, 200 x 270 mm,
English / Finnish.
Editorial Office
Tiilimäki 20
00330 Helsinki
ptah@alavaraalto.fl

www.alvaraalto.fl/academy/ptah/
index.htm
Staff
Editor-in-chief: Esa Laaksonen
Publisher
The Alvar Aalto Academy

France

:éc/art S:
**[pratiques artistiques and
nouvelles technologies]**
Annual, founded in 1999,
245 x 265 mm, French.
Editorial Office
13 rue Brison
42300 Roanne
www.ecarts.org
Staff
Editor-in-chief: Eric Sadin

°Twill
A toast to the future
230 x 310 mm, 18€, French /
English / Italian.
Editorial Office
130 rue de Turenne
75003 Paris
twill-paris@wanadoo.fr
www.twill.info
Staff
Publisher and Editor-in-chief:
Fosco Bianchetti

9 / 9
Revue d'Art Plastique
9 / 9 is a kind of card carrier,
containing works and
interventions of artists, designers,
stylists, musicians. These works
have the form of user manuals,
recipes, games, missions, etc.
Quarterly, founded in 1998,
215 x 305 mm, 10.55€, French.
Editorial Office
49 rue Berthe
75018 Paris
Staff
Editor-in-chief: Stéphane Argillet

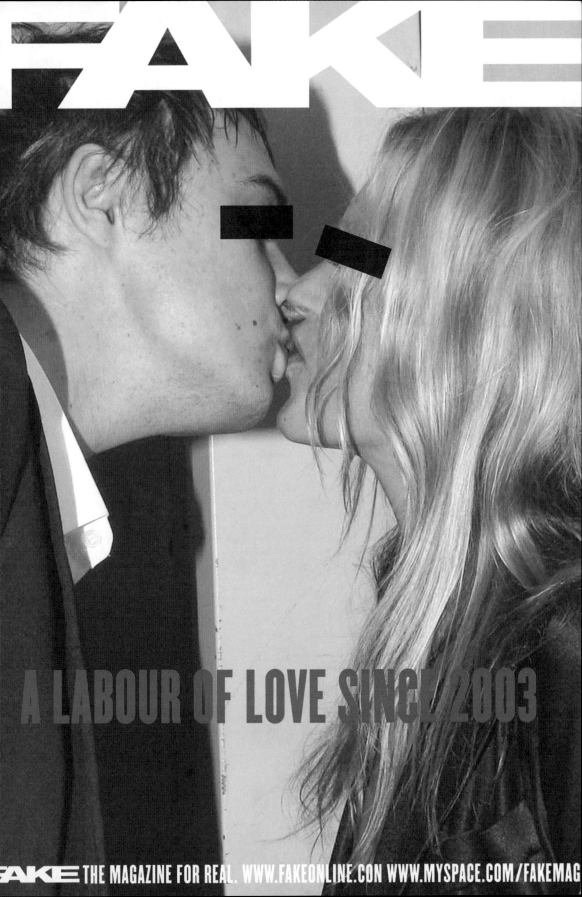

AD France
**Architectural Digest,
Architecture, Décoration,
Arts, Design**
Every two months, 213 x 275 mm,
5€, French.
Editorial Office
27 rue de la ville-l'Evêque
75008 Paris
Staff
Editor-in-chief:
Marie-Clémence Barbé-Conti
Creative director:
Angelica Steudel
Publisher
Condé Nast Publications
Piazza Castellano 27
20121 Milan
Italy
Phone: +39 02 856 11
Fax: +39 02 805 57 61

AE
aspire and emerge
Aspire and Emerge is, at once, a
creative platform for emergent
artists to communicate their work
and a source through which
emergent art is rendered
accessible to everyone. The
scope of the magazine is global.
Founded in 2005, 5€, English.
Editorial Office
editor@ae-magazine.com
www.ae-magazine.com
Staff
Editor: Don Duncan
Literary editor: Sarah Rigaud
Visual arts editor: Peter Joseph

Agenda
**News-Agenda Paris
jour par jour**
Founded in 2002, 200 x 260 mm,
50,000 copies, Free, French /
English.
Editorial Office
Paris
info@ofrpublications.com
www.ofrpublications.com
Staff
Publisher: Alexandre Thumerelle
Art director: Sophie Toporkoff
Editor-in-chief:
Sophie Berbar-Sollier
Publisher
OFR Publications
30 rue Beaurepaire
75010 Paris

Amaan
**The subversive avant-garde
of international luxury
magazine**
Offers its readers an artistic
vision, which is both subversive
and avant-garde.
Quarterly, English.
Editorial Office
12/14 Rond Point Des Champs
Elysées
75008 Paris
www.amaanmagazine.com
Staff
Publisher: Paul Steinitz
Executive manager:
Franck-Grégory Chaze

Anna Sanders
Founded in 1997, Free.
Editorial Office
113 Boulevard Richard Lenoir
75011 Paris
asf@annasandersfilms.com
www.annasandersfilms.com
Staff
Publisher: Pierre Huyghe
Publisher: Philippe Parreno
Creative director: Lili Fleury

Anomalie
Digital'arts
Digital Performance
International magazine about arts
and new technologies published
as a collection of thematic and
collective works.
Founded in 2002, French /
English / Italian.
Editorial Office
12-14 rue Léchevin
75011 Paris
anomos@anomos.org
www.anomos.org
Publisher
Anomos
12-14, rue Léchevin
75011 Paris
Phone: +33 1 43 66 15 90
Fax: +33 1 48 06 06 12
anomos@anomos.org
www.anomos.org

Antijour
Nightlife fanzine 3€, French.
Editorial Office
74 rue du Fg St Denis -
75010 Paris
Antijour@goldrushcrew.com
www.antijour.com

Area revue)s(
Creativity regardless of the
trends and market.
Quarterly, founded in 2002,
210 x 280 mm, 20€, French.
Editorial Office
50 rue d'Hauteville
75010 Paris
larevue@areaparis.com
www.areaparis.com
Staff
Editor-in-chief: Alin Avila

art 21
Quarterly, founded in 2005,
French.
Editorial Office
363b rue des Pyrénées
75020 Paris
frederic.wecker@art21.fr
www.art21.fr

art actuel
**Le Magazine des Arts
Contemporains**
Every two months, 220 x 280 mm,
5.90€, French.
Editorial Office
44 Avenue George 5
75008 Paris
mail@artactuel.info
www.artactuel.info
Staff
Editor-in-chief:
Jean-Pierre Frimbois
Director: Gilles Barissat
Art director: Vincent Le Bée
Publisher
Artoday sarl

Art présence
Quarterly, founded in 1985,
200 x 260 mm, 10€, French.
Editorial Office
4 rue des clos Grimault
22370 Pléneuf-Val-André
art.presence@wanadoo.fr
Staff
Editor-in-chief: Ghislaine Trividic
Publisher
Editions Alpa
4 rue de l'Hotel des Landes
22370 Pléneuf-Val-André
Phone: +33 0 2 96 72 99 85

art press
La revue d'art contemporain
Monthly, founded in 1972,
240 x 300 mm, 5€, French /
English.
Editorial Office
8 rue François Villon
75015 Paris
servicelecteurs@artpress.fr
www.artpress.com

WELCOME TO THE WORLD OF LE BOOK 2007

THE INTERNATIONAL
REFERENCE FOR
FASHION, BEAUTY,
PHOTOGRAPHY,
LUXURY, ADVERTISING,
GRAPHIC DESIGN,
PRODUCTION AND EVENTS.

Art by Jean-Paul Goude • Art Direction Claudio dell'Olio

paris
new york
london

www.lebook.com

ALAÏA

Staff
Editor-in-chief: Catherine Millet
Publisher
art press sarl
1 rue Robert Bichet
59440 Avesnelles
Phone: +33 01 53 68 65 65
Fax: +44 20 7813 6001
m.baaziz@artpress.fr
www.artpress.com

Art Sud
Les nuances culturelles de l'autre hémisphère
Quarterly, founded in 1986,
210 x 280 mm, 6€, French.
Editorial Office
200, avenue de coulin
13420 Gemenos Marseille
Staff
Editor-in-chief:
Salvator Lombardo

attitude
Sports and Société
3.90€, French.
Editorial Office
Paris
attituderugby@wanadoo.fr
Staff
Directrice de la publication:
Hélène Gaudin
Rédacteur en chef: Michel Briot

bag
Beautiful Address Guide
Shopping magazine
Quarterly, 5€, French.
Editorial Office
30 rue Saint Marc
75 002 Paris
contact@bag-magazine.com
www.bag-magazine.com

BAM
Beaux-Arts Magazine
220 x 290 mm, French.
Editorial Office
Tour Montparnasse,
33 avenue du Maine
75755 cedex 15 Paris
courrier@beauxartsmagazine.com
www.beauxartsmagazine.com
Staff
Editor-in-chief: Fabrice Bousteau
Publisher and Managing editor:
Thierry Taittinger
Director: Fabrice Bousteau
Publisher

TTM Editions
86/88 rue Thiers
92100 Boulogne
Phone: +33 01 41 41 55 60
Fax: +33 01 41 41 98 35

BANG!
Le Meilleur de la BD
Quarterly, founded in 2005,
230 x 300 mm, 7.50€, French.
Editorial Office
144 rue de Rivoli
75001 Paris
Staff
Editor-in-chief: Vincent Bernière
Publisher
Les Editions Indépendantes SA
144 rue du Rivoli
75001 Paris

Bestiaire
Animal Politik Magazine – culture urbaine
Irregularly published, 208 x 270
mm, 15,000 copies, Free, French.
Editorial Office
publication@bestiairemag.com
www.bestiairemag.com
Staff
Publisher and Editor-in-chief:
Olivier Braizat
Editor-in-chief: Mounir Salmi

Biba
Monthly, 216 x 280 mm, 1.80€,
French.
Editorial Office
1 rue Colonel-Pierre-Avia
75503 Paris Cedex 15
redac-chef.biba@ emapfrance.com
www.bibamagazine.fr
Staff
Editor-in-chief: Christine Leiritz
Director: Bruno Gosset
Fashion director:
Catherine Laroche
Publisher
Mondadori
contact@mondadori.fr
www.mondadori.fr

Bil Bo K
Magazines des errances contemporaines
Every two months, founded in
1995, Variable format, 7€,
French / English.
Editorial Office
15 rue Martel
75010 Paris
bbk@noos.fr
www.bilbok.com
Staff
Editor-in-chief and Creative
director: Philippe Blondez
Publisher
BILBOK

Blackpool
Street culture, lifestyle, fashion,
music, skateboard, world, graphic
layouts, unserious, no limit,
independent.
Quarterly, founded in 2005,
20,000 copies, 5€.
Editorial Office
63 bis rue du Cardinal Lemoine
75005 Paris
blackpoolmagazine@hotmail.com
www.blackpoolmagazine.com

Blast
Quarterly, 232 x 280 mm, 5€,
French.
Editorial Office
69 rue des Gravilliers
75003 Paris
contact@blast.fr
www.blast.fr
Staff
Editor-in-chief: Julien Millanvoye
Creative troublemaker:
Michel Mallard
Managing editor:
Frédéric Joignot
Publisher: Philippe Combres
Publisher
ICI Editions
58 rue Charlot
75003 Paris
Phone: +33 01 42 78 78 70
Fax: +33 01 48 87 73 56
www.blast.fr

Bloom

Magazine announcing a horti-cultural view of trends in flowers, plants and gardening for the public and professionals alike.
Bi-annual, English.
Editorial Office
L'Usine, 30 blvd St-Jacques
75014 Paris
www.edelkoort.com

C & G

Concept and Graphisme
Quarterly, 270 x 355 mm, 6€, French.
Editorial Office
95 rue La Boétie
75008 Paris
artchallenge@wanadoo.fr
Staff
Fashion and Beauty editor and Creative director:
Catherine Rochette
Editor manager: Philippe Amaro
Editor manager: Gérard Prévost
Publisher
Art Challenge Edition
95 rue La Boétie
75008 Paris
Phone: +33 01 48 46 46 56
artchallenge@wanadoo.fr

Challenges

Weekly, founded in 2005,
200 x 265 mm, 1.80€, French.
Editorial Office
33 rue Vivienne
75002 Paris
redaction@challenges.fr
Staff
Editor-in-chief:
Brigitte Gry-Régent
Editor-in-chief:

Pierre-Henri de Menthon
Publisher
Editions Croque Futur Sarl
10-12 Place de la Bourse
75002 Paris

Checkpoint

Review of art and contemporary reflection
Annual, founded in 2006,
297 x 420 mm, 2,000 copies, 8€,
Arabic / French.
Editorial Office
11 villa Saint Ange
75017 Paris
mariannederrien@laplateforme.net
www.revuecheckpoint.fr
Staff
Founder: Djamel Kokene
Publisher
LAPLATEFORME Editions
11, villa Saint Ange
75017 Paris

chronic'art

Monthly, founded in 2001,
French.
Editorial Office
19, rue Beranger
75003 Paris
info@chronicart.com
www.chronicart.com

Citizen K International

Quarterly, 240 x 295 mm,
Variable price, French.
Editorial Office
104 rue de la Folie Méricourt
75 011 Paris
Staff
Editor-in-chief: Vincent Bergerat
Founder and Creative director:
Kappauf
Publisher
BMJ Ltd
16 Old Bailey
London EC4M 7EG
United Kingdom

clam

Local everywhere
Bi-annual, founded in 1999.
Editorial Office
15 av. Jean Jaurès
75019 Paris
info@clammag.com
www.clammag.com
Staff
Creative director and fashion director: Andy Okoroafor
Editor-in-chief: Vanessa Coquet
Publisher
Clam sarl, Paris
Phone: +33 1 404 09 07
Fax: +33 1 404 09 14
andy@clammag.com

Clara Clara

Art and Cinema Magazine
Founded in 2006, 4€, French.
Editorial Office
22 rue de la Chapelle
75018 Paris
claraclara@free.fr
claraclara.free.fr
Staff
Graphics: Aline Girard
Artist: Clément Rodzielski

Clark

Street cultures-graphisme-musique
Every two months, founded in 2001, 4.50€, 35,000 copies, French.
Editorial Office
Po Box 143
75523 cedex 11 Paris
infos@clarkmagazine.com
www.clarkmagazine.com
Staff
Publisher: Guillaume Le Goff

Code d'accès

Le bookzine des tendances
Bi-annual, founded in 2005, 20€,
French.
Editorial Office
17-19 rue des Jeëneurs
75002 Paris
info@factoryeditions.com
www.code-acces.com
Publisher
Factoy Editions
17-19 rue des Jeëneurs
75002 Paris
info@factoryeditions.com
www.code-acces.com

Coming Up

Urban Guide: fashion / music / arts / sports and hang out
Quarterly, founded in 2002, 5€,
15,000 copies, French / English.
Editorial Office
26 Bd Notre Dame
13006 Marseille
redac@comingup.net
www.comingup.net
Staff
Editor-in-chief and Managing director: Eric Foucher
Publisher
Pimp Style sarl
Marseille

Computer Arts

2D / 3D / PAO / Video / Webdesign
Monthly, 7.50€, French.
Editorial Office
Paris
Staff
Art director: Nicolas Cany
Editor-in-chief:
Stéphanie Guillaume

Publisher
Future France
101-109 rue Jean Jaurès
92300 Levallois-Perret

crash
Mode / Style / Beauty / Art /
Music / Design / Food / Ideas
Monthly, 5€, French / English.
Editorial Office
257 rue Saint Honoré
75001 Paris
daniel@crash.fr
www.crash.fr
Staff
Creative director: Frank Perrin
Editor-in-chief: Armelle Leturcq
Publisher
Crash Production sarl
257 rue Saint Honoré
75001 Paris
Phone: +33 01 43 45 74 61
Fax: +33 01 43 45 76 87
www.crash.fr

Cultures
Le magazines des cultures
populaires
Monthly, founded in 2005,
3.90€, French.
Editorial Office
joel@cultures.com
www.culturesmag.com

de l'air
Reportages d'un monde
à l'autre
Monthly, 4.40€, French.
Editorial Office
23 avenue Jean Moulin
75014 Paris
medina@delair.fr
Staff
Editor-in-chief: Stéphane Brasca
General coordination:
Caroline Bourrus
Art director: Willima Hessel
Publisher
Médina sarl
23, avenue Jean Moulin
75014 Paris
Phone: +33 1 40 05 06 69
Fax: +33 1 40 05 19 56
cbourrus@delair.fr

DEdiCate
Un autre regard sur les
passions modernes
Founded in 2002, 5€,
40,000 copies, French.
Editorial Office
29 rue des petites écuries
75010 Paris
dedicateredaction@hotmail.com
www.dedicatemagazine.com
Staff
Founder and Publisher:
Olivier Bouché
Art director associate:
Benjamin Savignac
Publisher
DEdiCate publishing
45/47 rue des Petites Ecuries
75010 Paris
Phone: +33 1 48 01 65 50
Fax: +33 1 48 01 65 53
www.dedicatemagazine.com

divine
Monthly (10x / year), founded in
1999, French.
Staff
Director: Christophe Wagnies
Editor-in-chief: Karine Saporo
Publisher
IPC
9 rue de l'étoile
75017 Paris

Dong
Fashion Fanzine
Bi-annual, 9€, 3,000 copies,
French / English/ German.
Editorial Office
30, rue du doc. Potain
75019 Paris
nicole@dongmag.de
www.dongmag.de
Staff
Publisher and Editor-in-chief:
Nicole Hardt
Editor-in-chief: Axl Jansen
Advertising: Richard Blaumilch

Double
Quarterly, 5€, French / English.
Editorial Office
4 rue du Vertibois
75003 Paris
info@lemagazinedouble.com
www.lemagazinedouble.com
Staff
Fashion director:
Alexandra Elbim

Editor-in-chief: Vincent Bernière
Art and Editorial director:
Arnaud Pyvka
Editor: Christophe Wagnies
Publisher
All Publishing French
4 rue du Vertbois
75003 Paris
Phone: +33 1 44 64 06 40
Fax: +33 1 44 64 06 41
info@lemagazinedouble.com
www.lemagazinedouble.com

DS
Le premier féminin de société
Monthly, 1.80€, French / English.
Editorial Office
18-24 Quai de la marne
75 164 Paris
redaction.ds@groupe-
ayache.com
www.ds-magazine.com
Publisher
Groupe Alain Ayache
5 rue du Cirque
75 164 Paris cedex 19
Phone: +33 1 1 44 84 85 21
www.groupe-ayache.com

D-Side
L'actualité musicale et
culturelle Underground
Every two months, 7€, French.
Editorial Office
3 bis rue Pasteur
94270 Le Kremlin-Bicétre
www.d-side.org
Staff
Editor-in-chief: Guillaume Michel
Art director: Le Diese
Publisher
Edicide Publications Sarl
26 rue des Gravillers
75003 Paris

Dutch

Every two months, founded in
1995, English.
Editorial Office
2 rue de la Roquette,
Passage du Cheval Blanc
75011 Paris
dutchparis@artview.nl
www.dutch.sqr.nl
Staff
Editor-in-chief and Publisher:
Sandor Lubbe
Executive editor and Fashion and
Beauty: Rebecca Voight
Fashion director: Joanne Blades
Publisher
Art View bv
Po Box 94300
1090 GH Amsterdam
Netherlands
Phone: +31 0 20 597 95 00
Fax: +33 0 1 49 29 72 71
infi@artview.nl

Edgar

**Le premier magazine du luxe
au masculin**
Every two months, 4€, French.
Editorial Office
LuxmediaGroup-EDGAR /
06400 Cannes
Staff
Editor-in-chief:
Isabelle Garnerone
Publisher: Michel Karsenti
Art director: Emmanuelle Vella
Publisher
Lux Media Group

Egoïste

15€, French.
Editorial Office
1 rue Madame
75006 Paris
journalegoiste@noos.fr
Staff
Art director: Philippe Morillon
Founder: Nicole Wisniak
Publisher
Editions Cassini
Paris
Phone: + 33 01 45 49 00 85
Fax: +3301 45 49 95 41
www.cassini.fr

encens

Bi-annual, 95€, 20,000 copies,
English / French.
Editorial Office
26 rue Henri Martin
51200 Epernay
mail@encensrevue.com
www.encen
Staff
Creative director and Publisher:
Samuel Drira
Creative director and Publisher:
Sybille Walter

Enville

**City Magazine pour urbains
curieux**
Monthly, founded in 2005, Free,
150,000 copies, French.
Editorial Office
20 rue de Billancourt
92100 Boulogne-Billancourt
redaction@enville.fr
Staff
Editor-in-chief: Fanny Triboulet
Director: Stephane Brasca
Publisher
Urban France sarl
171ter Avenue Charles-de-Gaulle
92100 Neuilly-sur-Seine

étapes graphiques

**graphisme design image
création**
Monthly, founded in 1994,
French.
Editorial Office
15 rue de Turbigo
75002 Paris
www.etapes.com
Staff
Editor-in-chief and Art director:
Michel Chanaud
Deputy editor: Etienne Hervy
Deputy editor: Vanina Pinter
Publisher
Pyramyd NTCV
15 rue de Turbigo
75002 Paris

étapes: international

Quarterly, founded in 2004,
212 x 275 mm, 10.70€, English.
Editorial Office
15 rue de Turbigo
75002 Paris
www.etapes-international.com
Staff
Editor-in-chief and Art director:
Michel Chanaud
Deputy editor: Vanina Pinter
Deputy editor: Etienne Hervy
Publisher
Pyramyd NTCV
15 rue de Turbigo
75002 Paris

Exposé

**Revue d'esthétique et d'art
contemporain**
230 x 290 mm, French.
Editorial Office
Orléans
ecyriaque@editions-hyx.com
www.editions-hyx.com
Publisher
Editions HYX
1 rue du Taureau
45000 Orléans
Phone: +33 02 38 42 03 26
Fax: +33 02 38 42 03 25
contact@editions-hyx.com
www.editions-hyx.com

extrasmall

**pour que les petits voient
le monde + grand**
French.
Editorial Office
69 rue des Gravillers
75003 Paris
www.extrasmall.fr

French

Revue de Modes
Bi-annual, founded in 2005,
230 x 300 mm, 40,000 copies,
10€, English.
Editorial Office
3 Boulevard de Charonne
75011 Paris
contact@frenchrevue.com
www.frenchrevue.com
Staff
Editor-at-large: Lisa Tucker
Editor-in-chief: Alain Weis
Fashion director:
Benjamin Galopin
Publisher
Thierry Le Gouès

Fairy Tale

Fashion magazine with a focus on photography, graphic design and contemporary typefaces.
Bi-annual, founded in 2003,
230 x 330 mm, 11€, English.
Editorial Office
139 rue du Faubourg St Denis
75010 Paris
contact@fairytale-magazine.com
www.fairytale-magazine.com
Staff
Editor: Achim Reichert
Editor: Marco Fiedler
Publisher
VIER5
139, rue Faubourg ST Denis
75010 Paris
contact@vier5.de
www.vier5.de

Famous

Famous wants to be theoretical and practical, intimate and mundane.
Quarterly, founded in 2004,
Variable format, 10,000 copies,
7.50€, French / English.
Editorial Office
14 rue Therese
75001 Paris
talk@tsunami-addiction.com
www.tsunami-addiction.com
Staff
Editor-in-chief:
Reiko Underwater

Fashion Magazine
by Magnum

Founded in 2005, 230 x 320 mm,
15€, French / English.
Staff
Photographer: Martin Parr
Publisher
Magnum Photos
19 rue Hegesippe Moreau
75018 Paris
Phone: +33 01 53 42 50 00
www.magnumphotos.com

Fake-Real Magazine

Ghettoblaster magazine One artist / One band and its cultural environment.
Quarterly, founded in 2006,
200 x 280 mm, 28,000 copies,
Free, French / English/ German.
Editorial Office
Paris
gloria@plateformebureau.com
www.plateformebureau.com
Staff
Production: Joel Dagès
Publisher
Tsunami-Addiction for
Plateforme Bureau
130 rue de Turenne
75003 Paris

Fantaisies

Quarterly, 262 x 320 mm, Free,
French.
Editorial Office
48 Bd Haussmann
75009 Paris
Staff
Editor-in-chief: Stéphane Brasca
Art director: Thomas Dimetto
Publisher
Lafayette Gourmet
27 rue de la Chaussée d'Antin
75009 Paris

festiv'all

**Le mensuel des événements
culturels en France et en Europe**
Monthly, founded in 2006,
210 x 297 mm, 3.90€, French.
Editorial Office
17 rue Béranger
75003 Paris
Staff
Editor: Sylvain Florent

Free*

Irregularly published, founded in
2006, 300 x 380 mm, Free, French.
Editorial Office
5 rue Pizay
69001 Lyon
www.zai-batsu.org/free.html
Staff
Editor: Gilles Mahé
Editor: Gérald Caillat

Frog

Magazine about contemporary art
Bi-annual, founded in 2005,
230 x 300 mm, 12€, French.
Editorial Office
Paris
info@frogmagazine.net
www.frogmagazine.net
Staff
Publisher: Stéphanie Moisdon
Director: Eric Troncy
Publisher
Frog sarl
7 rue G. Laumain
75010 Paris

GaultMillau

Every two months, 210 x 280 mm,
4.50€, French.
Editorial Office
31 rue Madame de Sanzillon
92586 Clichy cedex
contact@gaultmilleau.fr
Staff

Culture &
Post-design
Magazine

Free-of-charge publication devoted to creativity, art and contemporary culture

Free suscription: www.dximagazine.com

d[x]i magazine headquarters: c/ Maldonado 19, Bajo Dcha. E46001 Valencia, SPAIN |
Tel.+34 963154215, Mobile:+34 636113858 | lex@dximagazine.com | www.dximagazine.com

Editor-in-chief and Director:
Patrick Mayenobe
Publisher
Société GaultMillau
RCS Bordeaux B418
576 955

Gloss
**Le magazine de la beauté et
du bien-être**
Quarterly, founded in 2001,
230 x 300 mm, 90,000 copies,
4.50€, French / English.
Editorial Office
101 bd Murat
75016 Paris
gloss.jb@wanadoo.fr
Staff
Editor: Thierry Taittinger
Editor-in-chief: Odile Chabrillac
Art director: Nicolas Valoteau
Deputy editor: Jérôme Badie
Production Manager:
Anne Regard
Publisher
Thierry Taittinger SEPEM
(a TTM Group company)
101 bd Murat
75016 Paris
Phone: +33 1 47 43 23 00
Fax: +33 1 47 43 23 19

Handmade Magazine
Founded in 2005, 210 x 210 mm,
10€, English.
Editorial Office
Paris
Staff
Founder and Creative director:
Sylvain Thirache
Founder and Creative director:
Alexandre Hervé
Co-founder and Editor-in-chief
and Art director: Tashi Bharucha
Publisher
ddb Paris

hiawatha
fashion books music
Quarterly, 150 x 210 mm, 4€,
English.
Editorial Office
65 rue de la Roquette
75011 Paris
hiawatha@free.fr
Staff
Editor and Publisher:
Jesse Brouns
Publisher
Wig Wam Press
Brussels

Hors d'Œuvre
**Le journal de l'Art
Contemporain en Bourgogne**
Quarterly, 300 x 420 mm, Free,
French.
Editorial Office
Dijon
Staff
Editor-in-chief: Luc Adami
Publisher
Association INTERFACE
Dijon
Phone: +33 0 3 80 65 19 07
interface@fr.europost.org

I don't understand
295 x 420 mm, 15€, English.
Editorial Office
therestissilence@trendypop.com
www.trendypop.com
Staff
Editor-in-chief: Matteo Vianello
Creative director: Alessio Krauss
Publisher
Trendy Pop

Icôn
Expression visuelle
Every two months, 245 x 310 mm,
15€, French / English.
Editorial Office
Paris
Staff
Editor-in-chief and Creative
director: Christophe Durand
Publisher
ADN sarl
9 route des Jeunes
1227 Geneva
Switzerland

iCoNoMiX
**Art, Brands and Business
Intelligence**
Annual, founded in 2004,
300 x 400 mm, 30,000 copies,
10€, English.
Editorial Office
52 rue Sedaine
75012 Paris
redaction@iconomix.fr
www.iconomix.info
Staff
Founder: Eric Mézan
Art director: Ludivine Billaud
Art director: Elisa Piquet
Managing editor:
Marie Lecoustey
Publisher
art process
52 rue Sedaine
75011 Paris
Phone: +33 0 1 47 00 90 85

Images Magazine
Every two months, 230 x 300 mm,
5€, French.
Editorial Office
14 avenue de Tourville
75007 Paris
le.monde.du.regard@wanadoo.fr
Staff
Director: Philippe Heullant
Editor-in-chief: Sophie Bernard
Art director: Delphine Tramalloni

impression
urban culture publication / words
and images
Bi-annual, founded in 2006,
210 x 297 mm, 5€, French.
Editorial Office
4 place Ste Opportune
75001 Paris
alicelitscher@gmail.com
www.myspace.com/impressionma
gazine

Influx
**Le journal de la nouvelle
intelligence**
210 x 270 mm, French.
Editorial Office
30, rue du château des rentiers,
75647 Paris
Staff
Editor-in-chief: Yves Vilagines

Intramuros
Design magazine.
Every two months, 225 x 300
mm, 9.50€, French / English.
Editorial Office
29 rue de Meaux
75019 Paris
info@intramuros.fr
www.intramuros.fr
Staff
Editor-in-chief: Chantal Hamaide
Creative director:
Thierry Houplain

Irregulomadaire

Irregularly published, founded in 1990, 210 x 297 mm, Variable price, French.

Editorial Office
1, rue de Metz
75010 Paris
irregulomadaire@
irregulomadaire.net
www.irregulomadaire.net

Staff
Editor-in-chief:
Jérôme Saint-Loubert Bié
Editor-in-chief: Susanna Shannon

it magazine
creating cultures

Magazine about art, culture, design and economy. *it magazine* wants to share better comprehension of the contemporary world with informations and thinking.
Every two months, founded in 2000, 210 x 280 mm, French.

Editorial Office
Paris

Staff
Editor-in-chief:
Alexandre P Charre

Publisher
It Company
12 place de Clichy
75 009 Paris

it's rouge

An attempt for visual brainstorming.
230 x 310 mm, 15,000 copies, 19€, English.

Editorial Office
26 rue Beranger
75003 Paris
info@itsrouge.com
www.itsrouge.com

Staff
Editor-in-chief and Creative director: Patrice Fuma Courtis
Publisher and Editor-in-chief:
Karine Chane Yin

Publisher
It Publishing sarl
26 rue Béranger
75003 Paris
Phone: +33 0 1 44 54 95 95
Fax: +33 0 1 44 78 01 19
info@itsrouge.com
www.itsrouge.com

Jalouse
audace et modernité

Monthly (10x / year), founded in 1998, 222 x 285 mm, 2.95€, French / English.

Editorial Office
10 rue du Plâtre
75004 Paris
www.jaloufashion.com

Staff
Editor-in-chief:
Marie-José Susskind-Jalou
Fashion director: Isabelle Peyrut

Publisher
Les Editions Jalou sarl
10 rue du Plâtre
75004 Paris
Phone: +33 0 1 53 01 10 30
Fax: +33 0 1 42 72 65 75
contact@editionsjalou.com
www.jaloufashion.com

Je t'aime tant

Je t'aime tant is a collection of images, a periodic and printed publication revealing modern artists' work.
210 x 297 mm, 500 copies, 15€.

Editorial Office
9 rue Luckner
33000 Bordeaux
benoitvial@yahoo.fr
www.jetaimetant.com

Staff
Publisher and Creative director:
Benoit Vial

Jules
Gentlemag

Monthly (11x / year), founded in 2005, 204 x 275 mm, 3.50€, French.

Editorial Office

54 rue de Paradis
75010 Paris
Staff
Editor-in-chief: Bruno Godard
Art director: Ivanuel Barreto
Publisher
Buzzer Press
221 rue Lafayette
75010 Paris

Kaiserin
A magazine for boys with problems

Bi-annual, founded in 2007, 176 x 250 mm, 1,500 copies, French / English.

Editorial Office
5 rue Titon
75011 Paris
contact@kaiserin-magazine.com
www.kaiserin-magazine.com

Staff
Founder and Producer:
Arnaud-Pierre Fourtané
Founder and Producer: Didier Fitan

Karnet
Voyage-Mode-Lifestyle

Every two months, founded in 2005, 210 x 285 mm, 4.50€, French / English/ German.

Editorial Office
Paris

Staff
Publisher: Pascale Costa
Editor-in-chief:
Jean-Pierre Manguian

Publisher
Bleucom Editions SAS
93 Avenue Aristide Briand
92541 Montrouge cedex

Klash Magazine
Buzz / Sound / Tendances / Art / Design / Ciné / Agena

Every two months, 195 x 195 mm, 100,000 copies, Free, French.

Editorial Office
24 av. Hoche
75008 Paris
rgacem@klashmag.com
www.klashmag.com

Staff
Managing editor:
Anthony de Anfrasio
Editor-in-chief: Pascal Iakovou

Publisher
Monday Market
100 Quai de Jemmes
75010 Paris
Phone: +33 01 42 03 58 66
www.klashmag.com

Lady Caprice

French.

Editorial Office
Paris
courrier@ladycaprice.com
www.ladycaprice.com

Staff
Editor-in-chief: Emilie Janin
Editor-in-chief: Brice Baudrino

Le Colette
magalogue

Le Colette is a regular rendez-vous aimed at informing readers about the world of colette with particular attention focused on fashion, beauty, art, design, music, books, magazines and more, including updates on our special limited edition projects collaborating with designers and artists.
Bi-annual, founded in 2003, 165 x 240 mm, 10,000 copies, Free, French / English.

Editorial Office
213 rue saint-honoré
75001 Paris
info@colette.fr
www.colette.fr

Le matricule des anges

Literature.
Monthly, founded in 1992, 7,000 copies.
Editorial Office
Po Box 20225
34004 Montpellier
lmda@lmda.net
www.lmda.net

The Purple Journal

Quarterly, founded in 2003, 210 x 275 mm, 7.5€, French / English.
Editorial Office
Paris
inquire@purple.fr
www.purple.fr
Staff
Publisher and Editor-in-chief:
Elein Fleiss
Editor-in-chief: Sébastien Jamain
Publisher
Purple Institute
9 rue Pierre Dupont
75010 Paris
Phone: +33 01 40 34 14 64
Fax: +33 01 40 34 27 55
inquire@purple.fr
www.purple.fr

Le Réservoir

Alimente gratuitement votre curiosité
Graphic design
Quarterly, founded in 2003, 150 x 210 mm, Free, French.
Editorial Office
12, allée des Sarments
37550 Saint-avertin
cedric@eleven-studio.com

www.eleven-studio.com
Staff
Managing editor: Cédric Neige
Editor-in-chief: Théophile Pillault

Le Tigre

Monthly, 2.50€, French.
Editorial Office
25 rue Saint-Vincent de Paul
75010 Paris
tigre@le-tigre.net
www.le-tigre.net

Le Travail de l'Art

Art, architecture, cinema, dance, design, literature and musique.
Bi-annual, 210 x 275 mm, French.
Editorial Office
4, rue Say
75009 Paris
Staff
Editor-in-chief:
Catherine Strasser
Publisher
Des Arts en Europe
4, rue Say
75009 Paris
Phone: +33 0 1 48 78 54 45
Fax: +33 0 1 48 78 54 67

Les Inrockuptibles

L'hebdo musique, cinéma, livres, etc
Weekly, founded in 1986, 230 x 280 mm, 12€, French.
Editorial Office
144, rue de Rivoli
75001 Paris
abonnements@inrockuptibles.com
www.lesinrocks.com
Staff
Editor-in-chief: Christian Fevret

Libération Style

240 x 340 mm, French.
Editorial Office
11 rue Beranger
75154 Paris
www.liberation.fr
Staff
Managing editor:
Vitorio De Filippis

Liié

Luxe et Culture Urbaine
Every two months, founded in 2005, 210 x 275 mm, 4.90€, French.
Editorial Office
Paris
contact@liiemag.com
www.liiemag.com
Staff
Editor-in-chief:
Rosemonde Pierre-Louis
Publisher
LIIE Edition sarl
24 rue Louis Blanc
75010 Paris
Phone: +33 0 1 48 67 11 02
contact@liiemag.com
www.liiemag.com

Lisières

Lisières is an independent art magazine; every issue is dedicated to a single artist / creator.
Irregular, founded in 1998, 105 x 150 mm, 1,000-1,500 copies, French.
Editorial Office
13 Hent Pen Duick
29930 Pont-Aven
revue.lisieres@9online.fr

www.lisieres.com
Staff
Editor-in-chief: Laurent Brunet

Livraison

revue d'art contemporain contemporary arts journal
Bi-annual, 165 x 240 mm, 13€, French / English.
Editorial Office
6 Rue Saint Guillaume
67000 Strasbourg
contact.rhinoceros@wanadoo.fr
www.r-diffusion.org
Staff
Editor-in-chief: Nicolas Simonin
Publisher
Rhinocéros
18 rue de Stosswihr
67100 Strasbourg
Phone: +33 0 6 61 83 59 00
contact.rhinoceros@wanadoo.fr

L'Officiel

de la couture et de la mode de Paris
L'Officiel, luxury and fashion magazine, published in over 70 countries, is the oldest French women's magazine and the heart of Editions Jalou.
Monthly (10 issues per year), founded in 1921, 220 x 282 mm, 4.50€, French.
Editorial Office
10 rue du Plâtre
75004 Paris
contact@editionsjalou.com
www.jaloufashion.com
Staff
Editor-in-chief and Managing director: Marie-José Jalou

Fashion director:
Anne Dupas-de Vertamy
Publisher
Les Editions Jalou sarl
10 rue du Plâtre
75004 Paris
Phone: +33 0 1 53 01 10 30
Fax: +33 0 1 42 72 65 75
contact@editionsjalou.com
www.jaloufashion.com

L'OFFICIEL
1000 MODELES
PARIS-
LONDRES
L'Officiel teams' choices
Haute couture, ready-to-wear,
accessories, men's fashion, design.
Monthly (11/year)
Editorial Office
10, rue du plâtre
75004 Paris
contact@editionsjalou.com
www.jaloufashion.com
Publisher
Les Editions Jalou sarl
10 rue du Plâtre
75004 Paris
Phone: +33 0 1 53 01 10 30
Fax: +33 0 1 42 72 65 75
contact@editionsjalou.com
www.jaloufashion.com

L'Optimum
Everything for Men
Fashion news, restaurants, high
tech, cinema, music, sports,
reports and interviews of
politicians.
Monthly (8x / year), founded in
1996, 227 x 275 mm, 3.95€, French.
Editorial Office
10 rue du plâtre
75004 Paris
contact@editionsjalou.com
www.jaloufashion.com
Staff
Director and Publisher:
Marie-José Susskind-Jalou
Editor-in-chief: Emmanuel Rubin
Fashion director: Anne Gaffié

Publisher
Les Editions Jalou sarl
10 rue du Plâtre
75004 Paris
Phone: +33 0 1 53 01 10 30
Fax: +33 0 1 42 72 65 75
contact@editionsjalou.com
www.jaloufashion.com

M
240 x 333 mm, 14€, English.
Editorial Office
19 rue Hégésippe Moreau
75018 Paris
m@magnumphotos.fr
www.magnumphotos.com
Staff
Publishing director: Diane Dufour
Photographer: Carl De Keyzer
Photographer:
Patrick Zachmann
Publisher
Magnum Photos
19 rue Hegesippe Moreau
75018 Paris
Phone: +33 01 53 42 50 00
www.magnumphotos.com

Magazine
You are what you read
Every two months (5x / year),
200 x 260 mm, Free, French /
English.
Editorial Office
32 boulevard de Strasbourg
75010 Paris
magazine75010@yahoo.fr
Staff
Founder: Angelo Cirimele
Publisher
ACP
32 rue de Strasbourg

75010 Paris
Phone: +33 06 16 399 242
magazine75010@yahoo.fr

magic
revue pop moderne
Monthly, 230 x 300 mm, 5€,
French.
Editorial Office
50 rue Notre-Dame de Lorette
75009 Paris
www.magicrpm.com
Staff
Directeur: Christophe Basterra
Publisher
Bonne Nouvelle Editions sarl
20 rue du Sentier
75002 Paris
Phone: +33 0 1 55 80 20 20
Fax: +33 0 1 55 80 20 53
www.magicrpm.com

MAP
Mouvement Action Plastique
Folded poster
Quarterly, founded in 2000,
420 x 595 mm, French / English.
Editorial Office
8, rue Monsigny
75002 Paris
m19@m19sites.org
www.m19sites.org
Staff
Editor-in-chief: Pierre Denan
Publisher
m19 (mouvement 19)
8, rue Monsigny
75002 Paris
Phone: +33 0 1 47 03 18 01
Fax: +33 0 1 47 03 18 02
m19@m19sites.org
www.m19sites.org

Médias
Lire entre les lignes
Quarterly, founded in 2004,
195 x 255 mm, 25,000 copies,
4.90€, French.
Editorial Office
16 rue Oberkampf
75011 Paris
contact@revue-medias.com
www.revue-medias.com
Staff
Publisher: Pierre Hessler
Publisher
Minuit moins le quart
16 rue Oberkampf
75011 Paris

Mixte
Every two months, founded in
1996, 230 x 300 mm, 50,000
copies, 6€, French / English.
Editorial Office
1 rue du Colonel-Pierre-Avia
75503 Paris
Staff
Director: Tiziana Humler-Ravera
Fashion director:
Christopher Niquet
Publisher
EMAP

Modem
Design guide
Annual, 15€.
Editorial Office
30 rue du Temple
75004 Paris
info@modemonline.com
www.modemonline.com
Publisher
Modem
30 rue du Temple

www.Hmagazine.com

75004 Paris
Phone: +33 0 1 48 87 08 18
Fax: +33 0 1 48 87 68 01

Monsieur
Eléments de style
Every two months, founded in
1920, 230 x 300 mm, 4.80€,
French.
Editorial Office
72 bd Berthier
75017 Paris
courrier@monsieur.fr
www.monsieur.fr
Staff
Editor-in-chief:
François-Jean Daehn
Publisher
Montaigne Publications
72 bd Berthier
75017 Paris
Phone: +33 0 1 47 63 90 83
Fax: +33 0 1 47 63 49 08

mouvement
**l'indisciplinaire des arts
vivants**
Every two months, founded in
1998, 225 x 285 mm, 6€, French.
Editorial Office
6 rue Desargues
750011 Paris
r.soudanne@mouvement.net
www.mouvement.net
Staff
Editor-in-chief:
Jean-Marc Adolphe
Editor-in-chief: Léa Gauthier
Publisher
Editions du mouvement
Paris
www.mouvement.net

muteen
**Il y a une vie avant vingt
ans... évidemment!**
Monthly, 220 x 282 mm, 2.20€,
French.
Editorial Office
36 rue des Archives
75004 Paris
www.muteen.com
Staff
Editor-in-chief: Catherin Nerson
Publisher
Les Editions Jalou sarl
10 rue du Plâtre
75004 Paris
Phone: +33 0 1 53 01 10 30
Fax: +33 0 1 42 72 65 75
contact@editionsjalou.com
www.jaloufashion.com

Muze
Culture / Allure / Littérature
Monthly, 230 x 270 mm, 5.90€,
French.
Editorial Office
3 rue Baillard
75393 Paris Cedex 08
www.muze.fr
Staff
Publisher: Bruno Frappat
Editor-in-chief: Florence Monteil
Publisher
Bayard Presse SA
3 rue Bayard
75393 Paris cedex 08

Neverending
Quarterly, founded in 2006,
210 x 280 mm, French / English.
Editorial Office
mail@neverendingmagazine.com
www.neverendingmagazine.com

Nuke
240 x 340 mm, 10€, French.
Editorial Office
11 rue Sainte Anastase
75003 Paris
www.nukemag.com
Staff
Editor and Creative director:
Jenny Mannerheim
Art direction: Verane Pina

Numéro
**Le magazine international
de mode**
Monthly, founded in 1998,
230 x 300 mm, 5€, French.
Editorial Office
5 rue du Cirque
75008 Paris
www.numero-magazine.com
Staff
Président Directeur général:
Alain Ayache
Directrice de la rédaction:
Babette Djian
Publisher
Numéro PRESSE SA
5 rue du Cirque
75008 Paris

Numéro Homme
**Le magazine international de
mode pour homme**
Quarterly, founded in 2000,
230 x 300 mm, 6€, French.
Editorial Office
5 rue du Cirque
75008 Paris
www.numero-magazine.com
Staff
Publisher: Alain Ayache
Director: Babeth Djian

Editor-in-chief:
Jonathan Wingfield
Fashion director: Serge Girardi
Publisher
Numéro PRESSE SA
5 rue du Cirque
75008 Paris

Nusign*
A magazine that sees itself as the
reflection of creation.
Quarterly, founded in 2007,
210 x 270 mm, 3,000 copies, 15€,
English / French.
Editorial Office
17 rue des recollets
75010 Paris
contact@laraignee.fr
www.myspace.com/nusign
Staff
Publisher: Piero Preitano
Editor-in-chief: Oliviero Stak
Creative director: L'ARAIGNEE
Publisher
L'ARAIGNEE sarl
17 rue des Récollets
75010 Paris
Phone: +33 01 42 09 23 90
Fax: +33 01 42 09 23 90
contact@araignee.fr
www.laraignee.fr

Oblik
lik(e) la culture
Every two months, founded in
2005, Free, French.
Editorial Office
12, Allée des Sarments
37550 Saint-Avertin
www.oblikmag.com
Staff
Publishing director: Jeremy
Editor-in-chief: Joao
Graphism: Cedric

offshore
Art contemporain
Tri-annual, French.
Editorial Office
Montpellier
offshore@wanadoo.fr
Staff
Editor-in-chief:
Jean Paul Guarino
Directeur de publication:
Emmanuel Berard
Publisher
Bmédiation
39 avenue Bouisson Bertrand
34090 Montpellier

ON
Bi-annual, founded in 2000,
170 x 210 mm, French.
Editorial Office
14 bis rue Saint Maur
75011 Paris
www.collectifmix.com
Publisher
collectif MIX
14 bis rue Saint Maur
75011 Paris
Phone: +33 0 1 43 73 66 53
mix@collectifmix.com
www.collectifmix.com

Palais/
In conjunction with the
exhibitions, events, lectures, and
performances that make up the
artistic program, the Palais de
Tokyo offers a new magazine.
Founded in 2006, 210 x 280 mm,
5€, French / English.
Editorial Office
13 av. du Président Wilson
75116 Paris
contact@palaismagazine.com

www.palaismagazine.com
Publisher
Palais de Tokyo and Crash
Production

Paris Capitale
Monthly, 210 x 275 mm, French.
Editorial Office
4 rue de l'Arcade
75008 Paris
information@pariscapitale.com
www.leclubparis.com
Staff
Publisher: Anne-Marie Herrmann
Publisher
Sarl Paris 3S
B 392 748 Paris

Permanent Food
A magazine made from
magazine pages gathered from
around the world by hundreds of
participants, a second generation
publication.
Bi-annual, founded in 1995,
170 x 235 mm, 17€,
Publisher
L'association des temps libérés

Perso
Monthly (10x / year),
216 x 286 mm, French.
Editorial Office

5 rue du Cirque
75008 Paris
perso@groupe-ayache.com
Staff
Director: Jean-Yves Le Fur
Editor-in-chief: Yan Céh
Publisher
Groupe Alain Ayache
5 rue du Cirque
75 164 Paris cedex 19
Phone: +33 1 1 44 84 85 21
www.groupe-ayache.com

philosophie Magazine
Monthly, founded in 2006,
215 x 280 mm, 4.90€, French.
Editorial Office
10, rue Ballu
75009 Paris
redaction@philomag.com
www.philomag.com
Staff
Editor-in-chief: Alexandre Lacroix

Photo
Monthly, 230 x 297 mm, 4€,
French.
Editorial Office
149 rue Anatole France
92 534 Levallois-Perret Cedex
photo@hfp.fr
www.photo.fr
Staff
Managing editor and Art
director: Eric Colmet Daage
Publisher
Hachette Filipacchi Associés
149 rue Anatole France
92534 Levallois-Perret Cedex

Photos nouvelles
A cultural magazine of
photographic activity.
Every two months, founded in
1999, 220 x 300 mm, 5.50€,
French.
Editorial Office
8, Rue Marie Politzer
64200 Biarritz
photosnouvelles@edi-pole.com
www.php.atlantica.fr/API/Photon
ouvelles.php
Staff
Editor-in-chief:
Isabelle Darrigrand
Publisher
API
18, Rue Marie Politzer
64200 Biarritz
Phone: +33 0 5 59 22 84 00

Point d'ironie
Free editions by contemporary
artists and thinkers, in an 8-page
tabloid format.
Quarterly, 305 x 430 mm,
French / English.
Editorial Office
17, rue Dieu
75010 Paris
ironie@agnesb.fr
www.pointdironie.com
Staff
Managing editor: Carrie Pilto
Editor-in-chief:
Hans Ulrich Obrist
Publisher
agnès b.
17, rue Dieu
75010 Paris
Phone: +33 01 53 38 43 41

polySTYLES
Fashion, Decoration and Design
Bi-annual, 230 x 297 mm,
15,000 copies, 4€, French.
Editorial Office
18 quai Zorn
67000 Strasbourg
polyredac@jempresse.com
www.jempresse.com
Staff
Art director: Lionel Shili
Editor-in-chief: Bruno Chibane
Publisher: Vincent Nebois
Publisher
jempresse
18 quai Zorn
67000 Strasbourg
Phone: +33 90 22 93 30
Fax: +33 90 22 93 37

Préférences mag
Le magazine des nouveaux genres
Every two months, 210 x 278 mm,
5€, French.
Editorial Office
64 rue Anatole France
92300 Levallois
info@preferencesmag.com
www.preferencesmag.com
Staff
Manager: Jean Gaspar
Managing editor:
Jacques Raffaelli
Publisher
Préférences Editions
64 rue Anatole France
92300 Levallois

Printfolio
Un magazine intime de mode
Annual, 240 x 320 mm,
2,000 copies, French.
Editorial Office
www.printfolio-magazine.com
Staff
Photographer: Mathias Walter
Text: Bernard Pautrat
Illustration: Julie Lamy

Purple Book
Editorial Office
Paris
inquire@purple.fr
www.purple.fr
Publisher
Purple Institute
9 rue Pierre Dupont
75010 Paris
Phone: +33 01 40 34 14 64
Fax: +33 01 40 34 27 55
inquire@purple.fr
www.purple.fr

Purple Fashion
Bi-annual, founded in 2004,
230 x 300 mm, 20€, English.
Editorial Office
Paris
inquire@purple.fr
www.purple.fr
Staff
Editor-in-chief and Creative
director: Olivier Zahm
Art director:
Christophe Brunnquell
Fashion editor: Yasmine Eslami
Executive producer:
Dorothée Perret
Creative and Design consultants:
M/M Paris
Publisher

Purple Institute
9 rue Pierre Dupont
75010 Paris
Phone: +33 01 40 34 14 64
Fax: +33 01 40 34 27 55
inquire@purple.fr
www.purple.fr

R de Réel
A profusely illustrated magazine,
which mixes the works of
draftsmen and contemporary
photographers with ancient
iconography.
Every two months, founded in
2000, 210 x 210 mm, 35€,
French.
Editorial Office
31, rue de Saintsonge
75003 Paris
info@rdereel.org
www.rdereel.org
Staff
Editor-in-chief: Raphaèl Meltz

R2 Mag
Regards sur l'air(e) Locale
Quarterly, founded in 2001,
260 x 210 mm, 15,000 copies,
Free, French.
Staff
Publisher, Editor-in-chief and Art
director: Bernard Sébastien
Publisher: Henry-Michel Dumont
Publisher and Art director:
Marie-Paule Navarro
Publisher
BandM
Résidence de la Coupiane-Bât 30
82160 La Valette

Redux
Collectif Combo présente
Quarterly, 170 x 250 mm, Free,
French / English.
Editorial Office
7 allée de la Douane
64600 Anglet
info@reduxmag.com
www.reduxmag.com
Staff
Editor and Art director:
Erwann Lameignère
Publisher
Erwann Lameignère
7 allée de la Douane
64600 Anglet
Phone: +33 0 5 59 31 11 42
Fax: +33 0 6 08 41 81 36

Rendez-Vous magazine
culture, fashion and society
Every two months (5x /year),
founded in 2005,
245 x 330 mm, 150,000 copies,
Free, French.
Editorial Office
15 rue Martel
75010 Paris
contact@rendezvousmagazine.fr
www.rendezvousmagazine.fr

Sans Titre
Art Contemporain
Sans Titre is a double page
printed in black and white as
a newspaper. This special paper
intends to promote and diffuse
contemporary art and the works
of artists from the north of
France.
Every two months, founded in
1988, 300 x 400 mm, Free,
French.
Editorial Office
14, rue Véronèse
59800 Lille
Staff
Editor-in-chief:
Denis - Laurent Bouyer
Publisher

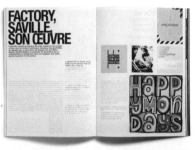 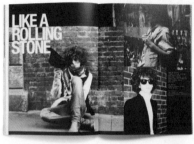

Spray

The best view on new trends, fashion & culture

Free in selected shops and galleries

A bimonthly publication from Brotherhood Communication

Spray: 25/27 rue de la Folie Méricourt, 75011 Paris, France. Tél: 01 48 03 41 45

ACRAC
14, rue Véronèse
59800 Lille
Phone: +33 0 3 20 21 09 46

self service

self service is the season's most complete fashion biannual, an intimate, influential diary, a must-have style-bible for front row seats to contemporary culture watching.
Bi-annual, founded in 1995, 235 x 305 mm, 30,000 copies, 15€, English.
Editorial Office
7 rue Debelleyme
75003 Paris
editorial@selfservicemagazine.com
www.selfservicemagazine.com
Staff
Fashion director:
Camille Bidault Waddington
Creative director: Suzanne Koller
Editor-in-chief: Ezra Petronio
Publisher
Ezra Petronio sarl
7 rue Debelleyme
75003 Paris
info@selfservicemagazine.com
www.selfservicemagazine.com

Simulacres

Magazine about cinema and filming the fear.
Quarterly, founded in 1999, 210 x 270 mm, French.
Editorial Office
39, rue d'Auteil
75016 Paris
Staff
Editor: Jean-Batiste Thoret

Sofa

Culture et grands coussins
Sofa speaks to those who see culture as a pleasure.
Every two months, 210 x 300 mm, French.
Editorial Office
44, rue Michel-Ange

75016 Paris
sofa@free.fr
Staff
Editor: Camille Sztejnhorn

Spore

Quarterly, founded in 1999, 145 x 210 mm, French.
Editorial Office
8, marché des Capucins
13001 Marseille
Staff
Editor-in-chief: Sylvie Coèllier
Colette Tronc
Eric Mangion
Fréderic Brice
Francesco Finizio
Gilles Barbier
Noèl Ravaud

Spray

Monthly style and urban magazine
Every two months, founded in 2004, 210 x 297 mm, 60,000 copies, Free, French / English.
Editorial Office
25/27 rue de la Folie-Méricourt
75011 Paris
philippe.graff@noos.fr
Staff
Editor-in-chief: Philippe Graff
Artistic director:
Yann Le Chatelier
Co-publisher: Yves Clémot
Publisher
Brotherhood Communication
4 rue du Chapelet
64200 Biarritz

Standard

Culture et Mode
Quarterly, founded in 2003, 170 x 230 mm, 4€, French.
Editorial Office
17 rue Godefroy Cavaignac
75011 Paris
richard.gaitet@standardmagazine.com
www.standardmagazine.com

Staff
Director: Magali Aubert
Editor-in-chief: Richard Gaitet
Art director: David Garchey
Publisher
Faites le zéro
17 rue Godefroy Cavaignac
75011 Paris

Stiletto

Tri-annual, founded in 2003, 230 x 300 mm, 35,000 copies, 6€, French / English.
Editorial Office
34 rue de Cléry
75002 Paris
www.stiletto.fr
Staff
Publisher and Editor-in-chief:
Laurence Benaëm
Art director: Sheeno
Editorial coordination:
Karine Porret
Artistic coordination:
Alice Martina
Style consultant (jewellery):
Franceline Prat
Style consultant (fashion):
Wayne Gross
Style consultant (fashion):
Barbara Loison
Publisher
Stiletto Editions
17 rue de la Banque
75002 Paris
Phone: + 33 1 47 20 26 55
Fax: + 33 1 42 60 03 08
stiletto@stiletto.fr

Stratégies

French.
Editorial Office
2 rue Maurice-Hartmann

92133 Issy-les-Moulineaux
www.strategies.fr
Staff
Director and Manager:
Annemiek Wortel
General director and Managing editor: Philippe Larroque
Publisher
Stratégies de Reed Business Information, SA

t.r.o.u

This magazine is presented as a laboratory in which the search of creation is show as raw document without any comment.
Every two months, founded in 1999, French.
Editorial Office
16, rue du Roi René
13007 Marseille
Staff
Editor-in-chief: Marie Bovo

Technikart

culture and société
Monthly, 210 x 275 mm, 4.50€, French.
Editorial Office
Passage du Cheval Blanc,
2 rue de la Roquette
75011 Paris
shauville@technikart.com
www.technikart.com
Staff
Rédacteur en chef:
Raphael Turcat
Publisher:
Fabrice De Rohant Chabot
Publisher
Technikart sarl
Passage du Cheval Blanc,
2 rue de la Roquette
75011 Paris
Phone: +33 0 1 43 14 33 44
Fax: +33 0 1 43 14 33 40
www.technikart.com

—

THE END.

International bimonthly magazine
fashion / art / music / culture
www.theendmagazine.com

—

Technikart Mademoiselle

Bi-annual, founded in 2003, 230 x 295 mm, 6€, French.
Editorial Office
2 rue de la Roquette,
Passage du Cheval Blanc,
cour de Fevrier
75011 Paris
www.technikart.com
Staff
Editor-in-chief: Raphael Turcat
Publisher
Technikart sarl
Passage du Cheval Blanc,
2 rue de la Roquette
75011 Paris
Phone: +33 0 1 43 14 33 44
Fax: +33 0 1 43 14 33 40
www.technikart.com

Têtu

Le magazine des gays et des Lesbiennes
Monthly (11x / year), 230 x 300 mm, 5€, French.
Editorial Office
Paris
redaction@tetu.com
www.tetu.com
Staff
Editor-in-chief: Thomas Doustaly
Director: Bergé Pierre
Publisher
CPPD SAS
6 bis rue Campagne-Première
75014 Paris

toc

Magazine about drawing where artists, graphic designers, illustrators and everybody interested in drawing join together.

Quarterly, 250 x 360 mm, French.
Editorial Office
smp, 31, rue consolat
13001 Marseille
gplloret@hotmail.com
Staff
Editor-in-chief:
Géraldine Pastor Lloret
Publisher
smp
31, rue consolat,
13001 Marseille
Phone: +33 0 4 9164 7446
Fax: +33 0 4 9164 7446
www.s-m-p.org

Tous

Des gens, des vies
Monthly (11x / year), founded in 2003, 230 x 285 mm, 3.50€, French.
Editorial Office
20 rue Cambon
75001 Paris
Staff
Director: Stéphane Bauche
Editor-in-chief: Anne Magnien

Transfuge

Every two months (5x / year), French.
Editorial Office
15, rue du Conservatoire
75009 Paris
www.transfuge.fr
Staff
Editor-in-chief: Vincent Jaury

Transpalette

Founded in 1998, 210 x 300 mm, Free, French.
Editorial Office
26 route de la Chapelle
18024 Bourges Cedex
emmetrop.adsl.bourges@
wanadoo.fr
http://perso.orange.fr/emmetrop/
Staff
Editor-in-chief: Jérôme Poret
Publisher

Le Transpalette - Ass. Emmetrop
26 route de la Chapelle
18024 Bourges Cedex

Trax

Monthly, 230 x 300 mm, 5.95€, French.
Editorial Office
Paris
Staff
Editor-in-chief: Alexandre Jaillon
Publisher
IXO Publishing SA
5/7 rue Raspail
93108 Montreuil cedex

Trésor Magazine

about dogs and beauty
French.
Editorial Office
191 rue du Fbg St-Martin
75010 Paris
contact@tresormagazine.fr
www.tresormagazine.fr
Staff
Publisher: Christine Demias

Tribeca

Monthly, 220 x 290 mm, French.
Editorial Office
8, boulevard de Ménilmontant
75020 Paris
tribeca@hi-box.fr

Trublyon

le magazine des scratch papiers
Quarterly, founded in 2003, 210 x 250 mm, 20,000 copies, Free, French.
Editorial Office
redaction@trublyon.com

www.trublyon.com
Staff
Publisher and Editor-in-chief:
Emma Hebert
Publisher
Trublyon Association
Po Box 1039
69201 Lyon cedex 01
Phone: +33 06 15 15 55 88

Turbulences Vidéo

Quarterly, founded in 1993, 147 x 210 mm, 5€, French (every 4th issues is bilingual: French / English).
Editorial Office
Po Box 50
63002 Clermont-Ferrand cedex 1
videoformes@videoformes.com
www.videoformes.com
Staff
Editor-in-chief:
Gabriel Soucheyre
Editor-in-chief: Loēez Deniel
Editor: Frédérick Legay
Publisher
Videoformes

tyler

sport, musik et cultures urbaines
Every two months, 4.50€, French.
Editorial Office
94 rue Saint-Lazare
75009 Paris
info@tyler-magazine.com
www.tyler-magazine.com
Staff
Managing editor:
François Bocquier
Creative director:
Philippe Caubit

Un

Quarterly, 230 x 260 mm, Free, French / English.
Editorial Office
Paris
www.unsixhuit.com
Staff
Director and Publisher:
Michel Rivière
Editor-in-chief:
Jean-Pierre Saccani
Fashion director: Carole Martray
Publisher
Publications 3+
17 rue de Calais
75009 Paris

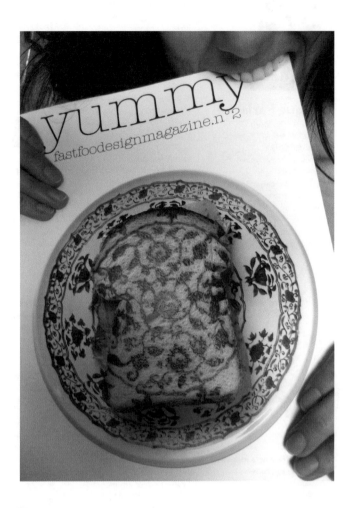

eat it fast

yummy
junkfoodesignmagazine www.eat-fast.net • www.myspace.com/yummymagazine
COLETTE, OFR, THE LAZY DOG, GALERIE LAFAYETTE LIBRARY, CENTRE GEORGES
POMPIDOU LIBRARY **PARIS** ALICE **BRUXELLES** OFR, NOG GALLERY, NOONE **LONDRES**

View on Colour

Speaks the language of colour and investigates how trends will influence.
Quarterly, 240 x 305 mm, 58€, English.
Editorial Office
L'Usine, 30 blvd St-Jacques
75014 Paris
www.edelkoort.com
Staff
Art director: Lidewij Edelkoort
Art director: Anthon Beeke
Editor: Lisa White
Publisher
United Publishers SA
30 Boulevard Saint Jacques
75014 Paris

Vogue Hommes International

Bi-annual, 230 x 297 mm, 6€, English.
Editorial Office
56A rue du Faubourg-Saint-Honoré
75008 Paris
voguehommes@condenast.com
www.voguehommes.com
Staff
Editor-in-chief and Creative director: Bruno Danto
Fashion director: Paul Mather
Publisher
Condé Nast Publications
Piazza Castellano 27
20121 Milan
Italy
Phone: +39 02 856 11
Fax: +39 02 805 57 61

Vogue Paris

Monthly (10x / year),
220 x 285 mm, 4.70 €, French.
Editorial Office
56A rue du Faubourg-Saint-Honoré
75008 Paris
magazine@vogueparis.com
www.vogue.com
Staff
Editor-in-chief: Carine Roitfeld
Fashion director: Emmanuelle Alt
Publisher
Condé Nast Publications
Piazza Castellano 27
20121 Milan, Italy
Phone: +39 02 856 11
Fax: +39 02 805 57 61

WAD

We're different: le magazine des modes et cultures urbaines
A 100% fashion wear magazine.
Quarterly, founded in 1999,
230 x 300 mm, 200,000 copies,
5€, French / English.
Editorial Office
101 rue du Faubourg St Denis
75010 Paris
infos@wadmag.com
www.wadmag.com
Staff
Publisher: Bruno Collin
Fashion editor: Laura Walters
Editor-in-chief:
Samantha Bartoletti
Publisher
Les Editions Trevilly and Family
31 rue du Chapon
75003 Paris
Phone: +33 01 44 78 08 07
Fax: +33 01 44 78 07 02
infos@wadmag.com
www.wadmag.com

Young Blood

Monthly, 230 x 297 mm, 9.50€,
French / English.
Editorial Office
19 rue d'Orsel
75018 Paris
moph@club-internet.fr
Staff
Publisher: Héléna Marques
Editor-in-chief: Lionel Moinier
Art director: Pierre Henri Brunel
Publisher
SLC
77320 Montolivet
Phone: +33 1 64 03 75 03
Fax: +33 1 64 03 75 52

Yummy

fastfooddesignmagazine
Annual, founded in 2005,
212 x 275 mm, 1,000 copies, 30€,
French / English.
Editorial Office
9 Bd Ornano
75018 Paris
contact@eat-fast.net
www.eat-fast.net
Staff
Art director and Publisher:
Alexandra Jean
Editor-in-chief, Creative director and Publisher: Pascal Monfort

Zeuxis

Magazine international du Film sur l'Art
Zeuxis is a cinema magazine based on arts, fiction and international documenteries.
Monthly, founded in 2000,
210 x 270 mm, 4,000 copies,
3.50€, French.
Editorial Office

99-103, rue de Sèvres
75006 Paris
gisele.skira@wanadoo.fr
www.zeuxis.fr
Staff
Editor-in-chief, Creative director and Publisher:
Gisèle Breteau Skira

Germany

*fusion

experimental magazine
Irregularly published,
140 x 190 mm, English.
Editorial Office
Peter-Welter-Platz 2
50676 Cologne
pascal@glissmann.com
www.khm.de/mg/seminare/fusion

:Ikonen:

Zeitschrift für Kunst, Kultur und Lebensart
Cultural magazine focussing on art, philosophy, lifestyle
Bi-annual, founded in 2000,
210 x 297 mm, 2,000 copies, 5€,
German / English.
Editorial Office
Dw.-D.-Eisenhower-Str. 3 B
65197 Wiesbaden
wolfsmond@hotmail.com
www.ikonenmagazin.de
Publisher
Stiglegger Verlag

+rosebud

+rosebud is an international and experimental design magazine, exploring and exhausting the possibilities of paper and printed media.
Every 15 months, founded in 1998, 4,000 copies, 30€, English.
Editorial Office
Pelzetleite 65
90614 Ammerndorf
ask@rosebudmagazine.com

Anzahl der in Deutschland erhältlichen Ratgeber für unternehmerischen
und privaten Erfolg: **1184**

Anzahl der unternehmerischen und privaten Insolvenzen in Deutschland, 2005: **105 741**

Weitaus mehr als nur Zahlen.
--

Das Wirtschaftsmagazin brand eins.
Jetzt abonnieren: **www.brandeins.de**

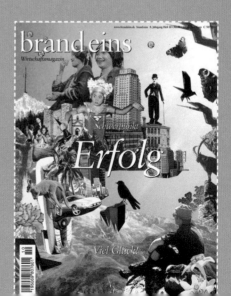

www.rosebudmagazine.com
Staff
Founder and Publisher:
Ralf Herms
Editor: Katja Fössel
Editor: Fritz Magistris

032c
fashion, art and conflict
Bi-annual, founded in 2000,
202 x 271 mm, 10€, English.
Editorial Office
Anklamerstrasse 35
10115 Berlin
office@032c.com
www.032c.com
Staff
Editor-in-chief:
Sandra Von Mayer
Publisher
032c workshop
Anklamerstrasse 35
10115 Berlin
Phone: +49 030 44 05 09 80
Fax: +49 030 44 05 09 81
office@032c.com
www.032c.com

11Freunde
Magazin für Fussball-Kultur
Monthly, founded in 2000,
210 x 280 mm, 3€, German.
Editorial Office
Raabestrasse 2
10405 Berlin
www.11freunde.de
Staff
Editor: Dirk Brichzi
Publisher
INTRO Verlag GmbH and Co
Herwarthstrasse 12
50672 Cologne
Phone: +49 0221 9 49 93 0

Fax: +49 0221 9 49 93 99
verlag@intro.de
www.intro.de

44 Flavors
Als Platform für Grafik und
Design
Annual, English.
Editorial Office
Berlin
www.info@44flavors.de
www.44flavours.de

Achtung
Zeitschrift für Mode
Bi-annual, founded in 2003,
225 x 300 mm, 10,000 copies,
8€, German.
Editorial Office
Strassburger Str. 38
10405 Berlin
presse@achtung-mode.com
www.achtung-mode.com
Staff
Editor-in-chief and Creative
director: Markus Ebner
Publisher
Markus Ebner

AD Germany
Architectural Digest
Monthly, 214 x 277 mm, 5€,
German.
Editorial Office
Ainmillerstrasse 8
80801 Munich
leserbriefe@ad-magazin.de
www.ad-magazin.de
Staff
Director: Bernd Runge
Editor-in-chief: Margit J.Mayer
Art director: Markus Thommen
Publisher
Condé Nast Publications
Piazza Castellano 27
20121 Milan
Italy
Phone: +39 02 856 11
Fax: +39 02 805 57 61

ahead
**The Unisex Magazine about
Fashion, Entertainment and
All-day-art**
Quarterly, founded in 1999,
240 x 326 mm, English.
Editorial Office
Schlesische Strasse 29-30
10997 Berlin
Staff
Publisher: Alexander Geringer
Fashion editor: Desirée Stürgkh
Publisher
ahead MedienberatungsGmbH
Hollanstrasse 10/46
1020 Vienna
Austria
Phone: +43 1 214 06 01
Fax: +43 1 214 06 01-11
ahead@neteway.at

alert
Every two months, 235 x 295 mm,
4.40€, German.
Editorial Office
Schlesische Strasse 28, Hof 4,
10997 Berlin
info@alertmagazin.de
www.alertmagazin.de
Staff
Art director: Sibylle Trenck

AM7
Akademische Mitteilungen 7
A Magazin about communication.
Annual, 8.50€, German.
Editorial Office
Am Weisshof 1
70191 Stuttgart
info@amsieben.com
www.amsieben.com
Staff

Webmaster: Andreas Mayer
Publisher
Academy of Arts and Design
Am Weisshof 1
70191 Stuttgart

Amico
Das A und O für den Mann
168 x 224 mm, 1.50€, German.
Editorial Office
Milchstrasse
22786 Hamburg
service@amica.de
www.amica.de
Staff
Director: Dirk Manthey
Editor-in-chief: Angela Oelckers
Publisher
Verlag GmbH and Co.KG

Amore Poster Magzine
Published irregularly, founded in
2003, 297 x 420 mm, German.
Editorial Office
Schellingstrasse 20
80799 Munich
gomma@gomma.de
www.gomma.de

An Architektur
Bi-annual, 10€.
Editorial Office
Alexanderplatz 5
10178 Berlin
redaktion@anarchitektur.com
www.anarchitektur.com
Publisher
An Architektur e.V.
Alexanderplatz 5
10178 Berlin
redaktion@anarchitektur.com
www.anarchitektur.com

anyway
There is no other way to travel
Every two months, founded in
2005, 200 x 250 mm, 5€,
German / English.
Editorial Office
Schlesische Strasse 29-30
10997 Berlin
Staff
Editor and Creative director:
Alexander Geringer
Publisher
Ahead Media GmbH
Schlesische Strasse 29-30
10997 Berlin

archplus
journal for architecture
Quarterly, founded in 1967,
235 x 297 mm, 32,000 copies,
14€, German.
Editorial Office
Bergengruenstr. 35
14129 Berlin
berlin@archplus.net
www.archplus.net
Publisher
ARCH+ Verlag GmbH

Art
**Das Kunstmagazin mit
Wolkenkratzer Art Journal**
Monthly, 212 x 280 mm, 7.80€,
German.
Editorial Office
Am Baumwoll 11
20459 Hamburg
kunst@art-magazin.de
www.artmagazin.de
Staff
Director: Axel Hecht
Editor-in-chief: Tim Sommer
Publisher

Gruner + Jahr AG and Co KG
Am Baumwall 11
20459 Hamburg
www.guj.de

Artic
Founded in 1993, 1,000 copies,
14€.
Editorial Office
Berlin
www.artic-magazin.de
Staff
Editor: Stefanie Lotus Brinkmann
Editor: Renate Grassmann
Editor: Tosten Kohlbrei

ARTinvestor
230 x 298 mm, 6.50€, German.
Editorial Office
Hauptstrasse 42a
37412 Herzberg / Harz
info@artinvestor.de
www.artinvestor.de
Publisher
ARTinvestor / artpartners GmbH
Karlstrasse 46
80333 Munich
Phone: +49 0 89 45 2236 11
Fax: +49 0 89 45 2236 10

auf abwegen
Magazine for music and culture,
Annual, 3.50€, German.
Editorial Office
Cologne
info@aufabwegen.de
www.aufabwegen.de

Baumeister
Zeitschrift für Architektur
German.
Editorial Office
Streitfeldstr 35
81673 Munich
info@baumeister.de
www.baumeister.de
Staff
Editor-in-chief:
Dr Ing Wolfgang Bachmann
Publisher
Georg D.W. Callwey GmbH and
Co KG
Streitfeldstr 35
81673 Munich
Phone: +49 89 4360 05-0
Fax: +49 89 4360 05-113
info@baumeister.de
www.baumeister.de

Bauwelt
235 x 297 mm, 9.50€, German.
Editorial Office
Schlüterstrasse 42
10707 Berlin
mail@bauwelt.de
www.bauwelt.de
Staff
Editor-in-chief: Felix Zwoch

BB Bulletin
the essence of a culture
Quarterly, founded in 2006,
215 x 304 mm, 35,000 copies,
7.50€, English / German.
Editorial Office
Münzstrasse 13
10178 Berlin
contact@breadandbutter.com
www.breadandbutter.com
Staff
Editor-in-chief: Danielle De Bie
Fashion director:
Linda Charlotte Ehrl
Publisher
Bread and butter GmbH
Münzstrasse 13
10178 Berlin

Berliner
Urbanity Culture Politics
Quarterly, founded in 2002,
215 x 328 mm, 11.50€, German /
English.
Editorial Office
Christburger Strasse 6
10405 Berlin
info@berlinermagazine.com
www.berlinermagazine.com
Staff
Publisher and Editor-in-chief:
Boris Moshkovits
Fashion director: Miles Cockfield
Creative director: Theos Dohm

blond magazine
We are one step ahead
Music, movies, fashion
Monthly, 230 x 300 mm, 2€,
German.
Editorial Office
Osterfeldstraße 12-14
22529 Hamburg
info@blondmag.de
www.blondmag.com
Staff
Editor-in-chief: Sven Bergmann
Publisher: Wolfgang Block
Publisher
blond Media GmbH
Osterfeldstraße 12-14
22529 Hamburg
Phone: +49 0 40 480 007 52
Fax: +49 0 40 480 007 69
www.bdverlag.de

Visit www.welovemags.com for an updated version of the directory

Booklet
Magazin für Fotografie
Photo editorials by the hottest
artists and artwork by renowned
illustrators and art directors
Bi-annual, founded in 2004,
190 x 230 mm, 30,000 copies,
5.80€, German / English.
Editorial Office
Lindenstrasse 17
50674 Cologne
office@booklet.ws
www.booklet.ws
Publisher
home made GmbH
Lindenstrasse 17
50674 Cologne
Germany
Phone: +49 221 46 90 960
Fax: +49 221 46 90 968
www.home-made.de

brand eins
Wirtschaftsmagazin
Monthly, founded in 1999,
212 x 280 mm, 6€, German.
Editorial Office
Schauenburgerstrasse 21
20095 Hamburg
briefe@brandeins.de
www.brandeins.de
Staff
Editor-in-chief: Gabriele Fischer
Art director: Mike Meiré
Publisher
brand eins Verlag GmbH and co
Schauenburgerstrasse 21
20095 Hamburg
Phone: +49 0 40 32 33 16 70
Fax: +49 0 40 32 33 16 80
verlag@brandeins.de
www.brandeins.de

Bransch
Annual, founded in 2002,
230 x 300 mm, 20,000 copies,
English.
Editorial Office
Hamburg
abatenni.verlag@bransch.net
www.branschmagazine.com
Staff
Publisher: Susanne Abatenni
Publisher
Abatenni Verlag
Muehlenkamp 31
22303 Hamburg
Phone: + 49 40 2781 8962
Fax: + 49 40 2781 8910
info@abatenniverlag.com
www.branschmagazine.com

brett
**Magazin für den Alltag am
Strand, auf der Strasse und in
den Bergen**
Quarterly, German.
Editorial Office
Jahnstr. 10
24116 Kiel
info@brettmag.de
www.brettmag.de

C'est la vie
Founded in 2004, 210 x 280 mm,
German / French.
Editorial Office
Schönhäuser Allee 167b
1043 BZ Berlin
Staff
Editor: Nicolas Bourquin
Editor: Sven Ehmann
Publisher
etc. publications
Schönhäuserallee 167b
10435 Berlin
www.etc-publications.com

Cicero
Magazin für politische Kultur
Monthly, 210 x 286 mm, 7 €,
German.
Editorial Office
Berliner Strasse 89
14467 Postdam
info@cicero.de
www.cicero.de
Staff
Editor-in-chief:
Dr. Wolfram Weimer
Publisher
Ringier Publishing GmbH
Berliner Strasse 89
14467 Postdam
Phone: +49 0 331 20134 0
Fax: +49 0 331 20134 39

Cover
**Medien beobachten die
Gesellschaft. Cover
beobachtet die Medien.**
Tri-Annual, German.
Editorial Office
Allende Platz 1
20146 Hamburg
www.covermagazin.de

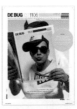

DE:BUG
Monthly, German.
Editorial Office
Schwedter Str 8/9,
Haus 9A
10119 Berlin
de-bug@de-bug.de
www.de-bug.de
Publisher
DE:BUG Verlags GmbH
Schwedter Str. 8/9,
Haus 9A
10119 Berlin

Phone: +49 0 30 2838 4458
Fax: +49 0 30 2838 4459
www.de-bug.de

Der Freund
Fire walk with me
Quarterly, founded in 2004, 10€,
German.
Editorial Office
Axel-Springer-Platz 1
20350 Hamburg
post@derfreund.com
www.derfreund.com
Staff
Editor-in-chief: Dr Eckhart Nickel
Publisher: Christian Kracht
Publisher
Axel Springer AG
Axel Springer Platz
20350 Hamburg
Phone: +49 040 34700

Designer's digest
The artwork magazine
Quarterly, founded in 1986, 11€,
25,000 copies, English / German.
Editorial Office
Bahrenfelder Str. 101a
22765 Hamburg
redaktion@designers-digest.de
www.designers-digest.de
Staff
Founder, Editor-in-chief and
Publisher: Klaus Tiedge

Deutsch
5€, German.
Editorial Office
Torstrasse 140
10119 Berlin
redaktion@deutschmagazine.org
www.deutschmagazine.org

Staff
Editor-in-chief: Bülent
Fashion director: Kasia Pysiak
Fashion director: Karola Wolf
Publisher
Art Berlin Verlag
Torstrasse 140
10119 Berlin
Phone: +49 30 25 76 27 50
Fax: +49 30 25 76 27 53
redaktion@deutschmagazin.org
www.deutschmagazin.org

dienacht
A magazine about international graphic design, photography and untrivial culture.
Bi-annual, founded in 2007, 5€, 500 copies, German.
Editorial Office
Trier
speak2me@dienacht-magazine.com
www.dienacht-magazine.com

Directions
A magazine published by Design Hotels, a global hotel group of more than 150 selected individual properties in 41 countries.
Bi-annual, founded in 2005, Free, 45,000 copies, English.
Editorial Office
Berlin
Publisher
design hotels AG
Stralauer Allee 2c
10245 Berlin
www.designhotels.com

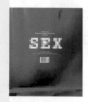

Dummy
Das Gesellschaftsmagazin
Quarterly, 6€, 30,000 copies, German.

Editorial Office
Schönhauser Allee 36 - Haus M
10435 Berlin
redaktion@dummy-magazin.de
www.dummy-magazin.de
Staff
Editor: Oliver Gehrs
Editor: Jochen Förster
Publisher
Schön and Gut
Schönhauser Allee 36 - Haust M
10435 Berlin
www.dummy-magazin.de

Echtzeit
Design Magazine
Echtzeit provides insight into individual lifestyles and very disparate, very private opinions.
Annual, founded in 2003, 9.50€, German / English.
Editorial Office
Pappelallee 8 - 9
14 469 Potsdam
redaktion@echtzeit.org
www.echtzeit.org
Publisher
Fachhochschule Potsdam, Fachbereich Design
Pappelallee 8 -9
14 469 Potsdam

etc.
issues that matter
etc. publications is a platform for independent publishing
Published irregularly, founded in 2002, 7€, 1,000 copies, English / German.
Editorial Office
Schönhauser Allee 167b
10435 Berlin

info@etc-publications.com
www.etc-publications.com
Staff
Publisher: Krystian Woznicki
Publisher: Nicolas Bourquin
Publisher: Sven Ehmann
Publisher
etc. publications
Schönhäuserallee 167b
10435 Berlin
www.etc-publications.com

European Photography
Bi-annual, founded in 1980, £16, German / English.
Editorial Office
Po Box 08 02 27
10002 Berlin
mail@equivalence.com
www.equivalence.com
Staff
Editor and publisher: Andreas Müller-Pohle
Assistant: Bernd Neubauer
Publisher
European Photography
Po Box 08 02 27
10002 Berlin
mail@equivalence.com
www.equivalence.com

Feld Hommes
Quarterly.
Editorial Office
Hamburg
info@feld-magazin.de
www.feld-magazine.com
Staff
Creative director: Mieke Haase
Editor-in-chief: Jan Weiler
Co-founder: Patrick Oldendorf
Fashion director: Isabelle Thiry
Publisher
Feld Verlag
Donnerstrasse 20
22763 Hamburg
Phone: +49 40 40 18 77-0
Fax: +49 40 40 18 77-15
www.feld-magazine.com

form
The European Design Magazine
Every two months, founded in 1957, 240 x 295 mm, 15€, English / German.
Editorial Office
Am Forsthaus Gravenbruch 5
63263 Neu-Insenburg
form@form.de
www.form.de
Staff
Deputy editor-in-chief: Gerrit Terstiege
Editor-in-chief: Petra Schmidt
Publisher
Birkhäuser Verlag AG
Po Box 133
4010 Basel
Switzerland
www.birkhauser.ch

form+zweck
Annual, founded in 1991, 35€, German.
Editorial Office
Dorotheenstraße 4
12557 Berlin
petruschat@t-online.de
www.formundzweck.com

Fragment Magazine
Fragment is presenting thoughts, opinions, ideas and insight point of views without demanding a certain style or form.
5.50€, English / German.
Editorial Office
Prenzlauer Allee 32
10405 Berlin
mail@fragmentmagazine.com
www.fragmentmagazine.com
Staff
Editor-in-chief: Rikard Lassenius

Frau Böhm
photography now
A picture magazine
Quarterly, founded in 1999,

210 x 297 mm, 8€, No text.
Editorial Office
Ronsdorfer Straße 77a
40233 Düsseldorf
info@frau-boehm.de
www.frau-boehm.de

Freier
Monthly (11x / year), 7€,
German.
Editorial Office
Brunnenstrasse 9A
10119 Berlin
funs@neuedokumente.de
www.neuedokumente.de
Publisher
Neue Dokumente
Schönhauser Allee
Berlin
www.neuedokumente.de

Galore
Das Interview Magazin
Monthly (10x / year), founded in
2003, 225 x 300 mm, 90,000
copies, 3.50€, German.
Editorial Office
Märkische Strasse 115-117
44141 Dortmund
info@galore.de
www.galore.de
Staff
Editor: Michael Lohrmann
Publisher
Dialog GmbH
Arnecke Str 82-84
44139 Dortmund
Phone: +49 0231 55 71 31 0
Fax: +49 0231 55 71 31 31
info@galore.de
www.galore.de

Gatsby Magazine
**The supercilious assumption
that on Sunday afternoon you
have nothing better to do.**
Quarterly, founded in 2006,
240 x 320 mm, 25,000 copies,
4€, English.

Editorial Office
Follerstrasse 46
50676 Cologne
Stefan@gatsbymagazine.com
www.gatsbymagazine.com

goon
**Magazin für
Gegenwartkultur**
Founded in 2002, German.
Editorial Office
Maybachufer 5
12047 Berlin
redaktion@goon-magazine.de
www.goon-magazine.de
Staff
Office editorial
Founder and Editor-in-chief:
Sebastian Hinz
Editor: Astrid Hackel
Editor: Jochen Werner
Publisher
goon Media e.V.
c/o Sebastian Hinz,
Colbestr. 3
10247 Berlin
Phone: +49 30 55 49 02 95
info@goon-media.de
www.goon-media.de

Groove
Every two months, German.
Editorial Office
Choriner Strasse 82
10119 Berlin
timon@groove.de
www.groove.de
Staff
Editor-in-chief: Heiko Hoffmann
Publisher
pop media people over profit
GmbH
Chorinerstrasse 82
10119 Berlin
Fax: +49 030 44 31 20 70
www.groove.de

H.O.M.E.
Das Magazin fürs Leben
Monthly, 223 x 290 mm, 3.83€,
German.

Editorial Office
Berlin
Staff
Editor-in-chief: Gerald Sturz
Art director: Ralph Manfreda
Publisher
Ahead Media GmbH
Schlesische Strasse 29-30
10997 Berlin

HekMag
Bi-annual, founded in 2005,
245 x 335 mm, 50,000 copies,
6.50€, English.
Editorial Office
Münzstrasse 15
10178 Berlin
welcome@hekmag.com
www.hekmag.com
Staff
Editor-in-chief and Creative
director: André Aimaq
Editor: Chris Knipping
Fashion director:
Eva-Maria Overmann
Publisher
Aimaq Rapp Stolle GmbH
Münzstrasse 15
10178 Berlin
www.ars-berlin.com

I/O
Every issue is published with a
certain topic. Our aim is to give
an overview on, how creatives
with different backgrounds and
techniques interpretate and work
on the topic.
1,000 copies.
Editorial Office
Lasdehner Str. 28
10243 Berlin
sekretariat@iomagazin.de
iomagazin.de

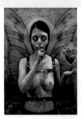

Inside artzine
**International Underground
Art Fanzine Paintings,
Drawings, Collages, Stories,
Photos, Reviews, Links**
Bi-annual, founded in 2006,
210 x 297 mm, 600-800 copies,
4€, English / German.
Editorial Office
Po Box 2266
54212 Trier
jenz@inside-artzine.de
www.inside-artzine.de

Intro
Musik und so
Monthly, 230 x 296 mm, Free,
German.
Editorial Office
Po Box 19 02 43
50499 Cologne
intro@intro.de
www.intro.de
Staff
Publisher:
Matthias Hörstmann
Publisher
INTRO Verlag GmbH and Co
Herwarthstrasse 12
50672 Cologne
Phone: +49 0221 9 49 93 0
Fax: +49 0221 9 49 93 99
verlag@intro.de
www.intro.de

Jam
Das Büchermagazin
Tri-Annual, founded in 2004,
123 x 142 mm, Free, German.
Editorial Office
Hamburg
office@jam-publications.com
www.jam-publications.com

Staff
Director and Editor-in-chief:
Enja Jans

j'n'c
Fashion Trend Magazine
Quarterly, founded in 1992,
230 x 300 mm, 8,000-15,000
copies, 5€, German.
Editorial Office
Ganspohler Str. 5
40764 Langenfeld
info@jnc-net.de
www.jnc-net.de
Staff
Director: Rainer Schlatmann
Director: Uwe Schaufler
Editor-in-chief and Fashion and
Art director: Ilona Marx
Publisher
JandC Publishing Services
GmbH
PO Box 15 20
D-40740 Langenfeld

Junge Karriere
Handelsblatt
210 x 280 mm, 2.50€, German.
Editorial Office
Po Box 10 27 41
40018 Düsseldorf
jungekarriere@vhb.de
www.jungekarriere.com
Staff
Editor-in-chief: Anette Eicker

Jungsheft
rude, nude, cute ...
Published irregularly, founded in
2005, 150 x 210 mm, 4,000
copies, 6€, German / English.
Editorial Office
Lübeckerstrasse 26
520670 Cologne
elke@jungsheft.de
www.jungsheft.de
Staff
Founder: Nicole Rüdiger
Founder: Elke Kuhlen

Katja
It's zine
Bi-annual, founded in 2005,
266 x 362 mm, 500 copies,
German / English.
Editorial Office
Berlin
Staff
Art director: Matthias Ernstberger
Art director: Katia and Philipp

Kid's Wear (International)
Kid's Wear is a magazine for
children's fashion, lifestyle and
culture.
Bi-annual, founded in 1995,
230 x 300 mm, 32,000 copies,
English.
Editorial Office
Pasteurstrasse 1a
50735 Cologne
info@kidswear-magazine.com
www.kidswear-magazine.com
Staff
Managing editor and Advertising
director: Ann-Katrin Weiner
Fashion editor: Iris Görling
Publisher: Achim Lippoth
Publisher
kid's wear verlag
Pasteurstrasse 1a
50735 Cologne

Kunst Forum international
Quarterly, 146 x 224 mm, 10€,
German.
Editorial Office
Zum Brunnentor 7
53809 Ruppichteroth
kunstforum@artcontent.de
www.artcontent.de

Lace
Sneakers Magazine
Bi-annual, founded in 2003,
German / English.
Editorial Office
Mülheim
info@lace-mag.de
www.lace-mag.de
Publisher
lace Verlag
Hingberg 146 (Im Hinterhof)
45470 Mülheim/Ruhr
Phone: +49 208 5 82 90 10
Fax: +49 30 48 49 87 85 3
info@lace-mag.com
www.lace-mag.de

Leica Fotografie International
Monthly (8x / year), 217 x 280
mm, 5.90€, German.
Staff
Editor-in-chief: Frank P.Lohstöter
Publisher
Image Division Publishing
GmbH
Steindamm 91
20099 Hamburg

Léonce
Quarterly, 227 x 320 mm,
26,000 copies, German.
Editorial Office
Am Treptower Park 75
12435 Berlin
leonce@leonce.de
www.leonce.de
Publisher
Léonce Verlags GmbH
Am Treptower Park 75
12435 Berlin
Phone: +49 030 53 43 21 23
Fax: +49 030 53 43 21 21
leonce@leonce.de
www.leonce.de

Liebling
Every two months, founded in
2005, 315 x 470 mm, 45,000
copies, 2.50€, German.
Editorial Office
Anklamer Strasse 1A
10115 Berlin
redaktion@liebling-zeitung.com
www.liebling-zeitung.com
Publisher
Liebling Verlag
Lousebergstrasse 59
52072 Aachen
Phone: +49 0 30 44 35 65 46
Fax: +49 0 30 44 35 65 71
verlag@liebling-zeitung.com
www.liebling-zeitung.com

Lieschen
Revolution of assiduity
Annual, founded in 2006,
335 x 215 mm, 1,000 -1,200
copies, 7€, German.
Editorial Office
Max-Ophüls-Platz 2
44139 Dortmund
info@lieschen.net
www.lieschen.net
Publisher
University of Applied Sciences
and Arts, Dortmund

Reading Design!

The Making of Design:

product design, graphic design, interior design, digital design, new materials, market surveys

www.form.de

Lodown
pop relevant subjects
before art
Lodown is about... Taking
contemporary pop- and
streetculture seriously without
commercialising the idea.
Every two months (5x /year),
265 x 232 mm, 6€, English.
Editorial Office
Koepenicker Str. 48/49
DAZ / G
10179 Berlin
info@lodownmagazine.com
www.lodownmagazine.com
Staff
Publisher and Editor:
Thomas Marecki
Editor: Sven Fortmann

Max
Monthly, founded in 2002,
230 x 297 mm, German.
Editorial Office
Milchstrasse 1
20148 Hamburg
service@max.de
www.max.de
Staff
Director: Dirk Manthey
Editor-in-chief: Christian Krug
Publisher
IPV Inland presse
vertrieb GmbH
Po Box 10 32 46
20022 Hamburg

McK
Das Magazin von McKinsey
195 x 280 mm, 15€, English.
Editorial Office
Hamburg
www.mckinsey.de
Staff
Publisher: Rolf Antrecht
Editor-in-chief: Susanne Risch
Publisher
McKinsey and Company

MINIInternational
Quarterly, founded in 2001,
207 x 264 mm, 200,000 copies,
4.50€, English / German /
French / Spanish / Japanese/
Italian / Arabian / Chinese.
Editorial Office
Grillparzerstrasse 12
81675 Munich
MINIinternational@mini.com
www.mini.com
Staff
Creative director: Mike Meiré
Editor-in-chief: Anne Urbauer
Art director: Stefan Pietsch
Executive editor: Peter Würth
Publisher
Hoffmann und Campe Verlag
GmbH
Harvestehuder 42
20149 Hamburg
Phone: +49 40 441 88 0
Fax: +49 40 441 88 202

möglich
Neue Perspektiven für Ihr
Unternehmen
190 x 270 mm, German.
Editorial Office
moeglich@de.ibm.com
Staff
Editor-in-chief:
Christian Smith
Publisher
John Brown
136-142 Bramley Street
London W10 6SR
United Kingdom
Phone: +44 20 7565 3121
Fax: +44 20 7565 3060
dean.fitzpatrick@johnbrownpublis
hing.com

Mono.Kultur
Interview magazine
Every two months, founded in
2005, 150 x 200 mm,
5,000 copies, 3€, English.
Editorial Office
Naunystrasse 80
10997 Berlin
editorial@mono-kultur.com

www.mono-kultur.com
Staff
Publisher: Kai Von Rabenau

Monopol
Magazin für Kunst und
Leben
Monopol is an innovative,
entertaining and aesthetically
premium magazine for art
and life.
Monthly, founded in 2004,
220 x 280 mm, 55,000 copies,
7.50€, German.
Editorial Office
Rosenthaler Straße 49
10178 Berlin
info@monopol-magazin.de
www.monopol-magazin.de
Staff
Editor: Florian Illies
Editor: Amélie von Heydebreck
Publisher
Juno Verlag GmbH
Rosenthaler Str. 49
10178 Berlin
Phone: +49 0 30 440 13 44 0
Fax: +49 0 30 440 13 44 3
info@monopol-magazin.de
www.monopol-magazin.de

Neid
Neid regards cultural analysis and
research as artistic work.
Founded in 1992, German.
Editorial Office
Schwedterstr 250
10119 Berlin
www.thing.de/neid
Staff
Co-founder: Ina Wudtke

Neon
Monthly, founded in 2003,
212 x 287 mm, 190,000 copies,
2.80€, German.
Editorial Office
Weihenstephaner Straße 7
81673 Munich
redaktion@neon.de
www.neon.de
Staff
Editor-in-chief: Michael Ebert
Editor-in-chief: Timm Klotzek
Art director:
Gunter Schwarzmaier
Publisher
Gruner + Jahr AG and Co KG
Am Baumwall 11
20459 Hamburg
www.guj.de

Neue Mode
Magazine
Bi-annual, founded in 2003,
235 x 295 mm, 35,000 copies,
15€, English.
Editorial Office
Goldsteinstr. 61a
60528 Frankfurt
email@neuemodemagazine.com
www.neuemodemagazine.com
Staff
Editor-in-chief and Creative
director: Oliver Daxenbichler
Fashion and Photographic
director: Nada Nadia Vagioka
Editor: Miranda Leonhardt
Arts editor: Marijana Condic
Creative and Design consultant:
Another ROMEOTM Design
Publisher
Oliver Daxenbichler and Nada
Nadia Vagioka

gatsby

Gatsby Magazine

The supercilious assumption that on a Sunday afternoon you have nothing better to do...

www.gatsbymagazine.com

Gatsby Magazine is part of the Cheekbone Couture Publishing Group

Goldsteinstrasse 61a
60528 Frankfurt / Main
Phone: +49 0 69 955 29 707
Fax: +49 0 69 955 29 708

NEUE PROBLEME

Das Magazin mit heißen Geschichten
Neue Probleme is an arty farty zine with text.
Quarterly, founded in 2006, 150 x 210 mm, 200 copies, 5€, German / English.
Editorial Office
Boltensternstr. 39
50735 Cologne
marcusboesch@hotmail.com
www.neue-probleme.de

novum

World of Graphic Design
Monthly, 230 x 297 mm, 8.60€, German / English.
Editorial Office
Dietlindenstrasse 18
80802 Munich
redaktion@novumnet.de
www.novumnet.de
Staff
Editor-in-chief: Bettina Ulrich
Publisher
New Media Magazine Verlag GmbH
Dietlinderstrasse 18
80802 Munich
Phone: +49 89 36 88 81 80
Fax: +49 89 36 88 81 81
www.novumnet.de

Ohio

Photomagazin
Founded in 1995.
Editorial Office
Eintrachtstr 54-56
50668 Cologne
www.ohiomagazine.de
Staff
Founder: Uschi Huber
Founder: Jörg Paul Janka

Outlook

Building Perspectives
Magazine for Architects, Designers and Engineers
Bi-annual, founded in 2004, 270 x 210 mm, Free, German / English.
Editorial Office
Ludwig-Erhard-Anlage 1
60327 Frankfurt am Main
michael.neser@fuenfwerken.com
www.outlook-info.de

PAGE

PAGE, the professional magazine for creative media design, publishing and trends, is a source of both inspiration and investment advice.
Monthly, founded in 1986, 210 x 297 mm, 7.95€, German.
Editorial Office
Leverkusenstrasse 54 VII
22761 Hamburg
www.page-online.de
Staff
Editor-in-chief: Gabriele Günder
Publisher
redtec publishing GmbH
Emmy-Noether-Strasse 2E
80992 Munich

Park Avenue

Founded in 2005, 210 x 275 mm, 6€, German.
Editorial Office
Hamburg
info@parkavenue-magazin.de
www.parkavenue-magazin.de
Staff
Publisher: Klaus Liedtke
Editor-in-chief:

Alexander Von Schönburg
Creative director:
Markus Thommen
Publisher
Gruner + Jahr AG and Co KG
Am Baumwall 11
20459 Hamburg
www.guj.de

Personal Folder

Art-Project
Published irregularly, founded in 2004, 170 x 230 mm, 10-30 copies, Variable price, No Text.
Editorial Office
Auenweg 173 / geb. 6
51063 Cologne
info@personal-folder.com
www.personal-folder.com
Staff
Founder and Editor: John Harten
Co-editor:
Sonia Jiménez Álvarez
Co-editor: Sven Lison
Co-editor:
Bernd Kleinheisterkamp
Publisher
John Harten

Photo Technik International

Das magazin für Foto-Profis
Monthly (10x / year), 230 x 300 mm, 7.65€, German.
Editorial Office
Munich
Staff
Editor-in-chief:
Hans-Eberhard Hess DGPh
Publisher
Jahr Top Special Verlag GmbH and Co
Jessenstrasse 1
22767 Hamburg

Port

Ausgesuchtes aus den Fakultäten der Bauhaus-Universität
Annual, founded in 2002, 3.50€, German.

Editorial Office
Bauhausstraße 11
99423 Weimar
port@fossi.uni-weimar.de
www.gonzo.uni-weimar.de/~port/

Public Folder

Book-sequence with main focus on the relation of pictures by using artist-contributions.
Published irregularly, founded in 2004, 170 x 230 mm, 1,000 copies, Variable price, English / German.
Editorial Office
Auenweg 173 / geb. 6
51063 Cologne
john@public-folder.com
www.public-folder.com
Staff
Founder and Editor: John Harten
Co-editor:
Sonia Jiménez Álvarez,
Co-editor: Sven Lison
Co-editor:
Bernd Kleinheisterkamp
Publisher
John Harten

Qompendium

Qompendium is an evolving and ever-changing platform for art and culture, represented by a series of print publications. English.
Editorial Office
Westendstrasse 11
65195 Wiesbaden
mail@qompendium.com
www.qompendium.com
Staff
Founder: Kimberly Lloyd
Publisher
Lloyd and Associates GmbH
Westendstrasse 11
65195 Wiesbaden
mail@lloyd-associates.de

Quer

Magazin für wilde Kreative
Founded in 2005, 190 x 297 mm,
German.
Editorial Office
Trier
quer@fh-trier.de
Staff
Editorial and Layout:
Sandra Wolter
Publisher
Fachhochschule Trier

Qvest

Qvest is an international
magazine based in Berlin: a city
packed with creative talent and
modern potential.
Every two months, 230 x 285
mm, 5€, German / English.
Editorial Office
Münzstrasse 14
10789 Berlin
contact@qvest.de
www.qvest.de
Staff
Publisher:
Constantin Rothenburg
Editor-in-chief: David Pfeifer
Publisher
Mediakom
Münzstrasse 14
10178 Berlin
www.mediakom.de

regina

Monthly, founded in 1994,
210 x 275 mm, 15€, English.
Editorial Office
Badstrasse 64
13351 Berlin
info@regina-magazine.de
www.regina-magazine.de
Staff
Founder and Editor:
Regina Möller
Publisher
artranspennine 98

Revolver

Zeitschrift für Film
Bi-annual, founded in 1998,
105 x 145 mm, 1,800 copies, 6€,
German.
Editorial Office
Schönhäuser Allee 130
10437 Berlin
kontakt@revolver-film.de
www.revolver-film.de
Staff
Editor: Jens Börner
Editor: Benjamin Heisenberg
Editor: Christophe Hochhäusler
Editor: Nicolas Wackerbarth
Publisher
Verlag der Autoren GmbH and
Co KG
Frankfurt
Phone: +49 0 69 23 85 74 0
Fax: +49 0 69 24 27 76 44

Roger

Design People Questions
Founded in 2004, 191 x 297 mm,
10,000 copies, 7.50€, German /
English.
Editorial Office
Auf Rheinberg 4
50676 Cologne
info@rogermagazine.net
www.rogermagazine.net
Publisher
daab GmbH
Friesenstr. 50
50670 Cologne
Phone: +49 221 9410 740
Fax: +49 221 9410 741
mail@daab-online.de
www.daab-online.de

Rund

Das Fussballmagazin
Monthly, 230 x 290 mm, 2.80€,
German.
Editorial Office
Pinneberger Weg 22-24
20257 Hamburg
info@rund-magazin.de
www.rund-magazin.de
Staff
Editor-in-chief: Rainer Schäfer
Publisher
Olympia Verlag GmbH
Bastrasse 4-6
90402 Nürnberg
Phone: +49 0911 2 16-0
www.olympia-verlag.de

Schnitt

Das Filmmagazin
Quarterly, 210 x 297 mm, 3€,
German.
Editorial Office
Breite Straße 118-120
50 667 Cologne
info@schnitt.de
www.schnitt.de
Staff
Editor-in-chief:
Olivier Baumgarten
Editor-in-chief:
Nikolaj Nikitin

Sepp

Sepp is the original magazine
that unites the two worlds of
fashion and football.
50,000 copies, 5€, English.
Editorial Office
Strassburger Strasse 38
10405 Berlin
editorial@sepp-magazine.com
www.sepp-magazine.com
Staff
Publisher and Editor-in-chief:
Markus Ebner

Shift!

Shift! pushes the limits of
publishing.
Published irregularly, founded
in 1996, Variable format,
1,500 - 2,500 copies, English.
Editorial Office
Choriner Strasse 50
10435 Berlin
info@shift.de
www.shift.de

Noticed a missing magazine?
Register it online: www.welovemags.com

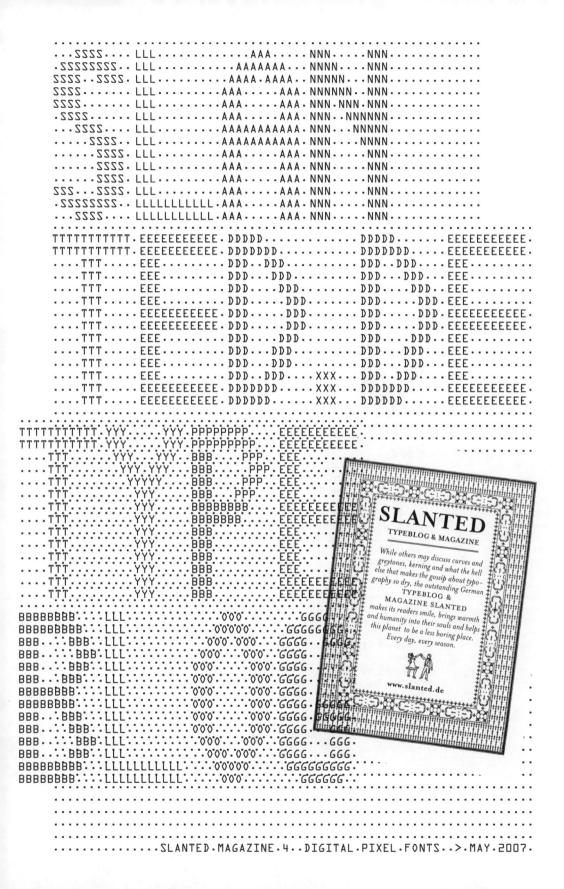

Staff
Art director: Anja Lutz
Publisher
gutentagverlag

Site Magazin
Bi-annual, founded in 1998,
210 x 280 mm, 1,300 copies,
11.80€, German / English.
Editorial Office
Lindenstrasse 47
40233 Düsseldorf
contact@sitesite.de
www.sitesite.de
Staff
Founder and Director:
Petra Rinck
Founder and Director: Ralf Brög
Publisher
hausammeer productions
40233 Düsseldorf
Phone: +49 0 211 6989733
contact@sitesite.de
www.sitesite.de

slack
**Surfen, Skateboarden,
Snowboarden**
245 x 320 mm, German.
Editorial Office
Hamburg
www.slackmag.de
Publisher
bandd Verlag GmbH
Osterfeldstraße 12-14
22529 Hamburg
Phone: +49 0 40 480007 22
Fax: +49 0 40 480007 29
christian.strobl@bdverlag.de
www.bdverlag.de

Slanted
Typography
Bi-annual, founded in 2005,
205 x 255 mm, 10,000 - 20,000
copies, 10€, German / English.
Editorial Office
Südenstr. 52
76135 Karlsruhe
www.slanted.de
Staff
Director: Lars Harmsen

sleek
magazine for art and fashion
sleek provides a platform for
contemporary art, photography
and fashion.
Quarterly, founded in 2003,
220 x 280 mm, 9.50€, English /
German.
Editorial Office
Potsdamer Platz 10
10785 Berlin
info@sleekmag.com
www.sleekmag.com
Staff
Publisher and Editor:
Lothar Eckstein
Art director: Christian Küpker
Publisher
sleek friends GmbH
Potsdamer Platz 10
10785 Berlin
Phone: +49 030 26 93 296
Fax: +49 030 26 93 2975
info@sleekmag.com
www.sleekmag.com

spatium
Magazin für Typografie
Annual, 150 x 230 mm, 15€,
German / English.
Editorial Office
Waldstrassee 10a
63065 Offenbach
info@typosition.de
www.typosition.de
Staff
Editor: Peter Reichard
Editor: Tanja Huckenbeck
Publisher
Peter Reichard
Waldstrasse 10a
63065 Offenbach
Phone: +49 69 260 178 65
info@spatium-magazin.de
www.spatium-magazin.de

Spector
cut + paste
A spectre is hunting Europe
Published irregularly, founded in
2001, 230 x 296 mm, 3,000
copies, 7€, German / English.
Editorial Office
Harkortstrasse 10
04107 Leipzig
spector@spectormag.net
www.spectormag.net
Staff
Founder and Publisher:
Tilo Schulz
Founder and Publisher:
Anne König
Founder and Publisher:
Markus Dreßen
Founder and Publisher:
Jan Wenzel

spex
Das Magazin für Popkultur
Monthly, 230 x 295 mm, 4.35€,
German.
Editorial Office
Rolandstrasse 69
50677 Cologne
www.spex.de
Staff
Editor-in-chief: Uwe Viehmann
Publisher: Alexander Lacher
Publisher
Piranha Media GmbH
Rolandstrasse 69
50677 Cologne
Phone: +49 0221 579 78 00
Fax: +49 0221 579 78 79
www.spex.de

squint
220 x 278 mm, 15€, English.
Editorial Office
Po Box 202105
20214 Hamburg
info@squintmagazine.com
www.squintmagazine.com
Staff
Publisher and Creative director:
Anita Mrusek
Publisher
Squint Magazine GmbH
Po Box 202105
20214 Hamburg
Phone: +49 40 46 77 97 37
Fax: +49 40 46 77 94 47
info@squintmagazine.com
www.squintmagazine.com

Streetwear
Today
International Styles
Streetwear Today is a magazine
for streetculture and everything

**Visit www.welovemags.com for an
updated version of the directory**

sleek

NO RELIGION
NO POLITIC
ART IS
TRUTH

related – from fashion to street art and music.
Quarterly, 240 x 340 mm, German / English.
Editorial Office
Bochum
www.streetwear-today.de
Staff
Editor-in-chief: Martin Magielka
Managing editor:
Kay Alexander Plonka
Editor: Romy Uebel
Publisher
Magseven GmbH
Karl-Lange-Straße 53
44791 Bochum
Phone: +49 0 234 58 80 85 0
Fax: +49 0 234 58 80 85 10
office@magseven.biz
www.magseven.biz

strippedbare

strippedbare is about new art and ideas and it's really the simplest, barest publication in the artworld.
Every two months, 2€, English.
Editorial Office
Memhardstr. 8
Berlin
helena@strippedbaremag.com
www.strippedbaremag.com

style and the family tunes
fashion music culture
Monthly, founded in 1993, 240 x 320 mm, 30,000 copies, 4.50€, German.
Editorial Office
Schlesischer Str. 28
10997 Berlin
style@spread.de
www.spread.de
Staff
Creative director:
Jay-Bo Monkey
Editor-in-chief: Cathy Boom
Art director: Jana Koch
Publisher
Boom Joint Publishing
Schlesische Str 28
10997 Berlin

Phone: +49 30 617 88 0
Fax: +49 30 617 88 111
style@spread.de
www.spread.de

sw magazin
Annual, founded in 1993, 6.50€, German.
Editorial Office
Flensburg
m.mueller@iworld.de
www.sw-magazin.com

Texte zur Kunst
Quarterly, founded in 1990, 166 x 230 mm, German.
Editorial Office
Torstr. 141
10119 Berlin
redaktion@textezurkunst.de
www.textezurkunst.de
Staff
Co-founder and Editor:
Isabelle Graw
Publisher
Texte zur Kunst Gmbh
Torstr. 141
10119 Berlin
Phone: +49 30 28 04 79 11
Fax: +49 30 28 48 49 38
www.textezurkunst.de

TUSH
Beauty all over
Quarterly, founded in 2005, 220 x 285 mm, 5€, German.
Editorial Office
Barmbeckerstrasse 33
22303 Hamburg
info@tushmagazine.com
www.tushmagazine.com

Staff
Director and Editor-in-chief:
Armin Morbach
Art director: Stefan Pietsch
Art director: Georgina Lim

useless
Bi-annual, 225 x 242 mm, 30,000 copies, 9.99€, German / English.
Editorial Office
Malsenstrasse 84
80638 Munich
useless@starshot.de
www.useless-mag.de
Staff
Editor-in-chief:
Kai Stuht v. Neupauer
Creative director: Tina Weisser
Art director: Lars Harmsen
Publisher
Messe München GmbH ispo and Starshot GmbH and Co KG

Visuell International
The news magazine of the picture industry
Every two months, 162 x 225 mm, 5.50€, English.
Editorial Office
www.piag.de
Staff
Publisher: Dieter Brinzer
Editor: Dr Stefan Hartmann
Publisher
PIAG Presse Informations AG
Landstrasse 67a
76547 Sinzheim
www.piag.de

Vogue Deutschland
Monthly, 212 x 277 mm, 6€, German.
Editorial Office
Ainmillerstrasse 8
80801 Munich
media@condenet.de
www.vogue.de
Publisher
Condé Nast Publications
Piazza Castellano 27
20121 Milan
Italy
Phone: +39 02 856 11
Fax: +39 02 805 57 61

Vogue Business
Bi-annual, 168 x 223 mm, 4€, German.
Editorial Office
Ainmillerstrasse 8
80801 Munich
redaktion@voguebusiness.de
Staff
Director: Bernd Runge
Editor-in-chief: Christiane Arp
Art director: Thomas Giller
Publisher
Condé Nast Publications
Piazza Castellano 27
20121 Milan
Italy
Phone: +39 02 856 11
Fax: +39 02 805 57 61

Visit www.welovemags.com for an updated version of the directory

Von Herzen

133 (numbered) copies, 6.50€, German.
Editorial Office
info@vonherzenweb.de
www.vonherzenweb.de
Staff
Founder: Jonas Natterer
Founder: Matthias Prechtl
Founder: Falko Ohlmer
Founder: Sebastian Schöpsdau

vorn magazin

Vorn, the magazine for design.
Bi-annual, 210 x 296 mm, 18€,
German / English.
Editorial Office
Barmbeker Strasse 33
22303 Hamburg
mail@vornmagazine.com
www.vornmagazine.com
Staff
Publisher: Joachim Baldauf
Publisher: Agnes Feckl
Publisher
Printkultur Gbr
Hamburg

Zonic
**Kulturelle Randstandsblicke
und Involvierungsmomente**
German.
Editorial Office
Gützkower Str. 59
17489 Greifswald
zonic@wortwelt.org
www.zonic.de

Zoo magazin

Bi-annual, founded in 2003,
230 x 298 mm, 4€, German.
Editorial Office
Strausberger Platz 4
10243 Berlin
info@zoomagazine.de
www.zoomagazine.de
Staff
Editor-in-chief: Sandor Lubbe
Editor-in-chief: Claudia Riedel
Executive editor in English:
Rebecca Voight
Publisher
Melon Collie
info@zoomagazine.de
www.zoomagazine.de

Greece

+design

Publication concerning graphic
design, illustration, web design
and product design.
Every two months, founded in
1998, 210 x 275mm, 5€, Greek.
Editorial Office
Sokratous 157
176 73 Athens
info@designmag.gr
www.designmag.gr

Charley

Charley is a pre-digested
combine, with pages assembled
from catalogues, brochures, press
clips, postcards, and other visuals.
Published irregularly, founded in
2000, Variable format, $10,
English.
Editorial Office

Filellinon 11 and Em. Pappa street
N.Ionia 142 34 Athens
info@deste.gr
www.deste.gr
Staff
Founder and Editor:
Maurizio Cattelan
Founder and Editor:
Massimiliano Gioni
Founder and Editor:
Ali Subotnick
Founder: Bettina Funcke
Designed by:
the Purtill Family Business

OZON

Greek magazine, covering art,
fashion and music from all around
the world, in a unique way.
Monthly, founded in 1996,
235 x 280 mm, 30,000 copies,
Free, Greek / English.
Editorial Office
Valtetsiou 50-52
10681 Athens
info@ozonweb.com
www.ozonweb.com

parallaxi
**ideas, stories, trends, people,
cities... where the cinema
meets life.**
Monthly, founded in 1989,
270 x 340 mm, 25,000 copies,
Free, Greek.
Editorial Office
216 Delfon
54655 Thessaloniki
paralaxi@hol.gr
Staff
Founder and Editor-in-chief:
George Toulas
Publisher
Katerina Karamfilidou
216 Delfon Str
54655 Thessaloniki
Phone: +30 2310429050
Fax: +30 2310429051

Guatemala

taxi

A publication showing the world
a different side of Guatemala:
fun, cosmopolitan, entertaining
and proactive.
Every two months, founded in
2004, 10,000 copies, Free,
Spanish / English.
Editorial Office
Vía 4, 1-30, Vía Zanetto,
Interior #4, Zona 4
4 Grados Norte Guatemala
info@revistataxi.com
www.revistataxi.com
Staff
Founder and Director:
Juan Manuel Alvarado
Founder and Director:
Alejandro de León
Publisher
Sin Título S.A.
Vía 4, 1-30 Vía Zanetto,
Interior #4, Zona 4
4 Grados N Guatemala
Phone: +502 23 62 97 10
Fax: +502 23 62 97 01

Hungary

PEP! magazine

PEP! is about lifestyle, fashion,
design, and culture
Quarterly, founded in 2003,
216 x 279 mm, 12,000 copies,
590 HUF, Hungarian.
Editorial Office
Jozsef Attila u. 24
1051 Budapest
info@pepmagazin.hu

www.pepmagazin.hu
Staff
Managing editor-in-chief:
Zsuzsanna Karpati
Art director: José Simon
Publisher
Optimal Marketing Bt.
1091 Budapest

praesens
**central european
contemporary art review**
Founded in 2002, English /
German.
Editorial Office
Filler u. 27
1024 Budapest
www.praesens.net
Staff
Editor-in-chief: Mária L. Molnár
Publisher
Praesens Bt.
Filler u. 27
1024 Budapest
www.praesens.net

India

Art India
Magazine about Indian art
and creation.
Founded in 1990, 220 x 290 mm,
English.
Editorial Office
Jindal Mansion, 5a,
Dr. G. Deshmukh Marg
400 026, Mumbai
Publisher
Art India Publishing Co. Pvt. Ltd.
Jindal Mansion, 5a,
Dr. G. Deshmukh Marg
400 026 Mumba
Phone: +91 22 496 3000
Fax: +91 22 496 1400

Better Photography
**Better Technique. Better
Insight. Better Pictures.**
Monthly, INR 50, English / Hindi.
Editorial Office
InfoMedia India, Ruby House,
A Wing, JK Sawant Marg,
Dadar, Mumbai
400028 Mumbai
www.betterphotography.in

Kyoorius Design Magazine
**A Design magazine by
Kyoorius Exchange**
A magazine that aims to cover
Indian design scene and provide
designers a platform to showcase
and share their work in a hope to
bring about a positive change on
the Indian design scene.
Quarterly, English.
Editorial Office
Mumbai
magscene.com@gmail.com
Publisher
Kyoorius Exchange
5 Garment House 37/43
Worli, Mumbai

The Little Magazine
The Little Magazine is a journal
of ideas and letters with a special
interest in literature in translation
from the 25-odd languages of
South Asia.
Every two months, founded in
2000, 210 x 297 mm, 3,000-5,000
copies, English.
Editorial Office
A 708 Anand Lok, Mayur Vihar 1
110091 Dehli
writenow@littlemag.com
www.littlemag.com
Staff
Editor: Antara Dev Sen
Publisher: Pratik Kanjilal

Ireland

CIRCA Art Magazine
**Ireland's leading magazine
for contemporary visual arts
and culture**
Quarterly, founded in 1999,
215 x 265 mm, English.
Editorial Office

43/44 Temple Bar
2 Dublin
info@recirca.com
www.recirca.com
Staff
Editor: Shirley MacWilliam
Editor: Luke Gibbons
Editor: Brian Kennedy

Hot Press
With an abiding commitment to
music at its core, it remains the
essential guide to rock, pop,
dance and all the best in
contemporary music, both
nationally and internationally.
Every two months, £2.75, English.
Editorial Office
13 Trinity St
28010 Dublin
info@hotpress.com
www.hotpress.com

Irish Arts review
Quarterly, founded in 1984,
£6.80.
Editorial Office
State Apartments, Dublin Castle
Dublin 2 Dublin
info@irishartsreview.com
www.irishartsreview.com
Staff
Editor: John Mulcahy

Printed Project
Printed Project is an ongoing
collaboration amongst artists,
critics and curators, writers and
readers devoted to making sense
of contemporary art and culture.
Bi-annual, English.
Editorial Office
Cnr Halston St / Marys Lane
Dublin 7
info@visualartists.ie
www.visualartists.ie/AP_printed_
project.html
Publisher
Visual Artists Ireland

Source
photographic review
Source is the leading UK and Irish
photographic review.
Quarterly, founded in 1991,
£4.25, English.
Editorial Office
Po Box 352
BT1 2WB Belfast

info@source.ie
www.source.ie
Staff
Editor: John Duncan
Editor: Richard West
Publisher
Photo Works North

Israel

(H)earat Shulaym
(Note in the Margin)
Independent Journal of
Contemporary Art and
Literature.
Published irregularly, founded in
2001, 240 x 325 mm,
1,000 - 1,200 copies, 11€.
Editorial Office
Po Box 24169
91240 Jerusalem
salamanca00@gmail.com
www.no-org.net
Staff
Editor: Lea Mauas
Editor: Diego Rotman

Block
**Architecture / City / Media /
Theory**
Quarterly, founded in 2005,
185 x 250 mm, 6,000 copies,
76 NIS, Hebrew / English.
Editorial Office
27 Sutin St., Office 105
64684 Tel Aviv
info@blockmagazine.net
www.blockmagazine.net
Staff

parallaxi

where cinema meets life

ideas_stories
trends_ people
city_cinema

23|0

parallaxi

ΘΕΣΣΑΛΟΝΙΚΗ: Ο ΠΛΑΝΗΤΗΣ ΤΗΣ ΑΝΕΡΓΙΑΣ

monthly city & cinema review
216 Delfon str. 546 55
Thessaloniki Greece
Tel+Fax: +32310 429050-51
paralaxi@hol.gr

Founder and Editor-in-chief:
Carmella Jacoby-Volk
Founder and Editor-in-chief:
Iftach Aloni
Editor: Shira Sprecher
Editor: Anat Messing
Graphic designer: Gila Kaplan
Editor: Einat Manoff
Graphic designer: Kobi Franco
Graphic designer:
Nirit Binyaminy

Italy

800zine

800zine is an automatic
illustration fanzine
297 x 420 mm, 100 copies, Free,
Italian.
Editorial Office
Via California 1a
20144 Milan
info@800zine.org
www.800zine.org
Staff
Sara Bianchi
Silvia Gherra
Giulia Guarnieri
Davide Di Gennaro
Davide Longaretti
Alessandro Maffioletti
Stefano Piccardo
Davide Rap
Fabio Rodaro

Abitare

Monthly, £7.50
Editorial Office
Via Ventura, 5
20134 Milano
www.abitare.it
Staff
Editor: Fulvio Irace
Editor: Maria Giulia Zunino

Seen a magazine
that is no longer
published?
Go online: www.
welovemags.com

Amica

Monthly, 215 x 285 mm, 2.50€,
Italian.
Editorial Office
Via Rizzoli 2
20123 Milan
amica@rcs.it
Staff
Editor: Daniela Bianchini
Editor-in-chief: Mario Cinelli
Publisher
RCS Mediagroup
Via Angelo Rizzoli 2
20132 Milano
www.rcsmediagroup.it

ARIA MAGAZINE

Aria-magazine for travellers is the
first magazine on "emotional
geography"
Quarterly, founded in 2005,
216 x 356 mm, 5€, English / Italian.
Editorial Office
Via cuore immacolato di maria 10a
20141 Milano
aria@ariamagazine.com
www.ariamagazine.com

Basement

Sounds and Urban Beats
Every two months, founded
in 2006, 210 x 297 mm,
80,000 copies, Italian.
Editorial Office
Viale S. Antonio 11
66034 Lanciano (Ch)
francesco@defragmag.com
www.basementmag.it
Staff
Art director: Francesco Galluppi
Editor-in-chief: Sara De Deo
Editor: Move Editore
Marketing: Davide Finzi
Publisher
MOVE Editore
Viale S. Antonio, n. 11
66034 Lanciano
info@defragmag.com
www.defragmag.com

Boiler

**Contemporary Art and
Cultural (R)evolutions**
Bi-annual, founded in 2001,
170 x 240 mm, 15,000 copies,
10€, English.
Editorial Office
Via Palmieri 34
20141 Milan
ivan@boilermag.it
www.boilermag.it
Staff
Creative director:
Susanna Cucco
Editor-in-chief: Ivanmaria Vele
Publisher
Boiler Corporation
Via Adda 87
00198 Rome
Phone: +39 06 4543 7275
info@dragolab.it

Book Moda (world)

Book Moda is full of exclusive
fashion photos, the most
important labels, the hottest
trends and the coolest
accessories.
Editorial Office
Via A. Manzoni,26
20089 Rozzano
www.bookmoda.com
Staff
Editor-in-chief:
Giovanna Roveda

caffe latte

Monthly, 200 x 270 mm, 6€,
Italian.
Editorial Office
Via Bettola 18

20092 Milan
caffelattemag@hotmail.com
Staff
Director: Fabrizio Ferrini

Carnet

Monthly, 110 x 145 mm, Italian.
Editorial Office
Via G. Fantoli 6/7
20138 Milan
carnet@darp.it
Staff
Managing editor:
Fausto Tatarella

Cluster

on innovation
Using an open and
multidisciplinary approach and
bringing together authoritative
articles and an avant-garde
graphic design.
Founded in 2003, 15,000 copies,
Italian / English.
Editorial Office
Turin
www.progettocluster.com
Staff
Editor-in-chief: Carlotta Oddone
Editor: Marcia Caines
Publisher
Cluster s.r.l.
Via Della Basilica 13
10122 Torino
Phone: +39 011 0702032
Fax: +39 011 52 16 164
f.degiuli@progettocluster.com
www.progettocluster.com

Collezioni

For years on the international
market with ever growing
success, the fashion magazines of
the *Collezioni* series punctually
and widely cover all sectors of
fashion, from men's and women's
clothing, to fashion for child-care
and infancy, accessories and
materials (fabrics and yarns),
bridal gowns, and the latest
streetwear and urban style trend

know what you don't know.

DROME
magazine

photo by Thomas Tukker for DROME magazine

English / Italian.
Editorial Office
Modena
www.logos.info
Staff
General manager:
Mauro Cagnoni
Editorial assistant: Anna Brida
Editorial assistant: Lidia Casari
Publisher
Logos Publishing, Srl.
Via Curtatona, 5/2
41100 Modena

Colors

Monthly, English / Spanish /
French / Italian / German.
Editorial Office
Villa Minelli
31050 Ponzano
colors@colors.it
www.colorsmagazine.com
Staff
Creative director:
Emily Oberman
Publisher
Colors Magazine s.r.l.
Villa Minelli
31050 Ponzano
letters@colors.it
www.colorsmagazine.com

Coolissimo

Stay-up-magazine
Coolissimo Bag-a-zine
Founded in 2001, Free,
10,000 copies, Italian.
Editorial Office
info@coolissimo.it
www.coolissimo.it

Cross

**A periodical of culture and
art steeped in defeatism, but
irresistibly so.**
Bi-annual, founded in 2003, 6€,
English.
Editorial Office
Via Alberto Mario 67
20149 Milano

valerio@crossmagazine.com
www.crossmagazine.com
Staff
Editor-in-chief: Valerio Spada
Art director: Kasia Korczak

Cube

Editorial Office
via Giardini, 476 / N
41100 Modena
info@sartoria.com
www.cubemag.com

Defrag

Art | Music | Urban Culture
Defrag Magazine captures the
spirit that animates the elements
of urban reality.
Bi-annual, founded in 1997, 18€,
10,000 copies, Italian / English.
Editorial Office
Viale S. Antonio 11
66034 Lanciano
info@defragmag.com
www.defragmag.com
Staff
Art director: Francesco Galluppi
Staff: Sara De Deo
Publisher: Move Editore
Publisher
MOVE Editore
Viale S. Antonio, n. 11
66034 Lanciano
info@defragmag.com
www.defragmag.com

Domus d'Autore

Annual, £ 16, Italian.
Editorial Office
redazione@domusweb.it
www.domusweb.it

Drome magazine

arts / cultures / VISIONS
Quarterly, founded in 2004, 7 €,
30,000 copies, Italian / English.
Editorial Office
Via Riccio da Parma 18
00176 Rome
drome@dromemagazine.com
www.dromemagazine.com
Staff
Creative director: Stefan Pollak
Editorial director:
Rosanna Gangemi
Publisher
Phlegmatics
Via delle Officine 15
98040 Venetico/M.
www.phlegmatics.com

Exibart

The most important and popular
art review in Italy
Every 6 weeks, founded in 1996,
30,000 copies, Italian.
Editorial Office
Via Calimaruzza 1
50123 Firenze
direttore@exibart.com
www.exibart.com

FAB Magazine

FAB is conceived to explore the
fascinating interaction between
images and text, at the same
time, it is the result of different
people and experiences that
meet by chance.
Quarterly, founded in 2004,
199 x 270 mm, Free, English.
Editorial Office
Via Ferrarezza
31020 Catena di Villorba

fabrica@fabrica.it
www.fabrica.it
Staff
Editor-in-chief: Sara Beltrame
Publisher
Fabrica
Via Ferrarezza
31050 Catena di Villorba
Phone: +39 0422 51 61 11
Fax: +39 0422 51 63 08

Flash Art

**The world's leading art
magazine**
Every two months, 205 x 270 mm,
7€, Italian / English.
Editorial Office
Via Carlo Farini 68
20159 Milano
info@flashartonline.com
www.flashartonline.it
Staff
Editor: Chiara Leoni
Editor: Valentina Sansone
Publisher
Giancarlo Politi Editore sas

Garage Magazine

Graffiti and visual amusement,
based in Italy and sold worldwide.
Bi-annual, founded in 1998,
210 x 297 mm, 12,000 copies,
7.50€, Italian / English.
Editorial Office
Galleria Manzoni 28
27100 Pavia
info@garagemagazine.net
www.garagemagazine.net
Staff
Federico Chiozzi
Stefano Viola
Savoldelli Luca
Scrinzi Alessandro
Rivasi Pietro

LABEL

vita contemporanea

architettura

moda

The contemporary

design

indipendente Italian style magazine

loved by a tiny handful of

arte

visionary people all over

musica

the world.

cinema

fiction

Grab

**Street Culture,
Contemporary Subjects,
Pop Art, Design Books, Art
Galleries, Concept Stores,
Poster, Stickers**
Every two months, founded in
2006, 297 x 210 mm, 60,000
copies, Italian / English.
Editorial Office
Via C.G. Bertero 45
00156 Rome
matteo@grabmagazine.it
www.grabmagazine.it

HOT

Monthly, founded in 2003,
190 x 260 mm, Free, Italian.
Editorial Office
Via Boiardo
620127 Milan
hot@eclettika.net
Staff
Director: Doriano Zunino
Art director: Christoph Radl
Editor-in-chief:
Pierfrancesco Pacoda

kult

**Fashion - Art - Music - Film -
Talents**
Monthly, founded in 1998,
230 x 280 mm, 110,000 copies,
4.90€, Italian / English.
Editorial Office
Via Cadolini 34
20137 Milano
segreteria@edizionipem.it
www.kultmagazine.com
Staff
Director: Enrico Cammarota

Art director: Giovanni Aponte
Fashion editor:
Alessandra Pellegrino
Publisher
Edizioni Pem srl
Via Cadolini 34
20137 Milano
Phone: +39 028 90 75 700
Fax: +39 025 50 16458
segreteria@edizionipem.it
www.edizionipem.it

Label

**the Italian style magazine for
international dreamers**
Quarterly, founded in 2001,
240 x 297 mm, 25€, Italian /
English.
Editorial Office
Via Regaldi 7 int 12/a
10154 Torino
label@labelmag.com
www.labelmag.com
Staff
Creative and Editorial director:
Luca Ballarini
Editor: Federico Confalonieri

l'Arca

Monthly, founded in 1986,
240 x 340 mm, 41,600 copies,
9€, Italian.
Editorial Office
Via Valcava 6
20155 Milano
arca@tin.it
www.arcadata.com
Staff
Editor-in-chief: Cesare M. Casati
Publisher
Cesare Maria Casati

Lineagragrafica

Every two months, Italian /
English.
Editorial Office
C. so Garibaldi 64
20121 Milano
linegrafica@progetto-ed.it
www.lineagrafica.progetto-ed.it
Staff
Editorial director: Giusi Brivio
Director and Art director:
Giovanni Baule

Max Italy

Monthly, 205 x 286 mm, 5€,
Italian.
Editorial Office
Via Rizzoli 2
Milan
max@rcs.it
www.max.rcs.it

mood

210 x 260 mm, 10€, Italian /
English.
Editorial Office
Corso Venezia 26
20121 Milano
www.moodmagazine.net
Staff
Art director:
Alessandrao Casinovo
Director: Gianni Bertasso
Publisher
Ventisei Editrice srl
Corso Venezia 26
20121 Milano
Phone: +39 02 7771 701
Fax: +39 02 760 22 311
www.moodmagazine.net

Mug Magazine

Mug is a magazine dedicated to
training, information and
communication in the fields of
fashion and design.
Bi-annual, founded in 2001,
300 x 200 mm, 12,000 copies,
Free, Italian / English.
Editorial Office
Via Paris Bordone 14/16
31100 Treviso
marco.altan@mugmagazine.com
www.mugmagazine.com

Muse

**The Fashion and visual
culture magazine**
Quartely, founded in 2005,
230 x 300 mm, 9.90€, English /
Italian.
Editorial Office
Via Della Moscova 60
20121 Milan
info@magmuse.com
www.magmuse.com
Staff
Editor-in-chief: Fabio Crovi
Creative director:
Giovanni Russo
Vice editor-in-chief:
Sophie Hirtzel
Publisher
Mag Srl
Via della Moscova, 60
20121 Milano
Phone: +39 02 29 01 4376
Fax: +39 02 29 01 4537
info@magmuse.com
www.magmuse.com

Neo Head

Street Magazine
English / Italian.
Editorial Office
Via Bonelli 2/c
Torino
info@neo-head.net
www.neo-head.net
Staff
Direction, Art direction and
Photography: Enrico Frignani

Most utopian experiments have failed, or appear as unwanted failures sooner or later. God gave me language and my profit of it is that I can lie. **I like mystery to happen in plain daylight. We are like 21st century alchemists, turning trash into treasure.** Politics is a way of re-partitioning the political from the non-political. THE WORLD IS ALWAYS BURNING.

I think in terms of contemporary art, process isn't as important as ideas anymore.

More than the word consumerism, I'm fascinated by seventies B– movies, or by Vincent Price, Klaus Kinsky, people like that. In future I would love to be able to create a horror vocabulary that is purely abstract. **Art is a small educated community. MEMORY IS A SCAR...**

"Aesthetic" is a dangerous word.
They are ciphers of the potential monstrousity that haunts the utopian plans of "mankind".

Faith, vision and courage are still all you need to change the world. **I think I never liked the really literal method of storytelling.**

I think it's possible for art to occupy a different realm. **CHARLATANS OF TODAY!**
The use value is to calm and to distract.
I never liked the artificial isolation.

A few years ago, I made shorter videos because I wanted to gain an audience and it wasn't working with thirty-minute epics, because of the art-world's three second attention span. I was musing about the supposed sedative qualities of these artworks in airports, banks, and lounges.

Nostalgia is a blanket
THE FREE MARKET ALLOWED US TO INDULGEIN THE IMPORTS OF IT'S POPULAR CULTURE. Maybe even the ideas are ok to give away.

THESE ARE BANAL SIMPLE OBJECTS THAT CREATE A NIGHTMARE.
I just try to make each painting the very best I can.
I'm more interested in trying to convey feelings that are more layered and not so easy to define.

THE CURRENT ART WORLD PARTICIPATES IN A CONSERVATIVE VERSION OF RADICAL, I AM MORE INTERESTED IN A RADICAL VERSION OF CONSERVATIVE. I then mix them all up, maybe creating an improbable combination.
I really don't know shit about the art world.

UOVO

an independent voice for contemporary art

§§§

>>>>>>>>>www.uovo.tv<<<<<<<<<

As art and the everyday become more indistinguishable the artists' role as a critical voice becomes imperative. What today separates "us" from "them" is only a very thin polished surface that is never srtongenough to conceal the fact that they are just regular people to begin with, so they are constantly embarrassing themselves both ways. **The priests who make daily sacrifices of integrity in order to keep the gods of profit happy.** IT'S NOT ART, IT'S THIS THING THAT WANTS TO CHANGE THE WORLD... IT LEADS TO CONFLICTIVE, DISJOINTED AND UNCERTAIN DISPLAY OF MOVEMENT AND SPEECH.

Neural
new media art, electronic music, hacktivism
Tri-Annual, founded in 1993, 210 x 275 mm, 6,000 copies, 5€, English.
Editorial Office
Via Lucarelli 16/i
70124 Bari
a.ludovico@neural.it
www.neural.it
Staff
Founder and Publisher:
Alessandro Ludovico
Publisher
Neural
via Lucarelli 16/i
70124 Bari

Next Exit
creatività e lavoro
Art, net art, photography, visual communication, video and digital world, cinema, 3D animation, advertisement, design, graphic, comics, fashion, textile production. Monthly, founded in 2002, 240 x 280 mm, 6€, Italian.
Editorial Office
Via Pesano, 35
00176 Roma
redazione@nextexit.it
www.nextexit.it
Staff
Managing editor: Lucas Marmigi
Director: Daniela Ubaldi
Editor-in-chief: Sabrina Ramacci

Pig
Monthly, founded in 2002, 4€
Editorial Office
Via San Giovanni Sul Muro 12
20121 Milano
www.pigmag.com

Staff
Managing editor:
Daniel Beckerman

Playzebra
Interactive crossing between contemporary art and visual design. Bi-annual, founded in 2003, 140 x 280 mm, 5,000 copies, 10€, Italian / English.
Editorial Office
Via Verdi 12
10124 Torino
look@playzebra.it
www.playzebra.it
Staff
Editor-in-chief: Anna Follo
Founder: Paolo Stenech
Founder: Beppe Vaccariello
Founder: Andrea Tambosco
Translation editor: Sarah Dewilde
Founder: Russo Nello
Press office and PR:
Diego Moriondo
Founder: Otto Riello
Publisher
ZEBRA SRL
Torino
Phone: +39 011 81 36 068
Fax: +39 011 81 36 068
info@zebra.to.it
www.zebra.to.it

Private
International review of black and white photographs and text.
Quarterly, founded in 1992, 240 x 280 mm, Italian / English / French.
Editorial Office
Via Marsala 20
40126 Bologna
private@private.it
www.privatephotoreview.com
Staff
Editor-in-chief: Oriano Sportelli

Rivista di Psicologia dell'Arte
A magazine about empirique aesthetic and psychology of art. Annual, founded in 1979, 170 x 240 mm, Italian / English.
Editorial Office
20 Via dei Pianellari
00186 Roma
Staff
Editor-in-chief: Sergio Lombardo

Rodeo
The First Italian Free Fashion Magazine
Monthly, founded in 2003, 265 x 380 mm, 215,000 copies, 2€, Italian.
Editorial Office
Via Forcella 13
20144 Milan
info@rodeomagazine.it
www.rodeomagazine.it
Staff
Founder and Publisher:
Simona Varchi
Managing editor:
Porzia Bergamasco
Art director and Fashion:
Tim McIntyre
Editor-in-chief:
Massimo Torrigiani

Simultaneita
To promote the strength of new media arts scene and the Futurist legacy.
Irregular, founded in 1997, 150 x 210 mm, 5€, Italian / English.
Editorial Office
Via Isole Curzolane 18/E
00139 Roma
info@simultaneita.net
www.simultaneita.net
Staff
Editor and Publisher: Giulio Lotti

Sportswear International
Sportswear International is the only worldwide trade magazine that covers jeanswear, sportswear, activewear, outerwear, contemporary clothing, young designers, new menswear and casualwear, footwear and the textile market. Every two months, founded in 1975, 265 x 330 mm, German / English.
Editorial Office
Via Forcella 3 - palazzo c
20144 Milan
zeine@sportswearnet.com
www.sportswearnet.com
Staff
Executive editor: Sabine Kühnl
Art direction: Gian Luca Fracassi
Production: Sacha Majidian
Publisher
Klaus N. Hang
Phone: + 39 02 58169 1
Fax: + 39 02 89401 674
editor@sportswearnet.com

Stirato
Poster Magazine
Art magazine
Quarterly, founded in 2003, 150 x 210 mm, 7,000 copies, Free, Italian.
Editorial Office
Via Marcello II 29
00164 Rome
info@stirato.net
www.stirato.net

sugo
sugo goes through all the different expressions of visual arts
Bi-annual, founded in 2003, 230 x 300 mm, 22€, Italian.

STREET

FRUiTS

TUNE

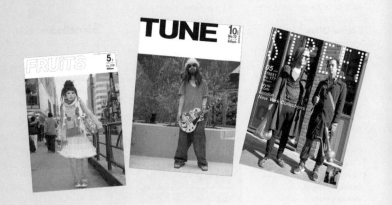

Editorial Office
Cannaregio 4132
30131 Venice
info@sugomagazine.com
www.sugomagazine.com
Staff
Editor-in-chief: Giorgio Camuffo
Coordination: Massimo De Luca
Creative director:
Sebastiano Girardi
Managing editor:
Michela Miracapillo

Tema Celeste

Every two months, founded in
1983, 8€.
Editorial Office
10 Piazza Borromeo
Milan
editorial@temaceleste.com
www.temaceleste.com
Staff
Executive Director:
Simona Vendrame
Publisher
ACS Editore S.r.l.
3 vai del Caravaggio
Milan

The End.

Fashion, Art, Music, Culture
Every two months, founded in
2006, 220 x 284 mm, 5€, Italian /
English.
Editorial Office
Via Vigevano 27
20144 Milano
info@theendmagazine.com
www.theendmagazine.com

The Plan

Every two months, £12, English /
Italian.
Editorial Office
Via del Pratello 8
40122 Bologna
serena.preti@centauro.it
www.theplan.it

This is a Magazine

This is not a Magazine
It has words and pictures in it.
Published irregularly, Variable
format, 1,400 copies, English.
Editorial Office
Viale Coni Zugna 4
20144 Milan
hello@thisisamagazine.com
www.thisisamagazine.com
Staff
Founder and Publisher:
Andy Simionato
Founder and Publisher:
Karen ann Donnachie
Publisher
Studio Donnachie / Simionato
Milan

UOVO

**an independent voice for
contemporary art**
Quarterly, founded in 2000,
170 x 240 mm, 10,000 copies,
10€, English / Italian.
Editorial Office
Via Maria Vittoria 49
10123 Torino
uovo@thebookmakers.net
www.uovo.tv
Staff
Publisher: Chiara Figone
Publisher: Franck Veyrieres

Vogue Italia

Monthly, 205 x 274 mm, 5€, Italian.
Editorial Office
Piazza Castello 27
20121 Milano
www.voguevanity.it
Publisher
Condé Nast Publications
Piazza Castellano 27
20121 Milan
Phone: +39 02 856 11
Fax: +39 02 805 57 61

Work

In a transitory epoch, in which the
shift towards the virtual is not yet
complete, there is maybe a need
for an instrument, an interface
between the material and the
immaterial. The magazine *Work*
may fulfill this function.
Quarterly, £5.50.
Editorial Office
Via Belenzani 46
38100 Trento
www.workartonline.it

yesplease

**The fashionable luxury
lifestyle magazine**
Quarterly, founded in 1990,
230 x 300 mm, 5€, English.
Editorial Office
Via Boccaccio 45
20123 Milan
yesplease@tin.it
www.yesplease.it
Staff
Editor-in-chief:
Trevor Albert Panton
Publisher
yesplease

Via Boccaccio 45
21123 Milano
Phone: +39 02 462 185
Fax: +39 02 433 177 68
yesplease@tin.it
www.yesplease.it

ZA!revue

**independent graphic
magazine**
It's a experimental project that
doesn't have fixed rules. Since
2004 is strongly supported by
segnoruvido.it
Published irregularly, founded in
2003, 160 x 160 mm, 100,000
copies, 10€, English / Italian /
German.
Editorial Office
Viale Corsica 1
20133 Milano
info@zarevue.org
www.zarevue.org
Staff
Filippo Anglano
Luca Bogoni
Simone Ferraro

Japan

+81

Introduces the world's most
respectful designers and artists.
Quarterly, founded in 1997,
210 x 297 mm, 1,200 Yen,
Japanese / English.
Editorial Office
Tokyo
plus81@dd-wave.co.jp
www.plus81.com
Staff
Director: Satoru Yamashita
Publisher
D.D.Wave CO.LTD
2-2-22 Jingumae, Shibuya-ku
Tokyo
Phone: +81 3 5411 5725
Fax: +81 3 5414 5236

beikoku
Editorial Office
Mifune Bldg. #605,
1-5-14 Jinnan, Shibuya-ku,
150-0041 Tokyo
webmaster@beikoku-ongaku.com
www.beikoku-ongaku.com

Bridge
Popular music culture
Every two months, Japanese.
Editorial Office
Tokyo
www.rock-net.jp

Brutus
210 x 285 mm, Japanese.
Editorial Office
www.brutusonline.com
Staff
Editor-in-chief:
Takefumi Ishiwatari
Art director: Yasushi Fujimoto
Deputy editor: Yoshio Suzuki
Deputy editor: Nobuaki Shibasaki
Deputy editor: Keiko Yamamoto
Chief designer: Takaaki Sakurai
Publisher
Magazinehouse Ltd

BUZZ
BUZZ was thus launched to
explore this expanding universe
of music, free of traditional
rock values.
Every two months, Japanese.
Editorial Office
Tokyo
www.rock-net.jp
Publisher
Rockin'on

Casa Brutus
Editorial Office
www.brutusonline.com/casa/
index.jsp
Publisher
Magazinehouse Ltd

Comic H
Comic H is dedicated to manga
and to the distinct culture
surrounding it.
Quarterly, founded in 2000,
Japanese.
Editorial Office
Tokyo
www.rock-net.jp

commons & sense
Seasonal glossy fashion magazine
from Japan. Slick, intelligent, edgy.
Published irregularly, founded in
2001, 448 Yen, English / Japanese.
Editorial Office
www.commons-sense.net
Staff
Editor-in-chief and Creative
director: Kaoru Sasaki
Fashion editor: Shun Watanabe
Publisher
Kaoru Sasaki- Cube Inc.
808 4-10-20 Minamisenba
Chuo-ku
542-0081 Osaka
Phone: +81 03 5420 8724
Fax: +81 03 5420 7708
info@commons-sense.net

commons & sense Man
667 Yen, English / Japanese.
Editorial Office
info@commons-sense.net
www.commons-sense.net
Staff
Editor-in-chief and Creative
director: Kaoru Sasaki
Publisher
Kaoru Sasaki- Cube Inc.
808 4-10-20 Minamisenba
Chuo-ku
542-0081 Osaka
Phone: +81 03 5420 8724
Fax: +81 03 5420 7708
info@commons-sense.net

composite
culture magazine
Founded in 1992.
Editorial Office
Tokyo
hgd2@netjoy.ne.jp
www.compositemag.com

Cyzo
Read to the heart of Japan in 100 minutes
Monthly, 690 Yen, Japanese.
Editorial Office
Tokyo
www.ultracyzo.com
Staff
Editor-in-chief: Hiroto Kobayashi
Publisher
Infobahn Inc.
1-22-7-9F Dogenzaka,
Shibuya Ku
150-0043 Tokyo
Phone: +81 03 5784 6700
mail@infobahn.co.jp
www.infobahn.co.jp

Daruma
Japanese Art and Antiques Magazine
Founded in 1994, English.
Editorial Office
Amagasaki Mukonoso Higashi
1-12-5
661-0032
www.darumamagazine.com
Staff
Editor-in-chief:
Takeguchi Momoko
Publisher
Daruma Publishing Japan
Amagasaki Mukonoso Higashi
1-12-5
661-0032
Fax: +81 6 6438 1882

Digmeout
Founded in 2001, 2,000 Yen,
English / Japanese.
Editorial Office
FM802
530-8580 Osaka
www.digmeout.net
Staff
Editor-in-chief and Creative
director: Yoshihiro Taniguchi
Publisher
Petit Grand Publishing

Fruits
Tokyo real culture photographs
magazine focus on girls' fashion
Monthly, founded in 1997,
190 x 264 mm, 540 Yen, Japanese.
Editorial Office
Ebisu-Nishi, Shibuya-Ku
1-16-8-5F Tokyo
infor@fruits-mg.com
www.fruits-mg.com
Staff
Director: Aoki Shoichi

H
Every two months, Japanese.
Editorial Office
Tokyo
www.rock-net.jp
Publisher
Rockin'on

here and there
Published irregularly, founded in
2002, 210 x 297 mm, 1,700 Yen,
Japanese / English.
Editorial Office
Nakako Hayashi-Murano,
4-1-16-407 Sendagi,
Bunkyoku
113-0022 Tokyo
post@nieves.ch
www.nakakobooks.com
Staff
Publisher and Author:
Nakako Hayashi
Art direction: Kazunari Hattori

Idea Magazine

Idea Magazine is about graphic design.
Japanese / English.
Editorial Office
Tokyo
info@idea-mag.com
www.idea-mag.com
Staff
Editor: Kiyonori Muroga

Neo Tokyo

Japanese Pop Culture
Neo Tokyo is the magazine about japanese pop culture and covers every aspect of Japan, its population and culture.
Founded in 1996, English.
Editorial Office
philipp@neo-tokyo.com
Staff
Editor-in-chief: Philip Pendleton

Neut

An agent where new designs can be created for all areas of business and social life.
Japanese.
Editorial Office
Tokyo
www.altdesigners.com

NYLON Japan

NYLON Japan delivers fresh editoral with groundbreaking photography and illustations.
Founded in 2003, Japanese.
Editorial Office
New York
nylon@nylon.jp
www.nylon.jp
Publisher
NYLON LLC
394 West Broadway 2nd Floor
10012 New York
Phone: +1 212 226 6454
Fax: +1 212 226 7738

OK FRED

International cultural magazine based in Tokyo.
Quarterly, founded in 2001, 210 x 296 mm, 20,000 copies, 780 Yen, Japanese / English.
Editorial Office
4-33-9 Kamimeguro
153-0051 Meguro,
Tokyo
info@slidelab.com
www.slidelab.com
Staff
Editor-in-chief: Yoshi Tsujimura
Editor: Youth K. Nakamura
Designer: Motofumi Nakashima
Publisher
LittleMore
www.littlemore.co.jp

Ozone Rocks

3,000 copies, Japanese.
Editorial Office
info@ozonerocks.com
www.ozonerocks.com
Staff
Editor-in-chief: Fumihiro Hayashi
Creative director:
Katzuzo Yamaguchi
Publisher
Ozone Community

PetitGlam

1,429 Yen, Japanese.
Editorial Office
info@petit.co.jp
www.petit.org
Staff
Editor-in-chief: Cornel Ito
Creative director: Takaya Goto
Publisher
Petit Grand Publishing, Inc.

Ready Made Magazine for Young Girls and Boys

Editorial Office
www.readymade-intl.com

relax

Let's be adulty!
Monthly, 210 x 298 mm, 880 Yen, Japanese.
Editorial Office
Tokyo
www.relaxmag.com

Richardson

224 x 305 mm, English.
Editorial Office
2-7-26-502 Kitaaoyama
Minato-Ku
Tokyo
Staff
Editor-in-chief:
Andrew Richardson
Art director: Laura Genninger
Editor-in-chief: Fumihiro Hayashi
Editor: Takako Kochiya

Rockin'on

Rock music and pop culture.
Monthly.
Editorial Office
Tokyo
www.rock-net.jp
Publisher
Rockin'on

Rockin'on Japan

The japanese alternative rock scene
Founded in 1986, Japanese.
Editorial Office
Tokyo
www.rock-net.jp
Publisher
Rockin'on

roomservice

Fashion Guide Book
110 x 175 mm, English / Japanese.
Editorial Office
4F System Ueno Bldg.,
2-22-6 Higashi-Ueno,
Taito-Ku
110-0015 Tokyo
roomservice@hpgrp.com
www.roomservice-japan.org
Publisher
H.P. FranceS.A.
4F System Ueno Bldg,
2-22-6 Higashi-Ueno,
Taito-Ku
110-0015 Tokyo
Phone: +81 3 5688 5321
Fax: +81 3 5688 6640
www.roomservice-japan.org

Ryuko Tsushin

Fashion magazine.
Monthly (12x / year), Japanese.
Editorial Office
www.infaspub.co.jp/ryuko-tsushin/rt.html
Publisher
Infas Publications
www.infaspub.co.jp

Sal

A new type of media to introduce new art.
Quarterly, founded in 2001, 250 x 353 mm, Free, Japanese / English.
Editorial Office
2-24-9, Kami-Osaki,
Shinagawa-ku
141-8677 Tokyo
sal@elesal.com
www.elesal.com/
Staff
Editor-in-chief: Jiro Ohashi

Shoes Master

Shoes Master Magazine is THE Japanese Sneaker Magazine. With its in-depth features on the

most sought-after brands – and focus on the business' leaders and innovators *Shoes Masters* has established itself as a premium source for sneaker enthusiasts. 210 x 297 mm, Japanese.

Sight
General interest magazine for readers reaching their thirties and forties, covering such topics as politics, music, films, cars, fashion and travels.
Quarterly, founded in 1999, Japanese.
Editorial Office
Tokyo
www.rock-net.jp

Spoon
Japanese.
Editorial Office
Tokyo
info@spoon01.com
www.spoon01.com

Sprout
1,200 Yen, Japanese / English.
Editorial Office
www.sproutmag.com
Staff
Editor-in-chief and Creative director: Yoshikazu Shiga
Publisher
Sprout Japan, Inc.

Street
Photography magazine of foreign STREET fashion.
Monthly, founded in 1985, 205 x 275 mm, 700 yen, No text.
Editorial Office
Ebisu-Nishi, Shibuya
1-16-8-5F Tokyo
infor@fruits-mg.com
www.street-mg.com
Staff
Director: Aoki Shoichi

The International
£5, English / Japanese.
Editorial Office
thedeep@club-internet.fr
Staff
Editor-in-chief and Creative director: Makoto Ohrui
Publisher
Fiction INC Tokyo

Tune
Tokyo real culture photographs magazine focus on boys fashion
Monthly, founded in 2004, 210 x 297 mm, 650 yen, Japanese.
Editorial Office
Ebisu-Nishi, Shibuya
1-16-8-5F Tokyo
infor@fruits-mg.com
www.street-mg.com
Staff
Director: Aoki Shoichi

Vogue Nippon
Monthly, 230 x 298 mm, 780 Yen, Japanese.
Editorial Office
Osuga Bldg. 3F,
2-11-8 Shibuya, Shibuya-ku
150-0002 Tokyo
www.vogue.co.jp
Staff
Editor-in-chief: Kazuhiro Saito
Fashion director: Kaori Tsukamoto
Fashion editor: Yuki Matsuyama
Publisher
Condé Nast Publications
Piazza Castellano 27

20121 Milan
Italy
Phone: +39 02 856 11
Fax: +39 02 805 57 61

Foto Kvartals
Contemporary photography
Quarterly, founded in 2006, 228 x 240 mm, 2,000 copies, 3.50€, Latvian / English.
Editorial Office
Terbatas 49/51-8
1011 Riga
fotokvartals@apollo.lv
www.neputns.lv

Studija
Visual Arts Magazine
Every two months.
Editorial Office
11. November Krastmala 35 - 206
1050 Riga
studija@studija.lv
www.studija.lv
Staff
Editor-in-chief: Laima Slava

Adato Architecture
Quarterly, founded in 2002, 210 x 297 mm, 1,500 copies, 13.25€, French / German.
Editorial Office
19 rue des Prés

5441 Remerschen
office@hvp.lu
www.adato.lu

désirs
luxe mode intérieurs
Bi-annual, founded in 2004, 5€, 20,000 copies, French / English.
Editorial Office
10 rue des Gaulois,
Po Box 728
2017 Luxembourg
office@mikekoedinger.com
www.tempo.lu/desirs/
Publisher
Mike Koedinger Editions SA
10 rue des Gaulois,
Po Box 728
2017 Luxembourg
Phone: +352 29 66 18
Fax: +352 29 66 19
office@mikekoedinger.com
www.mikekoedinger.com

Flydoscope
Luxair's inflight magazine
Every two months, founded in 1975, 210 x 297 mm, 30,000 copies, Free, English / French / German.
Editorial Office
10 rue des Gaulois,
Po Box 728
2017 Luxembourg
www.flydoscope.lu
Publisher
Mike Koedinger Editions SA
10 rue des Gaulois,
Po Box 728
2017 Luxembourg
Phone: +352 29 66 18
Fax: +352 29 66 19
office@mikekoedinger.com
www.mikekoedinger.com

nico
interviews and fashion
Bi-annual, founded in 2003,
230 x 280 mm, 30,000 copies,
10€, English.
Editorial Office
Po Box 728
2017 Luxembourg
office@mikekoedinger.com
www.nicomagazine.com
Staff
Founder and Publisher:
Mike Koedinger
Publisher
Mike Koedinger Editions SA
10 rue des Gaulois,
Po Box 728
2017 Luxembourg
Phone: +352 29 66 18
Fax: +352 29 66 19
office@mikekoedinger.com
www.mikekoedinger.com

paperJam
**média économique et
financier**
Monthly, founded in 2000,
238 x 300 mm, 20,000 copies,
5€, French / English.
Editorial Office
10 rue des Gaulois,
Po Box 728
2017 Luxembourg
press@paperjam.lu
www.paperjam.lu
Staff
Editor:
Jean-Michel Gaudron
Publisher
Mike Koedinger Editions SA
10 rue des Gaulois,
Po Box 728
2017 Luxembourg
Phone: +352 29 66 18

Fax: +352 29 66 19
office@mikekoedinger.com
www.mikekoedinger.com

Queesch
**Das magazin für und über
selbstbestimmung /
Le magazine pour et sur
l'autodétermination**
210 x 297 mm, 5€, French /
German / English.
Editorial Office
53 Ellergronn
3811 Schifflange
info@queesch.lu
Staff
Layout: Patrick Hallé
Layout: Joel Thill

Rendez-vous
City Magazine Luxembourg
Monthly (11x / year), 230 x 300
mm, 35,000 copies, Free,
French / English / German.
Editorial Office
Po Box 728
2017 Luxembourg
office@mikekoedinger.com
www.rendez-vous.lu
Staff
Editor: Corinne Briault
Editor: Alexis Juncosa
Publisher
Ville de Luxembourg / Mike
Koedinger SA

salzinsel
Founded in 2004, 180 x 295 mm,
1,000 copies, 3€, French.
Editorial Office
Luxembourg
Staff
Editor-in-chief:
Karolina Markiewicz

sneaker
marmalade
**Welcome to the Sneaker
Culture**
Quarterly, founded in 2005, 230
x 280 mm, Free, French / English.
Editorial Office
6 Allée du Carmel
1354 Luxembourg
sneakers@sneaker-marmalade.com
www.sneaker-marmalade.com
Staff
Editor-in-chief: Gregory Kulus
Art director: Runa Egillsdottir

Upfront
Upfront is a publication for
Luxembourg in English. It
predominately focuses on Music
and Nightlife, but also features
Arts and Culture, Stage, Gay,
Books and Film, Restaurants,
Mind-Body and Soul, Kids, 18-24,
Sports.
Monthly, founded in 2006,
289 x 385 mm, 10,000 copies,
Free, English.
Editorial Office
13, rue Adolphe Omlor
2262 Luxembourg
info@upfrontlistings.com
www.upfrontlistings.com

XnonMagazine
the only one with faults
Irregularly published, founded in
1984, 210 x 297 mm, 100 copies,
French / English.
Editorial Office
Luxembourg
Staff
Publisher, Art director and
Editor-in-chief: Gino Ricca

Mexico

BabyBabyBaby
Bi-annual, founded in 2004,
220 x 290 mm, N $40, Spanish.
Editorial Office
Mexico City
www.babybabybaby.com.mx
Staff
Editor-in-chief:
José Garcia Torres
Director: Vanesa Fernandez
Director: Aldo Chaparro
Publisher
El Tiempo Celest S.A.
Nuevo Leon 96 piso 4
Col. Condesa
06140 Mexico
Phone: +52 5553 1922

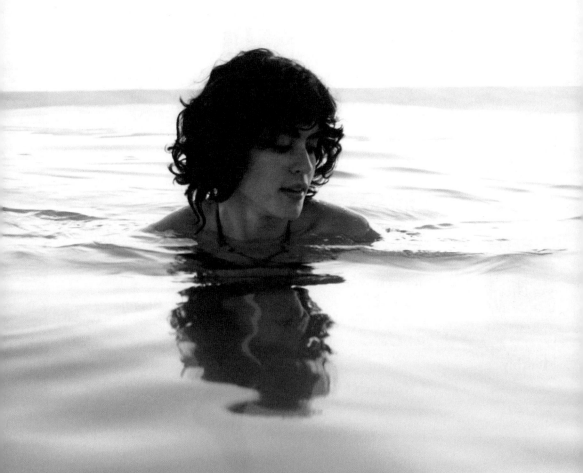

celeste magazine
www.celeste.com.mx
Foto: Todd Cole

celeste

El tiempo celeste
A unique editorial project in
Mexico that involves several core
competences of the vanguard
contemporary culture.
Quarterly, founded in 2001,
220 x 280 mm, 80 pesos, Spanish.
Editorial Office
www.celeste.com.mx
Staff
Director: Aldo Chaparro
Director: Vanessa Ferandez
Editor-in-chief:
Jose Garcia Torres
Publisher
El Tiempo Celest S.A.
Nuevo Leon 96 piso 4
Col.Condesa
06140 Mexico
Phone: +52 5553 1922

Mexico City Monthly

Monthly, founded in 2006,
290 x 390 mm, Free, English /
Spanish.
Editorial Office
buenaidea@vivamexicocity.com
www.vivamexicocity.com
Publisher
El Tiempo Celest S.A.
Nuevo Leon 96 piso 4
Col.Condesa
06140 Mexico
Phone: +52 5553 1922

picnic

Supervivencia y bienestar
Every two months, founded in
2004, 230 x 286 mm, N $55,
Spanish.

Editorial Office
Tabasco 75, col Roma
06700 Mexico City
contacto@picnic-mag.com
www.picnic-mag.com
Staff
Director: Véronique Ricardoni
Director:
Victor Manuel Roddriguez

Wow

Spanish.
Editorial Office
Nuevo Leon 96-1
06200 Condesa
contacto@wow-internacional.com
www.wow-internacional.com
Staff
Editor-in-chief:
Jorge Lestrade Sadumi
Publisher
El Tiempo Celest S.A.
Nuevo Leon 96 piso 4
Col. Condesa
06140 Mexico
Phone: +52 5553 1922

Morocco

L'etendard

Moroccan magazine for the
culturel development in
Morocco.
Weekly, 10,000 copies, 3 MAD,
French/ Moroccan Dialect.
Editorial Office
240, lot municipal, Bloc 5,
Hey Hassani
20200 Casablanca
rebornabyl@gmail.com

L'Kounach

Annual, French / Moroccan
Dialect.
Editorial Office
240, lot municipal, Bloc 5,
Hey Hassani
20200 Casablanca
rebornabyl@gmail.com

Netherlands

A

Founded in 2001, 13€,
Staff
Creative director: Paul Bouders
Publisher
ARTIMO

A10

**Magazine for new European
Architecture**
Every two months, 247 x 330 mm,
25,000 copies, 6.50€.
Editorial Office
Po Box 51137
1007 EC Amsterdam
mail@a10.eu
www.a10.eu
Staff
Editor-in-chief: Hans Ibelings
Art director: Arjan Groot
Publisher: Arjan Groot
Publisher: Hans Ibelings

Archis

**International bimonthly for
architecture to go beyond
itself**
Every two months, 230 x 290 mm,
English.
Editorial Office
Hamerstraat 20a
1021 JV Amsterdam
info@archis.com
www.archis.org
Staff
Managing editor:
Arjen Oosterman
Editor-in-chief: Ole Bouman
Publisher
ARTIMO

Baby!

Quelle der Inspiration
Quarterly, founded in 2000,
218 x 280 mm, 7.50€, English.
Editorial Office
Hartenstraat 36
1016 CC Amsterdam
readbaby@babysite.nl
www.surfbaby.com
Staff
Art and Editorial director:
René Eller
Publisher
ReadBABY
Nieuwezijds Voorburgwal 262
1012 RS Amsterdam
Phone: +31 20 530 66 66
www.surfbaby.com

Blaadje

Tijdschrift over Tijdschriften
Blaadje: an annual magazine
about magazine making
Annual, founded in 2004,
230 x 300 mm, 36,000 copies,
10€, Dutch.
Editorial Office
Stadhouderskade 157
1074 BC Amsterdam
info@blaadje.nl
www.blaadje.nl
Staff
Publisher: Ernst Coenen
Publisher: Frank Meijer
Publisher: Rupert van Woerkom
Editorial Manager:
Sharon van Minden
Publisher
Stichting The Black Tiger
Stadhouderskade 157
1074 BC Amsterdam
Phone: +31 020 638 95 51
info@blaadje.nl
www.blaadje.nl

**Visit www.welovemags.com for an
updated version of the directory**

Eyemazing devoted to International Contemporary Photography

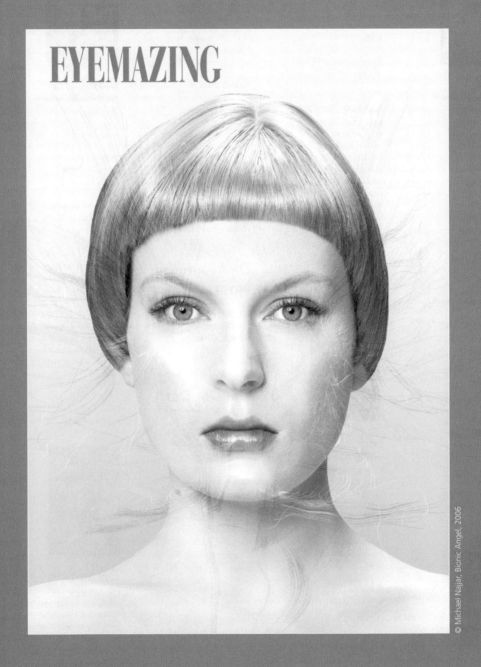

EYEMAZING

© Michael Najjar, Bionic Angel, 2006

www.EYEMAZING.com
Naritaweg 14, 1043 BZ Amsterdam, The Netherlands
t +31(0)20 5849250, f +31(0)20 5849201
info@eyemazing.com

Blend
mode, mensen, media, muziek en kunst
Upperground magazine,
10x / year, founded in 2004,
225 x 280 mm, 20,000 copies,
4.95€, Dutch.
Editorial Office
Zamenhofstraat 150 – unit 438
1022 AG Amsterdam
info@blend.nl
www.blend.nl
Staff
Publisher: Jurriaan Bakker
Editor-in-chief: Theo Paijmans

BLVD.
de glossy met inhoud
10x / year, 225 x 300 mm,
30,000 copies, Dutch.
Editorial Office
Singel 25-27
1012 VC Amsterdam
blvd@creditsmedia.nl
www.blvd.nl

Bright
Tech / Life / Style
6x / year, 185 x 245 mm,
25,000 copies, 5€.
Editorial Office
Postbus 14727
1001 LE Amsterdam
info@bright.nl
www.bright.nl

Butt
International magazine for homosexuals
Quarterly, founded in 2001,
165 x 234 mm, English.

Editorial Office
Prinsengracht 397
1016 HL Amsterdam
mail@buttmagazine.com
www.buttmagazine.com
Staff
Publisher: Gert Jonkers
Editor-in-chief and Creative director: Jop Van Bennekom

Casco Issues
Focused on artistic research,
highlighting experimental
methodologies and analytical
models of investigation that
connect the fields of art and
design to broader social and
political arenas.
Annual, founded in 1990,
170 x 250 mm, 8€, English.
Editorial Office
Oudegracht 366
3511 PP Utrecht
info@cascoprojects.org
www2.cascoprojects.org
Staff
Director: Emily Pethick

code
streetfashion now
Quarterly, founded in 2005,
5.90€, 22,000 copies,
Dutch / English.
Editorial Office
Po Box 69654
1060 CS Amsterdam
peter@boldpublishing.com
www.code-mag.nl
Staff
Editor-in-chief: Peter Van Rhoon
Publisher
Bold Publishing
Po Box 69654
NL-1060 CS Amsterdam
Phone: +31020 4085511
Fax: +31 020 4082280

Currency
25€, English / French / German.
Editorial Office
Jufferstraat 206, 14th floor
3011 XM Rotterdam
info@episode-publishers.nl
www.episode-
publishers.nl/currency.htm
Publisher
episode publishers
Marconistraat 52
3029 AK Rotterdam
Phone: +31 0 10 4253000
Fax: +31 0 84 2222717

De Avontuur bevat
A one-page photomagazine
Published irregularly, founded in
2003, Dutch.
Editorial Office
Witte de Withstraat
Den Haag

Dot Dot Dot
graphic design magazine
Bi-annual, founded in 2000,
12.50€, 3,000 copies, English.
Editorial Office
Zwaardstraat 16
2584 The Hague
editor@dot-dot-dot.nl
www.dot-dot-dot.nl
Staff
Editor and Publisher:
Bailey Stuart
Editor and Publisher: Peter Bailey

Duf
onafhankelijk gedurfd
Bookazine. Youngsters love to
read it. 300 different pages of
fun, fiction, info and a lot more.
Annual, founded in 2006,
24.95€, Dutch.
Editorial Office
Van Bylandtstraat 21
2562 GH Den Haag
ontwerphaven@wanadoo.nl
www.duf.nu
Staff
Publisher, Design and Art
direction: Suzanne Hertogs
Editor: Petra Boers
Editor: Nicole Ros
Editor: Suzanne Hertogs

expreszo
gay / lesbian youth magazine
Every two months, 168 x 230 mm,
10,000 copies, 6.50€, Dutch.
Editorial Office
Po Box 3836
1001AP Amsterdam
info@expreszo.nl
www.expreszo.nl

Eyemazing
Devoted to international
contemporary photography
Quarterly, founded in 2003,
245 x 340 mm, 10,000 copies,
25€, English.
Editorial Office
Naritaweg 14
1043 BZ Amsterdam
info@eyemazing.com
www.eyemazing.com
Staff
Founder and Publisher:

Visit www.welovemags.com for an updated version of the directory

foam

international
photography
magazine

The highly
appreciated and
internationally acclaimed
Foam Magazine has been
relaunched.

Subscribe now!

Find out more at
www.foammagazine.nl

Susan Zadeh
Publisher
Picture Booklets Publishers B.V
Naritaweg 14
1043 BZ Amsterdam
Phone: +31 20 5849250
Fax: +31 20 5849201
info@eyemazing.com
www.eyemazing.com

Fantastic Man
Bi-annual, founded in 2005,
240 x 300 mm, 8.95€, English.
Editorial Office
Prinsengracht 397
1016 HL Amsterdam
office@fantasticmanmagazine.com
www.fantasticmanmagazine.com
Staff
Editor: Jop Van Bennekom
Editor: Gert Jonkers
Publisher
TOP Publishers BV

Foam Magazine
**Quarterly Photography
Magazine**
Foam Magazine is an
international, quarterly
photography magazine. Each
issue features a specific theme
that unites 6 diverse portfolios of
16 pages each, accompanied by
an essay or interview.
Quarterly, founded in 2002,
230 x 300 mm, 6,000 copies,
12.50€, English.
Editorial Office
Keizersgracht 609
1017 DS Amsterdam
foam@foammagazine.nl
www.foammagazine.nl

Staff
Editor-in-chief: Marloes Krijnen
Founder and Publisher:
Foam_Fotografiemuseum
Amsterdam and Vandejong
Communications
Publisher
Foam Magazine BV
Keizersgracht 609
1017 DS Amsterdam
info@foammagazine.nl
www.foammagazine.nl

Frame
the great indoors
Every two months, 230 x 297 mm,
34,000 copies, 19.95€, English.
Editorial Office
Lijnbaansgracht 87hs
1015 GZ Amsterdam
info@framemag.com
www.framemag.com
Staff
Editor-in-chief: Robert Thiemann
Publisher
Peter Huiberts

Girls Like Us
Lesbian Quarterly
For women who are seeking a
contemporary representation of
lesbian identity.
Tri-Annual, founded in 2005,
165 x 228 mm, 3,000 copies, £6,
English.
Editorial Office
Po Box 10717
1001 ES Amsterdam
info@glumagazine.com
www.glumagazine.com
Staff
Editor: Jessica Gysel

Editor: Kathrin Hero
Publisher
Capricious Inc.
619 E. 6th Street
NY 10009 New York
USA

Glamcult
Dutch.
Editorial Office
Puntegaalstraat 173
3024 EB Rotterdam
info@cglamcult.com
glamcult.com
Staff
Publisher and Editor-in-chief:
Rogier Vlaming
Editor: Hanka van der Voet
Publisher
Glamcult
Puntegaalstraat 173
3024 EB Rotterdam
Phone: +31 010 24 40 525
Fax: +31 010 42 58 049
info@glamcult.com
www.glamcult.com

goodies
Dutch.
Editorial Office
Postbus 2720
3000 CS Rotterdam
info@goodies.nl
www.goodies.nl
Staff
Editor-in-chief: Ruth Gorissen

hunch
hunch focuses on the changing
profession of architecture /
urbanism and its intersection with
contemporary culture.
Bi-annual, founded in 1999,
165 x 300 mm, English.
Editorial Office
Botersloot 25
3011 HE Rotterdam
info@berlage-institute.nl
www.berlage-institute.nl
Publisher

Berlage Institute
Botersloot 25
3011 HE Rotterdam
Phone: +31 10 4030 399
Fax: +31 10 4030 390
info@berlage-institute.nl
www.berlage-institute.nl

Inside
**Independent Pop Culture
Magazine**
A vibrant visual record of the
publications that occupy the
niche that falls between the world
of underground 'zines' and the
mass market.
English.
Editorial Office
Amsterdam
Staff
Editor: Patrick Andersson
Editor: Judith Steedman

items
items is the Netherlands' major
professional design magazine.
Every two months, 8,000 copies,
Dutch.
Publisher
BIS Publishers
Herengracht 370-372
1016 CH Amsterdam
Nertherlands
Phone: 31 205 247 560
items@bispublishers.nl
www.bispublishers.nl

jong Holland
Quarterly, founded in 1984,
English.
Editorial Office
Po Box 90418
2509 LK The Hague
redactie@jong-holland.nl
www.jong-holland.nl

kanaal 0

Magazine for electronic music and experimental art
Published irregularly, founded in 2006, 200 x 270 mm, 2,000 copies, 8€, Dutch / English.
Editorial Office
Hanenburglaan 365
2565 GP Den Haag
info@kanaal-0.nl
www.kanaal-0.com
Staff
Founder and Publisher: Iris Uffen
Publisher
Platform Kanaal 0
Hanenburglaan 365
2565 GP Den Haag
Phone: +31 624774358
info@kanaal-0.com
www.irisuffen.com

La Vie en Rose

Every two months, founded in 2004, 233 x 300 mm, 6.95€, Dutch.
Editorial Office
A. Dortsmanplein 3
1411 RC Naarden-Vesting
lavieenrose@moodformagazines.nl
www.lavieenrosemagazine.nl

LiveXS

popmagazine
Monthly, 210 x 280 mm, 60,000 copies, Free, Dutch.
Editorial Office
Nachtwachtlaan 155
1058 EE Amsterdam
redactie@livexs.nl
www.livexs.nl

Mark

Another Architecture
An architecture magazine with a difference. Brilliant graphics. Arresting photography. Thought-provoking articles. That's *Mark*. Quarterly, founded in 2005, 240 x 320 mm, 15,000 copies, 19.95€, English.
Editorial Office
Lijnbaansgracht 87
1015 GZ Amsterdam
robert@mark-magazine.com
www.mark-magazine.com
Publisher
Peter Huiberts

Mediamatic

Occasional, £10.
Editorial Office
Po Box 17490
1001 JL Amsterdam
mail@mediamatic.net
www.mediamatic.net

Metropolis M

Outlines current discussions and tendencies within The Netherlands and abroad looking at art and its practice from a critical and international perspective.
Every two months, founded in 2006, Dutch / English.
Editorial Office
Po Box 19263
3501 DG Utrecht
redactie@metropol.nl
www.metropolism.org
Staff
Editor-in-chief:
Domeniek Ruyters

Final editor: Ingrid Commandeur
Managing editor:
Karolien van Gent
Associate editor: Maxine Kopsa

mister motley

Magazine over kunst
168 x 222 mm, 5€, Dutch.
Editorial Office
Po Box 17048
1001 JA Amsterdam
info@mistermotley.nl
www.mistermotley.nl
Staff
Editor-in-chief:
Hanne Hagenaars

MJ

Manifesta Journal – Journal of Contemporary curatorship.
Published irregularly, 12€.
Editorial Office
Po Box 71722
1008 DE Amsterdam
secretariat@manifesta.org
www.manifesta.org/frame6.html
Publisher
International Foundation Manifesta
Po Box 71722
1008 DE Amsterdam
Phone: +31 0 20 672 14 35
Fax: +31 0 20 470 00 73

Morf

Bi-annual, founded in 2004, Dutch / English.
Editorial Office
Po Box 75905
1070 AX Amsterdam
redactie@morf.nl
www.morf.nl
Staff
Editor: Marjan Unger
Editor: Sybrand Zijlstra
Editor: Jan Konings
Editor: Chris Vermaas
Publisher
Premsela, Stichting voor Nederlandse vormgeving
Postbus 75905

1070 AX Amsterdam
Phone: +31 020 344 94 49
Fax: +31 020 344 94 48

Oase

Architecture Journal
Dutch / English.
Editorial Office
Po Box 20
1910 AA Uitgeest
www.oase.archined.nl
Publisher
NAi Uitgevers
Mauritsweb 23
3012 Rotterdam
Phone: +31 0 10 20 10 133
info@naipublishers.nl
www.naipublishers.nl

Objekt

Living in Style
Objekt is a premium publication for interior design and architecture with editorial features from around the world. Quarterly, founded in 1991.
Editorial Office
Raadhuislaan 22B
2451 AV Leimuiden
info@objekt.nl
www.objekt.nl

open

Cahier on art and the public domain
Bi-annual, 170 x 240 mm, 19.50€, English.
Editorial Office
Ruysdaelkade 2
1072 AG Amsterdam
open@skor.nl
Staff
Editor-in-chief: Jorinde Seijdel
Publisher
NAi Uitgevers
Mauritsweb 23
3012 Rotterdam
Phone: +31 0 10 20 10 133
info@naipublishers.nl
www.naipublishers.nl

Pages

Pages develops collaborative projects with practitioners in different cultural fields.
Published irregularly, founded in 2006, 240 x 330 mm, 1000 copies, Farsi / English.
Editorial Office

Nostalgia is dead. Lose the 'pop will eat itself' attitude. Give up on cynicism - it's just too late. Everyone send back that wink of an eye - you know it's irony. And bored to death? Welcome to FluxCapacity. Timetravel is the new watchword. Guess what that will do to fashion and the notion of 'new'. From DADA - mailorder catalogues/liberating type; to Fluxus - idealism with expiring dates. From fashion - hello American Typewriter ; to art - get ready with that intellect. And then the publication that doubles for an exhibition, presentations, parties. Stereo came not a moment too soon.

LA RÉVOLUTION

illustrated magazine
— SPECIAL THEME ISSUE —

C'EST CHIC

Featuring multiple artist cooperations, fashion showing true colours, a modern classic called Dogville, illustrators and ideology, Neasden Control Centre, Ill Designers and chinese underwear.

stereo
issue #3 - 2005

STRAFE NORM!

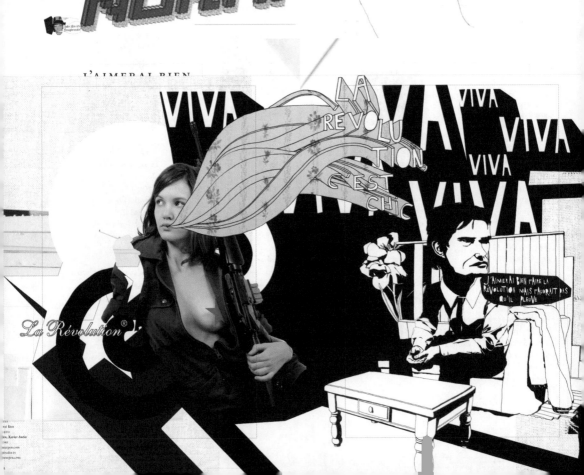

Po Box 23354
3001 KJ Rotterdam
info@pagesmagazine.net
www.pagesmagazine.net

Past Imperfect
Founded in 2003, 170 x 250 mm,
1,000 copies, English.
Staff
Editor-in-chief: Lisette Smits
Concept by: Bik Van der Pol
Final editing: Emily Pethick
Publisher
Casco, Office for Art, Design
and Theory
Nieuwekade 213-215
3511 PP Utrecht
Phone: +31 30 2319995
Fax: +31 30 2319995
info@cascoprojects.org
www.cascoprojects.org

pts.
Magazine on type design,
typography and other areas
of interest.
Published irregularly,
founded in 1998, 17€, English.
Editorial Office
Schouwburgstraat 2
2511 VA Den Haag
info@underwear.nl
www.underware.nl
Publisher
Underware
Schouwburgstraat 2
2511 VA Den Haag
Phone: +31 070 42 78 117
Fax: +31 070 42 78 116
info@underwear.nl
www.underware.nl

Rails
Maanblad voor reizigers
Monthly (11x / year),
205 x 275 mm, Free, Dutch.
Editorial Office
Amsterdam
rails@multimag.nl
Staff
Editor-in-chief: Oscar Steens

Reload
board lifestyle magazine
Every two months, 203 x 276 mm,
20,000 copies, 4.95€, Dutch.
Editorial Office
Po Box 69654
1060 CS Amsterdam
info@reload.nl
www.reload.nl
Staff
Publisher: Peter van Rhoom
Editor: Joris Van Drooge
Editor: Thimon de Jong

Re-Magazine
A magazine about one person
Re-Magazine is interested in
stories about extreme
personalities, people who make
a difference.
Bi-annual, Variable format, 9€,
English.
Editorial Office
Prinsengracht 397
1016 HL Amsterdam
mail@re-magazine.com
www.re-magazine.com
Staff
Chief editor: Jop Van Bennekom
Chief editor: Arnoud Holleman
Publisher
ARTIMO

Stereo
**international publication that
sets out to inspire artists to
collaborate.**
Bi-annual, Variable format,
1,500 copies, 7€, English.
Editorial Office
Jaffadwarsstr 46b
3061 JS Rotterdam
info@stereopublication.com
www.stereopublication.com
Staff
Coordination and Art director:
Arjen de Jong

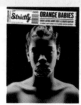

Strictly
Monthly, founded in 2002,
230 x 300 mm, 3.5€, Dutch.
Editorial Office
Postbus 96089
1006 EB Amsterdam
Staff
Editor-in-chief: Josselien Meijss
Publisher: Edwin Reinerie

The Issue Magazine
English.
Editorial Office
Westeinde 16
1017 ZP Amsterdam
www.the-issue-magazine.com
Publisher
Mets and Schlit Publishers

View
Textile view magazine
Quarterly, 215 x 285 mm, 42€,
English.
Editorial Office
Amsterdam
Staff
Publisher: David R.Shah
Managing director:
Martin G Bührmann
Publisher
Metropolitan Publishing BV
Saxen Weimarlaan 6
1075 CA Amsterdam
Phone: +31 20 617 76 24
Fax: +31 20 617 93 57
view@euronet.nl
www.viewpublications.com

viewpoint
**The trends brands futures
and ideas magazine**
Bi-annual, 215 x 284 mm, 61€,
English.
Editorial Office
Saxen Weimarlaan 6
1075 CA Amsterdam
office@view-publications.com
www.view-publications.com
Staff
Editor: Martin Raymon
Publisher: David Shah
Publisher
Metropolitan Publishing
Saxen Weimarlaan 6
1075 CA Amsterdam
Phone: +31 20 617 7624
Fax: +31 20 617 9357
office@view-publications.com
www.view-publications.com

Volume
To beyond or not to be
Quarterly, Variable format,
17.50€, English.
Editorial Office
Po Box 14702
1001 LE Amsterdam
info@archis.org
www.archis.org
Staff
Editor-in-chief: Ole Bouman
Managing editor:
Arjen Oosterman
Contributing editor:
Rem Koolhaas
Contributing editor: Mark Wigley
Publisher
The Stichting Archis
Po Box 14702
1001 LE Amsterdam
info@archis.org
www.archis.org

YDN

YDN is a dutch inspirational magazine where young creatives explore in the fields of graphics, interactive media, architecture, fashion, furniture, music and film. Quarterly, founded in 2003, 230 x 297 mm, 3,000 copies, 8.50€, English.
Editorial Office
Nieuwlandstraat 28
5612 PK Eindhoven
info@ydn.nl
www.ydn.nl
Staff
Editor: Robert Andriessen
Publisher
Designlab

Zone5300

Quarterly, founded in 1993, 210 x 275 mm, 5.75€, Dutch.
Editorial Office
Po Box 6080
3002 AB Rotterdam
blad@zone5300.nl
www.zone5300.nl/530
Staff
Editor-in-chief: Marcel Ruijters
Editor-in-chief: Tonio Van Vugt

New Zealand

Log Illustrated

Magazine about art and literary creation. Founded in 1997, 210 x 300 mm, English.
Editorial Office
Po Box 902
Christchurch
www.physicsroom.org.nz
Staff
Editor-in-chief:
Gwynneth Porter

Pavement

Beauty special
Every two months, 240 x 320 mm, English.
Editorial Office
Po Box 309
Auckland
Staff
Editor-in-chief:
Bernard D McDonald

Pulp

Popular Culture
English.
Editorial Office
Auckland
www.pulp.co.nz
Staff
Publisher: Kevin Schluter
Editor: Elisabeth Easther
Publisher
Pulp Publishing Limited
175b Symonds Street,
PO Box 8461,
1001 Auckland

Norway

carl*s cars

a magazine about people
Features with a highly personal view and a socio-cultural presentation by renowned writers

and photographers.
Quarterly, founded in 2001, 230 x 280 mm, 25,000 copies, 69 NOK, English.
Editorial Office
Riddervoldsgt. 12
0258 Oslo
karl@carls-cars.com
www.carls-cars.com
Staff
Co-founder: Stéphanie Dumont
Co-founder: Karl Eirik Haug
Publisher
carl*s cars

Fjords

Fjords magazine helps the cosmopolitan explorer in a stylish way to get to know Norwegian culture, people and friends. Quarterly, 230 x 260 mm.
Editorial Office
Po Box 2164 Grünerlokka
0505 Oslo
www.screenplay.no/fjords/
Staff
Editor-in-chief: Pauline Nearholm
Creative director: Per Heimly

Hot Rod

Hot Rod is a forum for new and established creativity. The main aim is to inspire.
Quarterly, founded in 1998, 235 x 295 mm, 2,000 - 5,000 copies, £5, English.
Editorial Office
Po Box 1053 s
0104 Oslo
Staff
Editor: Jan Walaker
Publisher
Jan Walaker
Po Box 1053 S
0104 Oslo
Phone: +47 47 04 17 50
www.manualdesign.no/hotrod/

Verksted

A series of publications and seminars focused on on current discourses relating to contemporary cultural production. Published irregularly, founded in 2003, 15€.
Editorial Office
Wergelandsvn. 17
0167 Oslo
office@oca.no
www.oca.no
Publisher
Office for contemporary art Norway

Paraguay

Guarara

Otros Ruidos
Magazine about cultural and sociopolitical themes.
Monthly, founded in 2005, 210 x 310 mm, 1,500 copies, Free, Spanish / Guarani.
Editorial Office
Avda Eusebio Ayala 1035 c/
Avda. Gral. Santos
Asuncion
guarara@gmail.com
www.guarara.org

Phillipines

Manual Magazine

Assembling the man
English.
Editorial Office
18/F Strata 100 Building,
Emerald Ave.
1605 Ortigas Center Pasig
inquiry@mmpimedia.com
www.manualmag.com
Staff
Editor-in-chief: RJ Ledesma
Publisher
Mega Magazines

Poland

2+3D
Grafika Plus Produkt
2+3D is devoted to applied graphics.
Quarterly, founded in 2001, 210 x 280 mm, 5,500 copies, 3€, Polish / English.
Editorial Office
Fundacja Rzecz Piekna, WFP, ASP Kraków
31-108 Cracow
2d@2plus3d.pl
www.2plus3d.pl
Publisher
Fundacja Rzecz Piekna, WFP, ASP Kraków

A4
Fashion, design, art and culture with all the accoutrements; distinct from the cookie-cutter covers of the most widely read magazines. Subjective, authentic, independent.
210 x 297 mm, $4.95, Polish / English.
Editorial Office
Ul. Wiktorska 14/17
02-587 Warsaw
box@a4mag.com
www.a4mag.com
Staff
Publisher: Iwona Czempinkska
Editor-in-chief: Mikolaj Komar
Managing editor:
Aleksandra Janiszewska
Art director: Jakub Jezierski

DIK Fagazine
Artistic magazine merging the homosexual art and culture with inimitable graphic and form.
Published irregularly, founded in 2005, 1,000 - 1,200 copies, Polish / English.
Editorial Office
Ul. Batalionu Parasol 14/33
01-118 Warsaw
karol@szuszu.pl
www.dikfagazine.com

Exklusiv
Exklusiv is a monthly urban lifestyle title dealing with books, films, fashion, comics, music, design, urban planning, new technology, clubs and extreme media/urban phenomena from around the world.
Monthly, 230 x 297 mm, 65,000 copies, English.
Editorial Office
Warsaw
daria.oldak@aktivist.pl
www.exklusiv.pl
Staff
Publisher: Zuzanna Ziomecka
Editor-in-chief:
Kamil Antosiewicz
Associate editor:
Hanna Rydlewska
Publisher
Valkea Media Sp. zo.o.
ul. Elblasks 15/17
01-747 Warzawa
Phone: + 48 22 639 85 67 -8
Fax: + 48 22 639 85 69

fluid
Founded in 2002, 230 x 270 mm, Polish.
Editorial Office
ul. Pilchowicka 16 A
02-175 Warsaw
fluid@fluid.com.pl
www.fluid.com.pl
Staff
Editor-in-chief: Robert Kowalik
Art director: Michal Kaczkowski

Kwartalnik Fotografia
The object of the magazine is to provide a platform for confronting Polish photography with foreign photographers.
Quarterly, founded in 2000, 230 x 290 mm, 3,000 copies, 15€, Polish / English.
Editorial Office
Fromborska 18
62-300 Wrzesnia
i.zjezdzalka@fotografia.net.pl
www.fotografia.net.pl
Staff
Editor-in-chief: Ireneusz Zjezdzalka
Publisher
Wydawnictwo Kropka
Fromborska 18
62 300 Wrzesnia
Phone: +48 61 437 49 50
Fax: +48 61 436 72 85
redakcja

Pop up
Polish.
Editorial Office
mikolaj@popupmagazine.pl
www.popupmagazine.pl

VIP ZIN
"We don't cooperate with anybody. VIP room is where we are."
VIP ZIN is very limited photo-documentary magazine made by two artists from Poland – Karol Radziszewski and Monika Zawadzka.
Published irregularly, founded in 2006, 210 x 285 mm, 500 copies, 30 PLN, Polish / English.
Editorial Office
Warsaw
contact@vipzin.com
www.vipzin.com

Portugal

Biblia
200 x 260 mm, 5€, Portuguese.
Editorial Office
Rua da Boavista n°76,2°
1200-068 Lisbon
cimagomes@hotmail.com
www.werbehure.com
Staff
Editor: Tiago Gomes
Design director: Inźs Pereira

DIF
New tendencies magazine.
Monthly, founded in 2002, Free, 20,000 copies, Portuguese.
Editorial Office
Rua Conceićčo da Glória, 79 - R/C dtľ
1250-080 Lisbon
carlaisidoro@hotmail.com
www.difmag.com
Staff
Coordinator: Carla Isidoro
Director:
Francisco Vaz Fernandes
Art director: Valdemar Lamego

Visit www.welovemags.com for an updated version of the directory

THE FASHION MAGAZINE OF POLAND

210 x 297

A4

A'CZTERY magazyn / A'FOUR magazine

A'FOUR

PHOTO ARTUR WESOŁOWSKI
STYLIST MAREK ADAMSKI

38/2006
9.90 PLN (0% VAT)
$4.95 US
MONTHLY FASHION MAGAZINE
MADE IN POLAND
ISSN 1731-1454
CIRCULATION 15000

9 771731 145001

Flirt

Editorial Office
Lisboa
Publisher
zdb - galeria zé dos bois
Rua da barroca 59 Bairro alto
1200 Lisboa
Phone: +531 213430205
zdb@zedosbois.org
www.zedosbois.org

icon

Estilo e substancia
225 x 295 mm, Portuguese.
Editorial Office
Lisbon
iconmagazine@mail.soci.pt
Staff
Director: Paula Ribeiro
Editor-in-chief: Ana Sousa Dias
Art director: Jorge Silva
Publisher
Artes and Leiloes sociedade
editorial SA
rue jose estevao 87
1169-010 Lisboa

magnolia

zine de Beach Culture
Founded in 2004, 190 x 256 mm,
8,000 copies, 2.50€, Portuguese.
Editorial Office
magnolia@revistamagnolia.com
www.revistamagnolia.com
Staff
Director: Zézé Adao da Fonseca
Editor: Marta Lopes

Nada

Quarterly, founded in 2003,
6.50€, Portuguese.
Editorial Office

Rua Dr. Jočo Soares, 13, 1ľ Esq.
1600-060 Lisbon
mail@nada.com.pt
www.nada.com.pt
Staff
Co-ordinatior: Joao Urbano
Publisher
Urbanidade Real Lda
Rua Dr. Jočo Soares, 13, 1ľ Esq.
1600-060 Lisbon
Phone: + 351 96 256 0227
mail@nada.com.pt
www.nada.com.pt

numero magazine

revista fast-forward
Every two months, 205 x 285 mm,
5€, English.
Editorial Office
rua Pinheiro Chagas 28, 1dto
1050-178 Lisbon
info@numerofestival.com
www.numerofestival.com
Staff
Publishing Director:
Dinis Guarda

Op

Quarterly, 210 x 270 mm, 15,000
copies, 2€, Portuguese.
Editorial Office
Apartado 52236
1721-501 Lisboa
revistaop@hotmail.com
Staff
Editor: Bruno Benard-Guede

artphoto

contemporary art magazine
Quarterly, 225 x 285 mm,
English / Romanian.
Editorial Office
Bucharest
artphoto@pcnet.ro
www.artphoto.ro
Staff
Editor and Publisher: Razvan Ion

Balkon Cluj

Contemporary Art Magazine
Quarterly, founded in 1999,
240 x 323 mm, Romanian / English.
Editorial Office
Balkon Cluj, str. Paris 5
3400 Cluj
redactia@balkon.ro
Staff
Editor-in-chief: Timotei Nadasan

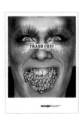

Omagiu

Omagiu is the name of the first
urban-style and contemporary art
magazine in Romania.
Quarterly, founded in 2005,
240 x 278 mm, 28 Lei,
Romanian / English.
Editorial Office
Lascar Catargiu 14 / parter
010671 Bucharest
contact@omagiu.com
www.omagiu.com
Staff
Editor-in-chief: Ioana Isopescu

Afisha

Founded in 1999.
Editorial Office
St Petersburg
www.afisha.ru

Kak

Quarterly, Russian.
Editorial Office
Street 14 / 2, office 423
125015 Moscow
editor@kak.ru
www.kak.ru
Staff
Editor-in-chief: Peter Bankov
Chief editor: Maria Kumova
Art director: Mikhail Los`kov
Sales manager: Andrew Ladunko
Publisher
Design Depot

Monitor

**All Contemporary Design
Magazine**
Every two months, founded in
2000, 230 x 300 mm, 14.95€,
English / Russian.
Editorial Office
Po Box 75905
125481 Moscow
info@monitorunlimited.com
www.monitorunlimited.com
Staff
Editor-in-chief: Rem Khassiev
Deputy editor: Anna Yudina

Singapore

playtimes

playtimes, a toy publication that reaches designers and collectors across the globe with its timely updates.
Monthly, founded in 2005, 205 x 290 mm, 15,000 copies, $6, English / Mandarin.
Editorial Office
Block 203, Wing B,
Henderson Road #03-07
159546 Henderson Industrial Park
yiting@playimaginative.com
www.playtimes-magazine.com

Solitaire

Asia Pacific's Jewellery and Watch Magazine
Every two months, founded in 2002, 220 x 300 mm, SGD 8, English.
Editorial Office
101 Cecil Street #10-12,
Tong Eng Building
069533 Singapore
editor@solitairemedia.com
www.solitairemedia.com
Staff
Publisher and Business editor:
Rainer Sigel
Managing director: Michelle Tay
Managing editor: Julia Goh
Publisher
Solitaire Media Pte Ltd
101 Cecil Street #10-12,
Tong Eng Building
069533 Singapore
Phone: +65 6835 9030
Fax: +65 6835 9520
mail@solitaire.com
www.solitaire.com

territory

International designers territory
territory is a design magazine that features various designers at their creative best.
Quarterly, founded in 2003, 241 x 292 mm, 24,000 copies, 18€, English.
Editorial Office
231 Bain Street, #04-19 Bras Basah Complex,
180231 Singapore
juan@bigbrosworkshop.com
www.bigbrosworkshop.com

Werk

SGD 15.
Editorial Office
Singapore
contact@workwerk.com
www.workwerk.com
Publisher
Work
13 Bukit Merah View n°01-540
150113 Singapore
Phone: 65 63233202
Fax: 65 63233163
contact@workwerk.com
www.workwerk.com

Slovak Republic

3/4

arts / culture / media magazine
Tri-annual, founded in 1999, 215 x 287 mm, 1,000 copies, 4€, Slovak / Czech.
Editorial Office
Gallayova 43
841 02 Bratislava
slavo@34.sk
www.34.sk
Staff
Editor-in-chief: Slavo Krekovic

Slovenija

M'ARS

Magazine of the Museum of Modern Art Ljubljana
M'ARS is aimed at local and global readers interested in contemporary culture and visual arts.
Quarterly, founded in 1989, 210 x 260 mm, English / Slovene.
Editorial Office
Tomsleceva 14
10001 Llubjana
mars@mg-lj.si
Staff
Editor and Publisher:
Spela Mlakar

South Africa

Chimurenga

who no know go know
Chimurenga - a Shona, Zimbabwe, word loosely translated as "liberation struggle". A literary journal of arts / culture / politics. A pan-African space for radical ideas.
Tri-annual, founded in 2002, 164 x 235 mm, R50, English / French / Portuguese / Xhosa / Swahili...so far.
Editorial Office
Po Box 15117
Vlaeberg 8018 Cape Town
info@chimurenga.co.za
www.chimurenga.co.za
Staff
Contributing editor:
Dominique Malaquais
Founding editor: Ntone Edjabe
Contributing editor: Sean Jacobs
Contributing editor:
A. Naomi Jackson
Art director: Rucera Seethal
Design and Layout:
Sergio Rinquist
Design and Layout:
Mimi Cherono Ng'ok
Administrator:
Nombulelo Maringa
Publisher: Kalakuta Trust

Design Indaba

Focus on non-western visual disciplines. Create a high-quality record of high-tech and high-culture global content.
Quartely, R50, 5,000 copies, English.
Editorial Office
3 Port Road, VandA Waterfront
8001 Cape Town
magazine@designindaba.com
www.designindabamag.com
Staff
Publisher / Editor: Ravi Naidoo

one small seed

the south african contemporary culture magazine
Quarterly, founded in 2005, 174 x 246 mm, 5,000 copies, R18.50, English.
Editorial Office
5 Constitution Street
8001 Cape Town
contact@onesmallseed.com
www.onesmallseed.com
Staff
Founder and Creative director:
Giuseppe Russo

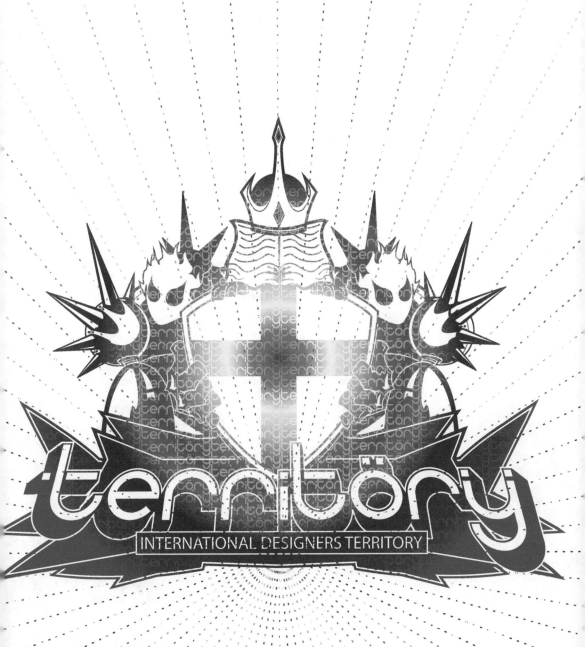

INTERNATIONAL DESIGNERS TERRITORY

territory
INTERNATIONAL DESIGNERS TERRITORY

BIGBROS
WORKSHOP
~ www.bigbrosworkshop.com ~

BASHEER
GRAPHICS BOOKS

WWW.BIGBROSWORKSHOP.COM

Spain

2G
International Architecture Review
Quarterly, founded in 1997, 230 x 300 mm, 15,000 copies, 28.37€, Spanish / English.
Editorial Office
Rosselló 87-89
08029 Barcelona
info@ggili.com
www.ggili.com
Staff
Editor: Anna Puyuelo
Editor-in-chief: Mènica Gili
Editor: Moisés Puente
Publisher
Editorial Gustavo Gili, SL
Rosselló 87-89
08029 Barcelona
Phone: +34 93 322 81 61
Fax: +34 93 322 92 05
info@ggili.com
www.ggili.com

AAAM
Acces all Areas Music
186 x 240 mm, Free, Spanish.
Staff
Editor-in-chief: Juanma Garcia
Publisher
Zona Abierta AC

actitudes
Tri-annual, 200 x 210 mm, 6,000 copies, Free, Spanish.
Editorial Office
C/ Licenciado Poza 59, 1l' D
48013 Bilbao
Staff
Director: Fernando Sanz
Editor: Tensi Sanchez
Publisher
Espacio Actitudes
Bilbao
www.espacioactitudes.com

Alevosia
Belleza Moda Tendencias
Every two months, founded in 2004, 148 x 200 mm, 3€, Spanish.
Editorial Office
Madrid
info@alevosia.com
www.alevosia.com
Staff
Director: Silvia Barroso
Editor: José A. Gilarranz
Publisher
Electro Criaturas Virtuales SL
Carranza 7, 1*1
28004 Madrid
Phone: +34 91 594 45 34
Fax: +34 91 448 72 40
info@alevosia.com
www.alevosia.com

AlterEgo
Encuentra tu alterego Moda, Musica, Diseno, Fotografia, Estilos de Vida
A new tendency, lifestyle and avant-gardist magazine.
10x / year, 230 x 300 mm, 3€, Spanish.
Editorial Office
C/ Hermosilla, 46 - 2l' Izq.
28001 Madrid
alterego@alteregomagazine.net
www.alteregomagazine.net
Staff
Director: Carlof Torregrofa

Aminima
A magazine on present-day art and new media that documents the work of artists and researchers interested in the involvement of science and technology in art and culture
Variable format, Castellano / English copies.
Editorial Office
Rambla Catalunya, 50 ppal. 1Ĺ
08007 Barcelona
aminima@aminima.net
www.aminima.net

ars nova mediterránea
Quarterly, founded in 1996, 235 x 300 mm, French / Spanish / English.
Editorial Office
C. Aribau, 240,
5°letra L bis
08006 Barcelona
morin.delphine@wanadoo.fr
Staff
Editor-in-chief:
Ramon Tio Bellido

art.es
International_Contemporary _art
A bilingual magazine produced in Spain with contributions from all over the world, and aimed at the world of genuinely contemporary art.
Every two months, £6.00, Spanish / English.
Editorial Office
Caracas 15, 7l' dcha
28010 Madrid
contact@art-es.es
www.art-es.es
Staff
Editor-in-chief:
Fernando Galán
Publisher
Salamir Creación y Arte, S. L

Arte y Parte
Revista de Arte Espana, Portugal y America
Every two months, Spanish.
Editorial Office
Tres de Noviembre 31
39010 Santander
revista@arteyparte.com
www.arteyparte.com

aZ / Magazine
Places
Unusual visual dictionary
Bi-annual, founded in 2004, 225 x 280 mm, 20,000 copies, 6-10€, Spanish / Catalan / English.
Editorial Office
Torrent de l'Olla 61
08012 Barcelona
marina@escucurucuc.com
www.escucurucuc.com

Belio
experimental art and design magazine
Tri-annual, founded in 1999, 210 x 200 mm, 10€, Spanish / English.
Editorial Office
C/Argente 14, local
28053 Madrid

Noticed a missing magazine?
Register it online: www.welovemags.com

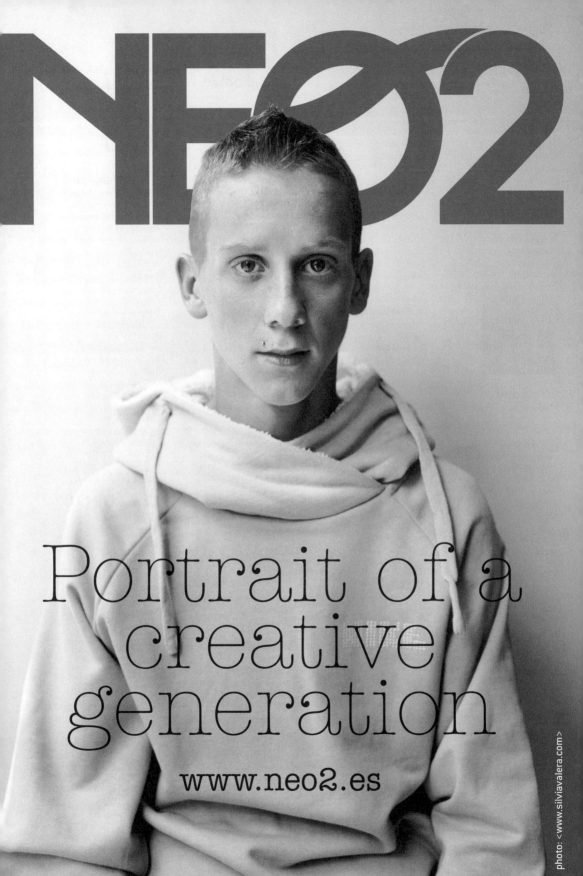

NEO2

Portrait of a creative generation

www.neo2.es

info@beliomagazine.com
www.beliomagazine.com
Staff
Direction: Pablo Iglesias Algora
Direction: Javier Iglesias Algora
Publisher
Belio Magazine sl
Phone: +34 914782526
Fax: +34 914782526

BG magazine
Spanish.
Editorial Office
www.bgmagazine.com.ec

b-guided>
Quarterly, founded in 1999,
165 x 210 mm, 3.80€, Spanish /
English.
Editorial Office
Pg. Joan de Borbo 27 6
08003 Barcelona
b-guided@b-guided.com
www.b-guided.com
Staff
Editor and Art director:
Juan Montenegro
Publisher
b-guided S.L.
Pg. Joan de Borbo 27 6
08003 Barcelona
Phone: +34 93 224 71 35
Fax: +34 93 221 90 75
b-guided@b-guided.com
www.b-guided.com

Blank Magazine
€9, Spanish.
Editorial Office
Av. de la Albufera 71,
3A interior
28038 Madrid
s@blankmgz.com
www.blankmgz.com
Staff
Creative director:
Salvador Cuenca Fromesta
Editor-in-chief:
Armando Vega-Gil Rueda
Publisher
Dos Click S.L.

boca
Editorial Office
Rua antonio Pedro 111,
172 Pina Recife
PE 51011-510
boca@revistaboca.org
www.revistaboca.org

Bon Art
Monthly, Catalan.
Editorial Office
c/Albi, 19
17003 Girona
planas@girona.net
Staff
Editor-in-chief: Ricard Planas

Casatomada
Arts magazine
Spanish.
Editorial Office
revista@casatomada.com.
www.casatomada.com
Publisher
Ars Longa

Cateados
Founded in 1996, 145 x 208 mm,
2€, Spanish.
Editorial Office
Sede Norte:C/Progreso 33 n°1
08012 Barcelona
carteados@mixmall.com
es.geocities.com/cateados
Staff
Editor: Raoul Sabin
Editor: Jon Sabin

Clone
Every two months, Free,
Spanish.
Editorial Office
C/Cuna 46 planta 2 modulo 4
41004 Sevilla
clone@clonemagazine.com
www.clonemagazine.com
Staff
Director: Jose M. Maraver

Codigo06140
Spanish.
Editorial Office
www.codigo06140.com
Staff
Creative director:
Ricardo Porrero
Editor: Claudia Muzzi
Editorial assistant:
Nadia Benavides

Copyright Magazine
**All about graphic design,
illustration, typography and
new technologies.**
Founded in 2001, 8€, 3,000
copies, Spanish / English.
Editorial Office
C/Girona 106 - 3
08009 Barcelona
info@copyrightmagazine.com
www.copyrightmagazine.com
Staff
David Pocull
Editor: Joel Lozano
Editor: Laura Alejo
Editor: Juanjo Ribas

Curator
3€, Spanish / English.
Editorial Office
Aribau 15 7o Of.20
08011 Barcelona
Staff
Director: Sonia Ros
Director: Sandra Sarmiento

d(x)i Magazine
culture and post-design
A 100% experimental platform
that goes beyond the limits of
editorial work, generating an
independent environment that
gathers different viewpoints of
contemporary culture.
Quarterly, founded in 2000,
Free, 25,000 copies, Spanish /
English.
Editorial Office
c/ Maldonado 19, bajo dcha.
46001 Valencia
lex@dximagazine.com
www.dximagazine.com
Staff
Director: Alejandro Benavent

Dance DE LUX
6€, Spanish.
Editorial Office
Barcelona
info@rockdelux.es
Staff
Editor-in-chief: Juan Cervera
Publisher
Ediciones RDL / Rockdelux

el Duende
culture in general, fashion, trends,
leisure.
Monthly (10x / year), founded in

HEART ATTACK artwork by Sakristan

rojo®

1998, Free, 30,000 copies, Spanish.
Editorial Office
c/Flora, 2.
28013 Madrid
redaccion@duendemad.com
www.duendemad.com
Staff
Founder and Director:
Rubén Arribas
Founder and Director:
Esther Ordax

El Temps d'Art
Spanish.
Editorial Office
Av. del baro de Carcer, 40, 13
46001 Valencia
art@eltemps.net
www.eltemps.net
Staff
Editor-in-chief: Eliseu Climent

Enser
4€, Spanish.
Editorial Office
Barcelona
Staff
Director: Rober Pallars

Eseté
Quarterly, 5€, Spanish.
Editorial Office
Aretxaga 10
48003 Bilbao
info@esete.net
www.esete.net
Staff
Director: Ricardo Anton
Director: Txelu Balboa
Publisher
Amasté Communicacion SL
Aretxaga 10
48003 Bilbao
Phone: +34 944 15 88 61
Fax: +34 944 15 88 61
info@amaste.com
www.amaste.com

Etecé
Quarterly, founded in 2004, Spanish.
Editorial Office
Aretxaga 10
48003 Bilbao
www.etece.net
Staff
Director: Itxato Diaz
Publisher
Amasté Communicacion SL
Aretxaga 10
48003 Bilbao
Phone: +34 944 15 88 61
Fax: +34 944 15 88 61
info@amaste.com
www.amaste.com

EXIT
Image and Culture
EXIT is a unique and innovative project dedicated to contemporary photography.
Quarterly, 20€, Spanish / English.
Editorial Office
San Marcelo, 30
28017 Madrid
exit@exitmedia.net
www.exitmedia.net
Staff
Editor-in-chief:
Celia Díez Huertas
Founder and Publisher:
Rosa Olivarez
Managing editor: Seve Penelas
Publisher
Olivarez and Asociados SL

Fake
Published irregularly, founded in 2003, 295 x 240 mm, 20,000 copies, Free, Spanish.
Editorial Office
Po Box 13.140
28080 Madrid
fake@fakeonline.com
www.fakeonline.com
Staff
Director: John Smith
Editor-in-chief: Jane Doe

Fucklet
A booklet which is to be used and disposed quickly. A zine for very special photography.
145 x 205 mm, 8€, English.
Editorial Office
info@fucklet.com
www.fucklet.com

Gallery
A luxury fashion / lifestyle magazine, dedicated to men and women between 30-40 years
Monthly, founded in 2006, 210 x 275 mm, Free, Spanish.
Editorial Office
C/ Europa 19
08028 Barcelona
caroline.fabre@gallerymagazine.es
www.gallerymagazine.es

Staff
Editor-in-chief: Caroline Fabre
Art director: Superbold

go
Discover the real meaning of cutting edge music
An independent music magazine run by young people with a deep interest in cutting edge music and street culture.
Monthly, founded in 2000, 230 x 300 mm, 60,000 copies, Free, Spanish.
Editorial Office
Muntaner 492 bajos
08022 Barcelona
go@go-mag.com
www.go-mag.com
Staff
Director: Janina Canet
Editor-in-chief: Manu Gonzalez

H Magazine
Don't Believe The Hype
Trendy glossy magazine focused on fashion, music, art...
Monthly (11x / year), founded in 1998, 230 x 270 mm, 45,500 copies, Free, Spanish.
Editorial Office
Trafalgar 39 7o 1a
08010 Barcelona
moda@hmagazine.com
www.hmagazine.com
Staff
Editor: José Manuel Bejarano
Editor-in-chief: Cristian Campos

Hercules
About men, fashion and people
Bi-annual, 230 x 329 mm, 6€,
Spanish.
Editorial Office
Mallorca 330 Ent 2
08037 Barcelona
info@herculesmag.com
www.herculesmag.com
Staff
Editor and Creative director:
Francesco Souriques
Editor and Fashion director:
David Vivirido
Publisher
Magna Productions S.L.
Mallorca 330 Ent 2
08037 Barcelona
Phone: +34 932075459
info@magnaprod.com

kink
Founded in 2006, 6€,
Castellano / English.
Editorial Office
Barcelona
kink@pacoymanolo.com
www.pacoymanolo.com/kink

La Fotografia
245 x 330 mm, Spanish.
Editorial Office
Sabino de Arana 26 2o 2a

08028 Barcelona
Staff
Editor: Victor Puig
Director: Salvador Obiols
Publisher
Tiempo Libre Ediciones
Sabino de Arana 26 2o 2a
08028 Barcelona

La Mas Bella
Experimental magazine about art
and creation.
Published irregularly, founded in
1993, Variable format, 1,000
copies, Variable price, Spanish /
Catalan / English.
Editorial Office
Madrid
info@lamasbella.org
www.bellamatic.com
Staff
Founder: Diego Ortiz
Founder: Pepe Murciego
Publisher
Pepe Murciego and Diego Ortiz
Madrid

Ladinamo
Every two months, 220 x 220 mm,
Free, Spanish.
Editorial Office
Mira el sol 2 local
28005 Madrid
info@ladinamo.org
Publisher
Asociacion cultural ladinamo

lamono
An art and fashion magazine
Monthly, 170 x 210 mm, Free,
Spanish.
Editorial Office
Bruc 82 bajos
08009 Barcelona
www.lamono.net
Staff
Director: Eva Villazala
Art director and Design: Inaki Guridi
Graphic director: Núria Rius
Publisher
Edicions La Nit

Lo Magazine
Monthly, 240 x 330 mm, Spanish.
Editorial Office
Luis Antunez 16
08006 Barcelona
info@lomagazine.com
Staff
Director: Carlos Hernando
Art director: Juan Carlos Rego
Publisher
Prensa y comunicacion
Agrip-Pina SL

Lolabrigi
Quarterly, $18, English /
Spanish / Italian.

Lux
Luxury Lifestyles Magazine
Quarterly, 230 x 297 mm, 7€,
English.
Staff
Publisher: David Stein
Director: Alex Marashian
Editor-in-chief: Guy Fiorita
Publisher
Stein Group

Matador
**Journal of Culture, Ideas and
Trends 1995 - 2022**
Annual, founded in 1994,
300 x 400 mm, English.
Editorial Office
Alameda 9
Madrid
matador@lafabrica.com
www.lafabrica.com
Staff
Editor-in-chief: Camino Brasa
Art director: Fernando Gutierrez
Publisher and Director:
Alberto Anaut
Publisher
La Fabrica
Alameda 9
828014 Madrid

Metal
**Fashion, music, literature,
arts, "Zeitgeist"**
Every two months, founded in
2006, 225 x 300 mm, 15,000
copies, 4.50€, Spanish / English.
Editorial Office
Barcelona
yolanda@revistametal.com
www.revistametal.com
Staff
Editor: Yolanda Muelas
Fashion Director: Alberto Murtra
Publisher
Jazzmetal SL
Aribau 168 1o 1a
08036 Barcelona

Neo
design + art + architecture + nature + fashion + living
240 x 300 mm, 5.80€, English / German.
Editorial Office
www.neotabu.com
Staff
Art director: Pepe Barroso
Editorial director: Karin Mehnert
Publisher
Ibermaison Home Designers
Serrano 98
Madrid
Phone: +34 91 426 28 37
www.neotabu.com

Neo2
Fashion por lo nuevo
Monthly, 214 x 274 mm, 3€,
Spanish / English.
Editorial Office
San Bernardo 63, 2e F
28015 Madrid
colabora@neo2.es
www.neo2.es
Staff
Director: Ruben Manrique
Director: Javier Abio
Director: Ramon Fano
Publisher
Neo2
San Bernardo 63 2F
28015 Madrid
Phone: +34 915 229 096
Fax: +34 915 233 474
colabora@neo2.es
www.neo2.es

nox
Vanguardia Singular
Trends, Design, Photography,
Architecture, Art, Travelling,
Fashion.
Bi-annual, 230 x 300 mm, 4€,
Spanish / English.
Editorial Office
Paseo de la Castellana 129
28046 Madrid
redaccionnox@focusediciones.com
Staff
Director:
Antonio Marquez Coello
Editor-in-chief:
Juan Luis Gallego
Publisher
Focus Ediciones
Paseo de la Castellana 129
28046 Madrid

OjodePez
Tri-annual, 235 x 300 mm, 10€,
Spanish / English.
Editorial Office
Alameda 9
28014 Madrid
info@ojodepez.org
www.ojodepez.org
Staff
Director and Publisher:
Frank Kalero
Publisher
La Fabrica
Alameda 9
828014 Madrid

Ortodòncia
Revista independent de cultura
Founded in 2004, 170 x 240 mm,
Catalan / Spanish.
Editorial Office
Nou de la Rambla 40, 4-1
08001 Barcelona
ortodoncia@lallauna.biz
www.lallauna.biz/ortodoncia
Staff
Editor: Daniel Pujal
Editor: Roger Estrada
Publisher
Ortodoncia SCP

Papermind
The after 8 Fanzine
165 x 240 mm, 10€, English.
Editorial Office
Gran Via 646, 5l 3l
08007 Barcelona
fanzine@papermind.net
www.papermind.net

Pupu
Fashion ruined my life
Founded in 2004.
Editorial Office
Paseo Picasso 22 entl. 2a
Barcelona
patrick@espaipupu.com
www.espaipupu.com

Rockdelux
Monthly, Spanish.
Editorial Office
Barcelona
info@rockdelux.es
www.rockdelux.com

ROJO®
Emotionally structured textless magazine
Quarterly, founded in 2001,
210 x 280 mm, 32,000 copies,
Variable price, No Text.
Editorial Office
Ros de Olano 34
08012 Barcelona
info@revista-rojo.com
www.rojo-magazine.com
Staff
Founder and Editorial director:
David Quiles Guilló
Coordination director:
Marc Mascort i Boix
Executive director:
Alejandra Raschkes
Publisher
Sintonison S.L.

Salir
Monthly, founded in 2003,
100 x 150 mm, Spanish.
Editorial Office
Calle Londres 38
28028 Madrid
Publisher
Indoor Media sl

Serie B
Underground Magazine
Every two months, founded in
2004, 210 x 280 mm, 5€, Spanish.
Editorial Office
info@sbum.com
www.sbum.com
Staff
Director: Antonio Garcia Mora
Publisher
Serie B Editores SL
Juan Alvarez Mendizabal 39 3e B
28028 Madrid
info@sbum.com

Snowplanet
**Free snowboard magazine
since 1994**
5x / year, founded in 1994,
230 x 295 mm, 15,000 copies,
Free, Spanish / English.
Editorial Office
Pasaje Maluquer,
13 entresuelo 2L
08022 Barcelona
snowplanet@planetbase.net
www.snowplanetmag.com
Staff
Director: Antonio Kobau
Art direction: Sebastian Saavedra
Editor-in-chief:
Thomaz Autran Garcia
Art design: Filip Zuan
Production: Natalia Tortosa
Publisher
Snowplanetbase s.l.
Pasaje Maluquer 16

Tela
Variable format, Spanish.
Editorial Office
tramatela@telamagazine.com
Staff
Founder and Designer:
Felipe Ibanez
Manager: Virginia Rivero

the balde
Keeping an eye on last design
tendencies.
Every two months, founded in
2001, 240 x 280 mm, 20,000
copies, Free, Euskera / English.
Editorial Office
Antsoain 1 Behea
31014 Irunea
info@thebalde.net
www.thebalde.net
Staff
Director: Koldo Almandoz
Editor: Ingo Martinez

UNO Pop
**Skateboarding and
Pop Culture Mag**
Every two months, founded in
2000, 230 x 278 mm, 90,000
copies, Free, Spanish.
Editorial Office
Pasaje Maluquer, 13 entresuelo, 2L
08022 Barcelona
sebastian@planetbase.net
www.unopopmag.com

vanidad
Monthly, founded in 1992,
230 x 300 mm, 3€, Spanish.
Editorial Office
Pizarro 22
28004 Madrid
www.vanidad.es
Staff
Editor and Creative director:
Emilio Saliquet
Manager: Olga Liggeri
Publisher
Egoiste Publicaciones SL and
Vanidad SL

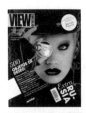

View Of The Times
Magazine about fashion, art,
music, cinema, design,
architecture. Bi-annual, founded
in 2005, 230 x 302 mm, 4.50€,
Spanish / English.
Editorial Office
Egoiste Publications Pizarro 22
28004 Madrid
info@viewofthetimes.com
www.viewofthetimes.com
Staff
Editor and Creative director:
Emilio Saliquet
Publisher
Egoiste Publicaciones
Madrid

Visual
**Magazine de Diseño,
Creatividad Grafica y
Comunicacion**
Every two months, Spanish.
Editorial Office
C/ Abtao, 25. Interior, Nave C
28007 Madrid
informa@visual.gi
www.visual.gi
Publisher
Blur Ediciones, S.L.

Wendy and Rita
Every two months, founded in
2003, 217 x 286 mm, 25,000
copies, Free, Spanish.
Editorial Office
Barcelona
www.wendyandrita.com
Staff
Director: Oihana Iturbide
Art director and Photographer:
Maxx Figueiredo
Fashion director: Amaia Iturbide

Zehar
A magazine of art and
contemporary culture.
Quarterly, founded in 1989,
290 x 220 mm, 5,000 copies,
Spanish / English / Basque.
Editorial Office
Kristobaldegi 14
20014 San Sebastian
arteleku@gipuzkoa.net
www.zehar.net

Zona de Obras

Magazine about Latin music and culture. Includes a musical CD. Every two months, founded in 1995, 220 x 240 mm, 8,000 copies, 6€, Spanish.

Editorial Office
Don Juan de Aragón, 16
Local 50003 Zaragoza
infozona@zonadeobras.com
www.zonadeobras.com
Staff
Editor-in-chief:
Rubén Scaramuzzino
Editor: Marcelo Gabriele
Editor: Daniela Rossi

Zoot

A Go Magazine Production
Bi-annual, 230 x 300 mm, Free, Spanish.
Editorial Office
Muntaner 492 Bajos
08022 Barcelona
go@go-mag.com
www.go-mag.com
Staff
Founder and Director:
Janina Canet
Publisher
Uniprensa S.A.

Sweden

Acne Paper

Each issue is created around one key idea – a timeless theme that in various ways touches all those working in the creative fields regardless of age, cultural background or social status. Bi-annual, founded in 2005, 280 x 375 mm, 4€, English.
Editorial Office
Nybrogatan 57A
114 40 Stockholm
contact@acnepaper.com
www.acnepaper.com
Staff
Editor-at-large: Johny Johansson
Publisher: Mikael Schiller
Editor-in-chief and Creative director: Thomas Persson

addictive magazin

Tri-annual, 1,500 copies, 12€, German.
Editorial Office
Po Box 3009
111174 Stockholm
addictive@addictive-magazin.com
www.addictive-magazin.com

Bon (International issue)

In *Bon Magazine*, the avant-garde future of fashion and art is revealed.
Quarterly, founded in 2004, 225 x 290 mm, 45,000 copies, £3.95, English.

Editorial Office
Repslagargatan 17B, 1tr
118 46 Stockholm
mail@bonmagazine.com
www.bonmagazine.com
Staff
Editor-in-chief and Publisher:
Marina Kereklidou
Art director: Christoffer Wessel
Editor: Anders Rydell
Fashion editor:
Marina Kereklidou
Art director: Pia Constenius
Publisher
Letterhead AB
Repslagargatan 17B 1st floor
118 46 Stockholm
Phone: +46 0 84494690
Fax: +46 0 86795710

Bon (Swedish Issue)

Contemporary Fashion and Art
In *Bon Magazine*, the avant-garde future of fashion and art is revealed
Every two months, 225 x 290 mm, 25,000 copies, 59 SEK, Swedish.
Editorial Office
Repslagargatan 17B, 1tr
118 46 Stockholm
contact@bonmagazine.com
www.bonmagazine.com
Staff
Editor-in-chief: Madelaine Levy
Editor: Anders Rydell
Fashion editor:
Marina Kereklidou
Publisher
Letterhead AB
Repslagargatan 17B 1st floor
118 46 Stockholm
Phone: +46 0 84494690
Fax: +46 0 86795710

Cap and Design

Monthly (10x / year), Swedish.
Editorial Office
Karlbergsvägen 77
10678 Stockholm
capred@idg.se
www.capdesign.se
Publisher
IDG
106 78 Stockholm
Phone: +46 08 453 60 00
Fax: +46 08 453 60 00

EFX

Art and Design
Computer graphics and digital imaging multimedia and interaction.
Quarterly, founded in 1991, English.
Editorial Office
Stockholm
macartdesign@matchbox.se
Staff
Editor-in-chief:
Anders Frönnblom
Editor-in-chief: Alice Schwab (France)
Publisher
Studio Matchbox
Roslagsgatan 11
11355 Stockholm
Phone: +46 8 15 55 48
Fax: +46 8 15 55 49
macartdesign@matchbox.se
macartdesign.matchbox.se

Livraison

Livraison's first publication explores people with the help of interviews and portraits.
Annual, founded in 2005, 230 x 300 mm, 2,000 copies, 45€, English.
Editorial Office
Pipersgatan 8 FP
112 24 Stockholm
info@livraison.se
www.livraison.se
Staff
Director of the words:
Marie Birde

Visit www.welovemags.com for an updated version of the directory

COVER

DENMARKS LEADING FASHION MAGAZINE FOR MEN & WOMEN

COVER.DK

Loyal Magazine

Founded in 2000, 235 x 305 mm, 7€, English.
Editorial Office
Torsgatan 59
113 57 Stockholm
galleri@galleriloyal.com
www.galleriloyal.com
Staff
Editor: Martin Lilja
Editor: Kristian Bengtsson
Editor: Amy Giunta

Merge

Sound Thought Image
International cultural magazine covering a wide range of topics. Art, music, architecture, design, film, philosophy.
Quarterly, founded in 1998.
Editorial Office
Po Box 9223
102 73 Stockholm
info@mergemag.com
www.mergemag.com
Staff
Editor-in-chief: Bo Madestrand

Plaza Magazine

A truly international publication with its focus on design, interior decoration and fashion, all with a hip Scandinavian perspective and twist.
9x / year, 225 x 300 mm, 35,000 copies, 6.50€, Swedish / English / German / Arabic.
Editorial Office
Lindhagensgatan 98
Po Box 30210
10425 Stockholm
info@plazamagazine.com

www.plazamagazine.com
Publisher
Plaza Publishing Group
Po Box 30210
104 25 Stockholm
Phone: +46 08 618 80 00
Fax: +46 08 618 80 24
info@plazamagazine.com

Switzerland

Bolero

Das Schweizer Magazin für Mode, Beauty and Lifestyle
Monthly, 40,000 copies, German.
Editorial Office
Giesshübelstr. 62i
8045 Zurich
service@boleroweb.ch
www.boleroweb.ch
Staff
Editor-in-chief: Sithara Atasoy

Die Klasse
magazin

25 CHF, German / English.
Editorial Office
Sihlquai 125
8005 Zurich
Staff
Publisher: Yves Keel
Publisher: André Plattner
Publisher
Hochschule für Gestalung und Kunst Zurich
Austellungsstrasse 60
8005 Zurich

du

Monthly (10x / year), founded in 1941, 12€, German.
Editorial Office
Holbeinstrasse 31
8008 Zurich
redaktion@dumag.ch
www.dumag.ch
Staff
Editor: Andreas Kläui
Editor: Andreas Nentwich

edelweiss

Le magazine romand des envies et des passions
Monthly, 6 CHF, 24,466 copies, French.
Editorial Office
7 rue Saint Martin
1005 Lausanne
edelweiss@ringier.ch
www.edelweissmag.ch
Staff
Editor-in-chief:
Laurence Desbordes

embryomagazine

Quarterly, Free, 3,000 - 6,000 copies, German.
Editorial Office
Industriestrasse 17
6005 Luzern
info@embryografik.ch

www.embryografik.ch
Publisher
Verein Embryofrafik Luzern

Futuro

contemporaryart
Quarterly, 215 x 280 mm, CHF 8, English / German / Italian.
Editorial Office
Seefeldstrasse 10
5616 Meisterschwanden
futuro@tele2.ch
www.futuro-magazin.ch

Geneve Tokyo

Published irregularly, English / Japanese.
Editorial Office
Geneva
info@genevetokyo.com
www.genevetokyo.com

Icon

Magazine d'expression visuelle
Bi-annual, English / German / French.
Editorial Office
9b rue de Sébeillon
1004 Lausanne
info@iconmagazine.ch
www.iconmagazine.ch

idpure

The Swiss magazine for visual creation
Quarterly, 220 x 280 mm, 6,500 copies, 12 CHF, French / English.
Editorial Office
Grand-rue 82
1110 /1 VD Morges
info@idpure.ch
www.idpure.ch
Staff
Publisher: Thierry Hausermann

SOMETHING IS MISSING IN IDP RE

it's You!
Subscribe to idpure magazine at **www.idpure.ch**

THE SWISS MAGAZINE FOR VISUAL CREATION

Kunstbulletin

Monthly (10x / year), founded in
1998, 131 x 190 mm, 5€,
German / French / Italian.
Editorial Office
Zeughausstrasse 55
8026 Zurich
info@kunstbulletin.ch
www.kunstbulletin.ch
Staff
Editor: Brita Polzer
Editor-in-chief: Claudia Jolles
Publisher
Schweizerischer Kunstverein
Zeughausstrasse 55
8026 Zurich
Phone: +41 1 241 63 00
Fax: +41 1 241 63 73

miuze

miuze consists of two different
tools: *miuze* print is an art / media
magazine.
Bi-annual, 375 copies, 23€.
Editorial Office
Zentralstr. 161
8003 Zurich
info@miuze.com
Staff
Editor: Barbara Corti

Our Magazine

Tri-annual, founded in 2003,
190 x 250 mm, 2,000 copies,
English.
Editorial Office
Po Box 1574
8031 Zurich
info@our-magazine.ch
www.our-magazine.ch
Staff
Nick Widmer
Urs Lehni
Martin Jaeggi
Melanie Hofmann
Publisher
Our magazine
Gasometerstrasse 32
8031 Zurich
Phone: +41 01 272 95 42
www.our-magazine.com

Parkett

Parkett works directly with world
wide known artists and
comments their works with long
texts and critics.
Tri-annual, founded in 1991,
270 x 320 mm, 25 CHF, English /
German.
Editorial Office
Quellenstrasse 27
8031 Zurich
www.parkettart.com
Staff
Editor-in-chief: Bice Curiger
Editor-in-chief:
Cay-Sophie Rabinowitz
Editor: Jacqueline Burckhardt
Publisher
Parkett Publishers
155 Ave. of the Americas
NY 10013 New York
USA
Phone: +1 212 673 2660
Fax: +1 212 271 0704

soDA

magazin für visuelle kultur
Quarterly, founded in 1996,
220 x 270 mm, 11,000 copies,
18€, German / English.
Editorial Office
Po Box 1918
8021 Zurich
redaktion@soda.ch
www.soda.ch
Staff
Founder and Creative director:
Martin Loetscher
Publisher
soDA Verlag s.A.
Schöneggstrasse 5
8004 Zurich
Phone: +41 0 44 241 52 43
Fax: +41 0 44 241 52 42
verlag@soDA.ch

sodbrand

**sodbrand - mit alles und viel
scharf**
sodbrand is biannual postcard-
magazine for photography and
literature.
Bi-annual, founded in 2004,
210 x 105 mm, CHF 18.60,
German.
Editorial Office
Auf dem Wolf 5
4052 Basel
benjamin.fueglister@sodbrand.com
www.sodbrand.com
Staff
Art director: Benjamin Füglister
Text editor, Marketing/Sales:
Claudio Miozzari
Photo editor:
Andreas Zimmermann
Marketing/Sales: Felizitas Schaub
Text editor, PR: Miriam Glass
Text editor: Barbara Achermann
Longterm fundraising:
Andrea Freund

Temporale

Quarterly, founded in 1983,
210 x 300 mm, English / Italian.
Editorial Office
Corso Pestalozzi 1
69 000 Lugano
studio.dabbeni@span.ch
Staff
Editor-in-chief: Felice Dabbeni

tm-rsi-stm

Typografische Monatsblätter
Journal for lettering, typographic
composition, design and
communication.
Every two months, founded in
1932, 230 x 297 mm, CHF 26,
German/ French / English /
Italian.
Editorial Office
St. Alban-Tal 40a
4020 Basel
hartmann@hartmannbopp.ch
www.tm-rsi-stm.com

Seen a magazine
that is no longer
published?
Go online: www.
welovemags.com

TRUCE

**Independent publishing +
production**
TRUCE combines photography,
illustration, art and design with
timeless themes.
Quarterly, founded in 2006,
230 x 290 mm, 5,000 copies,
22 CHF, German / English.
Editorial Office
Rütschistrasse 15
8037 Zurich
stefan@jermann.com
www.truce.ch
Staff
Founding art director:
Walter Stähli
Founder and Creative director:
Stefan Jermann
Designer: Adrian Goepel
Producer: Martina Rychen

Type

**Le magazine de l'homme en
Suisse**
Bi-annual, 210 x 270 mm,
6 CHF, French.
Editorial Office
7 rue Saint Martin cp 6003
1002 Lausanne
Staff
Editor-in-chief:
Laurence Desbordes
Publisher
Ringier Publishing GmbH
Berliner Strasse 89
14467 Postdam
Germany
Phone: +49 0 331 20134 0
Fax: +49 0 331 20134 39

THERE IS A GOOD REASON TO CROSS

PLAYZEBRA MAGAZINE

INTERACTIVE CROSSING BETWEEN CONTEMPORARY ART AND VISUAL DESIGN

Photo: Ichibanto / flickr.com

PLAYZEBRA IS A BIANNUAL MAGAZINE
PUBLISHED AND DESIGNED WITH LOVE BY:
ZEBRA SRL / CROSS MEDIA PUBLISHING

VIA VERDI 12, I-10124 TORINO / ITALY
T/F +39 011 8136068
WWW.PLAYZEBRA.IT
LOOK@PLAYZEBRA.IT

ISSUE #05
FEBRUARY 2007
PLAY WITH FEELINGS

ISSUE #06
SEPTEMBER 2007
PLAY WITH TOYS

 PLAYZEBRA MAGAZINE

Zoo Magazine

Former *Zoo Magazine* evolved into a magazine with a different title for each issue. The new titles are published under Nieves Magazines. So far two issues have been published: "Individuals" guest edited by Nakako Hayashi and "Societe Anonyme" by Aaron Rose. Annual, founded in 1999, 215 x 275 mm, Variable price, English.

Editorial Office
Grabenweg 4
5600 Lenzburg
zoo@nieves.ch
www.nieves.ch/zoo.html

Staff
Editor-in-chief:
Benjamin Sommerhalder

Publisher
Nieves Books
Po Box 1932
8026 Zurich
post@nieves.ch
www.nieves.ch

Taiwan

EGG+

Monthly, founded in 2003, 50,000 copies.

Editorial Office
7F, #35, Ln177, Sec.1,
Duenhua S.Rd.,
106, R.O.C. Tapei
egg@eggmagazine.com
www.eggmagazine.com

Happening

$3.80.

Editorial Office
happening@wanadoo.nl

Staff
Publisher and Editor-in-chief:
Sabrina Yeh
Creative director: Jeff Hargrove

Thailand

VER magazine

Fabricated by stories out of everyday settings; food, music, sport, travel, fashion, fiction, art and living culture, politics and science.
Published irregularly,
270 x 400 mm

Editorial Office
71/31-35 Soi Klong San Plaza,
2nd Floor,
Chareon Nakorn Road,
Klong San
10600 Bangkok

Turkey

2'debir

Every two months, founded in 2005, 220 x 280 mm, 10,000 copies, 10 YTL, Turkish.

Editorial Office
Adnan Saygun Cad. Metehan
Sokak. 16 / 2
34000 2 Ulus Istanbul
info@ikidebir.com
www.ikidebir.com

34

34 is not just a magazine about style, but also a magazine about the philosophy of style. It is intelligent and unapologetically vain. Quarterly, 230 x 297 mm, 60,000 copies, TL 12.5M, English.

Editorial Office
Yayincilar sok. no:10, kat:4
Seyrantepe, 4. Levent
34418 Istanbul
info@34mag.com
www.34mag.com

Staff
Fashion director: Niki Brodie
Editorial director: John Weich
Editor and Creative director:
Murat Patavi

Publisher
Otto Iletsim Hizmetleri Ltd
Seyrantepe 4 Levent
34418 Istanbul
Phone: +90 212 325 16 53
info@34mag.com
www.34mag.com

bant

Music, art, cinema, etc
Monthly independent magazine which is full of illustrations, music articles.
Monthly (10 x / year), founded in 2003, 205 x 255 mm, 80,000 copies, 5 YTL, Turkish.

Editorial Office
merkez mah mazhar oktem sok.
no: 14 / A sisli
Istanbul
agungor@bantdergi.com
www.bantdergi.com

Fotografevi

Founded in 1989.

Editorial Office
Istanbul
funda@fotografevi.com
www.fotografevi.com

genis aci

Photography Magazine
Every two months, Turkish.

Editorial Office
Istanbul
genisaci@genisaci.com
genisaci.com

hillsider

Quarterly, 240 x 340 mm, 14,000 copies, Turkish / English.

Editorial Office
Ahular sok. No.6
Etiler 80630 Istanbul
hillsider@hillside.com.tr
www.hillside.com.tr

maviology

Quarterly, founded in 2003, 195 x 258 mm, Free, Euskera / English.

Editorial Office
Dereboyu Cad. Zagra is Merkezi,
Blok No:1
34398 Maslak Istanbul
info@mavi.com
www.mavi.com

Staff
"Head": Ersin Akarlilar
"Heart": Elif Akarlilar
"Brain": Izzeddin Ćalislar

Publisher

Visit www.welovemags.com for an updated version of the directory

www.bantdergi.com

Maviology Inc.
201 Pernhorn Avenue Unit 4
NJ 07094 Secausus

Moda Ankara
212 x 296 mm, Turkish.
Editorial Office
4 Cadde, N:60/7, Yildiz
Ankara

Trendsetter
Quarterly, 220 x 295 mm, 5 YTL,
Turkish.
Editorial Office
Halaskargazi Cad. Sait Kuran Is
Merkezi No. 301, Kat.5
Istanbul
info@trednsettermag.com
www.trendsettermag.com
Staff
Editor: Zeynep Kun

United Kingdom

(a-n) Magazine
Monthly, English.
Editorial Office
1st Floor, 7-15 Pink Lane
Newcastle upon Tyne NE1 5DW
www.a-n.co.uk
Publisher
AN The Artist Information
Company
1st Floor, 7-15 Pink Lane
Newcastle upon Tyne NE1 5DW
Phone: +44 0 191 241 8000
Fax: +44 0 191 241 8001

10 Magazine
Fashion and beauty for men and women.
Quarterly, founded in 2001,
245 x 310 mm, £10, English.
Editorial Office
3 Lower John Street
London W1F 9DX
Staff
Design and Art direction:
Daren Ellis
Editor-in-chief:
Sophia Neophitou-Apostolou
Publisher
ZAC Publishing Ltd
England

125 Magazine
international photography showcase
Contemporary photography and
image.
Bi-annual, founded in 2003,
230 x 270 mm, 29,000 copies,
£6.99, English.
Editorial Office
5 Calvert Avenue
London E2 7JP
rob@wrk.me.uk
www.125magazine.com
Staff
Editor-in-chief: Perry Curties
Editor: Jason Joyce
Art director: Rob Crane
Art director: Martin Yates
Advertising director: Ed Searle
Publisher
125 World Ltd
5 Calvert Avenue
London E2 7JP
Phone: +44 0 20 7613 2015

33 Thoughts
Founded in 2005,
170 x 230 mm, English.
Editorial Office
33thoughts@bdo.co.uk
www.bdo.co.uk
Publisher
John Brown
136-142 Bramley Street
London W10 6SR
Phone: +44 20 7565 3121
Fax: +44 20 7565 3060
dean.fitzpatrick@johnbrownpublishing.com

A bit special
Quarterly, founded in 2005,
£4, English.
Editorial Office
info@abitspecialmag.co.uk
www.abitspecial.net
Staff
Editor-in-chief and Creative
director: Marc Taylor
Publisher
Marc Taylor

above magazine
A cutting-edge publication with
strong editorial content focussing
on the newest tendencies
throughout the world of luxury.
Bi-annual, 210 x 300 mm,
21,800 copies, £10, English.
Editorial Office
London
info@above-magazine.com
www.above-magazine.com
Staff
Editor-in-chief: Sascha Lilie
Art director: Giorgio Martinoli
Fashion editor-at-large:

Jenny Capitain
Publisher
SL Magazines Ltd
30 Cooper House
London SW6 2AD
Phone: +44 20 73710808
Fax: +44 20 7731 73 11
info@above-magazine.com
www.above-magazine.com

adrenalin magazin
Documents and defines the truly
global culture of surf, skate and
snowboarding.
Quarterly, English / French /
German / Italian.
Editorial Office
Metropolis,
140 Wales Farm Road
London W3 6UG
vince.medeiros@metropolis.co.uk
Staff
Editor: Michael Fordham
Publisher
The Media Cell LTD
10-16 Tiller Road,
Docklands
London E14 8PX
ads@bogey.com

Afterall
**A Journal of Art, Context
and Enquiry**
Bi-annual, founded in 1998,
190 x 295 mm, 6,500 copies,
£10, English.
Editorial Office
107-109 Charing Cross Road
London WC2H ODU
london@afterall.org
Staff
Editor-in-chief:
Pablo Lafuente
Editor: Thomas Lawson
Editor: Charles Esche
Editor: Mark Lewis
Publisher
Central Saint Martins College of
Art and Design
107-109 Charing Cross Road

music, fashion, photography, illustration, art

www.ameliasmagazine.com

London WC2H ODU
Phone: +44 0 20 7514 7212
Fax: +44 0 20 7514 7166

Ag

The international journal of photographic art and practice
Published since 1991, every volume of *Ag* magazine brings the reader the very best in contemporary photography, published to exacting standards on fine quality paper and presented with the greatest attention to design and detail. Quarterly, founded in 1991, £12.50, English.
Editorial Office
62 Pemberton Road,
East Molesey
Surrey KT8 9LH
www.ag-photo.co.uk
Staff
Editor: Chris Dickie

Amelias' Magazine

Bi-annual, founded in 2004, 5,000 copies, £9.99, English.
Editorial Office
London
info@ameliasmagazine.com
www.ameliasmagazine.com
Staff
Founder, Editor, Art director and Designer: Amelia

AMP

minizine
An elegant pink pamplet dedicated to the finer things in life. For chicks and dicks and... just about anybody, really. English.
Editorial Office
Po Box 30639
London E1 6HR
amp@ampnet.co.uk
www.ampnet.co.uk

Another Magazine

The Luxury Fashion Bi-annual
Another Magazine is already setting the fashion and style agenda for the next six months. Bi-annual, founded in 2001, 230 x 320 mm, 175,000 copies, 13€, English.
Editorial Office
112-116 Old Street
London EC1V 9BG
info@anothermag.com
www.anothermag.com
Staff
Senior editor: Mark Sanders
Fashion editor:
Sofia De Romarate
Creative director: Alexis Wiederin
Fashion director: Alister Mackie
Editor-in-chief: Jefferson Hack
Publisher
Another Publishing Ltd
112 Old Street
London EC1V 9BG
Phone: +44 0 207 336 0766
Fax: +44 0 207 336 0966
info@anothermag.com
www.anothermag.com

Architectural Review

Monthly, £7.25, English.
Editorial Office
151 Rosebery Avenue
London EC1R 4GB
www.arplus.com
Staff
Editor: Paul Finch

Architecture Today

The leading independent architectural publishing house in the UK.
Monthly, founded in 1989, £4.
Editorial Office
161 Rosebery Avenue
London EC1R 4QX
mark.l@architecturetoday.co.uk
www.architecturetoday.co.uk

Arena

Style for Men
Monthly, 218 x 279 mm, £3.40, English.
Editorial Office
Endeavour House,
189 Shaftesbury Avenue
London WC2H 8JG
arenamag@emap.com
Staff
Editor-in-chief:
Anthony Noguera

Art & Architecture

An independent magazine representing the energy of national public art professionals - artists - architects - opinion makers in the fields of public art - urbanism - architecture.
Quarterly, founded in 1980, 230 x 270 mm, £10.
Editorial Office
70 Cowcross Street
London EC1M 6EJ
info@thisistomorrow2.com
www.artandarchitecturejournal.com

Art Monthly

Indispensable guide to today's fast-moving artworld
Magazine of contemporary visual art.
Monthly (10x / year), founded in 1976, 210 x 295 mm, English.
Editorial Office
4th Floor,
28 Charing Cross Road
London WC2H 0DB
info@artmonthly.co.uk
www.artmonthly.co.uk
Staff
Editor: Patricia Bickers
Publisher
Jack Wendler
Phone: +44 0 20 7240 0389
Fax: +44 0 20 7497 0726

Art Newspaper

Monthly, founded in 1990, 297 x 420 mm, £5.95, English.
Editorial Office
70 South Lambeth Road,
London SW8 1RL
contact@theartnewspaper.com
www.theartnewspaper.com
Staff
Editor: Chritina Ruiz
Publisher
Umberto Allemandi

Art of England

Monthly, 300 x 230 mm, £3.25, English.
Editorial Office
Woodgate Cortage,
Trentham Estate, Stone Road
ST4 8HQ Trentham
Pam@artofengland.uk.com
www.artofengland.uk.com

Art Review

Monthly, £4.90, English.
Editorial Office
1 Sekforde Street
London EC1R 0BE
editorial@artreview.com
www.artreview.com

Artesian

Bi-annual, £4.95, English.
Editorial Office
88 Morningside Road,
Edinburgh EH10 5NT
visionary@artesian-arts.org
www.artesian-arts.org

art in-sight

Filmwaves is a non-profit making
publishing project devoted to
filmmaking.
Quarterly, £3.90, English.
Editorial Office
Po Box 420
Edgware HA8 OXA
filmwaves@filmwaves.co.uk
www.filmwaves.co.uk

Artrocker

London-centric artrock magazine
in newsprint format.
Every two months, 326 x 246 mm,
£1.95, English.
Editorial Office
London
www.artrockermagazine.com

BAD IDEA

Modern Storytelling
A quiet revolution in quality and
style, *BAD IDEA* is a unique
magazine: of real life storytelling
for young people who love the
written word.
Quarterly, founded in 2006,
171 x 245 mm, 22,000 copies,
£4.50, English.
Editorial Office
Floor 4, Shacklewell Studios,
18-24 Shacklewell Lane, Dalston,
London E8 2EZ
info@badidea.co.uk
www.badidea.co.uk
Staff
Founding Editor: Jack Roberts
Editor: Daniel Stacey
Publisher
Good Publishing Ltd

baseline

Sets out to reflect all aspects of
type, including its design, history,
use, and links to the graphic, art
and craft scenes.
Founded in 1979, 356 x 255 mm,
English.
Editorial Office
East Malling
Kent ME 19 6DZ
type@baselinemagazine.com
www.baselinemagazine.com
Staff
Publisher: Mike Daines
Publisher: Jenny Daines
Publisher: Hans Dieter Reichert
Publisher: Veronika Reichert
Publisher
Bradboume Publishing Ltd
Bradboume House / East Mailing
Kent ME 19 6DZ
Phone: +44 0 17 32 87 52 00
Fax: +44 0 17 32 87 53 00
type@baselinemagazine.com
www.baselinemagazine.com

Beat

Beat appeals to those students
who download music, see live
music, are interested in the
environment and wider issues
and who are brand conscious.
Tri-annual, founded in 2007,
148 x 210 mm, 120,000 copies,
£2.50, English.
Editorial Office
416 The Custard Factory
Birmingham B9 4AA
info@blowback.co.uk
www.beatmagazine.co.uk
Staff
Editor: George Wilson-Powell

Bizarre

It's about life in the extreme
Bizarre is packed with hard-hitting
reportage, absorbing glimpses of
life in the extreme, and pictures
that demand a closer look.
English.
Editorial Office
30 Cleveland Street
London W1T 4JD
bizarre@dennis.co.uk
www.bizarremag.com
Publisher
Dennis Publishing Ltd
30 Cleveland Street
London W1T 4JD
Phone: +44 020 7907 6000
Fax: +44 020 7907 6020
theboard@dennis.co.uk
www.dennis.co.uk

blag

Founded in 1992, 30,000 copies,
£24.99, English.
Editorial Office
blag@blagmagazine.com
www.blagmagazine.com
Staff
Founder: Sally A. Edwards
Founder: Sarah J. Edwards
Publisher
Blag UK Ltd.

Blowback

Monthly, founded in 2003,
25,000 copies, Free, English.
Editorial Office
416 The Custard Factory
Birmingham B9 4AA
info@blowback.co.uk
www.blowback.co.uk
Staff
Editor: George

Blueprint

The best in critical journalism on
design and architecture.
Monthly, 270 x 337 mm, £4.25,
English.
Editorial Office
6-14 Underwood Street
London N1 7JQ
www.blueprintmagazine.co.uk
Staff
Editor: Vicky Richardson
Deputy editor: Tim Abrahams
Art director: Patrick Myles
Editorial director: Tony Loynes
Publisher
Wilmington Media Ltd
6 - 14 Underwood Street
London N1 7JQ
Phone: +44 0 207 490 0049
www.blueprintmagazine.co.uk

Bogey

Old Game, New Breed
Founded in 2002, 220 x 274 mm,
5€, German.
Editorial Office
London
Staff
Editorial director:
Michael Fordham
Creative director: Mickey Boy G
Editor: Steven Muncey
Publisher
The Media Cell LTD
10-16 Tiller Road, Docklands
London E14 8PX
ads@bogey.com

Bolz
Art Design Fashion Culture
Bolz is a cultural publication, refreshingly honest in its approach to subject matter and critical of conventions. English.
Editorial Office
Unit 108B,
Mare Street Studios,
203-213 Mare Street
London E8 3QE
www.bolzmagazine.com
Staff
Publication Director: Taiwo
Editor: Charlotte Illera

bulb
A not-for-profit communications cooperative written for and by young people.
Every two months, £4, English.
Editorial Office
5 Torrens Street
London EC1V 1NQ
hello@bulbmag.com
www.bulbmag.com
Staff
Editorial and Production manager: Ana
Editorial and Production assistant and Distribution manager: Emma
Fundraiser and Music editor: Jesse
Events co-ordinator: Josie

C
International Photo Magazine
Published with the ambition of promoting the discussion and creation of contemporary photography, without cultural, geographical or thematic boundaries.
Bi-annual, 230 x 337 mm, £55, English / Japanese / Chinese / Spanish.
Editorial Office
22 Hester Road
London SW11 4AN

www.ivorypress.com
Publisher
Ivory Press
22 Hester Road
SW 11 4AN London
www.ivorypress.com

Cent Magazine
UK-based magazine celebrating creativity in all its forms.
Bi-annual, founded in 2003, 297 x 210 mm, 8,000 copies, £9.95, English.
Editorial Office
9 Albany Mews,
Albany Road
London SE5 0DQ
editorial@centmagazine.co.uk
www.centmagazine.co.uk
Staff
Creative director and Publisher: Jo Phillips
Managing editor: Lou Owen
Editor: Lydia Fulton
Publisher
Onehundredpercent publishing ltd

clutter
UK-based with an international perspective, *clutter* is a magazine to focus on the designer-toy phenomenon.
Every two months, founded in 2004, English.
Editorial Office
Earlsdon
info@cluttermagazine.com
www.cluttermagazine.com
Staff
Contributing editor and Photographer: Brian McCarty
Founder, Publisher and Designer: Miranda O'Brien
Founder, Publisher and Designer: Nick Carroll

Computer Arts Projects
The in-depth guide for digital creatives
Monthly, £6, English.
Editorial Office
www.computerarts.co.uk
Staff
Associate editor: Rob Carney
Publisher
Future Inc. Ltd
100 Grays Inn Road
London WC1X 8AL
Phone: +44 0 20 7269 7480
Fax: +44 0 20 7269 7490

Condé Nast Traveller
Truth in travel
Monthly, £3.20, English.
Editorial Office
Vogue House,
Hanover Square
London W1S 1JU
www.cntraveller.co.uk
Staff
Editor: Sarah Miller
Publisher
Condé Nast Publications
Piazza Castellano 27
20121 Milan
Italy
Phone: +39 02 856 11
Fax: +39 02 805 57 61

Contagious
Identifies the ideas, trends and innovations behind the world's most revolutionary marketing strategies.
Quarterly, 1,500 copies, English.
Editorial Office

45 Foubert's Place
London W1F 7QH
hello@contagiousmagazine.com
www.contagiousmagazine.com
Staff
Editorial director:
Paul Kemp-Robertson
Staff Writer: Jess Greenwood

contemporary
A multi-faceted magazine, covering visual arts, architecture, design, fashion, film, music, media, photography, dance, books, and much more. In collaboration with leading world artists, contemporary offers original limited edition art works free to all subscribers.
Monthly, founded in 1993, £5.95, English.
Editorial Office
Suite K101,
Tower Bridge Business Complex,
100 Clement Road,

Bermondsey
London SE16 4DG
info@contemporary-magazine.com
www.contemporary-magazine.com
Staff
Publisher: Brian Muller
Senior editor: Michele Robecchi
Publisher
Art 21 ltd
London
brian@art-21.co.uk

Co-op
Founded in 2002, £2, 1,500 copies, English.
Editorial Office
London
mail@cooperatewith.us
www.cooperatewith.us

Copy
Fanzine about contemporary design culture.
Bi-annual, founded in 2005, 250 copies, English / French / German / Portuguese.
Editorial Office
London
info@copymagazine.org
www.copymagazine.org
Staff
Chief editor: Julie Aveline
Chief editor: Sarah Owens

Crafts
The Decorative and Applied Arts Magazine
Every two months, English.
Editorial Office
44a Pentonville Road
London N1 9BY
www.craftscouncil.org.uk
Staff
Editor: Emma Mills

Creative Review
Monthly, founded in 1980, £5.50, English.
Editorial Office
London
www.creativereview.co.uk
Staff
Editor: Patrick Burgoyne
Publisher

Centaur Communications Ltd
79 Wells Street
London W1T 3QN
Phone: +44 20 7970 4000
Fax: +44 20 7970 6712
www.creativereview.co.uk

Crystallized
Crystal Fashion Components by Swarovski
Bi-annual, founded in 2002, 20€, 100,000 copies, English.
Editorial Office
rachel.webb@johnbrowngroup.co.uk
Staff
Editor: Stephen Todd
Publisher
John Brown
136-142 Bramley Street
London W10 6SR
Phone: +44 20 7565 3121
Fax: +44 20 7565 3060
dean.fitzpatrick@johnbrownpublishing.com

CVA
Contemporary Visual Arts
Every two months, founded in 1997, English.
Editorial Office
Suite K11,
Tower Bridge Business Complex,
100 Clements Road
London SE16 4DG
www.cvamagazine.com
Staff
Editor-in-chief: Keith Patrick

Daniel Battams Fan Club magazine
Dedicated to an ordinary person
Quarterly, founded in 2003, £2.50, 1,300 copies, English.
Editorial Office
London
info@danielbattamsfanclub.com
www.danielbattamsfanclub.com
Staff
Editor-in-chief and Creative director: Daniel Battam

Daylight Magazine
Documentary Photography
Bi-annual, founded in 2004, £7.50, 3,000 copies, English.
Editorial Office
Po Box 57135
London SW6 3TY
info@daylightmagazine.org
www.daylightmagazine.org

Dazed and Confused
Be the first to know
Monthly, £3.40, English.
Editorial Office
112-116 Old Street
London EC1V 9BG
dazed@confused.co.uk
www.confused.co.uk
Staff
Publisher: Jefferson Hack
Publisher: Rankin
Associate publisher:
Rob Montgomery
Publisher
Dazed and Confused
112 Old Street
London EC1V 9BG
Phone: +44 020 7336 0766
Fax: +44 020 7336 0966
dazed@confused.co.uk
www.confused.co.uk

Design Week
Weekly, £2.80, English.
Editorial Office
50 Poland Street
London W1F 7AX
www.design-week.co.uk
Staff
Editor: Lynda Relph-Knight
Deputy editor: Mike Exon
Publisher
Morag Welham
morag.welham@centaur.co.uk

Digit
Comprehensive coverage of the art of graphic design, 3D, animation, video, effects, web and interactive design, in print and online.
English.
Editorial Office
99 Gray's Inn Road
London WC1X 8TY
www.digitmag.co.uk
Staff
Editor-in-chief: Matthew Bath
Editor: Lynn Wright

Diplo Magazine
New Global Navigators
Independent current affairs and style magazine based in London.
Monthly, founded in 2004, £4, 20,000 copies, English / French.
Editorial Office
156-158 Gray's Inn Road
London WC1X 8ED
charlesb@diplo-magazine.co.uk
www.diplo-magazine.co.uk
Staff
Editor: Mark Hudson
Publisher: Charles Baker

Gomma *No°03*

Out Now

Visual Indulgence

Draft

Quarterly, £12.95, 1,000 copies,
English.
Editorial Office
151 Marylebone Road
London NW5 4RY
info@draftmagazine.co.uk
www.draftmagazine.co.uk

Eco Tech

Professional architectural
magazine devoted to sustainable
design – an essential aspect of
the work of today's architect.
Bi-annual, £7.50, English.
Editorial Office
161 Rosebery Avenue
London EC1R 4QX
mark.l@architecturetoday.co.uk
www.architecturetoday.co.uk

Ei8ht

Ei8ht is photojournalism.
Challenging and enlightening
photography and commentary.
See the world through fresh eyes.
Quarterly, founded in 1998, £10,
5,000 copies, English.
Editorial Office
1 Honduras Street
London EC1Y 0TH
info@foto8.com
www.foto8.com
Staff
Editor: Jon Levy
Publisher
Jon Levy

Emitron

Published irregularly,
Variable price.
Editorial Office
Po Box 3429

Brighton BN1 5UR
mail@borbonesa.co.uk
www.borbonesa.co.uk/emitron
Publisher
Borbonesa
mail@borbonesa.co.uk

European Business

**For movers, shakers and
dealmakers**
Monthly, founded in 2004, £3.25,
English.
Editorial Office
London
Staff
Editor: John Lawless
Publisher
Future Inc. Ltd
100 Grays Inn Road
London WC1X 8AL
Phone: +44 0 20 7269 7480
Fax: +44 0 20 7269 7490

Exit

**The award-winning art,
fashion and photography
magazine**
Bi-annual, founded in 2000, £12,
20,000 copies, English.
Editorial Office
Po Box 32605
London W14 OUL
info@exitmagazine.co.uk
www.exitmagazine.co.uk
Staff
Publisher and Editor-in-chief:
Stephen Toner
Creative director:
Mark Constantine

eye

Quartery, 237 x 297 mm,
11,977 copies, £15.75, English.
Editorial Office
174 Hammersmith Road
London W6 7JP
david.leith@telus.net
www.eyemagazine.com

Fact

A music and street culture
magazine unlike any other.
Quarterly, founded in 2003,
173 x 173 mm, 28,000 copies,
Free, English.
Editorial Office
45 Foubert's Place
London W1F 7QH
submissions@factmagazine.co.uk
www.factmagazine.co.uk
Staff
Editor: Sean Bidder
Publisher
Vinyl Factory Publishing, Ltd.

FAD

Explores art from personal
perspectives, highlighting artists
over a certain period of time.
Published irregularly,
2,000 - 5,000 copies, English.
Editorial Office
54 Bendemeer Road
London SW15 1JU
just@fademail.com
www.fadwebsite.com
Staff
Creative director: Westall Mark
Creative director:
John Crumpton
Editor-in-chief: Daniel Sumption
Publisher
FAD Industries

Fashion Theory

**The Journal of Dress, Body
and Culture**
Quarterly, founded in 1997, 20€,
English.
Editorial Office
1st Floor, Angel Court,
81 St Clements Street,
Oxford OX4 1AW
www.fashiontheory.com
Staff
Editor: Dr. Valerie Steele
Publisher
Berg Publishers
Angel Court,
81 St Clements Street
Oxford OX4 1AW
Phone: +44 0 1865 245 104
Fax: +44 0 1865 791 165
www.bergpublishers.com

Fashionline

Covering all aspects of fashion,
design and music, *Fashionline*
promotes and informs the next
generation of creative talents
throughout its pages of editorial,
photographic and illustrative
content.
Every two months, 225 x 300 mm,
35,000 copies, £3.60, English.
Editorial Office
Po Box 5255
London E8 9AP
editor@fashionlinemagazine.co.uk
www.fashionlinemagazine.co.uk
Staff
Assistant Editor:
Alessandra Estrada
Publisher
Icon Publishers UK Limited.

Filmwaves

Filmwaves is a non-profit-making
publishing project devoted to
filmmaking.
Quarterly, £3.90, English.
Editorial Office
Po Box 420
Edgware HA8 OXA
filmwaves@filmwaves.co.uk
www.filmwaves.co.uk

grafik
fik
grafik
big
big!
design
we
love
ideas
design

Flesh and Blood
Cinema and Video for Adults
210 x 297 mm, English.
Editorial Office
info@fabpress.com
www.fabpress.com
Staff
Editor: Harvey Fenton
Publisher
FAB Press
7 Farleigh, Ramsden Road
Surrey GU7 1QE
info@fabpress.com
www.fabpress.com

FLUX
FLUX is the creative led
independent magazine covering
fashion, music, art and culture.
It's a stylish adventure into the
unknown and a beautiful antidote
to the increasingly uniform
mainstream.
210 x 297 mm, £3.30, English.
Editorial Office
42 Edge Street
Manchester M4 1HN
www.fluxmagazine.com
Staff
Visual arts: Mike Chavez-Dawson
Editor: Lee Taylor
Publisher
Flux Magazine
42 Edge Street
Manchester M4 1HN
England
Phone: +44 0161 832 0300
Fax: +44 0161 819 1196
lee@fluxmagazine.com
www.fluxmagazine.com

Frieze
Magazine of contemporary art
and culture.
8x / year, English.
Editorial Office
3-4 Hardwick Street
London EC1R 4RB
info@frieze.com
www.frieze.com
Staff
Publisher: Amanda Sharp

Publisher: Matthew Slotover
Editor: Jennifer Higgie
Editor: Joerg Heiser

Full moon empty sports bag
Cult literary magazine, one of a
new generation of intelligent
urban magazines.
Monthly, £5, English.
Editorial Office
223b Canalot Studios,
222 Kensal Road
London W10 5BN
info@utan.co.uk
www.utan.co.uk
Publisher
Orang-Utan Ltd
Phone: +44 0 20 7436 0502

FUSED
£2.75, English.
Editorial Office
Studio 315,
The Greenhouse,
Gigg Square
Birmingham B9 4AA
enquiries@fusedmagazine.com
www.fusedmagazine.com

gloom-magazine
**kisses on the line blow into
the shade, her glossy hair
starts to fade.**
A mysterious, individual
experience surrounding the
build-up of suspense.
Quarterly, founded in 2006,
200 x 285 mm, 50 copies, £8,
English.
Editorial Office
80 Wendover Road
Havant Hampshire PO9 1DW
email@gloom-magazine.com
www.gloom-magazine.com
Staff
Founder and editor-in-chief:
David Millhouse
Co-editor: Eloise Parrack
Publisher
defalign
Phone: +44 0 23 9264 0374
email@defalign.com
www.defalign.com

Gomma
A high-quality production
magazine with an excellent
collection of imagery portraying
renowned photographers as well
as emerging talents blended with
a hint of humour and cheekiness.
Annual, founded in 2004,
210 x 270 mm, 9,000 copies,
£5, English.
Editorial Office
Po Box 52215
London SW16 2ZT
info@gommamag.com
www.gommamag.com

Grafik
**Journal of the best in
international graphic design**
Monthly, 225 x 310 mm, 11,000
copies, £ 8, English.
Editorial Office
Third floor,
104 Great Portland Street
London W1W 6PE
hello.grafik@qmail.com
www.grafikmagazine.co.uk
Staff
Editor: Caroline Roberts
Design: SEA Design
Publisher
Grafik Ltd.

granta
Publishes new writing – fiction,
personal history, reportage and
inquiring journalism.
Quarterly, founded in 1889,
English.
Editorial Office
2/3 Hanover Yard,
Noel Road
London N1 8BE
info@granta.com
www.granta.com

graphic
**contemporary graphic culture
magazine**
Quarterly, 220 x 280 mm, 25€,
English.
Editorial Office
c/o Magma,
117-119 Clerkenwell Road
London EC1R 5BY
graphic@magmabooks.com
www.magmabooks.com
Staff
Editor-in-chief: Marc-A Valli
Publisher
BIS Publishers
Herengracht 370-372
1016 CH Amsterdam
Netherlands
Phone: 31 205 247 560
items@bispublishers.nl
www.bispublishers.nl

haddi and more
Quarterly, founded in 2003,
210 x 297 mm, 20€, English.
Editorial Office
4 Avondale Mansions,
Rostrevor Road
London SW6 4AH
info@surfandturflagence.com
www.haddiandmore.com

8

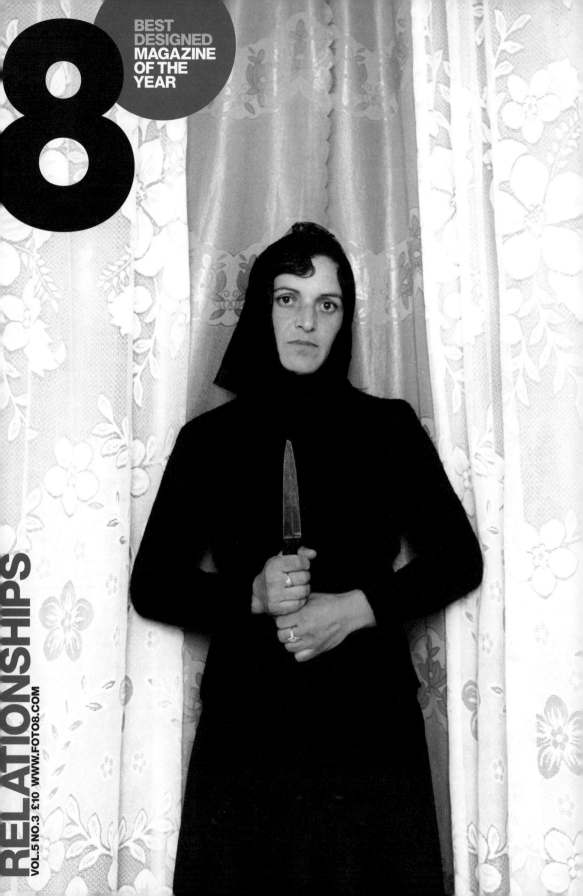

RELATIONSHIPS

VOL.5 NO.3 £10 WWW.FOTO8.COM

HALI

HALI is the glue that holds the international rug and textile art market together.
Every two months, £17, English.
Editorial Office
Poland Street
London W1F 7AX
hali@centaur.co.uk
www.hali.com

hooker

essential british streetwear
English.
Editorial Office
editorial@hookermagazine.com
www.hookermagazine.com

HotShoe

Fresh Perspectives on Contemporary Photography
167 x 240 mm, £4.50, English.
Editorial Office
29-31 Saffron Hill
EC1N 8SW London
melissa.dewitt@photoshot.com
www.hotshoeinternational.com
Staff
Editor: Melissa DeWitt
Publisher: Charles Taylor
Publisher
World Illustrated Limited

huck

Every two months (5x / year),
English / German / French / Italian
Editorial Office
45 Rivington Street
London EC2A 3QB
www.huckmagazine.com
Staff
Vince Medeiros

icon

A major international design and architecture magazine.
Monthly, founded in 2003,
250 x 320 mm, £4.50, English.
Editorial Office
National House,
High Street, Epping
Essex CM16 4BD
info@icon-magazine.co.uk
www.icon-magazine.co.uk
Staff
Editor: Marcus Fairs
Publisher
Media 10 Ltd
National House,
High Street, Epping
Essex CM16 4BD
Phone: +44 1992 570030
Fax: +44 1992 570031
info@icon-magazine.com
www.icon-magazine.com

i-D

i-Deas
Monthly, founded in 1980,
230 x 300 mm, 7.50€, English.
Editorial Office
124 Tabernacle Street
London EC2A 4SA
editor@i-dmagazine.co.uk
www.i-dmagazine.com
Staff

Fashion director:
Edward Emninful
Editor: Glenn Waldron
Founder, Editor-in-chief and Creative director: Terry Jones
Publisher
Levelprint Ltd.

Intersection

Car Style Magazine
Photographed like a fashion magazine, written like a novel, *Intersection* takes the scenic route to get straight to the point.
Quarterly, founded in 2001,
227 x 276 mm, 39,000 copies,
£3.95, English.
Editorial Office
Studio 9, 49-59 Old Street
London EC1V 9HX
info@intersectionmagazine.com
www.intersection.com
Staff
Editor: Shiraz Randeria

Issue One

An aspirational luxury fashion.
Quarterly, founded in 2006,
245 x 310 mm, £7, English.
Editorial Office
Unit 202, 28 Lawrence Road
London N15 4EG
paulus@issue-one.com
www.issue-one.com
Staff
Editor-in-chief: Paulus

Karen

made out of the ordinary
Celebrates the ordinary in everyday life.
Bi-annual, founded in 2004,
168 x 230 mm, £6.50, English.
Editorial Office
Godwins Farmhouse,
Rodbourne
Malmesbury SN16 0EY
Wiltshire
karen@karenmagazine.com
www.karenmagazine.com
Publisher
Karen Lubbock

Kilimanjaro

It likes to bring together like-minded contributors stemming from different art disciplines including photography, illustration, fine art and collage.
Founded in 2003, 480 x 640 mm.
Editorial Office
Po Box 50245
London EC 1V9XZ
editor@kilimag.com
www.kilimag.com
Staff
Publisher, Founder and Creative director: Michael Olu Odukoya

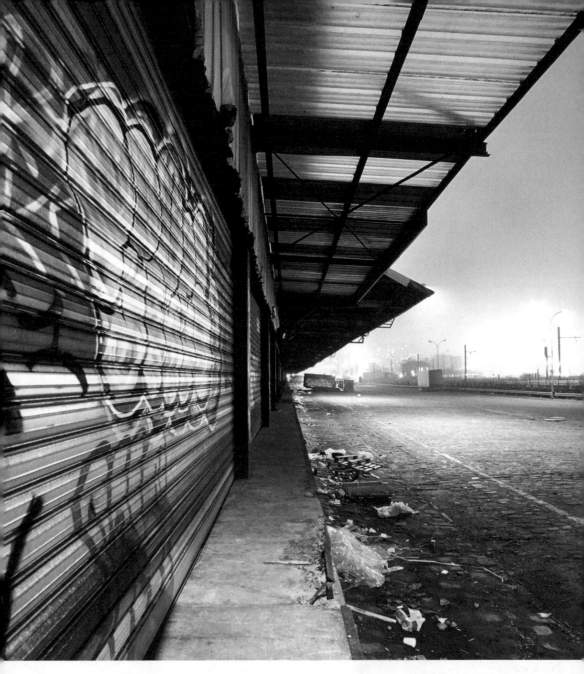

ART | MUSIC | URBAN CULTURE
Six-monthly Magazine. Worldwide Distribution
For subscription, shops and details: www.defragmag.com

DEFRAG®
BEFORE OPTIMIZING IT IS RECOMMENDED

Let them eat cake

For the the fashion conscious, for the intelligent and forward thinkers.
Quarterly, founded in 2006, 250 x 190 mm, 2,000 copies, English.
Editorial Office
London
press@letthemeatcakemagazine.com
www.letthemeatcakemagazine.com

Little White Lies

Truth and Movies
£3.25, English.
Editorial Office
45 Rivington Street
London EC2A 3QB
www.littlewhitelies.co.uk
Staff
Managing editor: Danny Miller
Editor: Matthew Bochenski

Loose Lips Sink Ships

Underground music magazine.
Quarterly, English.
Editorial Office
Po Box 4226
London E7 0WP
www.llss.tv/mag/06/labelmag6.html

Lula

Girl of my Dreams
Founded in 2005, 210 x 297 mm, 9.95€, English.
Editorial Office
www.lulamag.com
Staff
Editor-in-chief: Leith Clark
Creative director: Rebecca Smith
Editor-at-large:
Charlotte Sanders
Publisher
Lula Publishing Ltd
www.lulamag.com

Magazine World

The international Federation of the periodical press
Quarterly, 210 x 297 mm, 9,000 copies, English.
Editorial Office
Queens House,
55-56 Lincoln's Inn Fields
London WC2A 3LJ
info@fipp.com
www.fipp.com
Staff
Editor-in-chief: Helen Bland
Editor: Cristina Esposito

Make

The magazine of women's art
Quarterly, founded in 1983, English.
Editorial Office
107-109 Charing Cross Road
London WC2H 0DU
Staff
Editor-in-chief:
Rebecca Gordon Nesbitt

Marmalade Magazine

The only magazine with a dog on each page
204 x 275 mm, £4.25, English.
Editorial Office
50 Fitzroy Street
London W1T 5BT, Fitzrovia
mail@marmaladeworld.com
www.marmalademag.com
Staff
Managing editor:
Kirsty Robinson
Managing editor:
Sacha Spencer Trace

Miser and Now

An art magazine with the wide variety of content that includes photography, painting, sculpture and writing.
Quarterly, 210 x 265 mm, £5, English.
Editorial Office
London
Staff
Art director and Designer:
Christian Küsters
Publisher
Keith Talent Gallery
2-4 Tudor Road

London E9 7SN
Phone: +44 0 20 8986 2181
keith.talent@tiscali.co.uk

mixmag

Monthly, founded in 1982, 210 x 285 mm, 42,235 copies, £3.80, English.
Editorial Office
Mappin House,
4 Winsley Street
London W1W 8HF
www.mixmag.net
Staff
Editor: Tom Farewell
Publisher
Development Hell Ltd
90-92 Pentonville Road
London N1 9HS
info@developmenthell.co.uk
www.developmenthell.co.uk

Modern Painters

Monthly (10x / year), £5.99, English.
Editorial Office
London
info@modernpainters.co.uk
www.modernpainters.co.uk
Publisher
LTB Ltd.
111 8th Avenue, Suite 302
NY 10011 New York
USA
Phone: +1 212 447 9555
Fax: +1 212 447 5221

Modern Toss

Bi-annual, founded in 2004, 150 x 170 mm, £4.99, English.
Editorial Office

Visit www.welovemags.com for an updated version of the directory

Po Box 386
Brighton BN13SN
trade@moderntoss.com
www.moderntoss.com
Staff
Editor-in-chief and Creative
director: Jon Link
Editor-in-chief and Creative
director: Mick Bunnage

Monocle
A new, global, European-based
media brand, delivering the most
original coverage in global affairs,
business, culture and design.
Monthly (10x / year), founded in
2007, English.
Editorial Office
20 Boston Place
Marylebone London
info@monocle.com
www.monocle.com
Staff
Editor-in-chief and Chairman:
Tyler Brûlé
Affairs and Business editor:
Andrew Tuck
Design editor: Takeharu Sato
Culture editor: Robert Bound
Edits editor: Saul Taylor
Director of web and
Broadcasting: Dan Hill
Creative director:
Richard Spencer Power
Press Manager: Gabriella Karie

M-real galerie papers magazine
The purpose of the magazine is
to encourage print media
professionals to look at the visual
quality and appeal of print media
from different perspectives:
creative, psychological and
technological.
Bi-annual, founded in 2001,
210 x 270 mm, 25,000 copies,
Free, English.
Editorial Office
c/o 136-142 Bramley Road
London W10 6SR
info@johnbrowngroup.co.uk

www.m-real.com/visualperception
Staff
Editor: Andrew Losowsky
Creative director: Chris Parker
Publisher
John Brown
136-142 Bramley Street
London W10 6SR
Phone: +44 20 7565 3121
Fax: +44 20 7565 3060
dean.fitzpatrick@johnbrownpublis
hing.com

n.paradoxa
**International feminist art
journal KT Press**
The only international feminist
art journal on contemporary
women (visual) artists and
feminist theory with a global
perspective.
Bi-annual, founded in 1998,
210 x 260 mm, £9, English.
Editorial Office
38 Bellot Street
East Greenwich,
London SE10 OAQ
k.deepwell@ukonline.co.uk
www.ktpress.co.uk
Staff
Editor-in-chief:
Katy Deepwell
Publisher
KT Press
38 Bellot Street
East Greenwich,
London SE10 OAQ

Naked
**The magazine for the weird
and the wonderful**
177 x 244 mm, £4.95, English.
Editorial Office
Bristol
naked@hot-cherry.co.uk
www.hot-cherry.co.uk
Publisher
Hot Cherry
Bristol
naked@hot-cherry.co.uk
www.hot-cherry.co.uk

Naked Punch
**The engaged review of
contemporary art and
thought**
Philosophy, art theory, and social
criticism the main strands.
Quarterly, founded in 2002,
176 x 250 mm, 8,000 copies,
£24.99, English.
Editorial Office
82-102 Hanbury Street
London E1 5JL
info@nakedpunch.com
www.nakedpunch.com

Next Level
An independent Art,
Photography and Issues
publication.
Bi-annual, founded in 2002,
£15, English.
Editorial Office
Po Box 52128
London E8 1WR
www.nextleveluk.com
Staff
Editor-in-chief:
Jimo Toyin Salako
Editor-in-chief and Creative
director: Sheyi Antony Banks

Nice Magazine
Editorial Office
BMC@flymail.fm
Staff
Publisher and Creative director:
Brendan Michael Carey

Notes from the Borderland
Britain's premier parapolitical
investigative magazine Notes
from the Borderland (NFB).
Bi-annual, founded in 1997,
£3.50, English.
Editorial Office
Po Box 4769
London WCIN 3XX
contactnfb@tiscali.co.uk
www.borderland.co.uk

P.S. I Love You
**The world's premier style and
mischief magazine**
Founded in 2005, Variable
format, £5, English.
Editorial Office
5 Pakemand House,
Pocock St,

London SE1 0BH
kisskiss@psiloveyou-
magazine.com
www.psiloveyou-magazine.com
Staff
Editor: Roderick P. Bruce

pablo internacional magazine
**Macho not rough – art, men
and architecture**
Bi-annual, founded in 2005,
140 x 215 mm, English.
Editorial Office
Blow de la Barra, 2nd Floor,
35 Heddon Street
London W1B 4BP
plbarra@hotmail.com
Staff
Publisher: José Garcia Torres
Design: Carlos Flores
Editor: Pablo Léon de la Barra

Photoworks
We are a visual arts organisation
and commission new photography
projects, produce exhibitions and
publications, and initiate research
and education programmes.
Every two months.
Editorial Office
100 North Road
Brighton BN1 1YE
info@photoworksuk.org
www.photoworksuk.org

Plastic Rhino
Art, fashion, music, popular culture.
Aimed at the gap between style magazine and fanzine, *Plastic Rhino* is a compilation of visual and editorial experimentation documenting popular culture. Every two months, founded in 2004, 260 x 300 mm, £3.50, English.
Editorial Office
85-89 Duke Street
Liverpool L1 5AP
info@plasticrhino.com
www.plasticrhino.com
Staff
Director: Chris Morris
Creative director: Peter Kellet
Publisher
Peppered Sprout Limited
85-89 Duke Street
Liverpool L1 5AP
Phone: +44 0151 707 0660
Fax: +44 0151 707 1661
info@plasticrhino.com
www.plasticrhino.com

pluk
An index for photography and lens-based media.
Quarterly, founded in 2001, 120 x 200 mm, 10,000 copies, £3.50, English.
Editorial Office
13 Mason's Yard (2nd floor)
London SW 1Y 6BU
info@plukmagazine.com
www.plukmagazine.com
Staff
Publisher: Daniel Newburg
Managing editor: Anna Smith

Polished T
English.
Editorial Office
www.polishedt.com
Staff
Creative director: Peter Kellett
Publisher
Peppered Sprout Limited
85-89 Duke Street

Liverpool L1 5AP
Phone: +44 0151 707 0660
Fax: +44 0151 707 1661
info@plasticrhino.com
www.plasticrhino.com

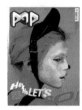

pop
With top-notch visuals, *pop* has contributions from celebrated artists, famous photographers, wayward fashion designers, deluded writers and a fair few celebrity types.
Bi-annual, 230 x 300 mm, £5, English.
Editorial Office
London
info@popmagazine.co.uk
Staff
Art director: Stuart Spalding
Art director: Lee Swillingham
Editor-in-chief: Katie Grand

Portfolio
Contemporary Photography in Britain.
Bi-annual, 245 x 295 mm, £10, English.
Editorial Office
43 Candlemaker Row
Edinburgh EH1 2QB
info@portfoliocatalogue.com
www.portfoliocatalogue.com
Staff
Editor: Gloria Chalmers
Publisher
Portfolio, Photography Workshop Edinburgh Ltd
43 Candlemaker Row
Edinburgh EH1 2QB
Phone: +44 0131 220 1911
Fax: +44 0131 226 4287
www.portfoliocatalogue.com
info@portfoliocatalogue.com

Printmaking Today
Quarterly, founded in 1990, £5.20, English.
Editorial Office
Office G18 Spinners Court,
55 West End
Oxon OX 28 1NH
cellomail@pt.cellopress.co.uk
www.cellopress.co.uk
Staff
Editor: Anne Desmet

Product
Occasional, £3.50.
Editorial Office
Po Box 23071
Edinburgh EH3 5WS
contact@product.org.uk
www.product.org.uk

Pseudonym
A creative magazine project aimed at celebrating alternative and underground cultures, whilst also providing a platform for artists to showcase their work and discuss ideas.
Founded in 2005, Variable format, Free, English.
Editorial Office
17 Pembroke Road
Old Portsmouth PO1 2NT
Hampshire
pseudonym@process-response.co.uk
www.process-response.co.uk
Staff
Founder: Dan
Founder: Carl

Q
The Ultimate Rock'n Roll Magazine
Monthly, founded in 1986, English.
Editorial Office
Mappin House,
4 Winsley Street
London W1W 8HF
Q@emap.com
www.q4music.com

RA
In-depth features about exhibitions and current debates in the arts, as well as national and international previews.
Quarterly, £4.50.
Editorial Office
press.office@royalacademy.org.uk
www.ramagazine.org.uk
Publisher
The Royal Academy of Arts

Rant Magazine
Fashion, lifestyle, critique, illustrations, opinionated ideas, off-the-wall photography, crosswords, comic strips, music features and commentary articles.
Quarterly, founded in 2003, Variable format, 5,000-10,000 copies, £3.99, English.
Editorial Office
Po Box 4042
Manchester M60 1XZ
info@rant-magazine.com
www.rant-magazine.com
Staff
Founder, Publisher, Editor and Art director: Irene Rukerebuka
Publisher

Tilfeldig Productions
Manchester
info@tilfeldigproductions.com
www.tilfeldigproductions.com

Rossica

A finest quality international
magazine devoted to the many
facets of Russian heritage and
culture.
Quarterly, £8, English.
Editorial Office
151 Kensington High Street
London W8 6SU
mail@academia-rossica.org
www.academia-rossica.org

RPM

Editorial Office
paul@rpmmagazine.co.uk
www.rpmmagazine.co.uk

Rubbish

It's what everybody's talking
Annual, 215 x 280 mm, 25€,
English.
Editorial Office
43 Rainham Road,
Kensal Green
London NW 10 5DL
order@rubbishmag.com
www.rubbishmag.com
Staff
Editor-in-chief: Jenny Dyson
Deputy editor-in-chief:
Jack Dyson
Art director: harrimansteel
Publisher
Rubbish Ltd
www.rubbishmag.com

Scarlet Cheek

Founded in 2006, English /
Chinese.
Editorial Office
London
scarletcheek2006@hotmail.com
www.scarletcheek.com
Staff
Editor-in-chief: Cindy Chen
Graphic designer: Menz
Translator: Prudence zou

scene

cutting edge
Every two months, founded in
1998, 210 x 297 mm, £2.25,
English.
Editorial Office
1st floor, 16 Maddox Street
London W1R 9PL
Staff
Editor: Deborah Bee
Publisher
Spiro Group

selvedge

Interior Decorationg
Magazine
Every two months, English.
Editorial Office
London
editor@selvedge.com

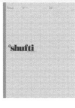

Shufti

Quarterly, 335 x 410 mm, 500
copies, £10, English.
Editorial Office
Foundry Street
Leeds LS11 5QP
someone@shuftimag.com
www.shuftimag.com

Special Ten

The magazine itself is a unique
format made up of a heavy card
gatefold cover that in one side
holds a colour booklet of 24
pages, displaying artwork and
illustration relevant to the issue.
Every two months, founded in
2002, £5, English.
Editorial Office
122 Holland Park Avenue
London W11 4UA
marcus@specialten.com
www.specialten.com

Sublime

An international lifestyle
magazine with ethical values and
intelligent content. It explores
community and celebrates
diversity and individuality.
Every two months, founded in
2004, English.
Editorial Office
167 Southwood Lane,
Highgate
London N6 5TA
info@sublimemagazine.com
www.sublimemagazine.com
Staff
Editor: Hanspeter Kuenzler
Editor: Nick Wyke
Editor: Helen Van Kruyssen
Editor: Jonathan Fordham

Super Super

Celebrating Style!
Monthly, founded in 2006,
245 x 342 mm, £2.50, English.
Editorial Office
2 Foulden Terrace
N16 7UT London
www.thesupersuper.com
Staff
Creative and Editorial director:
Steve Slocombe
Fashion and Editor-in-chief:
Namalee Bolle

Tank

Elitism for all
Tank magazine showcases an
ingenious blend of imagery from
fashion, art, graphics,
photojournalism and design in a
'bookzine' format. Resisting
celebrity worship and PR-led
editorial in favour of
experimentation and rising
voices, *Tank* gives new life to
magazine publishing. Quarterly,
230 x 300 mm, £8, English.
Editorial Office
49-50 Great Marlborough Street,
5th Floor
London W1F 7JR
mail@tankmagazine.com
www.tankmagazine.com
Staff
Editor-in-chief and Creative
director: Masoud Golsorkhi
Publisher
Tank Publications Ltd
49-50 Great Malborough Street
London W1F 7JR
Phone: +44 0 20 7434 0110
Fax: +44 0 20 7434 9232
editors@tankmagazine.com

Tate etc.
Visiting and Revisiting Art etcetera...
Seeks out thought-provoking and original insight into the work of international artists celebrated in the Tate galleries and beyond. Tri-annual, 210 x 270 mm, 85,000 copies, £5, English.
Editorial Office
20 John Islip Street
London SW1P 4RG
rachel.macrae@tate.org.uk
www.tate.org.uk/tateetc
Staff
Editor: Bice Curiger
Editor: Simon Grant
Publisher: Rachel MacRae
Art director: Cornel Windlin

The Art Newspaper
Monthly, founded in 1990, 260 x 375 mm, English.
Editorial Office
70 South Lambeth Road
London SW8 1RL
contact@theartnewspaper.com
Staff
Editor-in-chief and Creative director: Anna Somers Cocks

The Chap
A Journal For The Modern Gentleman
Quarterly, £1.75, English.
Editorial Office
PO Box 39216
London SE3 0XS
gustav@thechap.net
www.thechap.net

The Future
The magazine dedicated to dynamic, edgy and entertaining critical writing on contemporary art. *The Future* is here to provoke debate over what makes art today interesting, difficult, inspiring, aggravating and good. Recognising that art isn't just commerce, or fashion, or a subject for specialists, but an open, contradictory and vibrant part of contemporary culture, *The Future* brings together a wide range of writers to discuss what new art is doing, what it's doing well, and where it might be headed soon. Founded in 2004, 210 x 270 mm, £4, English.
Editorial Office
London
jj@thefuture-magazine.com
www.thefuture-magazine.com

The Idler
£3, English.
Editorial Office
Po Box 280
Barnstaple EX31 4WX
www.idler.co.uk
Staff
Editor: Tom Hodgkinson
Deputy editor:
Gavin Pretor-Pinney

The Illustrated Ape
Tri-annual, 245 x 300 mm, £ 5, English.
Editorial Office
Po Box 16329
London E17 4FD
cornelius@apemag.demon.co.uk
www.theillustratedape.com
Staff
Creative director: Daren Ellis
Joint editor: Christian Pattison
Joint editor: Michael Sims
Publisher
The Illustrated Ape Company
Po Box 16329
London E17 4FD

The Scorpion
The Scorpion is a new literary and satirical magazine featuring some of the finest new and established talents in Scotland. The magazine takes a critical and humorous look into modern life through literature, history, politics, art and intelligence matters, all produced to the highest editorial standards. 2,000 copies, English.
Editorial Office
editor@thescorpionscotland.co.uk
www.thescorpionscotland.co.uk

The Stool Pigeon
A UK-based, fully-independent and free music newspaper. Founded in 2005, 60,000 copies, Free, English.
Editorial Office
Po Box 52129
London E2 7XY
www.feedthepigeons.com
Staff
Editor: Phil Hebblethwaite
Art director: Mickey Gibbons

The Wire
The Wire is an independent, monthly music magazine dedicated to informed, intelligent coverage of a wide range of progressive, adventurous and non-mainstream musics. Monthly, founded in 1982, 230 x 280 mm, English.
Editorial Office
23 Jack's Place, 6 Corbet Place
London E1 6NN
www.thewire.co.uk
Staff
Publisher and Editor-in-chief and Creative director: Tony Herrington
Editor: Chris Bohn

Third Text
Third World Perspectives on Contemporary Art and Culture
An international scholarly journal dedicated to providing critical perspectives on art and visual culture.
Every two months, founded in 1987, £12.00, English.
Editorial Office
Po Box 3509
London NW6 3PQ
thirdtext@btopenworld.com

www.tandf.co.uk
Staff
Editor: Rasheed Araeen
Editor: Ziauddin Sardar

Trolley
160 x 245 mm, English.
Editorial Office
73A Redchurch Street
London E2 7DJ
www.trolleybooks.com
Staff
Publisher: Gigi Gianuzzi

Turps Banana
Magazine dedicated to painting. Quarterly, £6, English.
Editorial Office
45 Coronet Street
London N1 6HD
info@gradiate.co.uk
www.turpsbanana.com

Typographic
Tri-annual, £12.
Editorial Office
Po Box 725
Tauton TA 2 8 WE
Somerset
mail@istd.org.uk
www.istd.org.uk
Publisher
ISTD
mail@istd.org.uk

Untitled
Contemporary Art
Quarterly, 190 x 253 mm, £3.90, English.
Editorial Office
29 Poets Road
London N5 2SL
untitled@europemail.co.uk
www.untitledmag.co.uk

Urthona
Buddhism and the Arts
Inspiring, colourful and stimulating, *Urthona* magazine explores the arts and world culture from a Buddhist perspective. Bi-annual, founded in 1992, £3.95, English.
Editorial Office
9A Auckland Road
Cambridge CB5 8DW
urthonamag@onetel.com
www.urthona.com

V&A Magazine

The purpose of the Victoria and Albert Museum is to enable everyone to enjoy its collections and explore the cultures that created them; and to inspire those who shape contemporary design.
Quarterly, £4.
Editorial Office
Cromwell Road
London SW7 2RL
vanda@vam.ac.uk
www.vam.ac.uk

variant

The free arts and culture magazine. In-depth coverage in the context of broader social, political and cultural issues.
Tri-annual, founded in 1996, 15,000 copies, Free, English.
Editorial Office
1/2 189b Maryhill Road
Glasgow G20 7XJ
variant@ndirect.co.uk
www.variant.randomstate.org
Staff
Editor: Leigh French
Editor: Daniel Jewesbury

Varoom

The journal of illustration and mad images
A magazine celebrating and commenting on the international illustrated image.
Tri-annual, £12, English.
Editorial Office
2nd Floor, Back Building,
150 Curtain Road
London EC2A 3AT
info@varoom-mag.com
www.varoom-mag.com
Staff
Editor-in-chief:
Adrian Shaughnessy
Publisher
The Association of Illustrators
2nd Floor, Back Building,

150 Curtain Road
London EC2A 3AT
Phone: +44 20 7613 4328
info@theaoi.com
www.theaoi.com

VERYeye2eye

VERYeye2eye has a global vision and contributors are international experts on style, art, design. The creative pattern of this world is a global mix of individual influences transcending cultures and hemispheres.
Bi-annual, founded in 2004, 165 x 230 mm, 50,000 copies, £4.50, English.
Editorial Office
verytrolleygallery,
73a Redchurch Steet
London E2 7DJ
press@veryeye2eye.com
www.eye2eye-london.com
Publisher
Up&Co
New York, USA
www.upandco.com

VICE

What started out as a few Montreal drug addicts scamming welfare make-work programs back in 1994 has become a global empire of hedonism known simply as *VICE*.
Founded in 1994, Free, English.
Editorial Office
77 Leonard St
London EC2A 4QS
melissab@viceland.com
www.viceland.com

Staff
Founder: Suroosh Alvi
Founder: Gavin McInnes
Founder: Shane Smith
Publisher
Andrew Creighton
andrew@viceuk.com

View Magazine

Monthly, founded in 1995, English.
Editorial Office
370 Main St.
West Hamilton L8P 1K3
info@viewmag.com
www.viewmag.com
Staff
Editor-in-chief: Sarah Calms

VOLT Magzine

Bi-annual, founded in 2007, 345 x 420 mm, 5,000 copies, £5, English.
Editorial Office
42 Theobalds Road
London WC1X 8NW
rui@areia.com
www.volt-mag.com
Staff
Editor: Rui Faria
Creative director and Publisher: Michael Harrison
Fashion editor: Tilly Hardy

Wallpaper*

International Design Interiors Fashion Travel
Monthly (11x / year), 230 x 300 mm, £3.80, English.
Editorial Office
London
contact@wallpaper.com
www.wallpaper.com
Staff
Creative director:
Tony Chambers
Editor-in-chief: Jeremy Langmead
Publisher
The Wallpaper* Group
Brettenham House,
Lancaster Place

London WC2E 7TL
Phone: +44 20 7322 1177
Fax: +44 20 7322 1171
contact@wallpaper.com
www.wallpaper.com

Wears The Trousers

English.
Editorial Office
17b Church Crescent,
Muswell Hill
London N10 3NA
unzipped@thetrousers.co.uk
www.thetrousers.co.uk
Staff
Editor: Alan Pedder
Deputy editor: Clare Byrne

Wonderland

A uniquely positioned, independent, bi-monthly publication for both men and women spotlighting contemporary visual culture
Every two months, 220 x 285 mm, 104,000 copies, English.
Editorial Office
133 Notting Hill Gate
London W11 3LB
info@wonderlandmagazine.com
www.wonderlandmagazine.com

NEW MEDIA ARTS
magazine
www.simultaneita.net

SIMULTANEITÀ

S. Lotti

United Arab Emirates

Jumeira Beach Magazine

Leading luxury and lifestyle magazine in the gulf
Every two months, founded in 2000, 330 x 270 mm, 20 AED, English.
Editorial Office
Dubai, Deira
72244 Dubai
abdallah@dardubaipp.ae

Uruguay

freeway

Youth in our country.
Monthly, founded in 2003, 112 x 152 mm, 10,000 copies, Free, Spanish.
Editorial Office
Durazno 1504
C.P. 11.200 Montevideo
info@freeway.com.uy
www.freeway.com.uy/revista
Staff
Founder and Publisher:
Carlos Taran
Manager: Alvaro Kemper

Seen a magazine that is no longer published? Go online: www. welovemags.com

Pimba!

Cultural guide of Montevideo.
Monthly, founded in 2002, 105 x 150 mm, Free, Spanish.
Editorial Office
Pablo de Maria 1056
C.P. 11300 Montevideo
info@pimba.com.uy
www.pimba.com.uy
Staff
Editor-in-chief:
Constanza Narancio

United States

(t)here

(t)here

(t)here provides a creative outlet for the most talented and innovative artists of the moment.
Bi-annual, founded in 2000, 235 x 304 mm, 20,000 copies, $10, English.
Editorial Office
410 West 14th
10014 New York
jason@theremedia.com
www.t-here.com
Staff
Editorial director:
Jason Makowski
Creative director:
Chris Wieliczko
Publisher
There Media, Inc.
410 West 14th Street
NY 10014 New York
jason@theremedia.com
www.t-here.com

/ Magazine

The concept for *Slash* was /. The idea of being more than one, being able to label yourself without a label, and being different.
Founded in 2004, 240 x 305 mm, 10,000 copies, $3.99, English.
Editorial Office
61 E. 66th St. n° 6A
NY 10021 New York
info@slashmagazine.com
www.slashmagazine.com

2wice

An interdisciplinary arts journal that focuses on a specific theme for each issue.
Bi-annual, English.
Editorial Office
Po Box 980, East Hampton
NY 11937 New York
info@2wice.org
www.2wice.org
Staff
Managing editor: Jane Rosch
Editor-in-chief: Patsy Tarr
Editor and Designer:
J. Abbott Miller
Publisher
2wice Arts Foundation
New York
www.2wice.org

306090

Exploring contemporary issues in architecture from every angle.
Quarterly, founded in 2005, 279 x 432 mm, 15,000 copies, English.
Editorial Office
350 Canal Street
NY 10013-0875 New York
info@306090.org
www.306090.org
Staff
Editor: Jonathan D. Solomon
Editor: Emily Abruzzo
Publisher
306090, Inc.

32BNY

A journal of architecture and urban culture
Tri-annual, English.
Editorial Office
405 W 31st Street 11fl
NL 10001 New York
info@32bny.org
www.32bny.org

3x3

The magazine of contemporary illustration
Magazine devoted entirely to the art of contemporary illustration.
Tri-annual, 217 x 300 mm, 4,300 copies, English.
Editorial Office
244 Fifth Av. Suite F269
NY 10001 New York
www.3x3mag.com
Staff
Publisher and Design director:
Charles Hively
Publisher
3x3 Magazine
244 Fith Avenue, Suite F269
NY 10001 New York
Phone: 212 591 2566

African Vibes

A general-interest magazine for contemporary Africans in the diaspora, which will define, reflect and celebrate what it means to be an African in contemporary American culture.
English.
Editorial Office
Po Box 10203
CA 91309 Canoga Park
www.africanvibes.com
Staff
CEO and Founder: Amabel Niba

Capricious
by Pernilla Zetterman

capricious
by Martine Stig

Capricious
by Andrea Longacre White

CAPRICIOUS
by David Grey

Capricious
by Grant Worth

CAPRICIOUS
by Laura Heath

CAPRICIOUS
by Andrew Dosunmu

capricious
by Désirée Palmen

CAPRICIOUS
by Oscar Tuazon

capricious
by Michael Kloepfer

♡
by Mark Borthwick

CAPRICIOUS
by Stuart Hawkins

Capricious
by Keren Shavit

CAPRICIOUS
by Shaun Kessler

Capricious
by Shoplifter

Capricious

New Photography
available in all good bookstores close to you
www.becapricious.com

Alarm
Music and Art
Founded in 1995, 216 x 279 mm, 30,000 copies, $4.99, English.
Editorial Office
53 W Jackson Blvd. Suite 1256
IL 60604 Chicago
info@alarmpress.com
www.alarmpress.com
Staff
Founder and Publisher:
Chris Force
Publisher
Chris Force
53 W Jackson Blvd. Suite 1256
IL 60604 Chicago
Phone: +1 312 341 1290
Fax: +1 312 341 1318
www.alarmpress.com

Alef Magazine
A new language of beauty
Quarterly, 236 x 306 mm, 40,000 copies.
Editorial Office
231 W. 21 St. 1A
NY 10011 New York
www.alefmag.com
Staff
Publisher: Paul de Zwart
Editor-in-chief: Sameer Reddy

All Access
Keep Local Music Alive
Every two months, $12.95, English.
Editorial Office
15981 Yarnell St. Suite 122
Ca 91342 Rancho Cascades
ALLACCESSMGZN@aol.com
www.allaccessmagazine.com

Alt Pick Magazine
conspiracy + collaboration
Quarterly, $9.50, English.
Editorial Office
1133 Broadway, Suite 1408
NY 10010 New York
info@altpickmagazine.com
www.altpickmagazine.com

Alternative Press
Founded in 1985, English.
Editorial Office
1305 West 80th Street, Suite 2F
OH 44102-1996 Cleveland
publisher@altpress.com
www.altpress.com
Staff
President and CEO: Mike Shea
Editorial director: Aaron Burgess
Publisher
alternative press magazine inc
1205 West 80th Street, Suite F
OH 44102-1 Cleveland
Phone: +1 216 631 1510
Fax: +1 216 631 1016
publisher@altpress.com
www.altpress.com

America
The Premier Fashion and Entertainment Magazine for Young Adults
An upscale urban lifestyle publication with focus on music, fashion and celebrity.
Quarterly, founded in 2004, 60,000 copies, $8, English.
Editorial Office
30 Vandam Street, 4th floor
NY 10013 New York
help@americamag.us
www.americamag.us
Staff
Founder and Editor-in-chief:
Smokey D. Fontaine
Art director:
Graham Rounthwaite
Fashion director:
Heathermary Jackson
Publisher
America 001 Media LLC
New York
Phone: +1 212 242 6567
sfontaine@americamag.us
www.americamag.us

American art
Bi-annual, English.
Editorial Office
750 Ninth Street NW, MRC 970
Suite 3600
DC 20001-4505 Washington
Staff
Editor-in-chief and Creative director: Marisa Ruiz
Publisher
Office of Publications
Smithsonian American Art Museum
750 Ninth Street NW, MRC 970
Suite 3600
DC 20001-4 Washington

American Ceramics
An Art Magazine Like No Other
Every issue is a keeper, like a fine reference book.
Quarterly, 200 x 280 mm, 2,000 copies, $10, English.
Editorial Office
207 East 32nd Street
10016 New York
marta@Tzell.com

Anathema
Founded in 2005, $6.95.
Editorial Office
messages@anathemamagazine.com
www.anathemamagazine.com
Staff
Editor-in-chief: Ken Miller
Creative director: Dmitri Siegel

Animal New York
A living, breathing arts and lifestyle community. *Animal* represents a new breed of media: interactive, transparent, dynamic, and connected to an eclectic flock of culturecoholics.
Bi-annual, founded in 2003.
Editorial Office
New York
info@animalnewyork.com
www.animalnewyork.com

ANP Quarterly
A magazine that will educate and inform openly and without the social or financial restrictions that plague many publications today and contribute more often than not to the "same old thing" again and again.

Quarterly, Free, English.
Editorial Office
919 Sunset Drive
CA 92627 Costa Mesa
info@rvcaanp.com
www.rvcaanp.com
Publisher
RVCA

Anthem
Incorporates editorial coverage of emerging faces with some of the more well-known icons in film, music, style, art and design. English.
Editorial Office
110 West Ocean Blvd 10th floor
CA 90802-4605 Long Beach
info@anthem-magazine.com
www.anthem-magazine.com

Arkitip
Every two months, $30.
Editorial Office
Po Box 4108
90078 Los Angeles
submit@arkitip.com
www.arkitip.com
Staff
Creative director:
Scott Andrew Snyder
Publisher
ARKITIP

Art and Auction
English.
Editorial Office
111 8th Avenue,
Suite 302
NY 10011 New York
edit@artandauction.com
www.artandauction.com
Staff
Editor-in-chief and Creative director: Bruce Wolmer

know

ArtAsiaPacific
Today's art from Tomorrow's world
Every two months, 210 x 297 mm, 12$, English.
Editorial Office
245 Eighth Avenue #247
NY 10011 New York
info@aapmag.com
www.aapmag.com
Staff
Editor: Elaine W. Ng
Deputy editor-in-chief:
Andrew Maerkle
Art director: Nobi Kashiwagi
Publisher
Simon Winchester and Elaine W. Ng

ARTnews
Founded in 1902, *ARTnews* is the oldest and most widely circulated art magazine in the world.
Monthly (11x / year), founded in 1902, 83,000 copies, English.
Editorial Office
48 West 38th Street
NY 10018 New York
info@artnews.com
www.artnews.com
Staff
Editor-in-chief and
Creative director: Milton Esterow
Publisher
Milton Esterow

Art On Paper
An international magazine that presents award-winning coverage of artists working in a range of paper-based media, including limited-edition prints, drawings, photographs, books, and ephemera.
Every two months, founded in 1996, 215 x 275 mm, English.
Editorial Office
150 West 28th St. #504
NY 10001 New York
peter@dartepub.com
www.artonpaper.com/
Staff
Editor-in-chief and Creative director: Gabriella Fanning

Art Papers
Art Papers is about contemporary art
striking ideas + moving images + smart texts.
Every two months, founded in 1976, 230 x 296 mm, 162,000 copies, 8€, English.
Editorial Office
Po Box 5748
GA 31107 Atlanta
info@artpapers.org
www.artpapers.org
Staff
Creative director: Jennifer Smith
Editor-in-chief: Sylvie Fortin

Art Prostitute
English.
Editorial Office
2919-C Commerce
75226 Dallas, Texas
contact@artprostitute.com
www.artprostitute.com

Artext
Every two months, founded in 1984, 240 x 270 mm, English.
Editorial Office
Po Box 86187
CA 90086-9999 Los Angeles
artext@artext.org
www.artext.org
Staff
Editor-in-chief and Creative director: Susan Kandel

Artforum
International
Monthly, founded in 1992, 265 x 265 mm, English.
Editorial Office
350 Seventh Avenue
NY 10001 New York
generalinfo@artforum.com
www.artforum.com
Staff
Editor-in-chief and Creative director: Jack Bankowsky

Arthur
Influential underground music magazine *Arthur* magazine is high quality writing and artwork by some of the nation's finest scribes, cartoonists and photographers: People with good taste, people who break ground, people who have a sense of passion, humor and righteousness for what they're covering.
People like David Byrne, Kristine McKenna, Michael Moorcock and Douglas Rushkoff.
Every two months, Free, English.
Editorial Office
3408 Appleton St.
CA 90039 Los Angeles
www.arthurmag.com
Staff
Editor: Jay Babcock

ArtsEditor
Develops and publishes original feature-length articles, opinion pieces, and news items through independent arts reporting, reviewing, and relevant discourse(sm), in the areas of visual, performing, literary, film, and musical arts.
English.
Editorial Office
Po Box 38192
Cambridge, Massachusetts
info@artseditor.com
www.artseditor.com

aRUDE
the index of elegance
Quarterly, 245 x 330 mm, $9.95, English.
Editorial Office
Po Box 1914
Old Chelsea Station
10113 New York
arude@arudemag.com
www.arudemag.com
Staff
Publisher and Editor-in-chief:
Iké Udé
Co-publisher: Phyllis Hollis
Publisher
SweetSodium llc
New York

Atlantic
Monthly, founded in 1995, English.
Editorial Office
77 North Washington Street
MA 02114 Boston
www.theatlantic.com

Atomica
At first glance, *Atomica* is undeniably beautiful. On a deeper level, *Atomica* challenges its readers with the most creative and insightful perspectives on the ideas, movements and people that define the present and shape our future.
10$, English.
Editorial Office
400 South Beverly Drive Suite 214
CA 90212 Beverly Hills
info@atomicamagazine.com
www.atomicamagazine.com
Staff
Editor-in-chief: Mitch
Creative director: Jonathan

Visit www.welovemags.com for an updated version of the directory

breathing lifestyle
www.ozonweb.com

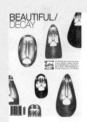

Beautiful/Decay

Bridge the gap between art and graffiti, underground and mainstream, design and fine art, punk rock and hip hop, illustration and design, and most importantly high and low art.
Founded in 1996, 216 x 286 mm, 45,000 copies, $6.95, English.
Editorial Office
Po Box 461419
CA 90046 Los Angeles
bd@beautifuldecay.com
beautifuldecay.com

BeE

BeE is a dynamic woman's magazine for active, hardworking, educated women.
English.
Editorial Office
3710 Rawlins Suite 1500
TX 75219 Dallas
margaret@rosengrouppr.com
www.beemag.com
Staff
CEO and Co-founding publisher: Celine Gumbiner
President and Co-founding publisher: Erik Velez
Editor-in-chief:
Ana Maria Castronovo
Publisher
Femme Publications
126 Winding Ridge Road
NY 10603 White Plains
margaret@rosengrouppr.com
www.beemag.com

Bidoun

Bidoun was created as a platform for ideas and an open forum for exchange, dialogue and opinions about arts and culture from the Middle East.
Quarterly, founded in 2004, 222 x 270 mm, 18,000 copies, $10, English.
Editorial Office
195 Chrystie St. Suite 900D
NY 10002 New York
info@bidoun.com
www.bidoun.com
Staff
Founder and Editor-in-chief:
Lisa Farjam
Creative director:
Ketuta Alexi-Meskhishvili
Publisher
Bidoun, Inc.
195 Chrystie St. Suite 900D
NY 10002 New York
Phone: +212 475 0123
Fax: +212 475 0110

Big

230 x 290 mm, $15, English.
Editorial Office
393 Broadway, 4th floor
NY 10013 New York
info@bigmagazine.com
www.bigmagazine.com
Staff
Founder, Editor-in-chief and Creative director:
Marcelo Junemann
Creative director: Daren Ellis
Publisher
BIG Communications

Bitch Magazine
Feminist Response to Pop Culture
Bitch is a print magazine devoted to incisive commentary on our media-driven world.
Quarterly, founded in 1996, 48,000 copies, English.
Editorial Office
1611 Telegraph Ave,
Suite 515.
CA 94612 Oakland
bitch@bitchmagazine.com
www.bitchmagazine.com
Staff
Publisher: Debbie Rasmussen
Founder, Editorial and Creative director: Andi Zeisler
Art director and Designer:
Nicholas Brawley
Publisher: Debbie Rasmussen
Founder: Benjamin Shaykin
Founder: Lisa Jervis

Black & White

For collectors of fine photography *B&W Magazine* is the premier high-quality magazine of black and white photography for collectors of fine photography.
Every two months, 28,000 copies.
Editorial Office
Po Box 700, Arroyo Grande
CA 93421 Arroyo Grande
www.bandwmag.com

BlackBook
Progressive Culture
Quarterly, founded in 1996, 225 x 274 mm, $4.95, English.
Editorial Office
678 Broadway, 2nd Floor
NY 10012 New York
www.blackbookmag.com
Staff
Art director: Tom Ackerman
Editor-in-chief: Aaron Hicklin
Editorial and Creative director:
Evan L. Schindler
Publisher

BlackBook Media Corp
116 Prince Street, 2nd Floor
10012 New York
Phone: +1 212 334 1800
Fax: +1 212 334 3364
www.blackbookmag.com

Blender
The ultimate guide to music and more
Monthly, English.
Editorial Office
Po Box 420235
FL 32142 Palm Coast
your2cents@blender.com
www.blender.com
Staff
Editor-in-chief: Craig Marks
Publisher: Lee Rosenbaum

Blind Spot
The Premier Photography-Based Fine Art Journal
Tri-annual, founded in 1992, 230 x 265 mm, 15,000 copies, $14.95, English.
Editorial Office
210 Eleventh Avenue
NY 10001 New York
www.blindspot.com
Staff
Founder and Publisher and Editor: Kim Zorn Caputo
Publisher and Editor:
Dana Faconti
Publisher
Blind Spot Photography Inc.
210 Eleventh Avenue
NY 10001 New York
Phone: +1 212 633 1317
Fax: +1 212 627 9364

Bloom Magazine
queer fiction, art, poetry and more
Bloom was founded to support the work of lesbian, gay, bisexual, and transgendered writers and artists and to foster the appreciation of queer literature and creation.
Bi-annual, $10, English.
Editorial Office
Po Box 1231,
Old Chelsea Station
NY 10011 New York
info@bloommagazine.org

For information on advertising and subscriptions go online: www.welovemags.com

Bomb

Bomb records deeply personal reflections on art and life, legendary exchanges which can only be found in our pages. Quarterly.
Editorial Office
80 Hanson Place,
Suite 703
Brooklyn
info@bombsite.com
www.bombsite.com
Staff
Publisher and Editor-in-chief:
Betty Sussler
Associate Publisher:
Mary-Ann Monforton
Senior editor: Nell Mc Clister

Bonus

a magazine about love, music, fashion, croissants and life in the city
7$, English / Japanese.
Editorial Office
124 Ridge Street 7F
NY 10002 New York
contact@bonusmagazine.com
Staff
Rie Takeuchi
Peter Kienzle

Bookforum

Every two months, founded in 1992, 37,000 copies, £4.95, English.
Editorial Office
350 Seventh Avenue
NY 10001-7204 New York
letters@bookforum.com
www.bookforum.net

Box

Box represents a varied audience of gay, lesbian, bisexual, transgendered, transsexual and heterosexual men and women. Founded in 2005, 355 x 355 mm, English.
Editorial Office
Po Box 4354
TX 78765 Austin
info@ box-mag.com
www.box-mag.com
Staff
Editor: Fifi D'aubigne

Brill's Content

Monthly, 204 x 265 mm, $4.25, English.
Editorial Office
1230 Avenue of the Americas
NY 10020 New York
www.brillscontent.com
Staff
Editor-in-chief: David Kuhn
Editor: Eric Effron
Publisher
Brill Media Ventures L.P.
1230 Avenue of the Americas
NY 10020 New York
Phone: +1 212 332 6300

Bust Magazine

For women with something to get off their chests
Every two months, founded in 1993, 209 x 266 mm, 93,500 copies, English.
Editorial Office
78 5th Ave #5
NY 10011 New York
artdepartment@bust.com
www.bust.com
Staff
Editor-in-chief and Publisher:
Debbie Stoller
Creative director and Publisher:
Laurie Henzel

Cabinet

A Quarterly of Art and Culture
Magazine of art and culture that confounds expectations of what is typically meant by the words 'art', 'culture', and sometimes even 'magazine'.
Quarterly, founded in 2000, 200 x 250 mm, $10, English.
Editorial Office
55 Washington St, Suite 327
NY 11201 Brooklyn
info@cabinetmagazine.org
www.cabinetmagazine.org
Staff
Editor-in-chief: Sina Najafi
Art director: Jessica Green
Senior editor: Jeffrey Kastner
Editor: Christopher Turner
Editor: Jenniser Liese
Graphic designer:
Leah Beeferman
Managing editor:
Colby Chamberlain
Associate editor: Ryo Manabe
Publisher
Immaterial Incorporated
181 Wyckoff Street
NY 11217 Brooklyn
Phone: +1 718 222 8434
Fax: +1 718 222 3700
info@immaterial.net
www.immaterial.net

Capricious

New Photography
Bi-annual, founded in 2003, 195 x 268 mm, 4,000 copies, 12.50€, English.
Editorial Office
619 E. 6th Street
NY 10009 New York

info@becapricious.com
www.becapricious.com
Staff
Editor and Publisher:
Sophie Mörner

cheap date

Editorial Office
New York
www.cheapdatemagazine.com

Cineaste

Quarterly, founded in 1967, 10,000 copies, £3.95, English.
Editorial Office
243 Fifth Avenue, Suite #706
NY 10016 New York
cineaste@cineaste.com
www.cineaste.com
Staff
Editor-in-chief and Creative director: Gary Crowdus
Editor: Cynthia Lucia
Editor: Richard Porton

Cinema Journal

The journal publishes essays on a wide variety of subjects from diverse methodological perspectives.
Quarterly, 115 x 229 mm, £4.50, English.
Editorial Office
Po Box 7819
Austin 78713-781 Texas
www.utexas.edu
Staff
Manager: Sue Hausmann
Publisher
University of Texas Press

Citizen Culture
Perspectives for the Young Professional
English.
Editorial Office
90 Washington Street, Suite 4 F
NY 10006 New York
editor@citizenculture.com
www.citizenculture.com

City Magazine
The Destination for Style
Embodies the creative expression of today's major cosmopolitan communities. English.
Editorial Office
Po Box 242, Prince Street Station
NY 10012-9541 New York
sales@city-magazine.com
www.city-magazine.com
Staff
Editorial director and Publisher:
John F. Mc Donald
Creative director: Fabrice Frere

Clear
Fashion / Design Magazine
Quarterly, $6.95, 100,000 copies, English.
Editorial Office
433 N. Washington,
Royal Oak
MI 48067 Washington
info@clearmag.com
www.clearmag.com
Staff
Publisher and Creative director:
Emin Kadi
Managing editor: Ivana Kalafatic

Comic Art
Comic Art is the beautifully produced, full-color art magazine focusing on the comic medium. Annual, $19.95, English.
Editorial Office
Po Box 23661
CA 94623 Oakland
comicartmagazine@buenaventurapress.com
www.comicartmagazine.com
Staff
Founding editor: Todd Hignite
Assistant editor:
Sara Rowe Hignite
Designer: Jonathan Bennett
Production advisor:
John Kuramoto
Publisher
Buenaventura Press
Po Box 23661
CA 94623 Oakland
comicartmagazine@buenaventurapress.com
www.buenaventurapress.com

Complex
The Original Buyer's Guide for Men
Every two months, English.
Editorial Office
40 W. 23rd Street
NY 10010 New York
info@complexmagazine.com
www.complexmagazine.com
Publisher
Complex Media LLC
260 West 36th Street, 10th Floor
NY 10018 New York
Phone: +1 212 868 7500
info@complexmagazine.com
www.complexmagazine.com

Continuous Project
$2, English.
Editorial Office
cproj1@continuousproject.com
www.continuousproject.com
Staff
Editor-in-chief: Bettina Funcke
Editor-in-chief: Wafe Guyton
Editor-in-chief: Joseph Logan
Editor-in-chief: Seth Price

Curve
The Best-Selling Lesbian Magazine
Founded in 1991, 68,200 copies, English.
Editorial Office
1550 Bryant Street, Suite 510
CA 94102 San Francisco
editor@curvemag.com
www.curvemag.com

Death + Taxes
Every two months, founded in 2006, $3.95, English.
Editorial Office
200 East 10th Street 125
NY 10003 New York
info@deathandtaxesmagazine.com
www.deathandtaxesmagazine.com
Staff
Editor-in-chief: Amy Fleischer

début
The black book for today's woman
début is fashion, style, and flair. *début* stands for a new beginning, representing a multi-cultural vision of beauty through a highly stylized landscape. English.
Editorial Office
info@debutmag.com
www.debutmag.com

Decoration
English.
Editorial Office
350 Canal Street
Ny 10013-0875 New York
oinfo@306090.org
www.306090.org
Staff
Editor: Emily Abruzzo
Editor: Jonathan D. Solomon
Assistant editor:
Lynne DeSilva-Johnson
Publisher
306090, Inc.

Details
Monthly, $2.75, English.
Editorial Office
New York
www.details.com
Staff
Editor-in-chief: Joe Dolce
Publisher
Condé Nast Publications
Piazza Castellano 27
20121 Milan
Italy
Phone: +39 02 856 11
Fax: +39 02 805 57 61

Dirty found
Brings you the world's finest sort-of-porn. A curious look at other people's love lives.
8$, English.
Editorial Office
3455 Charing Cross Road
MI 48108-1911 Ann Arbor
info@foundmagazine.com
www.dirtyfound.com
Staff
Editor: Davy Rothbart
Editor: Jason Bitner

Noticed a missing magazine?
Register it online: www.welovemags.com

d-mode

d-mode is Latin America's
biggest monthly import music
magazine and arguably the
greatest in the market – a
reputation earned through
unrivalled access, and popularity.
Monthly, founded in 1990,
English / Spanish.
Editorial Office
1111 Lincoln Road, Suite 800
33139 Miami Beach,Florida
www.d-mode.com

dork magazine

About us
Lifestyle magazine about people,
real people, and how people
reconcile their reality and make
sense of this crazy world.
Quarterly, English.
Editorial Office
New York
press@dorkmag.com
www.dorkmag.com
Staff
Founder: James Oyedijo
Founder: Taj Reid

Dumb Angel

The proclamation of Modernist
art, pop, surf culture and sound
design of the 1960s.
Annual, founded in 2005, $19.95,
5,000 copies, English.
Editorial Office
Po Box 406
91102 Pasadena, CA
brianc@yahoo-inc.com
www.dumbangelmagazine.com

dwell

10x / year, English.
Editorial Office
40 Gold St.
CA 94133 San Francisco
www.dwell.com
Staff
Editor-in-chief: Sam Grawe
Owner and Founder:
Lara Hedberg Deam
President and Publisher:
Michela O'Connor Abrams
Managing editor:
Ann Wilson Spradlin
Design director: Kyle Blue
Photo editor: Kate Stone

E&A Magazine

**Editor and Art director –
Fashion, Pop and Art**
Bi-annual, founded in 2004, $10,
1,000 copies, English / German.
Editorial Office
475 Kent Ave #607
11211 NY Brooklyn
studio@studiovonbirken.com
www.editorandartdirector.com
Staff
Editor and Art director:
Katia Kuethe
Editor and Art director:
Philipp Muessigmann
Publisher
Studio Von Birken
475 Kent Ave #607
NY 11211 Brooklyn

Ego Miami Magazine

Monthly, English.
Editorial Office
120 N.W. 25th Street, suite 302
F 33127 Miami
info@egomiami.com
www.egomiami.com
Staff
Creative director: Rick Delgado
Art director: Chris Salazar

Esopus

Esopus features artists' projects,
critical writing, fiction, poetry,
visual essays, and an audio CD
in every issue.
Bi-annual, founded in 2003, $10,
11,000 copies, English.
Editorial Office
532 LaGuardia Place, #486
NY 10012 New York

info@esopusmag.com
www.esopusmag.com
Staff
Editor: Tod Lippy
Publisher
The Esopus Foundation Ltd
New York
www.esopusmag.com

FADER

The FADER magazine is the
definitive voice of emerging
music and the lifestyle that
surrounds it. Through in-depth
reporting and a distinct street
sensibility, *The FADER*
aggressively covers the most
dynamic breadth of music and
style emanating from the fringes
of the mainstream to the heart of
the underground. *The FADER* is
the authority on what's next.
English.
Editorial Office
71 West 23rd Street, Floor 13
NY 10010 New York
info@thefader.com
www.thefader.com

Faesthetic

The fast aesthetic.
Annual, founded in 1999,
1,000 copies, English.
Editorial Office
Po Box 1020
43697 Toledo, Ohio
info@faesthetic.com
www.faesthetic.com

Fanzine137

An independent publication
devoted to art, fashion and
people, among other things.
Editorial Office
New York
info@fanzine137.com
www.fanzine137.com
Staff
Editor, Creative director,
Publisher: Luis Venegas

Fashion Projects

Publication about experimental
fashion and its relation to other
visual disciplines.
Bi-annual, founded in 2004,
240 x 650 mm, 2,000 copies, $5,
English.
Editorial Office

243 West 15th Street, 3RW
10011 New York
francesca@fashionprojects.org
fashionprojects.org

Filmmaker

Quarterly, English.
Editorial Office
104 West 29th Street, 12th Floor
NY 10001 New York
www.filmmakermagazine.com
Staff
Editor: Scott Macaulay
Publisher
Jay J. Milla
jay@filmmakermagazine.com

Flaunt

Instead of treading the path most
taken, *Flaunt* magazine has made
it a point to consistently break
new ground, earning itself a
reputation as an engine of the
avant-garde and an outlet for
outsider culture.
Monthly, 230 x 275 mm, $8.95,
English.
Editorial Office
1422 North Highland
CA 90028 Los Angeles
flauntla@aol.com
www.flaunt.com
Staff
Founder: Jim Turner
Founder: Long Nguyen
Founder: Luis A. Barajas
Publisher
Flaunt Magazine
1422 North Highland
CA 90028 Los Angeles
Phone: +1 323 650 9051
Fax: +1 323 851 1250
flauntla@aol.com

foam

Monthly, English.
Editorial Office
foam@foammagazine.com
www.foammagazine.com

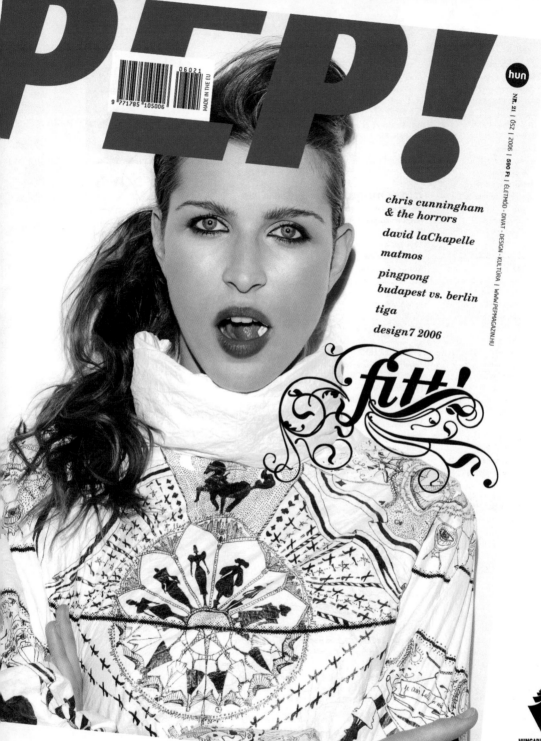

PEP!

hun

NR. 21 | ŐSZ | 2006 | 590 Ft | ÉLETMÓD · DIVAT · DESIGN · KULTÚRA | WWW.PEPMAGAZIN.HU

chris cunningham
& the horrors

david laChapelle

matmos

pingpong
budapest vs. berlin

tiga

design7 2006

fit!

HUNGARIAN
DESIGN AWARD
2005

PEP! ONLINE
www.pepmagazin.hu

PEP! MAGAZINE
to educate, to entertain, to provoke...

Found

Cult magazine *Found* is the ultimate in voyouristic irreverence. Each issue is a collection of found stuff.
$8, English.
Editorial Office
3455 Charing Cross Road
MI 48108-1911 Ann Arbor
info@foundmagazine.com
www.foundmagazine.com
Staff
Editor: Davy Rothbart
Editor: Jason Bitner

Fuego

The first men's magazine to uncover the spectrum of the modern Latino male lifestyle.
Quarterly, English.
Editorial Office
1115 Broadway
NY 10010 New York
fuegoinfo@harris-pub.com
www.fuego-magazine.com

Fugue

English.
Editorial Office
Los Angeles
info@fuguemagazine.com
www.fuguemagazine.com

Gastronomica
The Journal of Food and Culture
Quarterly, founded in 2001, English.
Editorial Office
Weston Hall,
995 Main Street,
Williams College
MA 01267 Williamstown
journals@ucpress.edu
www.gastronomica.org
Staff
Editor-in-chief: Darra Goldstein
Publisher
University of California Press
2000 Center St, Ste 303
CA 94704 Berkeley

Giant Robot

From movie stars, musicians, and skateboarders to toys, technology, and history, *Giant Robot* magazine covers cool aspects of Asian and Asian-American pop culture.

English.
Editorial Office
Po Box 642053
CA 90064 Los Angeles
info@giantrobot.com
www.giantrobot.com
Staff
Publisher: Eric Nakamura

gloss magazine

gloss magazine is the premier lifestyle resource for the gay community.
127 x 203 mm, English.
Editorial Office
584 Castro Street, Suite 329
CA 94114 San Francisco
info@sfgloss.com
www.sfgloss.com

Gotham Magazine

Loyal, wealthy, and sophisticated readers consider *Gotham Magazine* to be their virtual "golden pages" for the best in the metropolitan social scene.
Monthly, English.
Editorial Office
257 Park Avenue South, 5th Floor
NY 10010 New York
advertising@gotham-magazine.com
www.gotham-magazine.com
Staff
Editor-in-chief:
Jason Oliver Nixon
Managing editor:
Jennifer Ceaser
Publisher
Niche Media LLC
www.nichemediallc.com

Gothic Beauty
underground fashion and pop culture
Founded in 2000, English.
Editorial Office
4110 SE Hawthorne Blvd. #501
Ore 97214 Portland
www.gothicbeauty.com
Staff
Publisher and Editor-in-chief:
Steven Holiday

Graphis Advertising Journal

Publication covering graphic communications worldwide and has been revered for its artistic presentation, impeccable design, and exemplary production qualities.
Tri-annual, 60$, English.
Editorial Office
307 Fifth Avenue, 10th Floor
NY 10016 New York
info@graphis.com
www.graphis.com
Publisher
Graphis

Graphis Design Journal

Tri-annual, founded in 1944, 60$, English.
Editorial Office
307 Fifth Avenue, 10th Floor
NY 10016 New York
info@graphis.com
www.graphis.com
Publisher
Graphis

Graphis Photography Journal

Tri-annual, 60$, English.
Editorial Office
307 Fifth Avenue, 10th Floor
NY 10016 New York
info@graphis.com
www.graphis.com
Publisher
Graphis

Gum

$20, English.
Editorial Office
1334 W. Wolfram Street
IL 60657 Chicago
editors@gumweb.com
www.gumweb.com

H BOMB

H BOMB is Harvard University's first and premiere magazine about sex and sexuality.
Quarterly, founded in 2004, 213 x 277 mm, $5, English.
Editorial Office
Harvard
web@h-bomb.org
www.h-bomb.org
Staff
Founder and Editor-in-chief:
Katharina Cieplak-von Baldegg
Founder and President:
Camilla Hrdy

Half Empty

Founded in 1998, English.
Editorial Office
8520 National Blvd. Building A
CA 90232 Culver City
www.halfempty.com
Publisher
Marty Spellerberg
Phone: +1 416 795 5069
marty@halfempty.com

Hamburger Eyes
Photo Magazine
When opening *Hamburger Eyes* you enter a pictorial history of both the unseen and iconic moments of everyday life.
Tri-annual, 3,000 copies, English.
Editorial Office
Po Box 420 546
CA 94142 San Francisco
info@hamburgereyes.com
www.hamburgereyes.com
Staff
Editor-in-chief: Ray Potes
Publisher
Burgerworld Media
Po Box 420 546
CA 94142 San Francisco
info@hamburgereyes.com
www.hamburgereyes.com

FOR BETTER LIFE

Umělec

www.divus.cz
www.umelec.org
umelec@divus.cz

Hamptons

English.
Editorial Office
1724 County Road 39
NY 11968 Southampton
www.hamptons-magazine.com
Publisher
Niche Media LLC
www.nichemediallc.com

Harpers' Bazaar

Monthly, English.
Editorial Office
Po Box 7178
IA 51591 Red Oak
www.harpersbazaar.com
Publisher
Hearst
www.hearstcorp.com

Harvard's Design Magazine

Bi-annual, £13.
Editorial Office
48 Quincy Street
02138 Cambridge, Massachusetts
hdm@gsd.harvard.edu
www.gsd.harvard.edu/research/
publications/hdm

Heeb

The new Jew review
It is a sweaty prize fight between
hip hop and sushi in this corner
and klezmer and kugel in the
other.
Quarterly, English.
Editorial Office
New York
www.heebmagazine.com

Hi Fructose

Hi Fructose, like its pseudo
namesake, can be your source of
the sweetest contamination the
art world has to offer.
Founded in 2005.
Editorial Office
909 Pierce St.
CA 94706 Albany
info@hifructose.com
www.hifructose.com

How

Magazine that provides graphic
design professionals with
essential business information,
Every two months, founded in
1985, $12, English.
Editorial Office
4700 East Galbraith Road
OH 45236 Cincinnati
www.howdesign.com
Staff
Editor: Bryn Mooth
Art director: Tricia Barlow
Managing editor: Sarah Morton
Senior editor: Megan Lane
Publisher
FandW Publications
4700 East Galbraith Road
OH 45236 Cincinnati

Hyphen

Built around a clarity of image,
word and social awareness,
Hyphen takes form from the
artists, thinkers and creators who
are shaping a new multi-ethnic
generation.
English.
Editorial Office
Po Box 192002
CA 94119-2002 San Francisco
hyphen@hyphenmagazine.com
www.hyphenmagazine.com
Staff
Editor in Chief: Melissa Hung
Editor: Neelanjana Banerjee
Editor: Sita Bhaumik
Editor: Momo Chang
Editor: Lisa Katayama
Editor: Brian Lam
Editor: Harry Mok
Editor: Sabrina Tom

I.D.

I.D. Magazine is America's
leading critical magazine
covering the art, business and
culture of design.
$9, English.
Editorial Office
38 East 29th Street, Floor 3
NY 10016 New York
www.idonline.com
Staff
Editor-in-chief: Julie Lasky
Art director: Kobi Benezri
Managing editor: David Sokol
Associate editor:
Monica Khemsurov
Associate editor: Cliff Kuang

Inked

A lifestyle and fashion magazine
that covers the latest in art,
music, entertainment, style,
culture and delivers this content
to a savvy generation of forward-
thinking individuals.
Quarterly, English.
Editorial Office
27 West 24th St., Suite 501
NY 10010 New York
info@inkedmag.com
www.inkedmag.com

Interview

The Crystal Ball of Pop
No boundaries – no rules.
That's what makes *Interview*
unlike any other "entertainment"
magazine.
Monthly, founded in 1969,
255 x 305 mm, 210,000 copies,
$2.99, English.
Editorial Office
New York
www.interviewmagazine.com
Staff
Publisher: Sandra J. Brant
Editor-in-chief: Ingrid Sischy
Publisher
Brant Publications Inc.
575 Broadway
NY 10012 New York
Phone: +1 212 541 2900
Fax: +1 212 941 2934

Issue

Monthly, 216 x 278 mm,
40,000 copies, $10,
English.
Editorial Office
issue@issueinc.com
issuemagazine.com
Staff
Editor-in-chief and Creative
director: Jan-Willem Dikkers
Editor-in-chief:
Martynka Wawrzniak

Jane

Connecting with the under-30
crowd today means ignoring
cultural, ethnic and sexual-
preference stigmas because
they never had them in the first
place. Music, frank talk and
humor are the common ground
with this generation.
205 x 275 mm, 733,000 copies.
Editorial Office
750 3rd. Ave.
NY 10017 New York
www.janemag.com
Staff
Publisher: Mark Oltarsh
Editor-in-chief, Creative director
and Fashion director: Jane Pratt
Publisher
Fairchield Publications inc.

Jointz

for Los Angeles club-goers
Jointz is the most widely
distributed magazine to local
young professionals, college
students, DJs, musicians, artists
and visitors that want to
experience the L.A. nightlife.
Monthly, Free, English.
Editorial Office
1800 S. Robertson #0420
CA 90035 Los Angeles
listings@jointzmag.com
www.jointzmag.com

Juxtapoz

Art and Culture Magazine
Monthly, founded in 1994,
English.
Editorial Office
1303 Underwood Ave
CA 94124 San Francisco
editor@juxtapoz.com
www.juxtapoz.com
Staff
Editor: Jamie O'Shea
Managing editor:
Annie Tucker
Publisher
High Speed Productions inc.

K48

Independant fanzine about art,
music and candy-punk culture.
Annual, founded in 2000, $19.95.
Editorial Office
24-32 21st Street n 3D
NY 11102 Astoria
www.k48rules.com

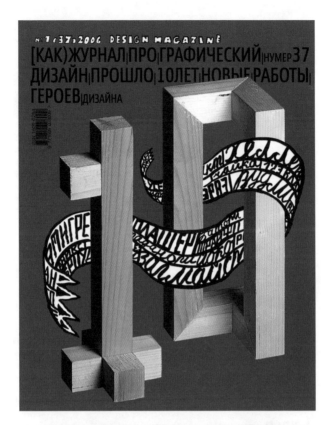

Staff
Editor-in-chief and Creative
director: Scott Hug

King

The first urban men's lifestyle
magazine that covers the entire
spectrum of what men desire.
8x / year, English.
Editorial Office
1115 Broadway
NY 10010 New York
www.king-mag.com

KnitKnit

KnitKnit is an artist's publication
dedicated to the intersection of
traditional craft and contemporary
art. Bi-annual, founded in 2002,
152 x 229 mm, 1,000 copies,
English.
Editorial Office
526 West 26th Street n°1022
NY 10001 New York
Sabrina@knitknit.net
www.knitknit.net
Staff
Founding Editor:
Sabrina Gschwandtner

Kotori

**Future Music Art Politics
Culture**
Quarterly, founded in 2003,
216 x 279 mm, 20,000 copies,
$3.99, English.
Editorial Office
3253 S. Beverly Dr.
CA 90034 Los Angeles
wasim@kotorimag.com
www.kotorimag.com
Staff
Editor-in-chief and Co-founder:
Wasim Muklashy

Lang

fashion / design
Quarterly, 216 x 279 mm, $6.95,
English.
Editorial Office
45071 Lothrop Court
MI 48188 Canton
paulcottrell@langstudiosinc.com
www.langstudiosinc.com
Staff
Founder: Paul Cottrell

Lemon

Pop Culture with a Twist
A publication that stakes its
claim at the intersection of 60s /
70s Pop and 21st century hyper-
culture.
Bi-annual, English.
Editorial Office
37 Fox Lane
MA 01742 Concord
www.lemonland.net
Staff
Editor-in-chief and Creative
director: Kevin Grady
Executive Editor and Creative
director: Colin Metcalf

Look-Look

**The magazine by young
photographers, writers, and
artists**
Bi-annual, English.
Editorial Office
6685 Hollywood Boulevard
CA 90028 Los Angeles
info@look-lookmagazine.com
www.look-lookmagazine.com

Love, Chicago

Love, Chicago magazine is to
enhance readers' awareness
about remarkable independent
businesspeople and artists
through excellent-quality editorial
and design.
Quarterly, 5,000 copies, English.
Editorial Office
3042 N. Christiana, Unit 2
IL 60618 Chicago
editorial@lovechicago.org
www.lovechicago.org
Staff
Editor-in-chief: Erica Burke

LTTR

Founded in 2002, 1,000 copies,
English.
Editorial Office
402 Graham Ave, PMB 163
NY 11211 Brooklyn
info@lttr.org
www.lttr.org

Lumpen

Every two months, English.
Editorial Office
960 w 31st St
Il 60608 Chicago
ed@lumpen.com
www.lumpen.com
Staff
Editor and Publisher:
Ed Marszewski
Music Editor: Zack Pink Shoes

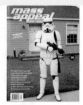

mass appeal

Urban Lifestyle Magazine
Every two months, founded in
1996, 210 x 275 mm, $4.99,
English.
Editorial Office
689 Myrtle Avenue 2A
NY 11205 Brooklyn
www.massappealmag.com
Staff
Editorial director: Sacha Jenkins
Publisher: Adrian Moeller
Editorial director: Noah
Callahan-Bever
Publisher: Patrick Elastik

McSweeneys

McSweeneys will include work
from some of the finest writers
in the country.
Quarterly, $24, English.
Editorial Office
custservice@mcsweeneys.net
www.mcsweeneys.net
Staff
Editor-in-chief and Creative
director: Dave Eggers
Publisher
McSweeneys

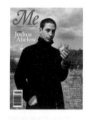

Me

A magazine devoted to
emerging individuals in creative
professions.
Quarterly, founded in 2004,
172 x 230 mm, $5, English.
Editorial Office
126 Winding Ridge Road
White Plains
NY 10603 New York
editor@memagazinenyc.com
www.memagazinenyc.com

"If A is success in life,
then A equals
x plus y plus z.
Work is x;
y is play;
and z is keeping your
mouth shut."

Albert Einstein
Physicist 1879 - 1955

Lancé au printemps 2000, le magazine paperJam s'est taillé une place à part dans l'univers économique et financier du Luxembourg et de la Grande Région.

La qualité des analyses, la finesse des portraits de ceux qui font et défont l'actualité de la Place, le regard éclairé des photographes et l'esthétique inégalée de la mise en page en font le premier mensuel économique du pays.

Riche de 200 pages, ce média bilingue français et anglais, diffusé à 20.000 exemplaires, démontre, au fil de ses 10 parutions annuelles, une indépendance incontestée.

paperJam »

Be ready for success.

Staff
Editor-in-chief and Creative
director: Claudia Wu
Publisher
Me Publications Inc.
126 Winding Ridge Road
White Plains
NY 10603 New York
editor@memagazinenyc.com
www.memagazinenyc.com

Megawords Magazine
Photomagazine of modern life
Quarterly, founded in 2005,
Variable format, 2,000 copies,
Free, English.
Editorial Office
3175 Belgrade Street
PA 19134 Philadelphia
info@megawordsmagazine.com
www.megawordsmagazine.com
Staff
Founder and Publisher:
Dan Murphy
Founder and Publisher:
Anthony Smyrski
Publisher
Megawords Magazine
3175 Belgrade Street
PA 19134 Philadelphia
info@megawordsmagazine.com
www.megawordsmagazine.com

Metro dot Pop
Every two months, founded in
2004, English.
Editorial Office
65 Pine Avenue n° 214
CA 90802 Long Beach
friends@metrodotpop.com
www.metrodotpop.com

Metropolis
Metropolis examines
contemporary life through
design, architecture, interior
design, product design, graphic
design, crafts, planning and
preservation. English.
Editorial Office

61 W. 23rd St. 4th Floor
NY 10010 New York
edit@metropolismag.com
www.metropolismag.com
Staff
Publisher: Horace Havemeyer III
Editor-in-chief: Susan S. Szenasy

milk
Sustenance for the masses
Annual, founded in 1999, English.
Editorial Office
5415 N. Sheridan Rd 2602
IL 60640 Chicago
www.milkmag.org
Staff
Editor: Larry Sawyer
Founder: Larry Sawyer
Founder:
Lina Ramona Vitkauskas

Mule
The publication hopes to
document and celebrate the
world of people who continue
making, thinking, and generating.
Quarterly, founded in 2002,
English.
Editorial Office
Po Box 18138
IL 60618 Chicago
mulemagazine@gmail.com
www.mulemagazine.com

neomu
The smallest magazine in the
world. No words, no advertising,
just inspirational images,
photographs and graphics.
Tri-annual, 110 x 110 mm, $18,
No text.
Editorial Office
New York
neomuworld@aol.com
www.neomu.com
Staff
Founder and Editor-in-chief:
Deanne Cheuk

nest
A Quarterly of Interiors
Quarterly, $12.50, English.
Editorial Office
Po Box 2446, Lenox Hill Station
NY 10021 New York
www.nestmagazine.com
Staff
Art director and Editor-in-chief:
Joseph Holtzmann
Publisher
nest LLC
1365 York Avenue
NY 10021 New York

North Drive Press
A boxed magazine.
Founded in 2003, 228 x 305 mm,
$30, English.
Editorial Office
info@northdrivepress.com
www.northdrivepress.com
Staff
Editor: Matt Keegan
Editor:
Sara Greenberger Rafferty

NY Arts
Monthly, English.
Editorial Office
473 Broadway, 7th Floor
NY 10013 New York
info@nyartsmagazine.com
nyartsmagazine.com
Staff
Editor-in-chief and Creative
director: Steven Psyllos

NYLON
Monthly (11x / year),
230 x 273 mm, $2, English.
Editorial Office
394 West Broadway, 2nd floor
NY 10012 New York
www.nylonmag.com
Staff
Art director: Lina Kutsovskaya
Editor-in-chief:
Marvin Scott Jarret
Publisher
NYLON LLC

394 West Broadway, 2nd Floor
10012 New York
Phone: +1 212 226 6454
Fax: +1 212 226 7738

NYLON guys
Quarterly, founded in 2005, English
Editorial Office
394 West Broadway
NY 10012 New York
guys.nylonmag.com
Publisher
NYLON LLC
394 West Broadway, 2nd Floor
NY 10012 New York
Phone: +1 212 226 6454
Fax: +1 212 226 7738

Ocean Drive
Founded in 1993, English.
Editorial Office
404 Washington Ave, Suite 650
FL 33139 Miami Beach
www.oceandrive.com
Staff
Editor-in-chief: Glenn Albin
Managing editor: Eric Newill

October
Examining relationships between
the arts and their critical and
social contexts, *October*
addresses a broad range of
readers.
Quarterly, 11€, English.
Editorial Office
New York
journals-info@mit.edu
www.mitpressjournals.org/loi/octo
Staff
Editor: Rosalind Krauss
Editor: Annette Michelson
Publisher
MIT Press Journals
55 Hayward Street
MA 02142 Cambridge
journals-info@mitpress.mit.edu
www.mitpressjournals.org

oneonenine
oneonenine is a graphic design /
art zine collaboration involving
many talented people.
235 x 300 mm, $10, English.
Editorial Office
173 Ludlow Street 5a
NY 10001 New York
info@oneonenine.org
www.oneonenine.org

Orlando Style
Luxury Lifestyle Magazine
Orlando Style, the lifestyle magazine is on the pulse of the latest, hottest, and most sophisticated scenes in Orlando City. Every two months, 35,000 - 50,000 copies, English.
Editorial Office
2295 S. Hiawassee Rd., Suite 410 FL 32835 Orlando
www.orlandostylemagazine.com

Outburn
From hard and heavy to subversive and sublime, *Outburn* is at the forefront of everything exciting in music today. Every two months, English.
Editorial Office
Po Box 3187
CA 91359-0187 Thousand Oaks
outburn@outburn.com
www.outburn.com

Overspray
International Street Art Magazine
Quarterly, founded in 2004.
Editorial Office
www.overspraymag.com

Paper
The Pervy Monthly with the Curvy Readers
Monthly (10x / year), 215 x 275 mm, 91,800 copies, $3.50, English.
Editorial Office
15 E. 32nd St., 11th Fl.
NY 10016 New York
edit@papermag.com
www.papermag.com
Staff
Founder and Editor-in-chief:
David Hershkovits
Editor and Publisher:
Kim Hastreiter

Paste
Rock'n'roll: It's not just for kids anymore
Monthly, founded in 2002, 150,000 copies, English.
Editorial Office
Po Box 292382
45429 Kettering, Ohio
mail@pastemagazine.com
www.pastemagazine.com

Pavement
Founded in 1999, English.
Editorial Office
172 Fifth Avenue 125
NY 11217 New York
editor@pavementmagazine.com
www.pavementmagazine.com
Staff
Publisher: Ned Schenck
Publisher
Pavement Magazine Inc.
New York
www.pavementmagazine.com

Peach
English.
Editorial Office
404 Washington Ave, Suite 650, FL 33139 Miami Beach
www.atlantapeach.com
Staff
Editorial director: Glenn Albin
Editor-in-chief:
Elizabeth Schulte Roth
Creative director: Carlos Suarez

Picture
For the emerging professional photographer
Every two months, 21,400 copies, English.
Editorial Office
41 Union Square West 504
NY10003 New York
picmag@aol.com
www.picturemagazine.com
Staff
Publisher: Brock Wylan

PIN-UP
Magazine for Architectural Entertainment
Bi-annual, founded in 2006, 235 x 285 mm, 10,000 copies, 9.90€, English.
Editorial Office
175 East Broadway 5A
10002 New York
info@pinupmagazine.org
www.pinupmagazine.org
Staff
Editor and Creative director:
Felix Burrichter
Art direction: Geoffrey Han
Art direction: Dylan Fracareta
Publisher
FEBU Publishing LLC
175 East Broadway 5A
NY 10002 New York
Phone: +1 212 228 7322
Fax: +1 212 228 6357

Pistil
Planted at the intersection of fashion and activism, *Pistil* is an independent, Chicago-based magazine that inspires young, urban readers to cultivate their perception, their world and their style. Quarterly, founded in 2003, English.
Editorial Office
Po Box 220225
IL 60622 Chicago
info@pistilmag.com
www.pistilmag.com
Staff
Editor-in-chief and Publisher:
Lauria E. Locsmondy
PR manager: Liz Wolf

Planet
Global Culture and Lifestyle
Quarterly, founded in 2001, 215 x 270 mm, $5.95, English.
Editorial Office
2390 Mission Street, Suite 10
CA 94110 San Francisco
info@planet-mag.com
www.planet-mag.com
Staff
Editor and Publisher and
Creative director: Derek Peck

Plazm
Collective of artists, designers, musicians, architects, capitalists and anarchists, printmakers, paper shredders, snowboarders and stargazers.
Annual, founded in 1991, 228 x 305 mm, 5,000 copies, $10, English.
Editorial Office
Po Box 2863
OR 97208 Portland
editor@plazm.com
www.plazm.com
Staff
Josh Berger
Jon Raymond
Tiffany Lee Brown
Publisher
Plazm Media, Inc.
Po Box 2863
OR 97208 Portland
Phone: +1 503 528 8000
josh@plazm.com
www.plazm.com

Plenty
It's easy being green
Every two months, founded in 2004, 130,000 copies, English.
Editorial Office
250 West 49th Street, suite 203
NY 10019 New York
info@plentymag.com
www.plentymag.com
Staff
Editor-in-chief: Mark Spellun
Creative director: Catherine Cole

print
America's Graphic Design Magazine
Bi-monthly, founded in 1940, English.
Editorial Office
38 East 29th Street, 3rd Floor
NY 10016 New York
info@printmag.com
www.printmag.com
Staff
Editor-in-chief:
Joyce Rutter Kaye
Managing editor: Emily Gordon
Senior editor: Caitlin Dover
Associate editor: James Gaddy

Quadrafoil
$8, English.
Editorial Office
40 Rivington Street, Suite 19
NY 10002 New York
mgmt@quadrafoil.com
www.quadrafoil.com
Staff
Editor-in-chief and Creative director: Walid Ghanem

Rap-Up
Quarterly, English.
Editorial Office
info@rap-up.com
www.rap-up.com
Staff
Founder and Editor-in-chief:
Devin Lazerine

Raw Vision
Quarterly, English.
Editorial Office
163 Amsterdam Avenue #203
NY 10028-5001 New York
info@rawvision.com
www.rawvision.com

RE:UP Magazine
Quarterly, English.
Editorial Office
828 G Street
CA 92101 San Diego
info@reupmag.com
www.reupmag.com

Reactor
News and Entertainment
The arts (fine or pop), scientific discovery, inspired leadership, personal and business success, love, etc.
Monthly, founded in 2005, 216 x 260 mm, $17, English.
Editorial Office
Po Box 2163
99352 Richland, WA
word@reactormag.com
www.reactormag.com
Staff
Editor: Aaron Pogue

Rebel
Arts and Literary Magazine
East Carolina University
Annual, founded in 1958, English.
Editorial Office
404 S. Evans St.
NC 27858 Greenville, Carolina
www.rebel.ecu.edu

Red
The Lifestyle Compass
English.
Editorial Office
PO Box #1169
75001 Addison, Texas
info@redmagonline.com
www.redmagonline.com

Relevant
Its purpose is to impact culture and show that a relationship with God is relevant and essential to a fulfilled life.
Founded in 2003, English.
Editorial Office
100 South Lake Destiny Drive, Suite 200
FL 32810 Orlando
info@relevantmediagroup.com
www.relevantmagazine.com
Staff
President and CEO:
Cameron Strang
Editorial director: Cara Davis
Managing director: Tyler Clark
Publisher
Relevant Media Group
FL 32810 Orlando
info@relevantmediagroup.com
www.relevantmediagroup.com

Repellent
Freestyle Expressionism
A multi-faced art and culture whirlwind organization focusing on shining a flashlight on underground and DIY photography, music, design, art and style. English.
Editorial Office
New York
dmccary@gmail.com
www.repellentzine.com

RES magazine
Film / Music / Art / Design / Culture
The magazine profiles creative individuals in digital media and features reviews of the latest tools and techniques in desktop film and video.
Every two months, 230 x 277 mm, $5.95, English.
Editorial Office
76 Ninth Avenue, 11th Floor
NY 10011 New York
editor@res.com
www.res.com
Staff
Editor: Jesse Ashlock
Design: Juliette Cezzar
Publisher
RES Media Group
76 Ninth Avenue, 11th Floor
NY 10011 New York
general@res.com
www.res.com

Richardson
$25, English.
Editorial Office
info@richardsonmag.com
www.richardsonmag.com

Staff
Editor-in-chief:
Andrew Richardson
Art director: Laura Genninger
Publisher
Oedipus LLC
83 Canal Street *203
NY 10002 New York
Phone: +1 212 219 3083
info@richardsonmag.com
www.richardsonmag.com

Rolling Stone
Fortnightly, founded in 1967, 1,400,00 copies, English.
Editorial Office
1290 Avenue of the Americas
NY 10104 - 0298 New York
rollingstone@real.com
www.rollingstone.com
Staff
Editor and Publisher:
Jann S. Wenner
Managing editor: Will Dana
Deputy managing editor:
James Kaminsky
Deputy managing editor:
Joe Levy

Royal Magazine
The publication focuses on collisions, culture and capitalism.
Free, English.
Editorial Office
New York
info@thekdu.com
www.theroyalmagazine.com
Publisher
Keystone Design Union
New York
info@thekdu.com
www.kdu.com

Severe
Pop Culture's Entertainment Magazine
Founded in 2005, English.
Editorial Office
8436 Denton Hwy,
Ste 208-166
TX 76148 Watauga
info@servemag.com
www.severemagazine.com
Staff
President and Publisher:
Tony Garza
Editor-in-chief: Jason M. Burns

Visit www.welovemags.com for an updated version of the directory

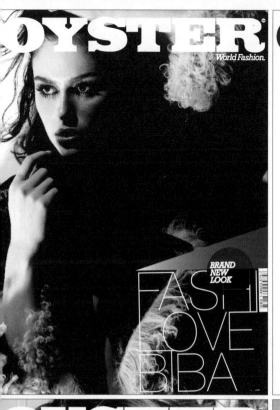
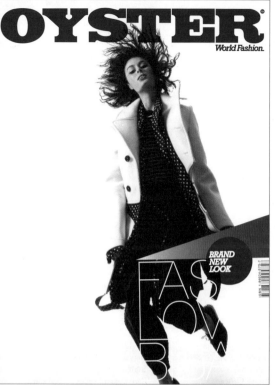
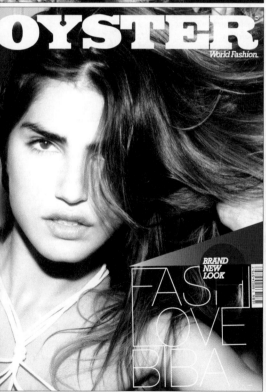
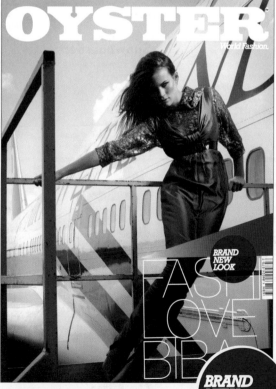

Shade Mag

A Phoenix-based magazine that focuses on contemporary art in all its possible manifestations-visual art, architecture, film, design, literature, animation and culinary arts.
Every two months, 190 x 239 mm, English.
Editorial Office
www.shademag.com

Sherbert

Exists on one simple idea: to inspire and to be inspired.
Founded in 2001, 180 x 215 mm, $3, English.
Editorial Office
593 Vanderbilt Ave. PMB 178
NY 11238 Brooklyn
info@sherbertmagazine.com.
www.sherbertmagazine.com
Staff
Publisher and Designer:
Dan Weise
Editor: Jenna Wilson
Publisher
Sherbert LLC
www.sherbertmagazine.com

Skin and Ink

Tattoo magazine
9x / year, founded in 1993, 206 x 283 mm, 80,000 copies, English.
Editorial Office
210 Route 4 East, Suite 211
NJ07652 Paramus
skinandink@hotmail.com
www.skinandink.com
Staff
Editor-in-chief: Bob Baxter

Smash

It's a Tennis Revolution
A core youth driven tennis / lifestyle magazine.
Quarterly, founded in 2006, $3.99, English.
Editorial Office

79 Madison Ave., 8th Floor
NY 10016 New York
designmm@charter.net
www.smashtennis.com
Staff
Editorial director: Norb Garrett
Editor: James Martin
Designer: Mark Michaylira
Publisher
Jeff Williams
11100 Santa Monica Blvd.,
Ste. 600
CA 90025 Los Angeles

smock

a modern attitude
smock makes art relevant to your life, fusing it with fashion, design, style, entertainment and culture.
A hip, new, edgy art magazine with a fresh art attitude
Every two months, English.
Editorial Office
49 Walker Street, 2nd floor
NY 10013 New York
www.smockonline.com
Staff
Publisher and Editor-in-chief and Creative director: Scott Bennett
Associate publisher: Nancy Hunt

Snowboarder

Youth-driven core Snowboard Magazine.
8x / year, founded in 1988, 2,000 copies, $3.99, English.
Editorial Office
33046 Calle Aviador
92675 San Juan Capistrano
designmm@charter.net
www.snowboardermag.com

Soma

left coast culture
The international acclaimed magazine of culture, fashion and the arts.
Monthly, 214 x 275 mm, $3.50, English.
Editorial Office
888 O'Farrel Street, Suite 103

California 94109 San Francisco
info@somamagazine.com
www.somamagazine.com
Staff
Art director: Timothy Peterson
Publisher and Editor-in-chief:
A. Ghanbarian
Publisher
Soma Magazine
888 O'Farell Street,
Suite 103
CA 94109 San Francisco
Phone: +1 415 777 4585
www.somagazine.com

Something in the way

Covers the best, brightest and most definitive in fashion, art and music.
Founded in 2005, Free, English.
Editorial Office
New York
somethinginthewaymag.com
Staff
Sarah Bronilla

Stop Smiling

The Magazine for High-Minded Lowlifes
Every two months, 62,000 copies, English.
Editorial Office
1371 N. Milwaukee Avenue
IL 60622 Chicago
info@stopsmilingonline.com
www.stopsmilingonline.com
Staff
Editor-in-chief: JC Gabel
Publisher
Stop Smiling Media LLC
Chicago
www.stopsmilingonline.com

strategy + business

Quarterly, English.
Editorial Office
101 Park Avenue
NY 10178 New York
editors@strategy-business.com
www.strategy-business.com
Staff
Editor-in-chief: Art Kleiner
Deputy editor: Amy Bernstein

'SUP Magazine

Free, English.
Editorial Office
874 Broadway #301
NY 10003 New York
www.supmag.com
Staff
Publisher, Editor-in-chief and Advertising: Marisa Brickman
Art direction: Brendan Dugan
Editor: Cameron Cook
Editor: Jaclyn Marinese

Super 7

Super 7 Magazine is a publication covering all aspects of Japanese toy culture.
$5.95, English.
Editorial Office
540 Delancey Street, Suite 303
CA 94107 San Francisco
info@super7magazine.com
www.super7magazine.com
Staff
Co-founder, Editor and Artist:
Mark Nagata
Co-founder, Editor and Designer: Brian Flynn

*surface

The American avant-garde
Reports first and in-depth on what's happening at the cutting edge of culture.
230 x 274 mm, $4.95, English.
Editorial Office
55 Washington Street, Suite 419
NY 11201 Brooklyn
surfacemag@surfacemag.com
www.surfacemag.com
Staff
Publisher and Creative director:
Riley John-Donnell
Richard M. Klein
Publisher
*Surface Publishing LLC
1663 Mission Street, Suite 700
CA 94103 San Francisco
Phone: +1 415 575 3100
Fax: +1 415 575 3105
surfacemag@surfacemag.com
www.surfacemag.com

MONITOR⊟

ALL CONTEMPORARY DESIGN MAGAZINE

MONITOR

DESIGN 38

PRODUCT
ARCHITECTURE
VISUAL
FASHION

NEIL M. DENARI
+ living special

plus aoki plan01 rintala newson morphosis bey nichetto grosse o'sullivan preutz tjep.

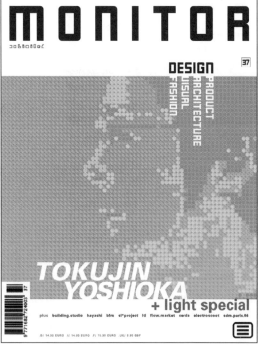

MONITOR

DESIGN 37

PRODUCT
ARCHITECTURE
VISUAL
FASHION

TOKUJIN YOSHIOKA
+ light special

plus building.studio hayashi bfm sî*project itl flow.market cerda electroscoot sdm.paris.06

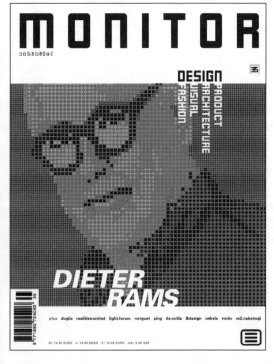

MONITOR

DESIGN 35

PRODUCT
ARCHITECTURE
VISUAL
FASHION

DIETER RAMS

plus duglis realitiesunited light.forum norguet ping da.cotiis &design uebela voidy m2.nakatsuji

DESIGN

PRODUCT
ARCHITECTURE
VISUAL
FASHION

www.monitorunlimited.com

Swindle

The definitive popular culture and lifestyle publication for women and men.
Quarterly, founded in 2004, 235 x 280 mm, $14.95, English.
Editorial Office
3780 Wilshire Blvd, suite 210
CA 90010 Los Angeles
info@swindlemagazine.com
www.swindlemagazine.com
Staff
Creative director: Shepard Fairey
Editor-in-chief: Roger Gastman
Publisher
Obey Giant Art

Tablet

A culture magazine
English.
Editorial Office
1122 E Pike Street, #1435
WA 98122 Seattle
www.tabletmag.com

Textfield

English.
Editorial Office
2404 Wilshire Boulevard,
Penthouse D
CA 90057 Los Angeles
e-mail@textfield.org
www.textfield.org

The Believer

The Believer is exploring the interconnected worlds of books, music, politics, and art.
Monthly, English.
Editorial Office
826 NYC, 372 Fifth Ave.
NY 11215 New York
www.mcsweeneys.net

The Colonial

Bi-annual, founded in 2005, 178 x 230 mm, $8, English.
Editorial Office
Los Angeles
Staff
Editor-in-chief: CW Winter

The Drama

Strives to provide an honest and considerate perspective on the ever-evolving world of contemporary art, but in a way that is pushing the boundaries of what a magazine is traditionally thought of.
Quarterly, founded in 2000, 229 x 229 mm, 8,500 copies, $5.95, English.
Editorial Office
Po Box 5534
VA 23220 Richmond
hello@thedrama.org
www.thedrama.org
Staff
Editor-in-chief and Creative director: Joel Speasmaker
Associate editor:
Travis Robertson
Assistant editor: Max Hubenthal
Copy editor: Mike Ball
Publisher
Joel Speasmaker
joel@thedrama.org

The Journal

contemporary culture
A unique publication that links contemporary culture, art, music, skateboarding and snowboarding like no other magazine does.

Quarterly, 25,000 copies, English.
Editorial Office
619 E, 6th Street
NY 10009-6801 New York
info@thejrnl.com
www.thejrnl.com

The Lowbrow Reader

Of Lowbrow Comedy
The Lowbrow Reader is a slim, heavily-illustrated magazine of and about comedy.
Annual, founded in 2001, 2,000 copies, $3, English.
Editorial Office
243 West 15th Street, 3RW
10011 New York
francesca@fashionprojects.org
www.lowbrowreader.com

The New Yorker

The New Yorker's mission has been to report and reflect on the world at large with wit, sophistication, and originality.
Weekly, founded in 1925, 200 x 273 mm, $4.95, English.
Editorial Office
4 Times Square
NY 10036 New York
www.newyorker.com
Staff
Editor-in-chief: David Remnick
Publisher
Condé Nast Publications
Piazza Castellano 27
20121 Milan
Italy
Phone: +39 02 856 11
Fax: +39 02 805 57 61

The Royal

Quarterly, Free, English.
Editorial Office
180 South 3rd Street, #A1
Brooklyn
NY 11211 New York
info@theroyalmagazine.com
www.theroyalmagazine.com
Staff
Publisher: David Gensler

TheBlowUp

New York City's preeminent new fashion, art and culture magazine.
Bi-annual, founded in 2003, 222 x 298 mm, $7, English.
Editorial Office
511 Canal St, 4th Flr.
NY 10013 New York
info@theblowup.com
www.theblowupmagazine.com
Staff
Publisher and Creative director: Seth P. Hodes
Creative director and TheBlowUp.com: Ray Lee
Advertising director: Janet Levy
Editor-in-chief: Kate Sennert

Theme

Asian Culture Quarterly
Quarterly, founded in 2005, 230 x 280 mm, $5.95, English.
Editorial Office
203 Rivington Street 1D
NY 10002 New York
thememagazine.com
Staff
Publisher and Managing editor: John Lee
Publisher and Creative director: Jiae Kim
Publisher
Theme Publishing
203 Rivington Street 1D
NY 10002 New York
www.thememagazine.com

one small seed **the south african contemporary culture magazine**

Time Out Chicago

Weekly, English.
Editorial Office
247 South State Street, 17th floor
IL 60604 Chicago
www.timeoutchicago.com
Staff
Editor-in-chief: Chad Schlegel
Managing editor: Amy Carr
Features editor: Craig Keller
Publisher
Time Out Group Ltd.

Time Out New York

The obsessive guide to impulsive entertainment. English.
Editorial Office
475 Tenth Avenue, 12th floor
NY 10018 New York
www.timeout.com/newyork
Staff
Editor-in-chief: Joerg Angio
Managing editor:
Nancy Sidewater
Features editor: Soren Larson
Publisher
Time Out New York Partners LP
New York
www.timeout.com/newyork/

Tokion

The Sound of Now
Tokion is a fictional word meaning "the sound of now"
Every two months, founded in 1996, 175 x 230 mm, 97,000 copies, $5.99, English.
Editorial Office
419 Lafayette Street, 2nd Floor
NY 10003 New York
usmail@tokion.com
www.tokion.com
Staff
Art director: Jesse Alexander
Editor-in-chief and Photo editor:
Ken Miller
Fashion director: Jay Massacret
Publisher: Larry Rosenblum
Associate editor: Saheer Umar
Assistant editor:

Maxwell Williams
Publisher
Downtown Media Group
419 Lafayette Street, 2nd Floor
NY 10003 New York
Phone: +1 646 723 4510
Fax: +1 646 349 5598
usmail@tokion.com
www.tokion.com

Topic

A magazine about the adventure of living
It is made up of real stories by real people. Our editorial mission: to explore today's world by discovering individuals whose extraordinary life stories intersect with a given topic – and to invite them to tell those stories themselves. No journalists, no middleman. Topic gets its material straight from the people who have lived it.
English.
Editorial Office
Po Box 502
NY 10014 New York
info@topicmag.com
www.topicmag.com
Staff
Editor-in-chief: David Haskell
Managing editor: Nina Weiss

Trace

Transcultural styles and ideas
8x / year, founded in 1995, English.
Editorial Office
476 Broome Street
NY 10013 New York
info@trace212.com
www.trace212.com

Under the radar

English.
Editorial Office
238 S. Tower Drive, #204
CA 90211 Beverly Hills
writers@undertheradarmag.com
www.undertheradarmag.com
Staff
Editor-in-chief: Mark
Creative director: Wendy

Undergr(s)ound

English.
Editorial Office
Po BOX 24281
OH 452241 Cincinnati
info@ugsmag.com
ugsmag.com

URB

Urban Alternative Culture
The mission of *URB Magazine* is simple: to capture the most exciting and essential elements of music and underground culture.
Monthly, 75,000 copies, English.
Editorial Office
6300 Wilshire Blvd, Suite 1750
CA 90048 Los Angeles
word2urb@urb.com
www.urb.com

V Magazine

The biggest magazine in fashion
Every two months, founded in 1999, 295 x 415 mm, $8.95, English.
Editorial Office
11 Mercer Street
10013 New York
www.vmagazine.com
Publisher
V Magazine LLC.
11 Mercer Street
10013 New York
Phone: +1 212 274 8959
Fax: +1 212 343 2595
editorial@vmagazine.com
www.vmagazine.com

V Man

Bi-annual, founded in 2003, 225 x 295 mm, $4.95, English.
Editorial Office
11 Mercer Street
NYC 10013 New York
editorial@vman.com
www.vman.com
Staff
Editor-in-chief and Creative director: Stephen Gan
Executive editor:
Julie Anne Quay
Fashion director:
Andrew Richardson
Publisher
V Magazine LLC.
11 Mercer Street
10013 New York
Phone: +1 212 274 8959
Fax: +1 212 343 2595
editorial@vmagazine.com
www.vmagazine.com

v.

v., short for a different word each issue, researches typography and language for the Graphic Design Department at Art Center College of Design.
Tri-annual, founded in 2005, 225 x 295 mm, 3,500 copies, Free, English.
Editorial Office
trees@wefakeid.com
www.artcenter.edu/gpk
Staff
Editor-in-chief: Joshua Trees
Contributing editor:
Yvan Martinez
Publisher
Graphic Design Department /
Art Center College of Design
www.artcenter.edu/gpk

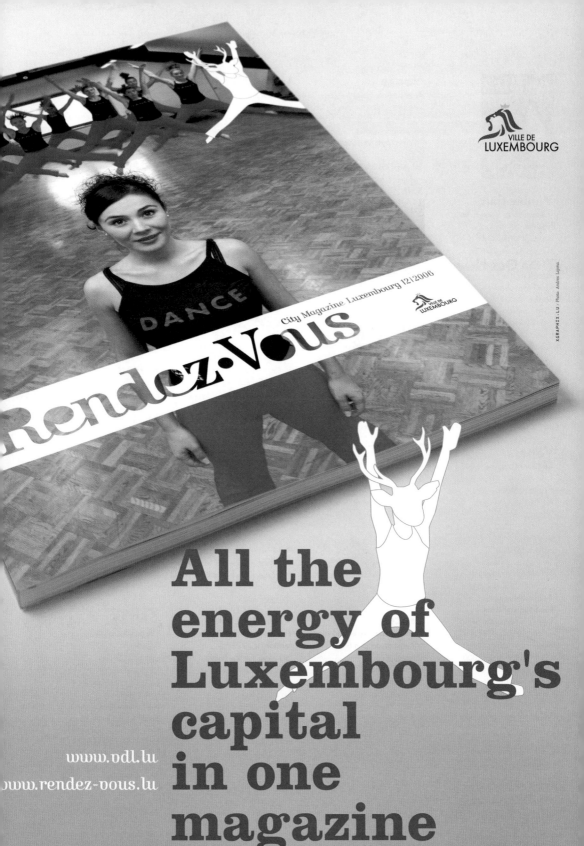

Vanity Fair

Monthly, 204 x 275 mm, $4.50, English.
Editorial Office
4 Times Square, 22nd floor
NY 10036 New York
letters@vf.com
www.vanityfair.com
Staff
Editor: Graydon Carter
Vice president and Publisher:
Louis Cona
Publisher
Condé Nast Publications
Piazza Castellano 27
20121 Milan
Italy
Phone: +39 02 856 11
Fax: +39 02 805 57 61

Vapors

All City Magazine
A progressive metropolitan
lifestyle publication focusing on
Art, Fashion, Music and
Skateboarding.
Founded in 2000, 215 x 279 mm,
English.
Editorial Office
6725 Sunset Boulevard, Suite 320
CA 90028 Los Angeles
helpdesk@overamerica.com
www.vaporsmagazine.com
Publisher
Vapours Multimedia

Vegas

A sexy, celebrity and fashion-
oriented publication that captures
the mystique, the sensuality and
the attitude that is Las Vegas.
Monthly, founded in 2003,
English.
Editorial Office
www.vegasmagazine.com
Staff
Editor-in-chief: Glenn Albin
Public relations director:
Kelli Maruca

Venus

**The No. 1 source for coverage
of women in music, art, film,
fashion, and D.I.Y. culture.**
Quarterly, 212 x 275 mm, $4.50,
English.
Editorial Office
2000 W. Carroll, suite 402
IL 60612 Chicago
www.venuszine.com
Staff
Editor and Publisher:
Amy Schroeder

VERY

VERY is known as one of the
first magazines focusing on
the fashion-and-art hybrid.
Bi-annual, founded in 1997,
80,000 copies, English.
Editorial Office
257 Church street
NY 10013 New York
Publisher
Up&Co
New York
www.up&co.com

Visionaire

Visionaire is a multi-format
album of fashion and art
produced in exclusive numbered
limited editions.
Tri-annual, founded in 1991,
English.
Editorial Office
11 Mercer Street

New York
info@visionaireworld.com
www.visionaireworld.com
Publisher
V Magazine LLC.
11 Mercer Street
10013 New York
Phone: +1 212 274 8959
Fax: +1 212 343 2595
editorial@vmagazine.com
www.vmagazine.com

W

W challenges standard views of
popular culture, covering the
worlds of fashion, beauty, the arts
and celebrity with an unbridled
passion for revelation.
Monthly, 254 x 328 mm, 469,243
copies, $4.5, English.
Editorial Office
7 West 34th Street
10001 New York
www.WMagazine.com
Staff
Vice President and Publisher:
Nina Lawrence
Chairman and Editorial director:
Patrick Mc Carthy
Publisher
Fairchild Publications inc.
57 Executive Park South,
Suite 120
30329 Atlanta
Phone: +1 404 633 8461

waxpoetics

It's all about the beats
Like an art history course at a
prestigious university.
Quarterly, founded in 2002,
English.
Editorial Office
45 Main Street, Suite 311
NY 11201 Brooklyn
www.waxpoetics.com

Whitewall

It's mission is to make art more
accessible.
Editorial Office
135 William St Apt n°8B
NY 10038 New York
michael@whitewallmag.com
www.whitewallmag.com
Staff
Editor-in-chief and Creative
director: Eve Therond
Publisher
Michael Klug

Wired

Monthly, 205 x 278 mm, $4.99,
English.
Editorial Office
520 Third Street, Suite 305
CA 94107-1815 San Francisco
info@wiredmag.com
www.wired.com
Staff
Editor-in-chief: Chris Anderson
Vice president and Publisher:
Drew Schutte
Publisher
Condé Nast Publications
Piazza Castellano 27
20121 Milan
Italy
Phone: +39 02 856 11
Fax: +39 02 805 57 61

XLR8R
Magazine

English.
Editorial Office
1388 Haight St. #105
CA 94117 San Francisco
letters@xlr8r.com
www.xlr8r.com
Staff
Creative director: Brianna Pope
Editor: Vivian Host
Managing editor: Ken Taylor
Design and Production assistant:
David Clark

Seen a magazine
that is no longer
published?
Go online: www.
welovemags.com

zingmagazine

zingmagazine publishes
contemporary art. Each issue
includes a CD and a poster.
Annual, founded in 1995,
217 x 280 mm, $20, English.
Editorial Office
New York
info@zingmagazine.com
www.zingmagazine.com
Staff
Managing editor: Anna Knoebel
Editor and Publisher:
Devon Dikeou
Art director: Janice Yu
Publisher
Zing LLC
83 Grand Street
NY 10013 New York
Phone: +1 212 966 4935
Fax: +1 917 237 0118
info@zingmagazine.com
www.zingmagazine.com

Zink Magazine

Monthly, founded in 2002,
212 x 277 mm, $4.99, English.
Editorial Office
304 Park Avenue South
NY 10010 New York
www.zinkmag.com
Staff
Managing editor: Casey Gillespie
Publisher
Jormic Media Group

Venezuela

dmente

Every two months, founded in
2002, 7,000 copies, Spanish.
Editorial Office
Caracas
info@dmente.net
www.dmente.com.ve
Staff
Editor: Eric Colon

Platanoverde

Quarterly, founded in 2003,
210 x 300 mm, 5,000 copies,
Spanish.
Editorial Office
Centro San Ignacio,
Torre Kepler, Piso 6,
Oficina 603-604
10600 Caracas
platanoverde@platanoverde.com
www.platanoverde.com
Staff
Art director: Alex Wright
Editor: Leo Felipe Campos
Web: Lope Gutiérrez-Ruiz
Publisher
A&B Producciones
Centro San Ignacio,
Torre Kepler, Piso 6,
Oficinas 603 and 604
Caracas
Phone: +58 0212 267 4177
Fax: +58 0212 265 0560
platanoverde@platanoverde.com
www.platanoverde.com

Magazine shops

Argentina

Asunto Impreso
Pasaje Rivarola 169
1015 Buenos Aires
T: 00 54 11 4383 6262
F: 00 54 11 4383 5152
www.asuntoimpreso.com
libreria@asuntoimpreso.com

Belleza y Felicidad
Aguna de Figueroa 900
1180 Buenos Aires
T: 00 54 11 4867 0073
www.bellezayfelicidad.com.ar
info@bellezayfelicidad.com.ar

Casa de la Cultura
Irigoyen 941
7150 Buenos Aires
T: 00 54 02296 454949
www.cculturadelacalle.org.ar
cultura@ayacucho.mun.gba.gov.ar

Centro Cultural España
Entre Rios 40
Córdoba
T: 00 54 351 4341617-4341647
www.ccec.org.ar
lavacaresponde@ccec.org.ar

Centro Cultural Recoleta
Junín 1930
1113 Buenos Aires
T: 00 54 11 4803 1040
www.centroculturalrecoleta.org
prensa@centroculturalrecoleta.org

Concentra
Montevideo 938 Buenos Aires
T: 00 54 11 4814 2479
F: 00 54 11 4814 2479
www.concentra.com.ar
libreria@concentra.com.ar

Cp67
Casa Central, Florida 689, Local 18,
CP1004AAM Buenos Aires
T: 00 54 4314 6303
F: 00 54 4314 7135
www.cp67.com
cp67@cp67.com

Fundación Proa
Av. Pedro de Mendoza 1929
C1169AAD Buenos Aires
T: 00 54 11 4303 0909
www.proa.org
info@proa.org

La Paragráfica
Av. Córdoba 1785 Locales 4,
5 y 6. Galería del Carmen
Buenos Aires
T: 00 54 11 4815 7670
www.paragrafica.com.ar
par@paragrafica.com.ar

Malba
Avda. Figueroa Alcorta
3415 Buenos Aires
T: 00 54 11 4808 6500
F: 00 54 54 11 4808 6598/99
www.malba.org.ar
info@malba.org.ar

Prana
Crámer 2383 Belgrano bs. as.
Buenos Aires
T: 00 54 47 88 67 08
www.pranapelu.com.ar
nestorprana@hotmail.com

Prometeo
Honduras 4912, Palermo
Buenos Aires
T: 00 54 4833 4669
www.prometeolibros.com.ar

Peccata Minuta
Córdoba 954,
Galería del Pasaje Pam, Local 26
Planta Baja. Rosario
www.peccataminuta.com
info@peccataminuta.com

Rayo Rojo
Av. Santa Fe 1670 Loc. 20-22
Buenos Aires
T: 00 54 11 4815 8351
F: 00 54 11 4633 3486
www.rayorojo.com.ar
rayorojo@mail.pccp.com.ar

Australia

Borders
Melbourne Central Latrobe St
Building,
Melbourne, VIC 300
T: 00 61 3 9663 8909
www.bordersstores.com

Borders
Sydney - Macquarie Centre
Shop 452, Macquarie Centre
North Ryde
New South Wales 2113
T: 00 61 2 9878 4322
www.bordersstores.com

Borders
Sydney - Skygarden
77 Castlereagh Street
Sydney
New South Wales 2000
T: 00 61 2 9235 2433
www.bordersstores.com

Borders
Shop 1007,
Westfield Garden Centre
Upper Mt. Gravatt QLD 4122
T: 00 61 7 3343 5544
www.bordersstores.com

Borders
162 Albert Street
Brisbane, Queensland 4000
T: 00 61 7 3210 1220
www.bordersstores.com

Canberra City Newsagency
83, Canberra City Newsagency
Canberra
T: 00 61 2 6248 6914

Dickson newsagency
6, Dickson Place
Dickson, Canberra
T: 00 61 2 6249 8135

Extra newsagency
HydePark Adelaide
Adelaide
T: 00 61 8 8271 5887

Gleebooks
49 Glebe Point Road
Glebe NSW 2037
T: 00 61 61 2 9660 2333
F: 00 61 61 2 9660 3597

Greville Street Bookstore
145 Greville Street
Prahran VIC 3181
T: 00 61 03 9510 3531
www.totaltravel.com.au

Kingston Newsagency
66-68 Giles Street
Kingston
T: 00 61 2 6295 9132

Mag Nation
88, Elizabeth St.
Melbourne VIC 3000
T: 00 61 3 9663 6559
F: 00 61 3 9663 2197
www.magnation.com.au
info@magnation

Manuka Newsagency
38, Franklin Street
Manuka
T: 00 61 2 6295 9703
F: 00 61 2 6295 6491

Melbourne - Uni Bookshop

P O Box 4144,
The University of Melbourne
Victoria 3052
T: 00 61 3 8344 4088
F: 00 61 3 8344 4089
www.bookshop.unimelb.edu.au
bookshop-info@unimelb.edu.au

Museum of Contemporary Art

140 George Street
The Rocks
Sydney
T: 00 61 2 9245 2400
F: 00 61 2 9241 6634
www.mca.com.au
mail@mca.com.au

National Galerie of Australia

Parkes Place,
Parkes ACT 2600
GPO Box 1150
Canberra ACT 2601
T: 00 61 2 6240 6530
www.nga.gov.au
RLR@nga.gov.au

National Gallery of Victoria

Federation Square,
Melbourne, VIC 8004
T: 00 61 3 8620 2222
F: 00 61 3 8620 2555
www.ngv.vic.gov.au
enquiries@ngv.vic.gov.au

Nivenclarke PTY Limited

Shop 50A Westfield S/Town
Belconnen, Canberra
T: 00 61 2 6251 7177

Powerhouse Museum

PO Box K346,
Haymarket
NSW 1238 Sydney
T: 00 61 2 9217 0111
www.powerhousemuseum.com

Published Art

Shop 2, 23-33 Mary Street
Surry Hills NSW 2010
T: 00 61 2 9280 2839
F: 00 61 2 9280 2841
www.publishedart.com.au
mail@publishedart.com.au

Southlands Newsagency

Shop 6, Southlands S/Centre
Mawson, Canberra
T: 00 61 2 6286 3811

The Queensland Art Gallery

PO Box 3686
South Brisbane
Queensland 4101
T: 00 61 7 3840 7303
F: 00 61 7 3844 8865
www.qag.qld.gov.au

Top News

Shop G69, Woden Plaza S
ACT Phillip

Austria

Buchhandlung ALEX

Hauptplatz 17
4020 Linz
T: 00 43 732 78 24 40
alex.projects.at
alex@demut.at

Buchhandlung Hugo Frick

Nauklerstraße 7
72074 Tübingen
T: 00 49 7071 22554
F: 00 49 7071 21650
www.frick-buecher.de
Info@Frick-Buecher.de

Buchhandlung Tyrolia

Maria-Theresien-Str. 15
6010 Innsbruck
T: 00 43 512 2233 0
F: 00 43 512 2233 444
www.tyrolia.at
innsbruck@tyrolia.at

Moser

Am Eisernen Tor 1, 8010 Graz
T: 00 43 316 83 01 10
F: 00 43 316 83 01 10 20
www.buchmoser.at
buchmoser@morawa-buch.at

Prachner im Museumsquartier

Museumsplatz 1
1070 Wien
T: 00 43 1 512 85 88 0
F : 00 43 1 512 85 88 18
mq@prachner.at

Belgium

All Magazines

Plezantstraat 245
9100 Sint-Niklaas
T: 00 32 3 766 67 64
F: 00 32 3 777 10 87

Alice Gallery

182 rue Antoine Dansaert
1000 Brussels
T: 00 32 25 13 33 07
F: 00 32 25 13 33 07
www.alicebxl.com

Arts Press

Rue Ravenstein 2D
1000 Bruxelles
T: 00 32 2 512 82 23

Copyright Bookshop

Natinalstraat 28a
2000 Antwerpen
T: 00 32 3 232 94 16
F: 00 32 3 233 31 73
www.copyrightbookshop.be
info@copyrightbookshop.be

Copyright Bookshop

Jakobijnenstraat 8
9000 Gent
T: 00 32 9 223 57 94
F: 00 32 9 233 31 73
www.copyrightbookshop.be
info@copyrightbookshop.be

Epicerie audiovisuelle

Rue Antoine Dansaert
1000 Brussels

Filigranes

Avenue des Arts 38
1040 Etterbeek
T: 00 32 2 511 90 15
F: 00 32 2 502 24 68
www.filigranes.be
info@filigranes.be

Ideabooks

Nieuwe Herengracht 11
1011 RK Amsterdam

IMS

Diestsestraat 115
3000 Leuven
T: 00 32 1 629 54 34

Librairie des Pagodes

Avenue des Pagodes 146
1020 Laken
T: 00 32 2 241 10 48

Librarie de Rome

Rue Jean Stas 16A
1060 Saint-Gilles
T: 00 32 2 511 79 37
F: 00 32 2 511 51 60
librairiederome@skynet.be

Peinture fraîche

10, rue du Tabellion
1050 Bruxelles
T: 00 32 2 537 1105
F: 00 32 2 534 65 87

Studio Spazi Abitati

55, Av de la Constitution
1080 Bruxelles
T: 00 32 2425 50 04
F: 00 32 2 425 30 22
studiospaziabitati@yahoo.fr

Brazil

FNAC
Avenida Paulista 901
Bela Vista, Sao Paulo
T: 00 55 11 2123 2000
www.fnac.com.br

FNAC
Praca dos Omaguas, 34
Pinheiros S - Sao Paulo
T: 00 55 11 4501 3000
www.fnac.com.br

FNAC
AV. Guilherme Campos, 500
LOJA A-017
Santa Generba - Campinas
T: 00 55 19 2101 2000
www.fnac.com.br

Canada

Chapters
various locations
www.indigo.ca

Le Bureauphile
librairie de l'UQAM
(Université du Québec à
Montréal)
Case postale 8888,
succursale Montréal,
Québec H3C 3P8
T: 00 1 514 987 6151
www.bureauphile.uqam.ca
magasin@uqam.ca

Le Point Vert
4040, boul. Saint-Laurent
Montréal,
Québec H2W 1Y8

Les Maisons de la presse internationale
8155, rue Larrey
H1J 2L5 Anjou,Québec

Librairie Renaud-Bray/Champigny
4380, rue St-Denis
Montréal, H2J 2L1
T: 00 1 514 844 2587
www.renaud-bray.com
admin@renaud-bray.com

Librairie Olivieri du Musée d'art Contemporain
185, rue Sainte-Catherine Ouest
Montréal, Québec H2X 3X5
T: 00 1 514 847 6903
www.macm.org

Multimags
3552 boul. Saint-Laurent
Montréal, QC H2X 2V1
T: 00 1 514 287 7355
F: 00 1 514 287 7355

Musée d'art contemporain de Montréal
185, rue Ste-Catherine Ouest
Montréal, H2X 3X5
T: 00 1 514 847 6903

Olivieri, librairie Bistro
5219, chemin Côte-des-Neiges
Montréal, H3T 1Y1
T: 00 1 514 739 3639
F: 00 1 514 739 3630
rina.olivieri@librairieolivieri.com

Presse Commerce
825 Mont Royal Est Montréal,
QC H2J1W9

Richard Kidd
65 Water St.
Vancouver
www.richardkidd.net

Sophia Books
492 W. Hastingstreet ST.
Vancouver
T: 00 1 604 684 0484
www.sophiabooks.com

China

American Magazine and Book Co
100A Hak Po Street,
Mongkok, Kowloon Hong Kong

Ah Lo Magazine Co
No. 8 Theatre Lane,
Central Hong Kong
T: 00 852 2522 1787

Basheer Design Books(HK) LTD
1/F, Flat A, Island Building
439-441 Hennessy Road
Causeway Bay
Hong Kong
T: 00 852 21267533
F: 00 852 21267535
www.basheergraphic.com
basheer@netvigator.com

Cosmos Books
B/F and 1/F, 30, Johnston Road
Wan Chai, Hong Kong
T: 00 852 28 66 1677
F : 00 852 25 293220
www.cosmosbooks.com.hk
info@cosmosbooks.com.hk

Page One
704-706, 7th Floor
Two Cainem Exchange
Square Hong Kong
www.pageonegroup.com

Page One
338, King's Road,
North Point, Hong Kong
T: 00 852 28 061028
F: 00 852 28 061808
www.pageonegroup.com

Czech Republic

Knihkupectvi Sedivy
Masarykova 6
602 00 Brno
T: 00 420 596617692
www.knihkupectvisedivy.cz
info@knihkupectvisedivy.cz

OC Futurum
Novinářská 6A
700 00 Ostrava
www.kanzelsberger.cz
ostrava_fut@kanzelsberger.cz

Denmark

Architegn
Norreport 16
8000 Aarhus C
T: 00 45 89 360225

Finland

Akateeminen Kirjiakauppa
Keskuskatu 1
Pohjoisesplanadi 39
00101 Helsinki
T: 00 358 9 121 41
www.akateeminen.com
tilaukset@akateeminen.com

Keski-Töölön Papierkauppa
Ruusulankatu 18
00250 Helsinki
T: 00 358 9 490 086
F: 00 358 9 490 080

Kiasma Store
Mannerheiminaukio 2
00100 Helsinki
T: 00 358 9 1733 6505
www.kiasma.fi
info@kiasma.fi

GUARARA IS REVOLUTION
OTHER NOISES FROM ASUNCIÓN, PARAGUAY

GUARARA IS A FREE
DISTRIBUTION KUATIA ÑE'Ẽ
ABOUT CULTURE AND SOCIALS
SUBJECTS, SINCE 2005.

MORE INFO & PDF DOWNLOAD AT:
WWW.GUARARA.ORG

INTERCHANGE!
SEND US YOUR MAG AND
WE'LL SEND YOU GUARARA
guarara@gmail.com

Myymälä 2

Uudenmaankatu 23
00100 Helsinki
T: 00 358 41 783 2327
www.myymala2.com
info@myymala2.com

Suomalainen kirjakauppa

Aleksanterinkatu 23
00100 Helsinki
T: 00 358 10 405 4200
F: 00 358 10 405 4201
www.suomalainenkk.fi
helsinki.aleksi@suomalainenkk.fi

Stockmann-Akateeminen

Keskuskatu 1
0100 Helsinki
T: 00 358 9 1214322
www.stockmann.fi

France

Artazart

83 quai de Valny
75010 Paris
T: 00 33 1 40 40 24 03
www.artazart.com
info@artazart.com

Bookstorming

18/20, rue de la Perle
75003 Paris
T: 00 33 1 4225 1558
F: 00 33 1 4225 1072
www.bookstorming.com
info@bookstorming.com
Marie de Jacquelot
m.dejacquelot@bookstorming.com

Corner shop

3, rue Saint-Paul
Paris 4ème

Espace My Monkey

15 rue du Faubourg
54000 Nancy
T: 00 33 3 83 37 54 08
F: espacemymonkey.com
contact@eypacemymonkey.com
press@colette.fr

Colette

213, rue Saint Honoré
75001 Paris
T: 00 33 1 42 61 74 46

Happy Home

76 Rue Francois Miron
75004 Paris

L'Arbre à Lettres

Rue du Faubourg Saint-Antoine
Paris 12ème
T: 00 33 1 43 31 74 08

L'art de rien

48, rue J-P Timbaud
75018 Paris
www.art-de-rien.com
info@art-de-rien.com

La Galerie d'Architecture

11, rue des Blancs Manteaux
75004 Paris
T: 00 33 1 49 96 64 00
F: 00 33 1 49 96 64 01
www.galerie-architecture.fr
mail@galerie-architecture.fr

La Hune

170, bd St-Germain
75006 Paris
T: 00 33 1 45 48 35 85

Librairie Flammarion Beaubourg

Centre Pompidou
Place Georges Pompidou
75004 Paris
T: 00 33 1 44 78 43 22
flammarion.centre@online.fr

Librairie Galerie du jour Agnès B.

44, Rue Quicampoix ,
75004 Paris
T: 00 33 1 44 54 55 90
www.galeriedujour.com

Librairie Palais de Tokyo

13, avenue du Président Wilson
75116 Paris

T: 00 33 1 4723 5401
F: 00 33 1 4952 0277
lalibrairie@palaisdetokyo.com
contact@palaisdetokyo.com

Librairie Yvon Lambert

108, rue Vieille du Temple
75003 Paris
T: 00 33 1 42 71 09 33
F: 00 33 1 42 71 87 47
www.yvon-lambert.com
librairie@yvon-lambert.com

L'œil du silence

91, rue des Martyrs
Paris

Mouvements Modernes

68, rue Jean-Jacques Rousseau
75001 Paris
T: 00 33 1 45080882
www.mouvementsmodernes.com
mouvementsmodernes@
wanadoo.fr

Surface to air

46 rue de l'Arbre Sec
75001 Paris
T: 00 33 1 49 27 04 54
surface2air.com
jeremie@surface2airparis.com

The Conran Shop

117, rue du Bac
Paris 6ème
T: 00 33 1 42 84 10 01
www.conranshop.fr

The Lazy Dog

2 Passage Thiere
75011 Paris
T: 00 33 1 58 30 94 76
www.thelazydog.fr
info@thelazydog.fr

Un regard Moderne

10 rue gît le Cœur
Paris

Ofr

30 rue Beaurepaire
75010 Paris
T: 00 33 1 42 45 72 88
www.ofrpublications.com
info@ofrpublications.com

Germany

Bretz Couture by Room Rules

2. OG
Grünstraße 15
40212 Düsseldorf
www.roomrules.com
hochscherf@roomrules.de

Bücher bogen

Potsdamer Str. 1
10785 Berlin
T: 00 49 30 26 11 090
www.buecherbogen.de
info@buecherbogen.de

Bücher bogen

Schloss Str. 1
14059 Berlin
T: 00 49 30 32 69 58 14
www.buecherbogen.de
info@buecherbogen.de

Buch and Kunst

Karlsruher Str. 83,
01189 Dresden
T: 00 49 351 402060
F: 00 49 351 4010337
www.buch-kunst.de
service@buch-kunst.de

Buchhandlung König

Ehrenstr 4
50672 Cologne
T: 00 49 221 20 59 60
F: 00 49 221 20 59 640
www.buchhandlung-walther-koenig.de
info@koppmedien.de

More information available at www.welovemags.com

Buchhandlung König

Im Martin Gropius Bau
Niederkirchnerstr. 7
10963 Berlin
T: 00 49 30 23 00 34 70

Buchhandlung König

Heinrich-Heine-Allee 15
40213 Düsseldorf
T: 00 49 211 13 62 11 0
F: 00 49 211 13 47 46
www.buchhandlung-walther-koenig.de
info@koppmedien.de

Buchhandlung von der Höh

Große Bleichen 21
22767 Hamburg
T: 00 49 40 34 63 88
F: 00 49 40 34 62 72
www.von-der-hoeh.de
mail@von-der-hoeh.de

Buchkaiser Gmbh

Kaiserstrasse 199
76133 Karlsruhe
T: 00 49 721 929 29 15
www.buchkaiser.de
werbun@buchkaiser.de

Deichtorhallen Hamburg

Deichtorstrasse 1-2
20095 Hamburg
T: 00 49 40 32 10 30
F: 00 49 40 32 10 3 230
www.deichtorhallen.de
mail@deichtorhallen.de

Gustav Weiland Nachf.

Ottensener Haupstr. 10,
22765 Hamburg
T: 00 49 3831 383638

HD Presse- und Buch

Hauptbahnhof
39104 Magdeburg
T: 00 49 391 543 268 9

Kopp Fachbuch-handlung

Kopp Fachbuch- und
Medienversand GmbH
Wilhelm-Röntgen-Str. 24-26
63477 Maintal
T: 00 49 6181 45075
F: 00 49 6181 94256
www.koppmedien.de

Konrad Wittwer

Am Hauptbahnhof 4
01069 Dresden
T: 00 49 0711 25 07 0
F: 00 49 711 25 07 145
www.wittwer.de

pro qm

Alte Schoenhauser Strasse 48,
10119 Berlin
T: 00 49 30 24728520
F: 00 49 30 24728521
info@pro-qm.de

Room rules Cologne

Hohenstaufenring 57A
50674 Cologne
T: 00 49 221 39 75 591
F: 00 49 221 39 75 729
www.roomrules.de
hochscherf@roomrules.de

Schaden

Burgmauer 10
50667 Cologne
T: 00 49 221 92 52 667
F: 00 49 221 92 52 669
www.schaden.com
books@schaden.com

soda

Baaderstrasse 74
80469 Munich
T: 00 49 089 20 24 53 53
www.sodabooks.com
info@sodabooks.com

Thalia Buchhandlung

Ballindamm 40
20095 Hamburg
T: 00 49 40 30 95 49 80
F: 00 49 40 3 09 54 98 10
www.service.thalia.de
spi@thalia.de

Thalia Buchhandlung

Spitalerstraße 8
20095 Hamburg
T: 00 49 40 48 50 10
F: 00 49 40 48 50 11 20
www.service.thalia.de
spi@thalia.de

The Corner

Französische Str. 40
10117 Berlin
T: 00 49 30 20 67 09 50
F: 00 49 30 206 70 951
www.thecornerberlin.de
mail@thecornerberlin.de

ZKM

Zentrum für Kunst und Medientechnologie
Museumsshop, Lorenzstrasse 19
76135 Karlsruhe
T: 00 49 721 81 00 12 50
www.zkm.de
mnk@zkm.de

Greece

Librairie Kauffmann

28, Stadiou St.
Athènes 105 64
T: 00 30 210 323 68 17
F: 00 30 210 323 03 20
www.kauffmann.gr
ord@otenet.gr

Molho

10, Tsimiski str.
Athens
T: 00 30 231 0 24 08 77
F: 00 30 231 0 22 97 38
molho@imagine.gr

Hungary

D2K

Ó u. 19. Contct
1066 Budapest
T: 00 36 1 331 4931
www.d2k.hu
andrea@d2k.hu
contact: Mrena Andrea

Forma

Ferenciek tere 4
1056 Budapest
T: 00 36 1 266 5053
www.forma.co.hu
fugerth@forma.co.hu
contact: Fugert András

Irok boltja

Andrassy ut 45
1061 Budapest
T: 00 36 1 322 1645
00 36 1 342 4336

Maison des photographes hongrois

Nagymező utca 20
1065 Budapest
T: 00 36 1 473 2666
F: 00 36 473 2662
www.maimano.hu
maimano@maimano.hu

Retrock de Luxe

Henszlmann I. u. 1
1053 Budapest
www.retrock.com
retrocker@gmail.com

Retrock ruhabolt

Ferenczy István u. 28
V. Budapest
T: 00 36 30 678 8430
www.retrock.com
retrocker@gmail.com

Vince Könyvesbeolt

Kristtina krt. 34
1013 Budapest
T: 00 36 1 3757682

Indonesia

Basheer Graphic Books

4.02 Plaza Blok M
Jalan Bulungan
Jakarta - 12130
T: 00 62 21 7209151
F: 00 62 21 7209151
www.basheergraphic.com

Italy

A+M Bookstore
Via Tadino 30
20124 Milano
T: 00 39 229527729
www.artecontemporanea.com
info@artecontemporanea.com

Armani Libri
Via Manzoni 31
20121 Milano

Armani Press
Via Borgonuovo 11
Milano
T: 00 39 2723181
F: 00 39 2 72318450
www.armani-viamanzoni31.com

Art Book Triennal
Viale Alemagna 6,
20121 Milano
www.artbooktrienale.com

Bookshop Palazo Delle Papesse
Via Di Citta 126,
53100 Siena
T: 00 39 577 220726
F: 00 39 577 42039
www.papesse.org
info@radiopapesse.org

Fashion Room Bari
Via Roberto da Bari, 6
70122 Bari
T: 00 39 80 5283595
F: 00 39 80 5751033
www.fashionroom.it
info@fashionroom.it

Fashion Room Florence
Via dei Palchetti 3/3a
50123 Firenze
T: 00 39 55 213270
F: 00 39 55215802
www.fashionroom.it
info@fashionroom.it

Feltrinelli bookshops
Via Ugo Foscolo 1/3
20121 Milano
T: 00 39 2 7529151
F: 00 39 2 74815339
www.lafeltrinelli.it

Ferro di cavallo bookshop
Via Ripetta 67
00186 Roma

Fondazione Sandretto Re Rebaudengo
Via Modane 16
10141 Torino
T: 00 39 11 3797600
F: 00 39 11 3797601
www.fondsrr.org

Interno 4 / Modo Info Shop
Via Mascarella 24/b
40126 Bologna
T: 00 39 51 5871012
www.modoinfoshop.com
info@modoinfoshop.com

Libreria d'arte della GAM
Via Magenta 31
10128 Torino
T: 00 39 11 44 296 10
F: 00 39 11 442 95 50
www.fondazionetorinomusei.it
info@fondazionetorinomusei.it

Librerie Feltrinelli
Via Roma, 80
10121 Torino (TO)
T: 00 39 11530869

Libreria Internazionale Ulrico Hoepli
Via Hoepli 5
20121 Milano
T: 00 39 2 864871
F : 00 39 02 72093700
www.hoepli.it
libreria@hoepli.it

Libreria Luxemburg
Via Cesare Battisti, 7
10123 Torino
T: 00 39 11 56 13896
F: 00 39 11 54 0370
www.librerialuxemburg.com
info@librerialuxemburg.com

Milano Libri
Via Verdi 2 (Piazza della Scala),
20121 Milano

MEL Bookstore
Via Nazionale 254-255,
00184 Roma
T: 00 39 06 4885405
F: 00 39 6 4885433
www.melbookstore.it
melromainfo@melbookstore.it

Mondo Bizzarro
(gallery and bookshop)
Via Reggio Emilia 32 c/d
00198 Roma
T: 00 39 6 44247451
F: 00 39 6 44247451
www.mondobizzarro.net
info@mondobizzarro.net

View on Trends
Via del Molinuzzo, 97
59100 Prato
T: 00 39 574 623112
F: 00 39 574 623112
www.viewontrends.it
info@viewontrends.it

Japan

Art Logos
B1F Parco Part 1
3496-7362 Tokyo

Athens
Shinsai-bashi, Osaka
www.athens.co.jp

Book first
Shibuya, Tokyo
www.book1st.net

café and books bibliotheque
Umeda, Osaka
T: 00 81 6 4795 7553
www.cporganizing.com/bibliotheque/osaka/index.html

Cow Books
1-14-11 Aobadai Meguroku, Tokyo
www.cowbooks.jp
staff@cowbooks.jp
Open: PM12:00-PM9:00
Closed: Wednesday

Keibunsha
10 Haraitono-cho Ichijoji
Sakyoku Kyoto
T: 00 81 3 5786 7420
www.keibunsha-books.com

Keibunsha
Ichi-jyoji, Osaka
T: 00 81 75 711 5919
F: 00 81 75 711 5919
www.keibunsha-books.com
info@keibunsha-books.com

Libro Parco Part I
15-1 Udagawa-cho
Shibuya Tokyo
www.libro.jp

Logos Tokyo
www.libro.jp/web/logos/index.html

On Sundays
3-7-6 Jingumae
Shibuya Tokyo
www.watarium.co.jp/onsundays
onsundays@watarium.co.jp

Nadiff
15-1 Udagawa-cho
Shibuya Tokyo
www.nadiff.com
artshop@nadiff.com

SuperDeluxe
B1F 3.1.25 Nishi Azabu,
Minato-ku, Tokyo 106-0031
T: 00 81 3 5412 0515
F: 00 81 3 5412 0516
www.super-deluxe.com

Tsutaya Tokyo Roppongi

Roppongi Hills 6-11-1
Roppongi, Minato-Ku
Tokyo 106-0032

Yohan Akasaka Community Bldg

6F Minato Ku 1-1-8
Moto Akasaka Tokyo 107-0051
Yurindo Ebisu
1-5-5 Ebisu-Minami, Shibuya-ku
150-0022 Tokyo
T: 00 81 54 75 8384
F: 00 815475-8389

Korea

World Magazine

PO Box 109/Seochu-ku,
137-897 Séoul
T: 00 82 2 31 81 6922

Luxembourg

Fellner Art Books

32, rue de l'Eau
1449 Luxembourg
T: 00 352 22 04 21
www.fellnerbooks.com
Contact: Hans Fellner

Malaysia

Basheer Graphic Book Sdn.Bhd

Third Floor 001, Bukit Bintang
Plaza, Jalan Bukit Bintang
Kulala Lumpur 55100
T: 00 603 2173 2236
F: 00 603 21432236
www.basheergraphic.com
bgbooks@tm.net.my

Borders

Berjaya Times Square
Kuala Lumpur 55100
T: 00 60 2141 0288
F : 00 60 2144 5037
www.bordersstores.com

Borders

The Curve, No. 6 Jalan PJU
Petaling Jaya,
Selangor 47800
T: 00 60 7725 9303
F: 00 60 7722 5037
www.bordersstores.com

Borders

Queensbay Mall Shopping
Centre,
Bayan Lepas Penang 11900
www.bordersstores.com

Shelf

Ayoma, Tokyo
T: 00 81 3 3405 7889
www.shelf.ne.jp

Shimada Yosho

T-PLace 5-5-25
Minami-Aoyama, Minato-Ku
Tokyo 107-0062
www.b-info.jp/shimadayosho

Netherlands

American Book Center

Spui 12
1012 XA Amsterdam
T: 00 31 20 625 55 37
F: 00 31 20 624 80 42
www.abc.nl
info@abc.nl

American Book Center

Lange Poten 23
2511 CM Den Haag
T: 00 31 70 364 27 42
F: 00 31 70 365 65 57
www.abc.nl
dh@abc.nl

Athenaeum Boekhandel

Spui 14-16
1012 XA Amsterdam
T: 00 31 20 5141 460
F: 00 31 20 6384 901
www.athenaeum.nl
info@athenaeum.nl

Athenaeum Nieuwscentrum

Spui 14-16
1012 XA Amsterdam
T: 00 31 20 5141 470
F: 00 31 20 6384 901
www.athenaeum.nl
nieuwscentrum@athenaeum.nl

Athenaeum Boekhandel

Dr. Meurerlaan 6
1067 SM Amsterdam
T: 00 31 20 5141 47
www.athenaeum.nl
dml@athenaeum.nl

Athenaeum Boekhandel

Wibautstraat 80-84
1091 GK Amsterdam
T: 00 31 20 5488 175
www.athenaeum.nl
janbommerhuis@athenaeum.nl

Athenaeum Boekhandel

Wenckebachweg 144-148
1096 AR Amsterdam
T: 00 31 20 5995 553
www.athenaeum.nl
wenckebachweg@athenaeum.nl

Athenaeum Boekhandel

James Wattstraat 77-79
1097 DL Amsterdam
T: 00 31 20 5952 810
www.athenaeum.nl
jameswatt@athenaeum.nl

Athenaeum Boekhandel

Ged. Oude Gracht 70
2011 GT Haarlem
T: 00 31 23 5318 755
F: 00 31 23 5322 603
www.athenaeum.nl
haarlem@athenaeum.nl

Premsela

Prinses Irenestraat 19
1077 WT Amsterdam
T: 00 31 20 34 49 449
F: 00 31 20 34 49 443
www.premsela.org
secretariaat@premsela.org

Nijhof and Lee

Staalstraat 13a
1011 JK Amsterdam
T: 00 31 20 6203 980
F: 00 31 20 6393 294
www.nijhoflee.nl

Scheltema Holkema

Koningsplein 20
1017 BB Amsterdam
T: 00 31 20 6227 684
www.selexyz.nl

Poland

Cafe Szpulka

Pl. Trzech Krzyzy 18
00-950 Warsaw
T: 00 48 628 91 32
www.mlask.home.pl

Centre for Contemporary Art

Ujazdowski Castle
Al. Ujazdowskie 6
00-461 Warsaw
T: 00 48 22 628 12 71 3
F: 00 48 22 628 95 50
www.csw.art.pl
csw@csw.art.pl

Centrala Handlu Zagranicznego "Ars Polona"

Krakowskie Przedmielcie 7,
00-068 Warszawa
T: 00 48 22 826 12 01
F: 00 48 22 826 62 40
ars_pol@bevy.hsn.com.pl

Faktoria Club

Rzemieslnicza 26
81-855 Sopot
T: 00 48 58 555 00 86
F: 00 48 600 447 369
www.faktoria.net
klub@faktoria.net

Galeria dla...

Browarna 6, NRD Club
Torun
T: 00 48 501 23 26 84
www.galeriadla.art.pl
weychert@poczta.onet.pl

Główna Ksilgarnia Naukowa im. Boleslawa Prusa

Krakowskie Przedmiescie 7
00-068 Warszawa
T: 00 48 22 826 18 35
www.gkn-prus.com.pl
gkn@gkn-prus.com.pl

Korporacja Ha!art

Pl. Szczepalski 3a
31-011 Kraków
T: 00 48 12 4228198
F: 00 48 12 4228198
www.ha.art.pl

Ksilgarnia Naukowa "Resursa"

ul. Krakowskie Przedmielcie 62
00-322 Warszawa
T: 00 48 22 828 18 16

Ksilgarnia Uniwersytetu Mikolaja

Kopernika w Toruniu
87-100 Toruniu, ul. Reja 25
T: 00 48 56 14 298
F: 00 48 56 14 298
www.cc.uni.torun.pl

Orpan

Plac Defilad 1 (PKiN),
Warszawa
T: 00 48 22 656 65 13

Studio BWA

ul. Ruska 46 a
50-079 Wroclaw,
T: 00 48 71 781 55 02
www.bwa.wroc.pl
sekretariat@bwa.wroc.pl

Traffic

ul. Bracka 25
00-028 Warszawa
T: 00 48 22 69 21 888
www.traffic-club.pl
kontakt@traffic-club.pl

Zoo Gallery

Krakowskie Przedmiescie, 17
Warsaw
T: 00 48 22 656 65 13

Portugal

Ananana

Travessa Água da Flor, 29
Bairro Alto
1200-010 Lisbon
T: 00 351 213 474770
F: 00 351 213 240059
www.ananana.pt
info@ananana.pt

Assirio and Alvim

R. Frei Miguel Contreiras. Edif.
Cinema King
1900 Lisbon
T: 00 351 21 847 99 92

Barata

Av. de Roma, 11
A-D1000 Lisbon
T: 00 351 21 848 16 31
F: 00 351 21 80 33 44

Bibliofila

R. Misericórdia, 102
1200 Lisbon
T: 00 351 21 346 34 76

Bisturi (sede)

Rua Helena Félix 7
B1600-121 Lisbon
T: 00 351 21 79 70 017
bisturi.shopping.sapo.pt
bisturi@net.sapo.pt

Bisturi Porto

Rua Mestre Guilherme
Camarinha 49 B 4200-537 Porto
T: 00 351 22 01 30107
bisturi.shopping.sapo.pt
bisturicoimbra@sapo.pt

Bisturi Outlet

Rua Sanches Coelho nº2
1600 Lisbon
T: 00 351 21 7971256
bisturi.shopping.sapo.pt
bisturioutlet@sapo.pt

Bisturi Leiria

Campus 2 do Inst. Politécnico
Leiria, Morro do Lena,
Alto do Vieiro
2400-441 Leiria
T: 00 351 24 48 5272
bisturi.shopping.sapo.pt
bisturi.leiria@sapo.pt

Buchholz

R. Duque Palmela, 4
1000 Lisbon
T: 00 351 21 315 73 58

Distri Lojas

R. Vasco da Gama, 4/4 A
2685 - Sacavem
T: 00 351 21 940 65 00
F: 00 351 21 942 59 90

Distri Cultural

R. Vasco da Gama, 4
4 A2685 Sacavem
T: 00 351 21 942 53 94
F: 00 351 21 941 98 93

Ler Devagar

Rua da Rosa, 277 - 1º
Bairro Alto. Lisbon
T: 00 351 21 325 9992
F : 00 351 21 325 9994
www.lerdevagar.com

Livraria Almedina

Rua de Entrevinhas
Lote 2A
Pragueira - Eiras
3020-171 Coimbra
T: 00 351 239 436 266
F: 00 351 239 436 267
www.almedina.net
vendas@almedina.net

Livraria Barata

Av. Roma, 11A
1049-047 Lisbon
T: 00 351 218 428 350
F: 00 351 218 428 366
www.livrariabarata.pt

Livraria Britânica

R. Luís Fernandes, 14/8
1200 Lisbon
T: 00 351 21 342 84 72
F: 00 351 21 347 82 09

Librairie Française

Av. Marquês de Tomar, 38
1050 Lisbon
T: 00 351 21 795 68 66

Livraria São Bento 34

R. S. Bento, 34
1200 Lisbon
T: 00 351 21 395 15 40
F: 00 351 21 395 15 41

20:21:33 monika zawadzka (GG# 2106997)
somebody keeps calling and I'm setting up the logotypes
20:21:37 monika zawadzka (GG# 2106997)
oki?
20:21:41 karol radziszewski (GG# 6633009)
ok
20:21:50 monika zawadzka (GG# 2106997)
tomorrow it'll be over
20:21:58 karol radziszewski (GG# 6633009)
ok
20:22:09 monika zawadzka (GG# 2106997)
now I feel like nobody's home
20:22:18 karol radziszewski (GG# 6633009)
allright, we'll come back to this tomorrow
20:22:18 karol radziszewski (GG# 6633009)
bye
20:22:22 monika zawadzka (GG# 2106997)
:)
20:22:27 monika zawadzka (GG# 2106997)
don't be angry with me :)
20:23:32 karol radziszewski (GG# 6633009)
i'm not angry, common
20:23:36 karol radziszewski (GG# 6633009)
:)
20:23:39 monika zawadzka (GG# 2106997)
good, good
20:23:52 karol radziszewski (GG# 6633009)
i've also plenty of things on my head
20:23:54 karol radziszewski (GG# 6633009)
and I'm confused
20:24:03 monika zawadzka (GG# 2106997)
:)

www.vipzin.com

VIP ZIN is very limited photo-documentary magazine made by 2 artists from Poland - Karol Radziszewski & Monika Zawadzka.
"We don't cooperate with anybody. VIP room is where we are."

Matériaprima

Rua Miguel Bombarda, 457
4050-382 Porto
T: 00 351 2260 66 131
F :00 351 2260 66 134
www.materiaprima.pt
materiaprima@materiaprima.pt

Ponto de Encontro

Shopping Imaviz, Lj. 21/22
1000 Lisbon
T: 00 351 21 357 58 14

Valentim de Carvalho

C. C. Belém,
Pç do Império, lj. 8
1300 Lisbon
T: 00 351 21 362 48 15

Valentim de Carvalho

Pç. D. Pedro IV, 59
1100 Lisbon
T: 00 351 21 342 58 95

Romania

Carturesti Bookshop

13 Arthur Verona Str.
1 Bucharest
T: 00 40 21 317 34 59
F: 00 40 721 518 351
www.carturesti.ro
info@carturesti.ro

Humanitas

Casa Presei Libere,
Corp C, 1st Floor
1 Bucharest
T: 00 40 21 311 23 30
F: 00 40 21 313 50 35
www.humanitas.ro
www.librariilehumanitas.ro
cpp@humanitas.ro

Inmedio

9-9A Dimitrie Pompei,
10 building
020335 Bucharest
T: 00 40 743 31 31 77
T :00 40 31 407 82 38
www.inmedio.ro
office@hdsnet.ro

Singapore

Basheer Graphic Books

231 Bain Street,
#04-19 Bras Basah Complex,
Singapore 180231
T: 00 65 6336 0810
F: 00 65 6334 1950
www.basheergraphic.com
enquiry@basheergraphic.com
abdul@basheergraphic.com

Bugis Junction Store

200 Victoria Street
#03-09/12 Bugis Junction
Singapore 188021

Kinokuniya Books

391B Orchard Road
#13-06/08 Ngee Ann City
Tower B
Singapore 238874
T: 00 65 6276 5558
F: 00 65 6276 5570
www.kinokuniya.com.sg
SSO@kinokuniya.co.jp

Liang Court Store

177C River Valley Road
#03-50 Liang Court
Singapore 179036
T: 00 65 6337-1300
F: 00 65 6338 1278

Singapore Main Store

391 Orchard Road Ngee Ann City
#03-10/15 Takashimaya
Shopping Centre
Singapore 238872
T: 00 65 6737 5021
F: 00 65 6738 0487

Spain

Anti bookshop

C\ Dos de Mayo n°2
48003 Bilbao
T: 00 34 944 150375
F: 00 34 944 150375
www.anti-web.com/web/index.php

Binario

C/ Iparraguirre, 9 bis Barcelona
T: 00 34 944 242 391
F: 00 34 944 242 354
www.binariolibros.com
tienda@binariolibros.com

Chopper Monster

C/ Corredera Alta de San Pablo,
21 Madrid
T: 00 34 914 458 434

Extasis

C/ Fuencarral, 45 (Local-11)
Madrid
T: 00 34 915215021

Fnac Callao

C/ Preciados, 28
28013 Madrid
T: 00 34 915 956 200
www.fnac.es
callao@fnac.es

Fnac L´Illa

Centro comercial L´Illa
Avenida Diagonal, 549
08029 Barcelona
T: 00 34 934 445 900
www.fnac.es
illa@fnac.es

Fnac Plaza de España

C/ Coso, 25
50011 Zaragoza
T: 00 34 976 763 50
www.fnac.es
pzaespana@fnac.es

Fnac San Agustín

C/ Guillén de Castro, 9-11
46007 Valencia
T: 00 34 963 539 001
www.fnac.es
sanagustin@fnac.es

Graphicook

C/ La Palma, 50 Madrid
T: 00 34 915 210019

Hontza Bookshop

Okendo, 4
20004 Donostia
T: 00 34 943 428289
F: 00 34 943 422363
hontzaliburu@euskalnet.net

La Central del Raval

C/ Elisabets, 6
08001 Barcelona
T: 00 34 933 170 293
F: 00 34 933 189 979
www.lacentral.com

La Central

C/ Mallorca, 237. 08008
Barcelona
T: 00 34 934 875 018
F : 00 34 934 875 021
www.lacentral.com

LAIE CCCB

Montalegre 5
08001 Barcelona
T: 00 34 93 48 13 886
laiecccb@laie.es

Librería Kowasa, S.L.

Mallorca , 235, Bajos
08008 - Barcelona
T: 00 34 93 215 80 58
F: 00 34 93 215 80 54
www.kowasa.com
info@kowasa.com

Libreira Ras

Doctor Dou 10
08001 Barcelona
T: 00 34 93 412 71 99
www.rasbcn.com
ras@rasbcn.com

Loring Art

Garvina 7
08001 Barcelona
T: 00 34 93 412 01 08
F: 00 34 93 412 41 87
www.loring-art.com
info@loring-art.com

Madrid Comics

Calle Silva 17
Madrid
T: 00 34 915 591602
www.madridcomics.com

Mercado del borne

Calle Rec 37-39
08003 Barcelona
www.mercadodelborne.com
info@mercadodelborne.com

Panta-rhei

C. Hernán Cortés 7
28004 Madrid
T: 00 34 91 319 89 02
panta-rhei.es
info@panta-rhei.es

SNAPO

Calle Espiritu Santo 5
Madrid
T: 00 34 915 321223

Subaquatica

c/ Caballero de Gracia 9
28013 Madrid
T: 00 34 91 521 84 15
www.subaquatica.com

Triburbana

Calle Bordadores 6
Madrid
T: 00 34 913 652147

Vallery

Calabria, 85
08015 Barcelona
T: 00 34 34935396430
www.vallery.es

Switzerland

Archigraphy

1, Place de Lille
1204 Genève
T: 00 41 22 311 60 08

Presse-Kiosk

Main Station
Zurich
www.railcity.ch
www.kiosk.ch
info@kiosk.ch

Sweden

Malmö Konsthall

S:t Johannesgatan 7
Box 17 127
200 10 Malmö
T: 00 46 40-34 12 93
www.konsthall.malmo.se
bookstore.konsthall@malmo.se

Press Stop Götgatan

Götgatan 31
116 21 Stockholm
www.press-stop.se

Taiwan

Basheer Graphic Books

998/7 Soi Sukhumvit 55
Sukhumvit Street, Wattana
Bangkok - 10110
T: 00 66 2 3919815
F: 00 66 2 3919814
www.basheergraphic.com
basheer_th@hotmail.com

Eslite Duennan Branch

#245, Sec. 1, Duenhua S. Road
Taipei, 106

Page One

4Fl, No.45, Shi Fu Rd
Sin Yi District, Taipei

Turkey

Robinson Crusoe

Beyoglu Istiklal Street 389
34433 Beyoglu Istanbul
T: 00 90 212 293 69 68
www.eslitebooks.com

United Kingdom

Analogue

102 West Bow
Edinburgh EH1 2HH
T: 00 44 131 220 0601
www.analoguebooks.co.uk
bursts@analoguebooks.co.uk

Artwords Bookshop

65a Rivington Street
London EC2A 3QQ
T: 00 44 20 7729 2000
F: 00 44 20 7729 4400
www.artwords.co.uk
shop@artwords.co.uk

Atlantis European

7-9 Plumber's Row,
London, E1 1EQ
T: 00 44 20 7377 8855
F: 00 44 20 7377 8850
www.atlantisart.co.uk

Beast

No. 5 Back Hill
London EC1R 5EN
T: 00 44 207 833 55 44
www.bestshopever.com
info@bestshopever.com

Blackwell

50 Broad Street
Oxford OX1 3BQ
T: 00 44 1865 792792
F: 00 44 1865 791438
bookshop.blackwell.co.uk
mail.ox@blackwell.co.uk

Bond International

17 Newburgh Street
London WIF 7RZ
T: 00 44 20 7437 0079
F: 00 44 20 7494 3692
www.bond-international.co.uk
mail@bondinternational.com

Borders

Stillerman House
120 Charing Cross Road
London WC2H 0JR
T: 00 44 207 379 7313
www.bordersstores.co.uk

Bug Vinyl

PO Box 227
Beverley
HU17 6AG
www.bugvinyl.com
sales@bugvinyl.com

Camden Arts Centre

Arkwright Road
London NW3 6DG
T: 00 44 20 7472 5500
F: 00 44 20 7472 5501
www.camdenartscentre.org
info@camdenartscentre.org

Canonbury Art Shop

65 Halliford Street
Islington N1 3HF
T: 00 44 20 7226 4652
www.canonburyarts.co.uk
sc@canonburyarts.co.uk

Cornerhouse

70 Oxford Street
Manchester M1 5NH
T: 00 44 161 228 7621
www.cornerhouse.org
info@cornerhouse.org

Design Museum

Shad Thames
London SE1 2YD
T: 00 44 870 909 9009
F: 00 44 870 909 9009
www.designmuseum.org
info@designmuseum.org

Foyles

113-119 Charing Cross Road
London WC2H 0EB
T: 00 44 20 7437 5660
F: 00 44 20 7434 1574
www.foyles.co.uk
customerservices@foyles.co.uk

Foyles

Riverside, Level 1
Royal Festival Hall
London SE1 8XX
T: 00 44 20 7437 5660
F: 00 44 20 7981 9739
www.foyles.co.uk
customerservices@foyles.co.uk

Ian Shipley Design

70 Charing Cross Road
London WC2H 0BB
T: 00 44 207 836 4872
F: 00 44 44 207 379 4358
www.artbook.co.uk
sales@artbook.co.uk

Magma Clerkenwell

117-119 Clerkenwell Road
London EC1R 5 BY
T: 00 44 20 7242 9503
F: 00 44 20 7242 9504
www.magmabooks.com

Magma Covent Garden

8 Earlham Street
Covent Garden
London WC2H 9RY
T: 00 44 20 7240 8498
www.magmabooks.com

Magma Manchester

22 Oldham Street
Northern Quarter
Manchester M1 1JN
T: 00 44 161 236 8777
www.magmabooks.com

Owl Bookshop

207-209 Kentish Town Road,
London NW5 2JU
T: 00 44 20 7485 7793

R D Franks

T: 00 44 207 636 1244
F: 00 44 207 436 4904
www.rdfranks.co.uk
kirsty@rdfranks.co.uk

Tate Modern

Millbank
London SW1P 4RG
T: 00 44 20 7887 8888
www.tate.org.uk/modern/
visiting.modern@tate.org.uk

THESE Records

112 Brook Drive
London SE11 4TQ
www.theserecords.com
these@theserecords.com

The Institute of Contemporary Arts (ICA)

12 Carlton House Terrace
The Mall,
London SW1Y 5AH
T: 00 44 207 7661 452
www.ica.org.uk

The Triangle Bookshop

36 Bedford Square
London WC1B 3JW
T: 00 44 20 7631 1381

Walther Koenig Books

At the Serpentine Gallery
Kensington Gardens
London W2 3XA
T: 00 44 20 7706 4907
F: 00 44 20 7706 4911
www.buchhandlung-walther-
koenig.de
info@koenigbooks.co.uk

Waterstones

Capital Court
Capital Interchange Way
Brentford
Middlesex TW8 0EX
T: 00 44 870 429 5858
www.waterstones.com

0fr

91 Brick Lane / 15 Hanbury Street
London E1 6QL
Liverpool Station
T: 00 44 207 053 2235
www.ofrpublications.com
info@ofrpublications.com

Uruguay

Antigona

Avda. A. Arocena 1680
Montevideo
T: 00 598 2 601 76 51

Ibana

Convención 1483
Montevideo
T: 00 598 2 903 24 85
ibana@adinet.com.uy

United States

Around the World

28 W. 40th St.,
New York NY 10001
T: 00 1 212 5758543

Casa Magazine

22 8th Ave,
New York NY 10014
T: 00 1 212 645 1197

Alpha

8623 Melrose Ave
Los Angeles, CA 90069

Barnes and Noble Booksellers

4 Astor Place
New York, NY 10003
T: 00 1 212 420 1322
www.barnesandnoble.com

Barnes and Noble Booksellers

Greenwich Village
396 Ave of the Americas at
8th Street
New York, NY 10011
T: 00 1 212 674 8780
www.barnesandnoble.com

Barnes and Noble Booksellers

Union Square
33 East 17th Street
New York, NY 10003
T: 00 1 212 253 0810
www.barnesandnoble.com

Visit www.welovemags.com and help improve our database

Barnes and Noble Booksellers

106 Court Street
Brooklyn, NY 11201
T: 00 1 718 246 4996

BJ Magazines

200 Varrick Street
Between King and Houston
New York, NY

New Museum Bookshop

556 W. 22nd St.,
New York, NY 10001
T: 00 1 212 3430460
www.newmuseum.org/shop_info.
html
newmu@newmuseum.org

Olsson's Books

Reagan Washington National
Airport, Terminal C
Arlington, VA 20001
T: 00 1 703 417 1087
www.olssons.com

Olsson's Books

2200-G Crystal Drive
Arlington, VA 22202
T: 00 1 703 413 8121
www.olssons.com

Olsson's Books

1307 19th St., NW
Washington, DC 20036
T: 00 1 703 525 4227
www.olssons.com

Rocketship

208 Smith Street
Brooklyn, NY 11000
rocketshipstore.blogspot.com
stmarksbooks@mindspring.com

Spoonbill and Sugar town

218 Bedford Avenue
Brooklyn, NY 11000
T: 00 1 718 387 7322
www.Spoonbillbooks.com
sugar@spoonbillbooks.com

St. Marks Bookshop

31 Third Ave.,
New York NY 10003
T: 00 1 2122607853
F: 00 1 212 598 4950
www.stmarksbookshop.com
stmarksbooks@mindspring.com

Universal News

T: 00 1 2126471761
Various locations
Manhattan
New York
www.universalnewsusa.com

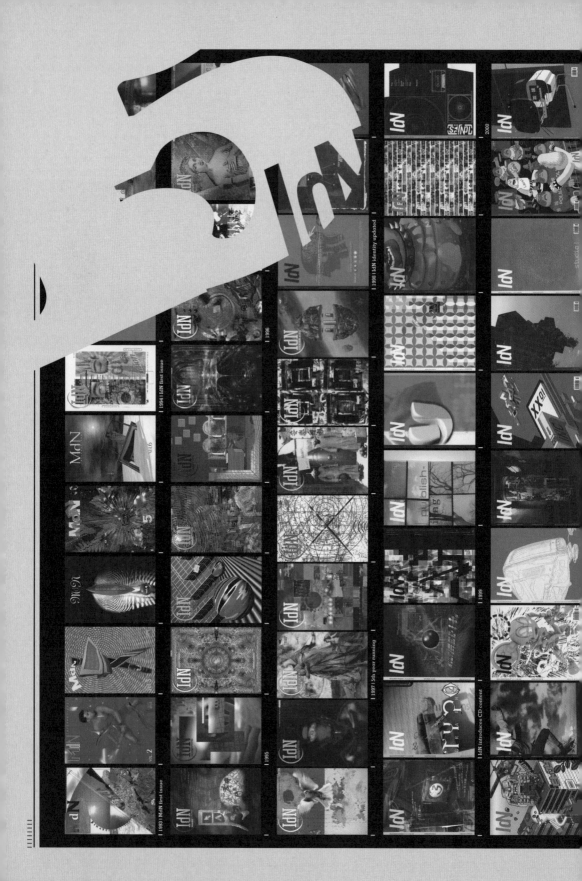

colophon

Colophon 2007 – International Magazine Symposium
Curators: Jeremy Leslie, Andrew Losowsky and Mike Koedinger

Produced by: Mike Koedinger in collaboration with Casino Luxembourg – Forum d'art contemporain within the framework of Luxembourg and Greater Region, European Capital of Culture 2007.

With the support of:

The book is printed in Luxembourg by Victor Buck on Tauro paper supplied by M-real.

The website www.welovemags.com has been developed by nVision, art directed by bizart and text editing by Mary Carey.

Book produced by John Brown. www.johnbrowngroup.co.uk
Exclusive worldwide distribution by Die Gestalten Verlag.
www.die-gestalten.de

Coordination: Ariane Petit, Rudy Lafontaine
Interns: Melodie Oralarkaya, Estelle Sidoni, Géraldine Grisey,
Anthony Magri

Thanks to: Nicolas Buck, Patricia Dolman, Enrico Lunghi, Mike
Sergonne and Raoul Thill for their very early engagement; The ten guest
magazines: Carl*s Cars, Coupe, Frame, Omagiu, Rojo, S-Magazine,
Shift!, Street/Fruits/Tune, thisisnotamagazine.com, Yummy; The
speakers: Lars Harmsen, Samir "Mr Magazine" Husni, Jeremy Leslie,
Luis Mendo, Horst Moser, David Renard, Boz Temple-Morris, Victor
Zabrockis; And also: Valerio d'Alimonte, Werner Amann, Aurelio Angius,
Marie-Caude Beaud, Jean-Claude Bintz, Nancy Braun, Barbara Buck,
Anne-Catherine Breit, Corinne Briault, Mary Carey, Catherine Chevreux,
Angelo Cirimele, Alain Cunisse, Laurent Daubach, Gudrun Dohl, Hans
Fellner, Jacques Floret, Francis Gasparotto, Ilka Grabener, Joanna
Grodecki, Thierry Hausermann, Sonia Hoffmann, Alexis Juncosa, Toon
Koehorst, Robert Klanten, Christina Koutsospyrou, Jo Kox, David
Laurent, Andres Lejona, Dany Lucas, Johann Marcot, Jean-Christophe
Massinon, Mike Maurer, Steph Meyers, Marc Molitor, Lyra Monteiro,
Raoul Mülheims, Neasden Control Center, Fred Neuen, Isabelle Ney,
Jeff Nothum, David Quiles, Valerie Quilez, Gino Ricca, Frank Sameri,
Stephanie Simon, Pamela Sticht, Fred Thouillot, Jannetje in 't Veld; The
teams of Casino Luxembourg – Forum d'art contemporain, bizart, John
Brown, nVision as well as Luxembourg and Greater Region, European
Capital of Culture 2007 for their passion and their patience.

We Love Magazines – picture credits: p30/31 still life by PSC; p37
Esquire covers courtesy of Esquire Magazine; p42 Rolling Stone and
Vanity Fair covers Vintage Magazine Archive (VMA); p53 Vu cover
VMA; p54/5 still life by PSC, Vu VMA; p67 Drum BAHA; p68/9 still life
by PSC, Drum BAHA; p70 Spare Rib VMA; p82-92 PSC; p103 New
York magazine and Time Out VMA; p104/5 still life by PSC, New York
magazine VMA; p141 Big Issue courtesy of Big Issue; p142/3 still life by
PSC, Big Issue courtesy of Big Issue, portrait from Alamy; p164
Simplicissimus VMA; p165 Sniffing Glue VMA; p167 Ty i Ja VMA;
p180/1 still life by PSC; p182 Yellow Book VMA; p184-9 Martin Beddall.
Other magazines from the collections of Jeremy Leslie and Mike Koedinger.

baby, baby, baby magazine / www.babybabybaby.com.mx / Foto: Napoleón Habeica

colophon

Call for entries

We are continually expanding our archive. If you are a magazine publisher, or want to dispose of a collection of back issues, please send single copies of unusual / interesting magazines (recent and not-so-recent editions are accepted, particularly launch issues, limited editions, etc.) to:

**Colophon, Mike Koedinger,
PO Box 728, L-2017 Luxembourg**
and help add to our collection.

If you are a magazine publisher, please get in touch with us at **office@mikekoedinger.com** – we constantly update the website with fresh interviews, your latest cover images, any staff changes and much more.

If you come across an unusual magazine on your travels that you'd love to share with us, please send an email to the above address.

The more we share, the more we know.

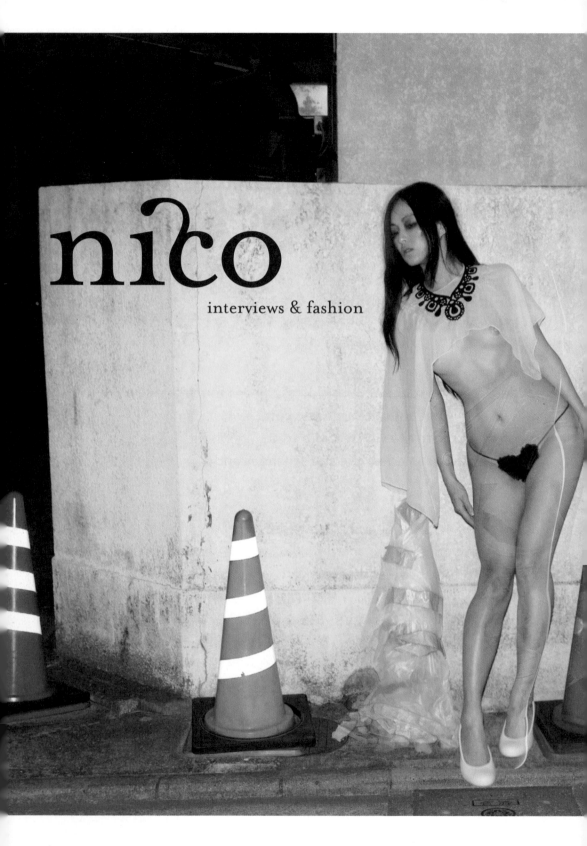

nico

interviews & fashion

international issue
bi-annual
www.nicomagazine.com

Publisher
Mike Koedinger
www.mikekoedinger.com
mike@mikekoedinger.com

Advertising
Tempo
www.tempo.lu
aurelio.angius@tempo.lu

Mike Koedinger
Independent Publisher